NATIONAL GEOGRAPHIC magazine
has found a new universal language …
the Language of the Photograph!
—*John Oliver La Gorce, 1915*

THE PHOTOGRAPHS ON THESE PAGES—OF THE EARTH AND HUMANITY,
OF THE EXOTIC AND THE FAMILIAR—ARE MILESTONES,
EACH A FINE MOMENT IN THE EVOLUTION OF THAT
UNIVERSAL LANGUAGE.

NATIONAL GEOGRAPHIC PHOTOGRAPHS

THE

MILESTONES

NATIONAL GEOGRAPHIC

WASHINGTON, D.C.

CONTENTS

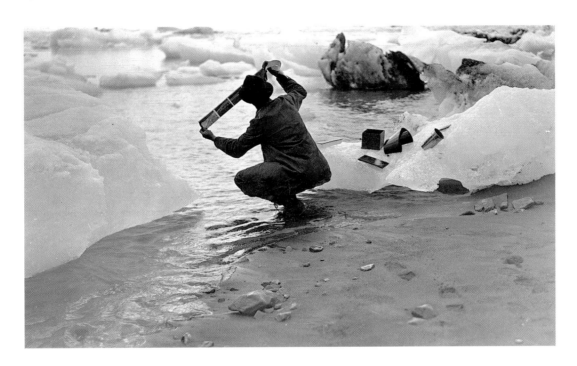

CIP & COPYRIGHT APPEAR ON PAGE 336

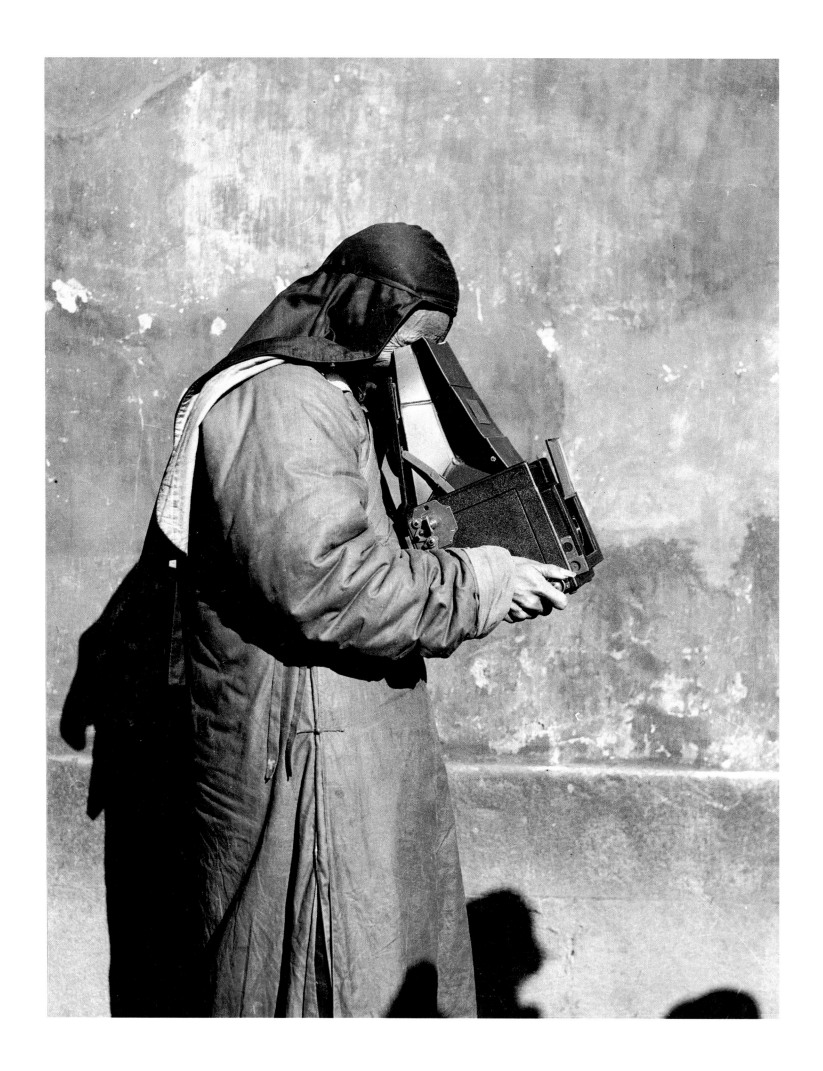

INTRODUCTION

Foundations

Leah Bendavid-Val

We were born into a NATIONAL GEOGRAPHIC world—a colorful place of exotic tribal peoples and fantastic animals living benign and wild lives in breathtaking landscapes—a glorious, good world where anything seemed possible. What gradually gave this viewpoint pictorial shape was gathered together with enormous enthusiasm in over a century of collecting, a still growing Society archive of more than ten million photographs, both published and unpublished. Far ahead of his time, Gilbert Hovey Grosvenor, the quintessential GEOGRAPHIC editor and the guiding soul of the Society, understood the educational (and public relations) possibilities in using stunning photographs and avidly acquired them for the GEOGRAPHIC from both public and private sources. He published them lavishly while experimenting with new printing technologies, and even took pictures of his own on world travels. Treasures still available in this incomparable archive range from old Russian lantern slides of tsarist times to raw, startling photographs from Robert E. Peary's turn-of-the century Arctic expeditions, from panoramic 19th-century images of the American West to rare scenes of China in the 1920s, from bird's-eye views from stratospheric balloons to explorations leagues under the sea. Many of these and similar Geographic milestones (a good number never published) will be introduced in this book.

Gilbert Hovey Grosvenor imbued his son Melville with his photographic passion, and he, in turn, passed it along to his son Gilbert M. Grosvenor. Along the way, the love of photography took root as unshakable Society policy, surviving lean fiscal times and fashion's ups and downs both outside and inside the GEOGRAPHIC. At first the young Gilbert H. Grosvenor faced outright hostility from Geographic board members when he decided to feature photography in the magazine. "Photography

Joel Sartore

OKLAHOMA, 1991 • In getting so close to young captive eagles soon to be released, the photographer must don camouflage so a human form won't imprint. This, the thinking goes, will help the birds remain wild.

Maynard Owen Williams

CHINA, 1921 • *Opposite:* Two thousand or more Buddhist monks lived on the Chinese island of Pu-to. They all resented being photographed—until one clever cameraman gave them the chance of looking through the lens themselves.

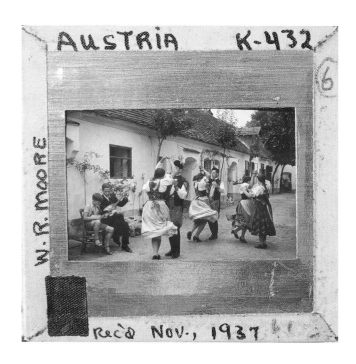

W. Robert Moore
AUSTRIA, 1937 • Kodachrome, which was introduced by
Eastman only a year earlier, made possible dramatic action in
color in the 35mm format. No one, at the time, worried that the
color would fade.

was not taken seriously by intellectuals at the turn of the century," says his grandson
Gil, now Chairman of the Board and past President. "The issue erupted in our
boardroom, but the controversy went further than photography. The real root of it
was the policy of offering geography to the lay reader. The photographs were the
crowning blow, but the idea that the magazine was evolving into a journal to appeal
to a mass audience, not strictly for the scientific community, that was the big issue,
and photography was strongly connected to that issue."

But once photography was embraced, the commitment was total. Amazed
themselves at each photographic success, the GEOGRAPHIC's editors assumed that
readers would be just as curious about what it took to get the pictures. The early
articles described in detail the risks of photographing in chillingly inhospitable
places, the ingenuity behind technical innovations, and even the simple joys of actu-
ally recording an exotic event. In long captions ample space was allowed for the
photographer's own words, which were designed to entertain as well as to satisfy
curiosity. Typical is the firsthand comment that accompanied a 1937 photograph of
folk dancers (left) taken in the village of Oslip, south of Vienna, Austria, by world-
traveling GEOGRAPHIC staff member W. Robert Moore.

> . . . I took potshots standing up and lying on my stomach in the dusty
> courtyard. Rough boots kicked up dust, dresses and petticoats swished; they
> were having an altogether good time in a spontaneous dance. So was I.

Like many GEOGRAPHIC pictures this particular photograph has had a second
life. Fished out of the archive, it was republished in October 1963 in a story entitled
"The Romance of the GEOGRAPHIC," which celebrated the Society's 75th anniver-
sary. In its reincarnation the picture illustrated how technology could now restore
natural color to a deteriorated image during the printing process. The new caption
touts this accomplishment: ". . . The 35-millimeter transparency . . . has faded con-
siderably since publication in April 1938, but that weakness has long been reme-
died." Color correcting, considered both a science and an art, was meant to serve
twin goals: the replication of reality and the dramatic showcasing of it. These were
not thought to be in conflict. Swept up in the technological beauty and possibility
of color, editors never considered color correction a form of manipulation or mis-
representation. This, after all, was an era in which the advancement of technology
was virtually an end in itself.

But at the time of the 75th anniversary celebrations, the Geographic was emerg-
ing from a period of stagnation that had lasted nearly a decade. One generation was
passing the torch to the next with even more emotional and logistical complications

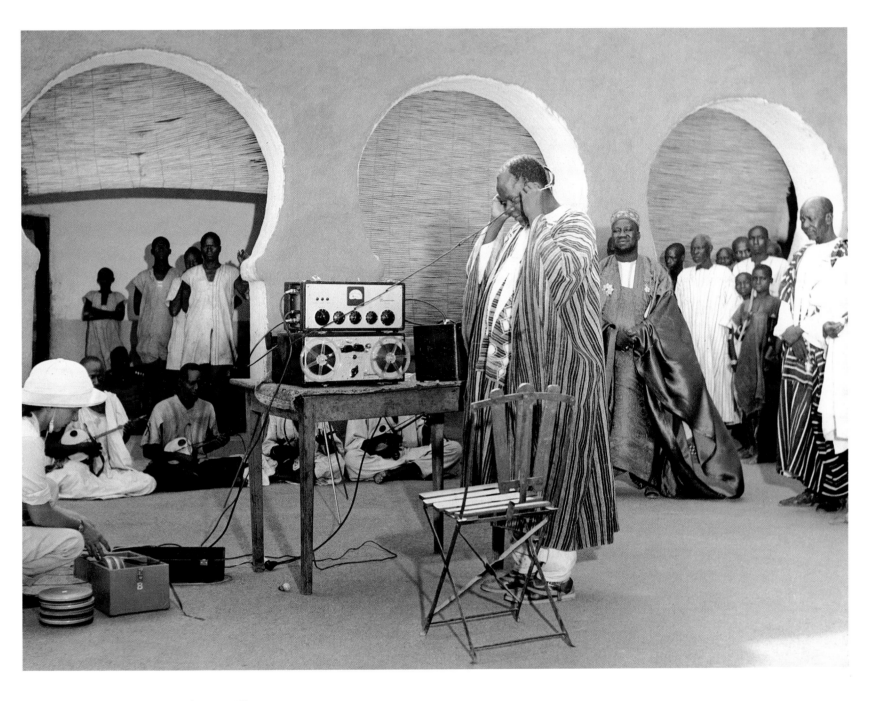

Arthur S. Alberts

UPPER VOLTA, 1951 • Though educated in Paris, Moro Naba, emperor of the Mossi tribe, was as astonished as his subjects to hear the play-back tape of a concert just recorded in his palace.

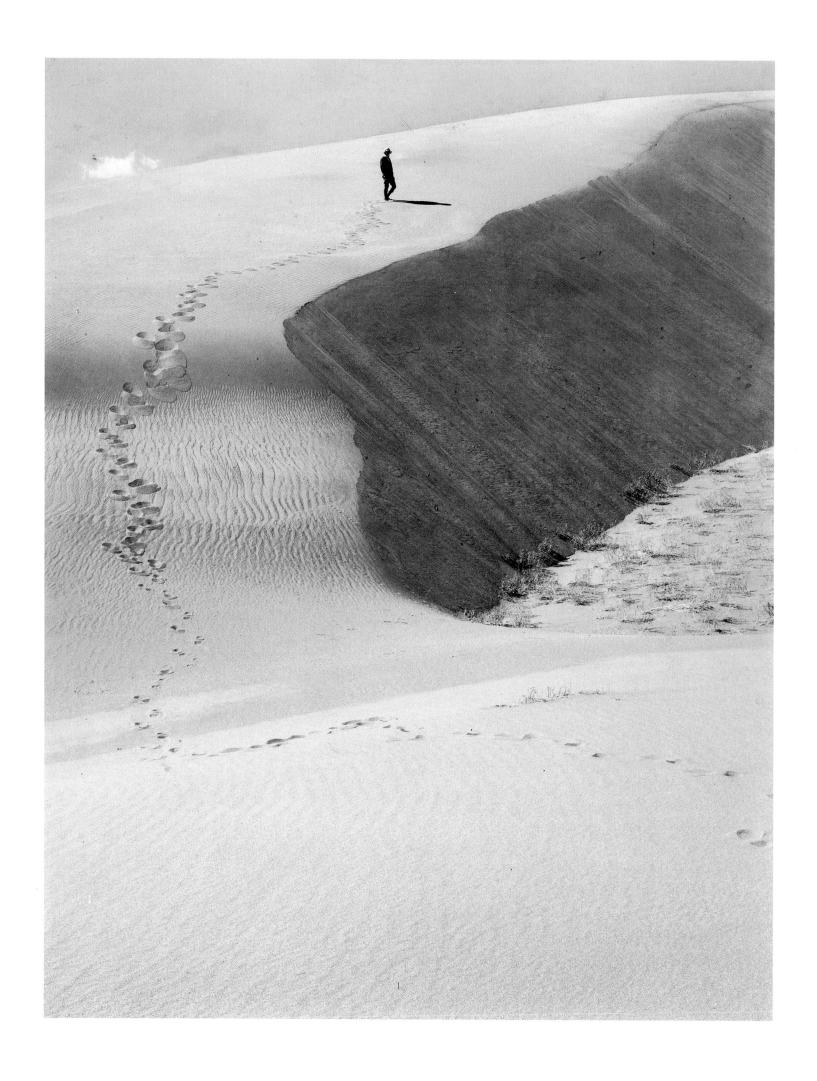

than such ordeals normally entail. Most of the Geographic's senior staff had been drawn to the Society's mission and its adventure at a young age and had remained for the long haul, devotedly staying until they became set in their ways.

Thomas J. Abercrombie, one of a half dozen new photographers recruited by Melville B. Grosvenor in the mid-1950s, grew up on *Life* magazine. In fact it was the journalistic pictures in *Life* and in Edward Steichen's groundbreaking book and the Museum of Modern Art exhibition, "The Family of Man," that had made him and his fellow rookies want to be photographers.

In the mid-fifties spontaneous-looking, journalistic pictures facilitated by small cameras had been around for 20 years, but the Geographic was using the 35-millimeter Leica only because of Kodachrome. Swept up in the technological beauty and possibility of color, the Society had partnered with photoengravers to produce state-of-the-art color printing. Color seduced Geographic staff people who never saw the compelling value of 35-mm portability—its ability to break down barriers between photographer and subject created by big cameras. When Abercrombie arrived, photographers in their late fifties were shooting color with 35-millimeter cameras simply so editors could run some color into an otherwise black-and-white story. Their formulas, using posed subjects and controlled composition, were time-worn, though some of the pictures managed to be good anyway.

Like all GEOGRAPHIC photographers, Abercrombie carried both black-and-white and color film and various cameras and lenses when then-novice picture editor Gil Grosvenor sent him to Lebanon on his first foreign assignment in 1957. He flung himself into the experience with an innate zest fueled by youthful energy and sent back more film than the GEOGRAPHIC had ever seen for a single story—over 150 rolls.

"Gil was very confused, and I got cables from him," Abercrombie recalls. "The sheer quantity overwhelmed him. They expected about a dozen rolls of color film, so I could have gotten away with as many as 16 rolls, not 150." The system couldn't handle it. When film was received in those days, the lab made small prints of each color and black-and-white frame (no contact sheets) and sent them to the photo library, where employees pasted every one into a book. "I came back to look at my stuff, and there were vast numbers of books full of ugly-looking pictures," Abercrombie says. In due course new systems that included contact sheets were instituted, "but the old crowd thought this was a waste of film," Abercrombie remembers. "Any photographer, given enough film, could get a good picture—like give a monkey a typewriter and an infinite amount of time. . . ."

Abercrombie stayed at the GEOGRAPHIC for nearly four decades and spent most of them working for Robert E. Gilka, the man who hired the photographers

Laura Gilpin
COLORADO, 1932 • *Opposite:* In 1807 the explorer Zebulon Pike was the first American to report that the San Luis dunes of Colorado shift continually but are always confined to a relatively small area—a miniature desert where footprints will soon vanish.

who took the majority of the pictures featured in the second half of this volume. Gilka began bringing in photographers almost four decades ago and continued to do so until about 1985. One of them, Annie Griffiths Belt, came onboard almost by accident in 1978. The year before, she happened to pick up the telephone at the small Minnesota paper where she was working, and, in answer to Gilka's question, was Jim Brandenburg there? she said no. In answer to his second question, could she shoot a hailstorm in a county about 60 miles away? she said yes. Her photograph was used, and this eventually gave her the courage to send in the portfolio that led to a job. "But that was Gilka's way," says Griffiths Belt. "He liked to find a candidate nobody had heard of, recognize something, and try to groom the person. That was his approach to his team."

Most of Gilka's hires came in through an internship program. "I don't know where the idea of the internships came from, to be truthful about it, but I latched onto it when I got the job and made it a regular thing, and we had three summer interns a year," says Gilka. "There must have been over a hundred. Emory Kristof was one of the interns, Bill Allard was an intern, Bruce Dale, Sam Abell, Jim Sugar, Dewitt Jones—a raft of people I believed in for some reason, I suppose."

But when it was first offered in 1957, Gilka himself didn't jump at the opportunity to leave his picture-editing post at the *Milwaukee Journal* for a job as a photo editor at the Society headquarters in Washington, D.C. He turned down the position because he felt too many people were involved in photography at the GEOGRAPHIC; there were too many layers for his taste. The magazine had eight picture editors in those days. They were divided into two groups, one handling only color and the other only black-and-white. Each group had its own head, and over them all was a chief picture editor. Magazine stories frequently used both color and black-and-white which meant that editors with conflicting ideas and agendas had to work together. Sometimes they didn't speak for days on end.

Melville Bell Grosvenor finally talked Gilka into coming to Washington as a black-and-white picture editor in 1958. At the time Melville was still sitting patiently at his entrepreneurial father's elbow, as he had been for years, waiting for his turn to run things. When G. H. Grosvenor finally stepped aside in 1957 Melville quickly moved toward a longtime dream: an all-color magazine—144 pages per issue, with the capability of running color on every page. Most staff in the early 1960s thought this an absurdly unrealizable fantasy, but Melville was determined. He involved himself in a structural overhaul that would affect the picture-editing arrangement, film-processing procedures, and relations with photographers in the field. A separate new department was put in place to review the increasing quantities of incoming film, so photographers would waste little field time and picture

editors little creative editing time on technical review work. Needless to say Melville got his way on color. It was a technical milestone, but he also wanted to update the aesthetics of photography at the GEOGRAPHIC, and he wanted more photographers who could shoot color.

In 1963 he offered Bob Gilka the position of director of photography. He was replacing Mississippi photographer Jim Godbold, the first to hold the title, who was leaving for a job with Encyclopedia Britannica. Godbold had hired several photo-journalists from his contacts at the National Press Photographers Association—Winfield Parks, Thomas Nebbia, Dean Conger, Albert Moldvay—but he hadn't stayed at the GEOGRAPHIC long enough to really define his own new role. In fact this was a job with creative possibilities unimagined by most key staff people on the magazine at the time.

"You're going to be responsible for all still photography in the National Geographic Society," Gilka remembers Grosvenor saying. "And I said something like, can I have that in writing?" So it went: the writing was produced, Gilka took the position, an office memorandum went out. "Everybody knew I was responsible for all those still photography assignments. I could go out and hire anybody I wanted," says Gilka, still a little incredulous decades later. He set out to exploit, in his words, the "power of that memorandum" to build a photographic staff. "Basically what I was looking for, or thought I was looking for," he says, "were people who 'saw' differently from the run of the mill, and I was also looking for versatility, because I don't like the star system."

Of the many photographers Gilka hired over the years, the most versatile was probably Jim Stanfield. Stanfield describes himself as a bit of a masochist who isn't satisfied until he's photographed his subject down to every blade of grass. His assignments have ranged from the Vatican to the Roman Empire, a story on choco-late, and even one on rats. "Gilka could talk you into anything," Stanfield says. "In three minutes he had me convinced that the rat story was going to be the best story in the world—I walked in shuddering and I walked out proud to be doing it." But somehow Gilka intimidated Stanfield, and most of the other photographers. "He is a man of very, very few words," Stanfield says. "You don't really know where he's coming from and you feel frightened, actually. But he's got a heart of gold and he'll do anything for you, and when he speaks you listen." (One thing Gilka told Stanfield, after complimenting some pictures he took of Canadian Indians at a pow-wow, was to get in closer, to get inside those tepees for a more personal look. Stanfield obeyed.)

Gil Grosvenor claims Gilka's greatest asset has been his skill with people, expressed by the way he supported his staff in the field. "Bob Gilka spent more than

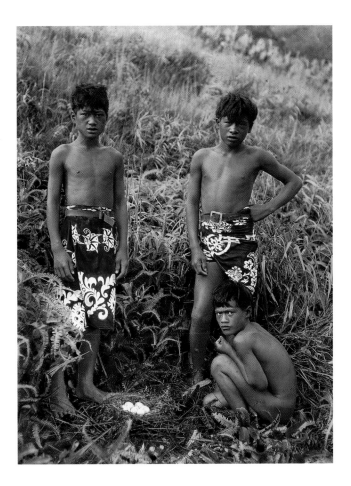

Rollo H. Beck

RAPA, TAHITI, 1925 • These Rapa boys, who served as guides, fail to grasp any cause for elation in the discovery of a Polynesian teal nest, and they do not welcome photography.

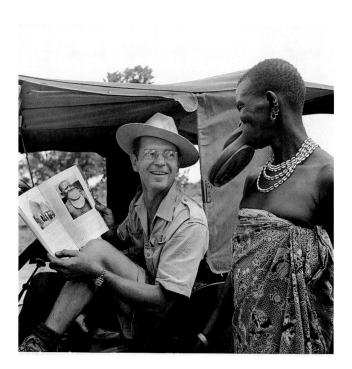

Volkmar Wenzel

FRENCH EQUATORIAL AFRICA, 1956 • A platter-lipped Sara woman peers at her look-alike in an earlier issue of the magazine. NATIONAL GEOGRAPHIC photographers stay in touch with their areas, for they're often called upon to return.

David Alan Harvey

GUATEMALA, 1995 • *Opposite:* The mayor of a Guatemalan village, a man seemingly unchanged by time, poses with his first NATIONAL GEOGRAPHIC portrait 13 years after it was taken.

one night repairing plumbing in somebody's house while a photographer was away," Grosvenor remembers. "He managed to make a photographer or a photographer's wife feel like they mattered." He became a father figure for many of the young men (and they were all men at first), away from home for the first time. "No matter how far away you were, it seemed like he was there," says Sam Abell who arrived as an intern in 1967. "He sent out his concern for you to the farthest corners of the earth. You always felt connected to the Geographic by the faith he had in you, by his integrity as an individual, by his habits of work."

But Abell adds, "I personally always tried to live up to that, and I never felt I did. I admired him but was intimidated, partly because the versatility and photography he wanted wasn't what I was best at or attracted to." Abell was mistaken about Gilka's response to his work: Gilka did appreciate Abell's restrained color and finely nuanced compositions. If that hadn't been the case, Abell wouldn't have been around very long.

Many would-be photographers were simply rejected when their portfolios came in. Early in the 1970s photographer Michael "Nick" Nichols was lighting caves to "escape from the army," and he sent his pictures to the GEOGRAPHIC. "I was petrified," he says. "I sat by my mailbox waiting for a letter of rejection to come from Bob Gilka, like kids all around this country did, and when one came I was devastated." But Nichols and the GEOGRAPHIC grew toward each other until eventually the match was made by Gilka's successor, Tom Kennedy. Nichols combined ambient light with flash and went on to bring back wildlife photographs like nothing anyone had seen before. He followed the tradition of working with Geographic technicians to tailor cameras to his particular vision, collaborating on shutters triggered by animals walking through infrared beams.

The Society's love affair with technology took imaginative forms from the start. Staff technicians devised gadgets to make the first color underwater pictures in 1926 and the first color aerials in 1930, pushing photography's limits to handle motion and light, and then experimenting with printing. Enormous effort and time could go into a single shot: Technical whiz Jack Fletcher, using large, heavy condensers stacked on a handcart, put together a 10,000 watt lighting unit to illuminate the House of Representatives for a GEOGRAPHIC photograph.

Remote cameras have held particular appeal. Bruce Dale used a remote camera to photograph a plane landing; Bill Curtsinger used one to photograph a shark tearing apart its prey; Charles "Flip" Nicklin used one to photograph whales from balloons. At each step the triggers, the lighting, the precise tailoring to the task at hand grew more sophisticated. In 1975 Gilka obtained a $25,000 development budget that was used by photographer Emory Kristof and his technical associates Al

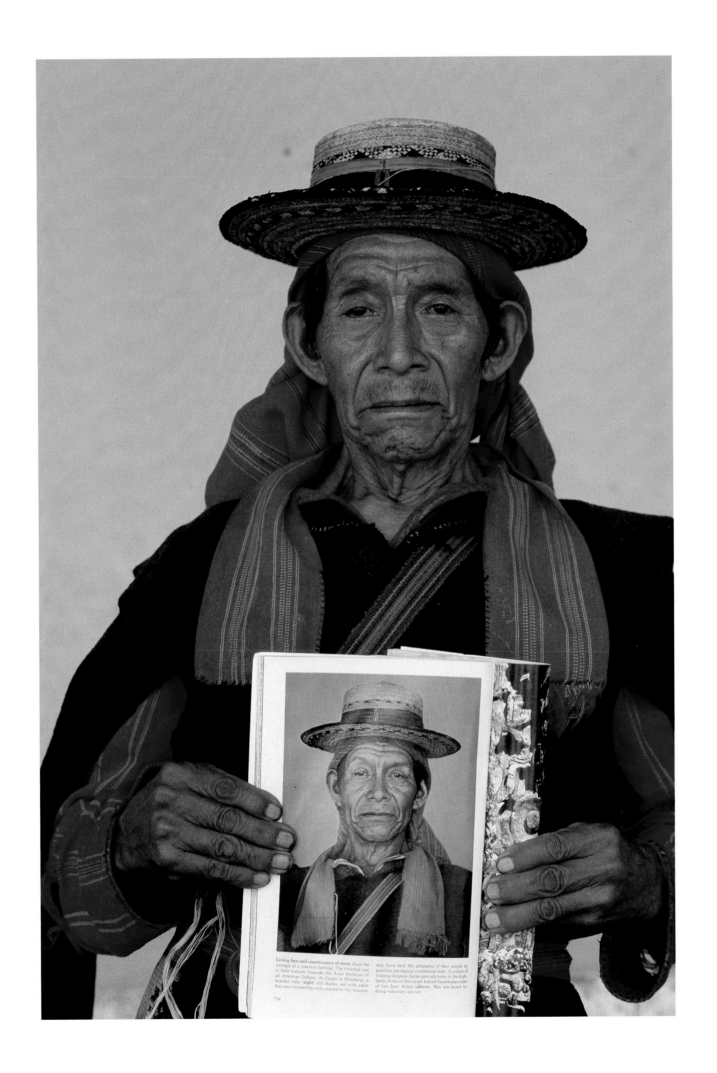

Living face and countenance of stone share the strength of a common heritage. The Oriental cast of their features bespeaks the Asian forebears of all American Indians. At Copán in Honduras, a bearded ruler (right) still flashes red with paint that once covered his stela, erected in 782. Leaders may have held the allegiance of their people by granting prestigious ceremonial tasks. A system of rotating religious duties prevails today in the highlands. Some of this straw-hatted Guatemalan elder of San Juan Atitán (above). Men win honor by doing voluntary service.

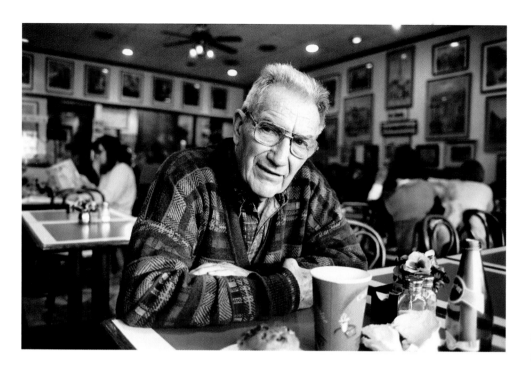

Sam Abell

WASHINGTON, D.C., 1999 • More than 30 years after arriving at NATIONAL GEOGRAPHIC as an intern, a photographer makes this affectionate portrait of his mentor, Robert E. Gilka, longtime director of photography. Even in retirement Gilka stays in touch with his former protégés.

Chandler and Pete Petrone to advance remote underwater lighting and gear. Kristof's groundbreaking pictures of the *Titanic* can be traced to the resources and freedom he was given to live out his obsession to go deeper and to photograph the impossibly dark depths.

Collaboration was always a key to success at the GEOGRAPHIC. Partnerships with technicians support all-important collaborations with editors. Photographers begin their involvement with a story at its conception and sometimes develop a relationship with a particular editor that succeeds from one assignment to the next. Louis Psihoyos, whimsical illustrator of science subjects, worked on several stories with editor Bill Douthitt, and pays him the compliment of being even crazier than himself. "Douthitt becomes an expert on any subject he's working on," says Psihoyos. "He takes home a pile of books and just absorbs them, then comes up with great ideas. Together we work out a shopping list." But Psihoyos is the one who suffers the occasional indignity of carrying out the ideas. Once, for a story on sleep, he photographed a full-grown stuffed sheep precariously suspended over a bed on a set he designed at Cornell University. Then he carried the sheep back to the GEOGRAPHIC, sitting next to it on the shuttle, futilely hoping he wouldn't be stared at. And Psihoyos has faced danger: For a dinosaur story he took 42 cases of equipment and about 5,000 feet of black velvet to China. "On a rutted road a 50-gallon gas tank in the back seat erupted and doused everything with gasoline," Psihoyos recalled. "It was like driving a Molotov cocktail around China with all the drivers smoking."

In spite of Gilka's desire that photographers be versatile, some got attached to particular subjects: Jim Brandenburg to wolves and Nick Nichols to apes, David Harvey to Spanish cultures, Loren McIntyre to South America, Dean Conger and Gerd Ludwig to Russia. The Society itself made a practice of reexamining subjects periodically, so it was logical for individual photographers to do the same. Once they learned the ropes, it was convenient to send them back over and over again. (As a corollary it made sense to have them stay in the field as long as it took to get the best photographs ever taken of their subjects.)

The photographers sometimes bring back remarkable, singular images as a result of the time spent, but more significantly their coverages are deep, subtle, intimate, and wide-ranging. Back in the office each photographer works with a picture editor to narrow hundreds of rolls of film to a slide tray of 80 pictures for the editor

to see. Assignments where photographer and picture editor share a common vision for stories and develop them together have the best chance of being published as originally conceived.

Writers and photographers sometimes travel separately and often stay in the field for different lengths of time, but collaboration between them is essential if a story is to have a single viewpoint and tone. Sam Abell adds another reason: "The field can be a lonely, distant place, and the writer can be the photographer's best friend," he says. "When I came to the Geographic I expected to work with great writers in a great way on great subjects. I didn't think I was the lone ranger, and this is a bad place for people to think they are."

But Abell is one of the photographers—with David Harvey, Bill Allard, Jodi Cobb, and others—who have something to say through their work and their own photographic style of seeing. Having hired them, Bob Gilka presided over an

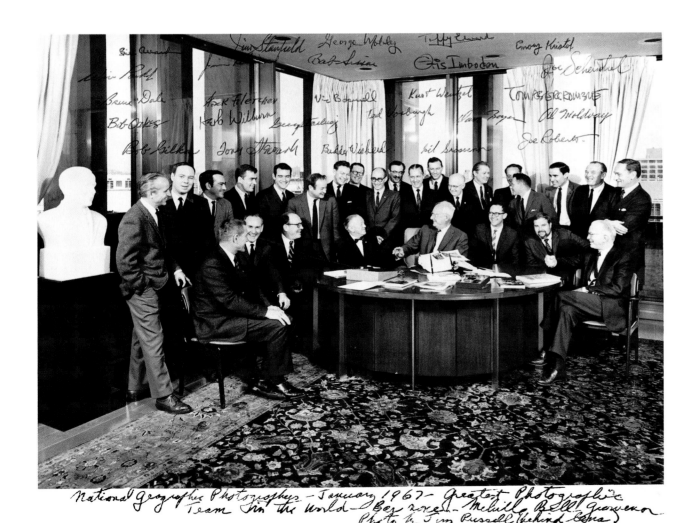

James E. Russell
WASHINGTON, D.C., 1967
The photographic staff of NATIONAL GEOGRAPHIC in the late 1960s, shown with editor Melville Bell Grosvenor. Several still work for the magazine. Back row: Robert S. Oakes, Bruce Dale, Winfield Parks, William Allard, James Stanfield, James Blair, John Fletcher, Guy Starling, Victor Boswell, Robert Sisson, Frederick Vosburgh, George Mobley, Walter Edwards, Volkmar Wentzel, Otis Imboden, David Boyer, Emory Kristof, Joseph Scherschel, Albert Moldvay. Front row: Robert Gilka, Herbert Wilburn, B. Anthony Stewart, Edwin Wisherd, Melville Bell Grosvenor, Gilbert M. Grosvenor, Thomas Abercrombie, J. Baylor Roberts.

evolution from versatility to specialization in style as well as subject. As long as he could keep the magazine's interest paramount, Gilka could support this, and he could allow, indeed encourage, each photographer to be his or her best self. His successors, Rich Clarkson, Tom Kennedy, and Kent Koberstein, working with the magazine's Editor, have built upon Gilka's successful groundwork, giving photographers a setting that allows them to express their passions and approaches.

What will happen now, with photographic technology undergoing its digital revolution? A related question might be, how did NATIONAL GEOGRAPHIC thrive all these years when so many other magazines came and went? From its early days, a century ago, the GEOGRAPHIC developed a fine and mysterious sense for balancing tradition and change—holding high its reputation, respecting its past, building on it, while keeping abreast of changing times, responding and occasionally contributing to change itself.

In the following chapters five outstanding photography curators independently consider the legacy of National Geographic photography, its present importance and future prospects. Following each of their essays we present a selection of fine photographs from the era they contemplate. Special portfolios showcase important photographic themes and accomplishments that span the whole of National Geographic history.

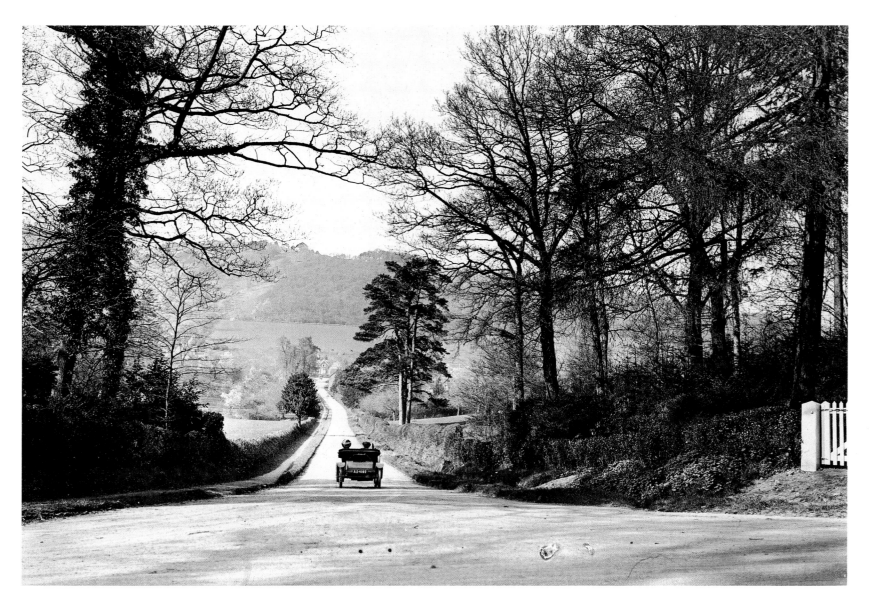

A.W. Cutler

ENGLAND, 1915 • A motorist drives through the beautiful Abberley Hills of Worcestershire, a section of rural England especially popular for an afternoon expedition. The stillness of the scene and the remoteness of the automobile among the hedgerows reflect the photographic approach more than the experience of the driver.

Sam Abell

WALES, 1993 • *Following pages:* Imagination, skill, and chance come together in this photograph that introduces an article on the decline of Britain's ubiquitous hedgerows after centuries of service.

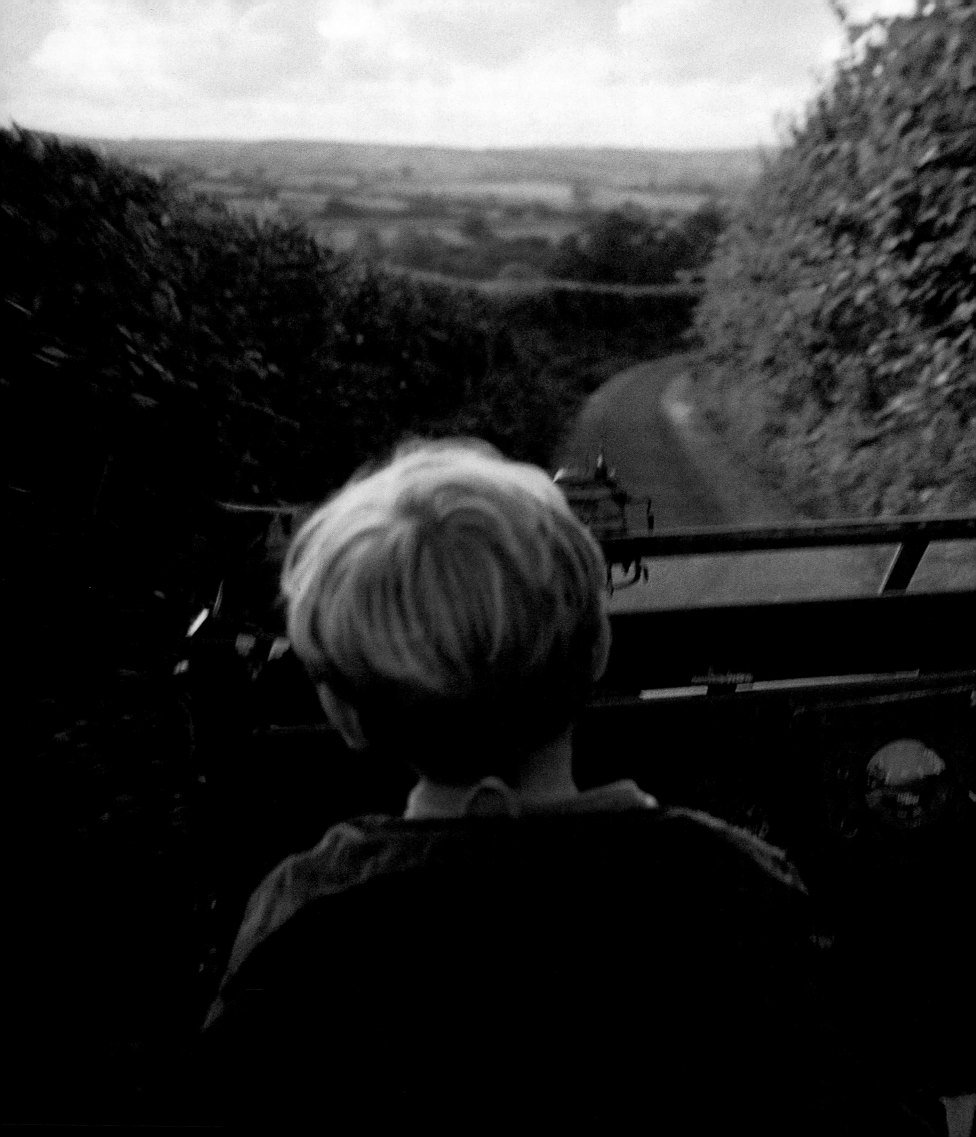

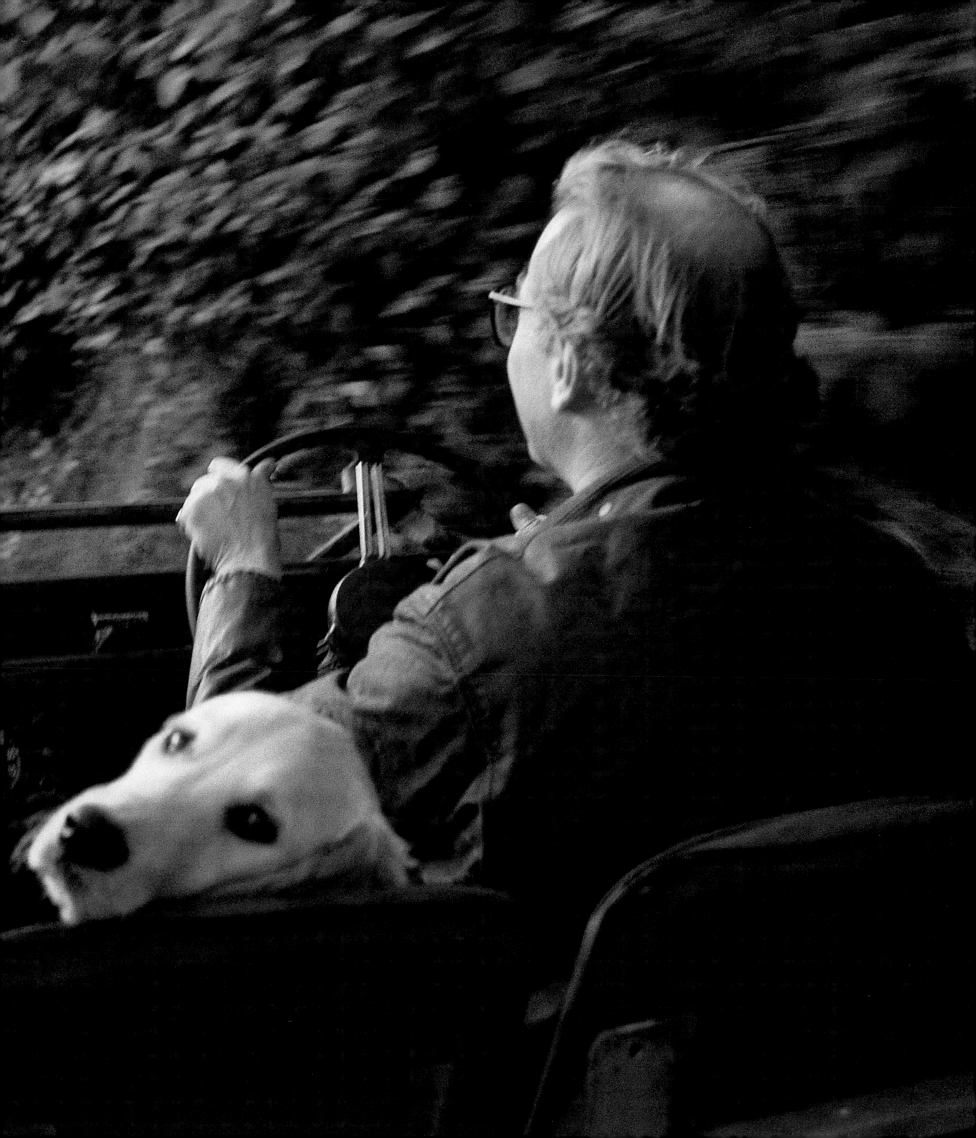

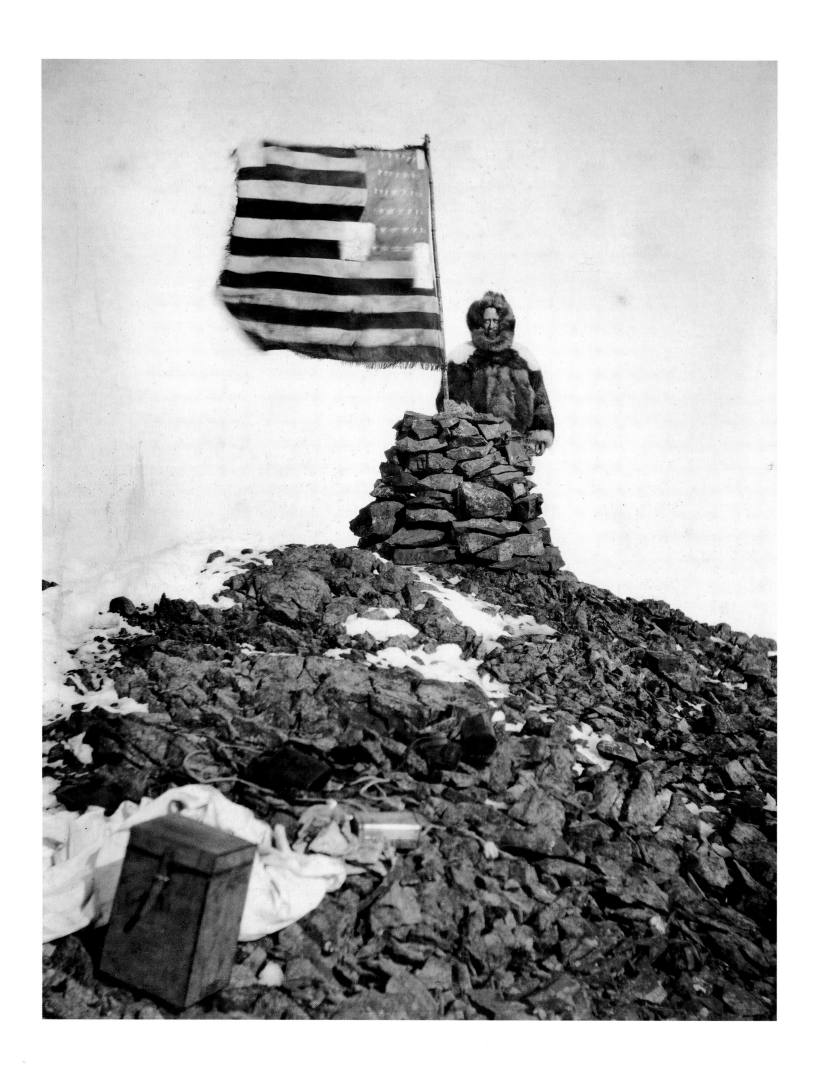

1888-1930

Novelty and Possibility

Robert A. Sobieszek

In America, long before the advent of television documentaries, long before the launching of Discovery Channel and such programs as Nova, Mutual of Omaha's Animal Kingdom, The Undersea World of Jacques Cousteau, or the World of National Geographic, and even before our exposure to educational filmstrips in high school classrooms, we usually had to satisfy our desire for exploring the world's visual wonders by turning the pages of illustrated magazines. The choices for the World War II generation, however, were fairly limited. *Life* and *Look* were much too topical and newsy, *Smithsonian* was far too textual and historically disposed, and *Time* only infrequently ran features on what could loosely be called world geography. Only one periodical truly satisfied our cravings for information and images on a regular basis. Only one was cherished over the years and all-too-often archived in boxes in the attic for reasons no one could clearly articulate except that most could not bear to dispose of a single copy. Only one American popular journal was a coveted status symbol in certain foreign lands during the 1950s, lending a cachet of sophistication by association to anyone seen carrying an issue. And only one was immediately recognizable by its distinctive format and its cover of yellow borders with laurel trim: it could only be the NATIONAL GEOGRAPHIC magazine. In its pages, we could freely wander the earth, explore beneath the sea, travel to distant planets and stars, and be introduced to unfamiliar and fascinating cultures and customs. Through this magazine's text and its illustrations, especially its photography, we gained an education certainly not to be found in our schools. It is not surprising, therefore, to learn that in 1912 Alexander Graham Bell, a member of the Society's board of managers, had already claimed that the GEOGRAPHIC was "the greatest educational journal of the world." Through this magazine we were, indeed, worldwide armchair travelers.

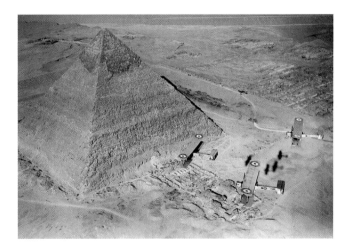

Ariel Varges,
International Newsreel Corp.
EGYPT, 1926 • In the early days, photographs printed in NATIONAL GEOGRAPHIC came from many sources, including the news services. This unusual aerial view of the pyramid of the Pharaoh Cheops was appreciated by the magazine's editors.

Robert E. Peary Collection
CANADA, 1906 • *Opposite:* Through 11 seasons of Arctic exploration, this tattered flag at Cape Stallworthy accompanied Adm. Robert E. Peary until a final scrap of it was deposited at his goal, the North Pole, on April 6, 1909. The explorer's photographs are now in the Society's archives.

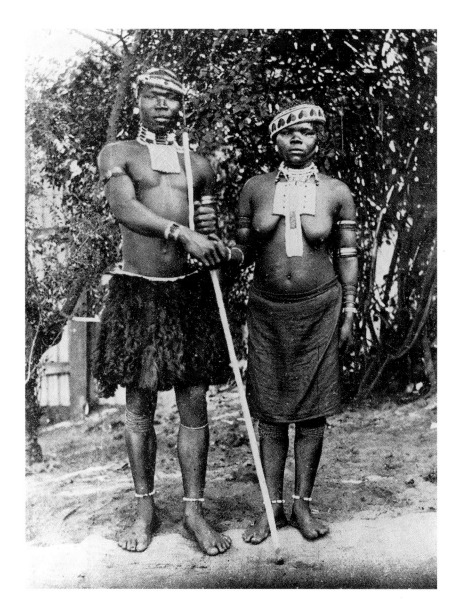

Unknown Photographer

AFRICA, 1896 • Captioned "Zulu Bride and Bridegroom," this image was indeed a milestone for the GEOGRAPHIC. It was the first of numerous pictures to be published of indigenous peoples "as they are."

In the 19th century many travelers went abroad to explore and to experience, to unite the twin desires of romantic or spiritual adventure and realistic or scientific observation with the ultimate objective of collecting information that validated our world, our pasts, and ourselves. It did not matter whether our destination was a sylvan glen in Windsor or a storm-lashed seacoast along the Mediterranean, the ruins of El Karnak in Luxor or Casa Grande in Arizona, an island pagoda near Foochow or a railbed along the Columbia River. The camera made the collecting of information all that much easier, more complete, and seemingly more truthful and "factual" than ever before. Just two decades after photography was invented, the British photographer William Lake Price wrote:

In a multiplicity of ways, Photography has already added and will increasingly tend to contribute to the knowledge and happiness of mankind: by its means the aspect of our globe, from the tropics to the poles,—its inhabitants, from the dusky Nubian to the pale Esquimaux, its productions, animal and vegetable, the aspect of its cities, the outline of its mountains, are made familiar to us.

In this passage the critical terms are "knowledge" and "made familiar to us," for linked with knowledge and familiarity was the unspoken assumption of superiority and otherness. Discussing the photography of ancient monuments in 1851, French critic Francis Wey claimed that such surveys would "prove our superiority, our supremacy . . . by associating héliography with these peaceful conquests [*conquêtes pacifiques*]." By the camera, the world was visually conquered by Western photographers.

This supremacy could be either personal or cultural—either that of the poetic or artistic soul successfully wrestling with the awesome grandeur of Nature, or that of nations striving for political hegemony and economic expansion across the globe. Far from being neutral and objective, landscape and topographic photography of the 19th century is fraught with hidden agendas and biases. For the artist the most mundane field in the Île de France could carry with it an appreciation of contemporary agrarian reform and urban growth, while the most spectacular rock formations and operatic mountainscapes of the American West were charged with a variety of subtexts ranging from Emersonian Transcendentalism to the latest controversial theories of evolution. Even the simplest photograph of a tree could amount to an emblem of

history, social status, or political persuasion. For those who commissioned these photographs (publishers, railroads, governments, et al.) there was a complementary set of meanings. Foreign lands were carefully documented by French, German, and British photographers, as earlier they had been by draftsmen, "to produce more complete information than was common in Europe of the commercial resources of a country." The latest bridge or lighthouse testified to a nation's modernization and technological progress. The mountainous landscapes of the American territories were photographed first to help survey possible routes for rail lines and later to entice settlers and tourists westward. And all this was done in the service of geographic knowledge.

What indeed was geographic knowledge in 1888, the year of the founding of the National Geographic Society? The mission statement issued in the Society's original by-laws simply stated: "The object of this Society is the increase and diffusion of geographic knowledge." In his introductory address to the Society that year, its first president, Gardiner G. Hubbard, spoke of the various historical geographies—comparative, political, and mathematical—and to these he added "geographic art," or cartography. From a slightly more positivist and scientific position, the Society had been organized into four broad sections—geographies of the land, of the sea (oceanography), of the air (meteorology), and the "geographic distribution of life" (ethnography). To these a section devoted to the "abstract science of geographic art, including the art of mapmaking," was appended. Citing modern American progress in adding to the contributions of European geographers, Hubbard argued that geographic knowledge directed the "current of exploration into the most useful channels," so that, for instance, by understanding the seas "it may now be possible to feed the world from the ocean." By the end of its first four decades, however, articles in the magazine had added other geographic categories, at least conceptually if not administratively. In 1903 William A. White published "The Geographical Distribution of Insanity in the United States," in which California was sometimes deemed to be least able to improve; and in 1919 an essay by J. R. Hildebrand was entitled "The Geography of Games: How the Sports of Nations Form a Gazetteer of the Habits and Histories of Their Peoples." In other words, geography was simply an ordering discipline, one by which anything could be abstracted, mapped, charted, indexed, measured, and placed into comparison with whatever was similar or dissimilar to it. Photography in the NATIONAL GEOGRAPHIC magazine was vastly instrumental in fostering this comparative study.

Geography is certainly a highly accredited field of study, and there are few individuals who are not entertained by images—whether verbal or visual—of distant lands, remote civilizations, and "exotic" peoples. But geography during the late 19th and early 20th centuries was neither a detached nor a disinterested cultural activity. It was locked into synchronous step with Western European and American influence, expansion, and colonialism. Lands were explored in search of unmined

resources and economic return, and peoples were most often studied in comparison to a predominate Eurocentric human standard that had existed since the late 18th century. The very first land map published by the GEOGRAPHIC, in its second issue in early 1889, charted the "Appropriation of Africa by Europeans." By the end of the 19th century global trade, colonization, and immigration had presented Europeans and Americans with an overwhelming range of "others" who had to be understood and governed. In fact, it was widely assumed that it was the West's obligation to maintain the "moral government of the world." In such a climate, it is no coincidence that both anthropology and ethnography were invented in the 19th century, and that both were enlisted into the discipline of geography. In 1893, the GEOGRAPHIC published a lengthy essay on the nation's shifting demographics, distributing the population along the lines of "native born of native parents," "native born of foreign parents," "foreign born," and "colored." (Mention should be made that those we now refer to as "Native Americans" were not part of this census.) During the first two decades of this century, articles in the magazine bore such titles as "American Progress in Habana" (1902), "French Conquest of the Sahara" (1905), and "The Non-Christian Peoples of the Philippine Islands, With an Account of What has Been Done for Them under American Rule" (1913). Two photographs, a "before" and an "after," illustrate the article on Havana: the "before" is a street scene with what appear to be ruts and animal waste, the "after" is the exact same scene with the road cleaned and graded, and a small boy dressed in his Sunday-best poses for the unidentified cameraman. Visually, these images argue the entire case.

Prior to the 1880s and with only a few, minor exceptions, magazine illustrations were customarily line engravings frequently copied or traced from photographs. Illustrating books with actual photographs then necessitated pasting prints into the pages by hand, a labor-intensive and costly proposition. Developing an economical means of photomechanically illustrating books and periodicals was eagerly sought after, but it was not until the invention of a screened, halftone printing process that a practical solution was found, which in turn revolutionized pictorial books, magazines, and newspapers. Pioneers like Frederic Eugene Ives and Stephen Henry Horgan in America and George Meissenbach in Germany had managed to convert the photographic image into a relief block or metal plate that could be inked and printed along with typeset texts. The *New York Daily Graphic* in 1880, the *Leipzig Illustrirte Zeitung* in 1884, and the Paris *Le Journal illustré* in 1886 all featured halftone facsimiles of actual photographs. According to the historian Beaumont Newhall, the first picture magazine deliberately designed to be exclusively illustrated by photographs was probably the *Illustrated American,* which began in 1890. The contents of the first issue sound rather familiar for a popular picture magazine: images of the U. S. Navy, a dog show, the Chicago Post Office, historical sites in New Jersey, and 14 photographs picturing "A Trip to Brazil." Unfortunately for it,

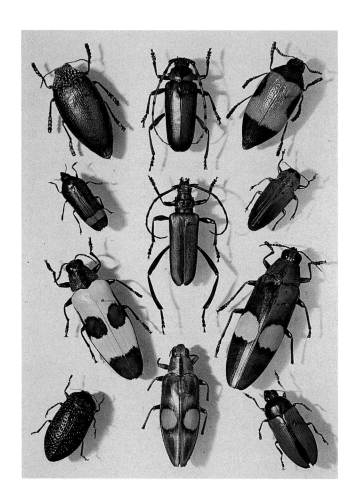

Edwin L. Wisherd

UNITED STATES, 1929 • Arrayed like gems on velvet, these insects of the metallic wood-borer and long-horned beetle families are among the most showy, their wing cases often rich in brilliant iridescence. The publication of photographs like these demonstrates the Society's interest in all aspects of the Earth's flora and fauna.

the *Illustrated American* seemed to run out of pictures within a few years and its entire character changed. Begun two years earlier, the NATIONAL GEOGRAPHIC magazine embraced photography more slowly, but within a decade its pages had become so filled with photographic images that the January 1896 issue added a subtitle: "An Illustrated Monthly."

A photograph of E. H. Butler's model of the North American continent, viewed as if seen from an orbiting satellite, is the featured illustration in the third number of the first volume of the GEOGRAPHIC in 1889. This "aerial" shot is loaded with significance, at least from a perspective of more than a century later. Obviously, the image is of a topographical modeling of a landmass that can be viewed in its entirety, measured, and contemplated. Apart from that, however, the image suggests one of the overwhelming themes that affected, if not infected, the National Geographic Society in its first two decades at least: expansion. Central to the "map" is the United States, the home of the Society. Central America and the Caribbean drift into shadows at the bottom right; while Canada, Alaska, and a part of Greenland rise to crown the continent. Through shading, it would appear that night is descending upon Greenland and the eastern coast of Canada and the United States, leaving the northern stretch of Alaska as the brightest area. It was, after all, 1889. Alaska had been purchased from Russia in 1867; it was becoming a site, especially in the Yukon, of extraordinary land and mineral speculation; and it was the closest American territory to the elusive North Pole. From the late 1880s to 1909, numerous international expeditions were organized to discover the North Pole, and successfully navigate a "Northwest Passage" across the North American continent to facilitate travel and trade. Neatly, at the very bottom of the model is Panama where the United States would begin construction of a canal that would further America's commercial interests even more. Here, then, is America's "Manifest Destiny" at its latest stage, and here is a symbol of what geography meant in the late 19th century—the description of the Earth's boundaries with an eye toward escaping them, both physically and mentally. North America is seen here, simulated by a model, standing for a conceptual center, and rendered with all the seeming fidelity and truthfulness of photography.

To appreciate the growth of photography in the magazine, a review of some photographic firsts during this period may now be in order. Initially, photographs in the GEOGRAPHIC were printed separately on what appears to be slightly heavier paper stock than was used for the texts and advertisements. The very first photograph of a natural scene appeared in March 1890: a depiction of Herald Island, bearing about 8°W (magnetic), taken by a J. Q. Lovell of the U. S. Navy. It shows a dreary bit of treeless land in the Arctic rising above a gray sea and under an overcast sky, the precursor of banal and inartistic images provided to the Geographic for more than a century. The first photographic image to be printed on the same page

as the text is found in an essay on forest management in the June 22, 1894, issue and depicts a controlled forest of German spruce trees. The first portrait, in the March 1896 issue, was of the Arctic explorer Dr. Fridtjof Nansen, who had mysteriously disappeared on his futile 1893 quest for the North Pole and an inland sea route and suddenly reappeared in 1896. The first disaster pictures, in September of that year, were of the effects of a tsunami in Japan. Also in November 1896, an ethnographic portrait of bare-chested natives, captioned "Zulu Bride and Bridegroom," was published. It is the first of all those vaguely salacious images of bare-breasted females that lured prepubescent males to the pages of the magazine for decades, and stands midpoint between the anthropometric photographs of clothed Madagascar natives taken by Désiré Charnay in 1863 and the social taxonomies of the German people photographed by August Sander in the late 1920s. The first photographs to be copyrighted by a photographer in the pages of the GEOGRAPHIC were by the preeminent Seattle-based photographer Edward S. Curtis, illustrating articles on the mineral resources of Alaska and the northwest passes to the Yukon in April 1898. Nothing in these desolate and strangely alien landscapes would seem to announce the pictorial genius of Curtis's much more famous portraits of Native Americans that would eventually be published in the magazine in 1907. Finally, color photography made an entrance with a hand-colored image of William W. Chapin's "Peasant in Rain-Coat and Hat: Seoul, Korea" in November 1910, accompanied by 38 other images. Reproductions of Autochromes, the first commercially available color photography, would have to wait until the July 1914 issue.

The GEOGRAPHIC relied on three different sources for its photography almost from the start. First, there were the explorers, scientists, and naturalists who were amateur photographers with little, if any, skills in the art of photography, but who, every so often, managed to make surprisingly good images. Second, images were acquired from picture services such as Underwood & Underwood whose photographs were fairly prosaic but functional documents, or the Pillsbury Picture Co. whose photography of Yosemite in the July 1915 issue anticipated that of Ansel Adams. Third, there were the commercial and professional photographers whose names have entered the canon of photographic history and others that should have. Among the so-called amateurs during the early years, there are a few names that immediately come to mind: Willard D. Johnson, Alexander G. McAdie, Ferdinand Ellerman, Wilson A. Bentley, and George Shiras 3d. Johnson, McAdie, and Ellerman could only be called meteorological photographers. Johnson's images such as his "Cloud Scenery of the High Plains"—the closing scene in the December 1898 issue—not only serve as able records of cloud formations, but are poetic testaments to nature's operatics. For the July 1907 issue, McAdie, forecast official of the U. S. Weather Bureau at San Francisco, was equally adept at rendering the lifting and billowing fog banks from his view atop Mount Tamalpais; as was Ellerman, stationed at

the Carnegie Institute Solar Observatory atop Mount Wilson, when he captured the majestic roiling of fog and storm clouds in the Los Angeles Basin and the San Gabriel Valley for the July 1908 issue. Following in the tradition of 19th-century paintings of cloud formations, like those of the British artist John Constable, these provocative images are not difficult to consider as somehow the direct antecedents of Alvin Langdon Coburn's symbolist plates in the limited edition of Shelley's "The Cloud," published in Los Angeles in 1912, or even of Alfred Stieglitz's famed series of cloud-scapes or equivalents of the 1920s.

Wilson A. Bentley is somewhat better known to historians as "Snowflake" Bentley, and his work is in at least four well-known photographic collections or archives. His remarkable macroscopic images of snowflakes, ice crystals, and dewdrops were begun as early as 1886 and featured in the January 1904 issue of the GEOGRAPHIC, and again in the January 1923 issue. Working out of Jericho, Vermont, Bentley photographed his specimens on black velvet out-of-doors during snow flurries; he then carefully cut away the film's emulsion surrounding the flakes and arrayed their crystalline forms in photographic grids of up to twelve on a sheet. One is immediately reminded of the delicate and near-abstract images of sea-urchin spines made by the British photographer Frederick H. Evans beginning in 1886, or of the typological grids of industrial architecture assembled by the contemporary German artists Bernd and Hilla Becher.

In a much different vein, George Shiras must be considered the father of animal night-stalking with a camera. His photography and texts filled two entire issues of the GEOGRAPHIC, in July 1906 and in June 1908; and his work was again revisited in the August 1921 issue. By 1906 Shiras had tracked wild game for nearly 20 years with a camera, had won a gold medal for his pictures at the Paris Exposition in 1900, and was awarded a grand prize at the St. Louis Exposition of 1901. His most spectacular images are those of birds in flight during the day and lynxes, deer, raccoons, and porcupines scurrying away or flash-frozen in surprise against the black of night. Shiras, slightly ahead of his time, firmly opposed the unfettered slaughter of wildlife by hunters. The time had come, he said, "when it is not necessary to convert the wilderness into an untenanted and silent waste in order to enjoy the sport of successfully hunting" wild game. And this was some decades before Osa and Martin Johnson made camera safaris in Africa a popular vacation excursion for the wealthy.

The photographs of the cameramen mentioned are the major pictorial high–

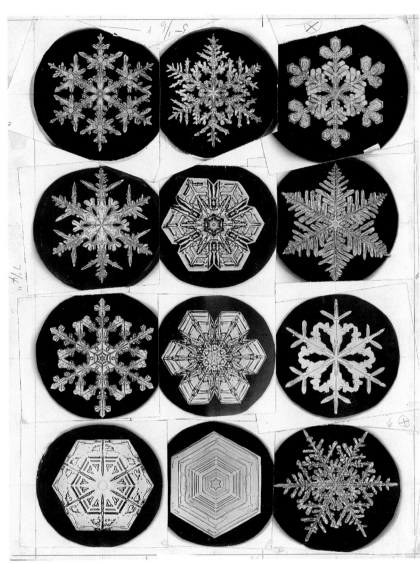

Wilson A. Bentley

VERMONT, 1923 • As early as 1886, "Snowflake" Bentley began to photograph individual snow crystals on black velvet and assemble their images into these grids. The middle crystal in the second row was his first successful specimen.

lights of the magazine up to 1907, although numerous single images by unidentified photographers stand out here and there: images of a steamship caught in a field of ice in the Bering Sea in 1896, a giant California redwood being cut down in 1899, or a striking anthropometric mug shot of a tattooed Philippine man in 1904 are only a few examples.

The greater majority of photographic illustrations in the GEOGRAPHIC during these years are quotidian gray images of geological expanses so devoid of any picturesque values that one might mistake them for studies of natural entropy or some prototypical conceptual exercises by late 20th-century artists like Robert Smithson or Lewis Baltz. Admittedly, pictures of this sort continued to be published; their aim was something other than aesthetic accomplishment. They also continue to be interspersed by many outstanding examples of photographic seeing and pictorial invention. In three issues, beginning in May 1907, it seems that someone paid unusual attention to the visual layouts, to the ordering of the images, and to their pictorial quality.

In May 1907, illustrating an article on the Rock City of Petra in today's Jordan, is Libbey and Hoskins's "Pharaoh's Treasury, Petra," a remarkably good shot of the ancient temple carved out of mountain wall and situated in a narrow and cramped canyon where photographing it was problematic. Libbey and Hoskins's names may not be familiar to most critics or historians, but the Editor of the magazine recognized their image for what it was and, for the first time, the GEOGRAPHIC commented directly on a particular photograph's quality; the caption reads: "The finest picture ever taken of this matchless monument of antiquity." The very next issue, June, ran an article entitled "Picturesque Paramaribo, the City That Was Exchanged for New York" by Harriet Chalmers Adams. Paramaribo, the capital of Suriname, was ceded to the Dutch by Britain in a historically prescient trade. That in itself is interesting for one of the magazine's pieces; what is much more significant are the illustrations—village scenes, descendants of escaped slaves posing in the "bush" in front of their thatched homes, and two of the most exceptional portraits ever to be run in the magazine. "A Belle of Surinam" and "Two Colored Girls of Surinam (Dutch Guiana)" are more than ethnographic documents, they are portraits, stunning portraits that instill dignity and humanity to their subjects. The "belle" is posed for a strictly formal, three-quarter-length portrait in the Western style; dressed in her richly patterned gown and headwear, she regally stands with one hand resting on a chair back, off to the side of a potted plant, and against what appears to be a painted backdrop. The two young women, on the other hand, are pictured as bust-length, against a blank white backdrop. Their clothes are as vibrantly patterned as is the "belle's," but what most sets this image apart from the single portrait is the wide, joyful smile stretching across the girl's face on the left. That these two images are positioned facing each other in the magazine is at once surprising and intelligent.

Who made this pictorial decision? That information is unavailable to us in the magazine itself. Who took these portraits, or even the other photographs that appear to be equally skillful approaches to their subjects? The only information we are given is that each photograph is "from Mrs. Harriet Chalmers Adams." Not "by" but "from." Adams was also the author of "The East Indians in the New World" in the July 1907 issue, an article on Hindu immigrants in Trinidad illustrated as well by some rather good photographs that are not credited at all. Adams's name also appears in the July 1915 issue within the article "The Wonderland of California" by Herman Whitaker, but here she is credited as the photographer of a spectacular shot of Vernal Falls in Yosemite National Park, one which, again like the work of H. C. Tibbets, Lucie King Harris, and the Pillsbury Picture Co., anticipates the grand landscape art of Ansel Adams.

Still, no matter who took the Suriname photographs, the decision to sequence them so sensitively is noteworthy. The same would apply to a pair of images facing each other in the July issue's "Expeditions Commanded by Americans," in which a portrait of a grave and serious Morris K. Jesup, president of the Peary Arctic Club and the bearer of an outstanding mustache and set of muttonchops, is shown oppo-site a live bull musk-ox whose drooping and solemn furred face bears an uncanny and rather humorous resemblance to Mr. Jesup's. In the same issue is a portfolio of full-page photographs by Edward S. Curtis, a prepublication selection from his pho-tographic survey, "The North American Indian." What is remarkable about these rather sensitive portraits of Native Americans is that they are images that do not appear in Curtis's final publication, out-takes, as it were, but just as polished and impressive. Again, the juxtaposition of the plates, such as the Hopi Maiden facing a San Ildefonso girl, is notable.

In the August 1915 issue, a photograph of a young boy drawing juice from an agave plant is cited as "from Mrs. Alexander Graham Bell." The Bells contributed significantly to the GEOGRAPHIC a number of times between 1902 and 1912, as well as later. Mr. Bell published at least four articles with sets of photographs illustrating tetrahedral kites and towers, an early aircraft or aerodrome, and a man-lifting kite. Mrs. Bell, apparently a collector of photographs on her travels, periodically gave the magazine images for publication.

For the January 1909 issue some of her pictures of shepherds and other peas-ant types were used to illustrate an article on "Sicily, Battle-Field of Nations and of Nature," a number of which bear a stylistic resemblance to the work of Count Wilhelm von Gloeden, a photographer noted for his mythologizing portraits of Sicilian peasants and blatantly homoerotic images of young nude boys. Von Gloeden's photography is showcased, in fact, in the December 1909 issue as a port-folio illustrating another essay on Sicily. The lead caption to the 27 plates claims that von Gloeden was attempting to photograph the "variety of race and romantic

charm of that island." Some of the plates, such as "A Sicilian Belle" and "Watching Mount Etna," are signature images by this photographer, and at least four feature nude or semi-nude young boys, while another is of a male youth in a sailor's outfit smoking a cigar. One has to wonder just what the picture editor's definition of photographic ethnography was at this time and whether it really could have been as naive as it now appears.

The GEOGRAPHIC's approach to the impending war in Eastern Europe was not quite so naive. The President of the United States, William Howard Taft, had an address published in the magazine in December 1911. Entitled "The Arbitration Treaties," Taft's text argued that the Panama Canal, then still under construction, would be defended by the United States against all foreign threats. Around the same time, the magazine began running articles on the Albania/Turkish conflict, most of which, like Edwin Pears' "Grass Never Grows Where the Turkish Hoof Has Trod" or James Bryce's "Two Possible Solutions for the Eastern Problem," were openly anti-Turkish and anti-Islam. A "particularly timely" map of Europe with the new Balkan borders was issued as a supplement to the magazine in August 1914. Both the March and April issues of 1917 were devoted almost exclusively to the First World War, although the March issue did contain 16 color photographs that included a number depicting young women clad in stereotypical Levantine dress that could only be described today as "orientalist." Perhaps reflecting the general mood of anxiety during the war, an advertisement for a new Savage automatic pistol appeared in this issue, asking in bold type, "Do You Love Your Wife? Can You Prove It?" An editorial appeared in the June 1918 issue entitled "Germany's Dream of World Domination." Later that year, Edwin A. Grosvenor's "The Races of Europe" and a map to those races was published. By December of 1919, the focus had shifted. Illustrated articles on military insignia and Mole and Thomas's famous images of thousands of soldiers arrayed as the Shield of the United States or the Emblem of the U. S. Marines were featured. And it was this war that contributed to the sudden increase in aviation and the GEOGRAPHIC's coverage of aerial expeditions across America and to Alaska in the following decade.

While the tone of the magazine had been somber immediately preceding and during the war years, the GEOGRAPHIC never lost sight of its mission statement. In August 1910, it featured the inordinately breathtaking views of the Grand Canyon by J. K. Hillers; and, in February of the next year, A. C. Vroman's quietly poetic scenes of Hopi culture illustrated Marion L. Oliver's "The Snake Dance." Perhaps the most interesting issue from a photographic point of view was that of April 1916. Presumably a bit of patriotic nationalism, Gilbert H. Grosvenor's long article "The Land of the Best" was accompanied by a more than usual number of black-and-white pictures and a portfolio of color plates. Panoramic views and landscapes by F. J. Haynes were intermixed with genre scenes, views of historical sites, and adamantly

kitschy fictions such as Edwin H. Lincoln's "The Barefoot Boy with Cheeks of Tan" who is portrayed on a dirt road on his way to the fishing hole. The color section begins with Franklin Pierce Knott's "A Pueblo Woman" at Laguna, New Mexico, the first color image in the GEOGRAPHIC to be reproduced from an Autochrome, a glass-plate photographic transparency whose emulsion consisted of potato starch and color dyes.

Following the war, the magazine began to increase the number of its color pages. Throughout the 1920s, a few photographers, such as Charles Martin, Jules Gervais-Courtellemont, and Luigi Pellerano, worked almost exclusively in color. Martin, whose black-and-white photographs had appeared as early as 1913, saw his "natural color photographs" in the December 1924 issue and worked with W. H. Longley to produce the first underwater Autochrome shots, which appeared in January 1927. Courtellemont covered Tunisia, France, Spain, and Egypt, while Pellerano photographed in Italian Libya. Fred Payne Clatworthy contributed portfolios of Western scenery in "natural color" in June 1928 and August 1929, notable for their lurid and saturated blues and violets. It is intriguing to think that the West's purple hills and sagebrush, so often referred to in the novels of the time, might have been so described from this photomechanical deformation of "natural color" and not from nature itself.

While a consistent theme of the GEOGRAPHIC's articles since almost the beginning, the American West became far more important after the war, and for potent reasons. First, it had all but been settled and rail travel was improving each year. Second, the automobile had given Americans vastly increased mobility. Combined, these two reasons built an empire of tourism within the United States. Beginning with the very first advertising that appeared in the January 1896 issue, ad pages in the GEOGRAPHIC were littered with railroad promotions. The Chesapeake and Ohio R.R.'s *Fast Flying Virginian* could transport riders from New York to Washington, from Cincinnati to St. Louis, and on to the West. It even had an observation car and a through dining car. The Burlington Route offered "winter tours in private pullman palace cars" from Chicago to San Francisco via southern or central routes. In the early twenties, more and more automobile advertisements are found in the magazine. One photograph, in October 1923 illustrating an article entitled "The Automobile Industry," captures the new mood perfectly. "At the End of the Trail: Glacier Point, Yosemite Park, California," shows a car perched atop a vertiginously cantilevered rock thousands of feet above the valley and surmounted by a dozen or so tourists waving their caps. Once the reserved spot where intrepid photographers or daring dancing girls posed to be photographed, it was now a stage for the automobile. "Through the automobile," the caption reads, "the American people have broken the bonds that formerly tied them to narrow localities." In January 1924 the magazine ran a piece entitled

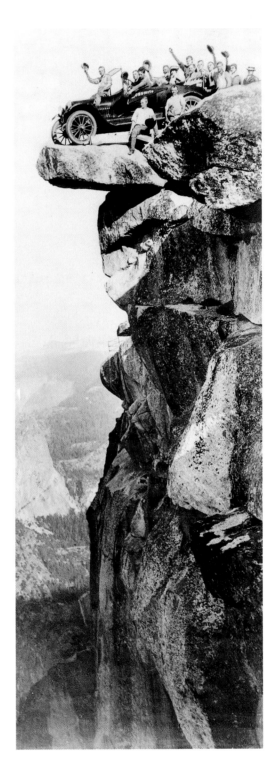

Unknown Photographer

CALIFORNIA, 1923 • In an automobile industry article celebrating the new mobility of the American people, this auto seems to have taken folks about as far as they can go. NATIONAL GEOGRAPHIC loved the automobile and photographed road trips domestic and remote.

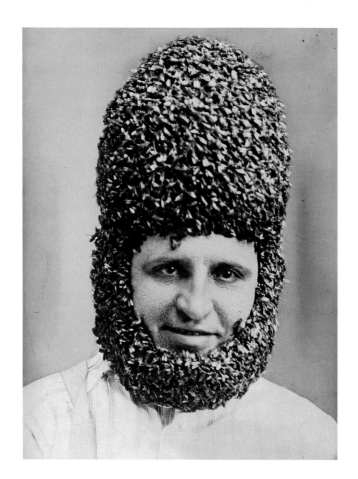

Wide World Photos

OHIO, 1929 • This Ohio beekeeper demonstrates that he understands honeybees, forming a living helmet and chin strap through a gentle and fearless handling of his swarm.

"Conquest of Sahara by Automobile"; and the following issue in November of that year, an essay on Luxembourg has the caption to a picture of a young, attractive woman reading: "She will welcome you to her father's inn in Esch-sur-Sûre. But she complains that she gets tired of having her picture taken by automobilists who visit her town."

Surrealism was the rage in the art world in the twenties, and, in a way, the GEOGRAPHIC contained its share of surreal images, although inadvertently. Basically it was a matter of scientists, photographers, and naturalist artists creating images that had never been seen before, beginning with N. A. Cobb's marvelous macroscopic shots of the common housefly in the May 1910 issue, including two terrifyingly alien-like views of the fly's head. In May 1913 and July 1914, David Fairchild, with help from his wife, Marian, published photographs of insects that became horrifying by the angle and scale imposed on them through Fairchild's macrophotography. In June 1921, E. J. Geske and W. J. Showalter's article "Familiar Grasses and Their Flowers" is illustrated not by photographs but by lithographic prints from Geske's paintings that are so luxuriously colored that in shape and form these plants appear as nothing less than works by a Surrealist artist like Max Ernst. Lithographs also illustrate William Crowder's "Living Jewels of the Sea" in September 1927. Ordinary varieties of ocean plankton are rendered by the author and look very much like some dreamlike phantoms imagined by Yves Tanguy or Matta. And, then, there is the wonderfully strange photograph, furnished to the magazine by Wide World Photos, of an Ohio beekeeper with his "Helmet and Chin Strap of Honey-Bees" seen on page six of the July 1929 issue. Yet, no matter how surreal certain of these images may appear, nothing surpasses an advertisement found in the very last issue of 1929. Just a month after the financial collapse of the American stock markets on October 29, too short a time to pull an ad from the pages, National City Company continued to urge readers of the Geographic to "Invest Today for Their Tomorrow!" More surprising is that six months after the crash the magazine still included advertisements for excursions and cruises, exotic fur coats, and expensive automobiles.

Advertising nevertheless continued unabated throughout the thirties, as did the growth of the GEOGRAPHIC's readership. What had started as an irregular journal for the diffusion of geographic knowledge in 1888, read by a select few, had become one of the most popular American periodicals by 1930 with subscriptions into the six digits and a readership exponentially greater if one factors in all the copies of the magazine read in doctors' and dentists' waiting rooms. The magazine certainly was and is not perfect, for it can only reflect the dominant perceptions and preconceptions of its time. One of the most famous geographers of our time, D. W. Meinig, once wrote, "Any landscape is composed not only of what lies before our eyes but what lies within our heads." To a great degree, and with all the faults of any era's

consciousness, the NATIONAL GEOGRAPHIC magazine has not only imparted vast amounts of information into our heads but has also certainly presented the entire world to our eyes through its photography. Considered carefully, this is a great achievement that has provided an incredibly important global archive of the geographies we all inhabit.

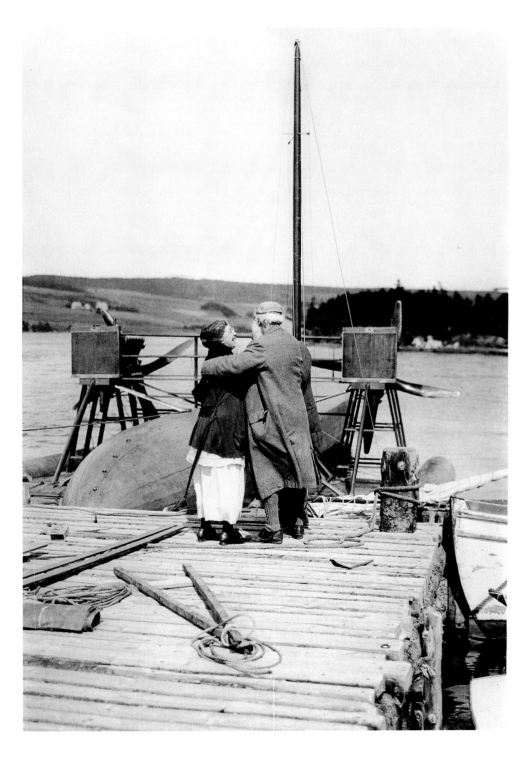

Gilbert H. Grosvenor
NOVA SCOTIA, 1919 • Inventor Alexander Graham Bell, a founder of the National Geographic Society, with his wife, Mabel, admires one of his designs, the HD-4, a hydrofoil that had just set a new world speedboat record of 71 miles per hour. Bell's inventive spirit was felt in every Society pursuit.

Gilbert H. Grosvenor
NOVA SCOTIA, 1908 • *Following pages:* Alexander Graham Bell, a founder of the National Geographic Society, the father-in-law of its first full-time Editor and forebear of two others, had long experimented with kites in hopes of being the first to invent a successful flying machine. His spectacular wheel-shaped kite was recorded by his photo-buff son-in-law, who had spent a month's salary on his camera.

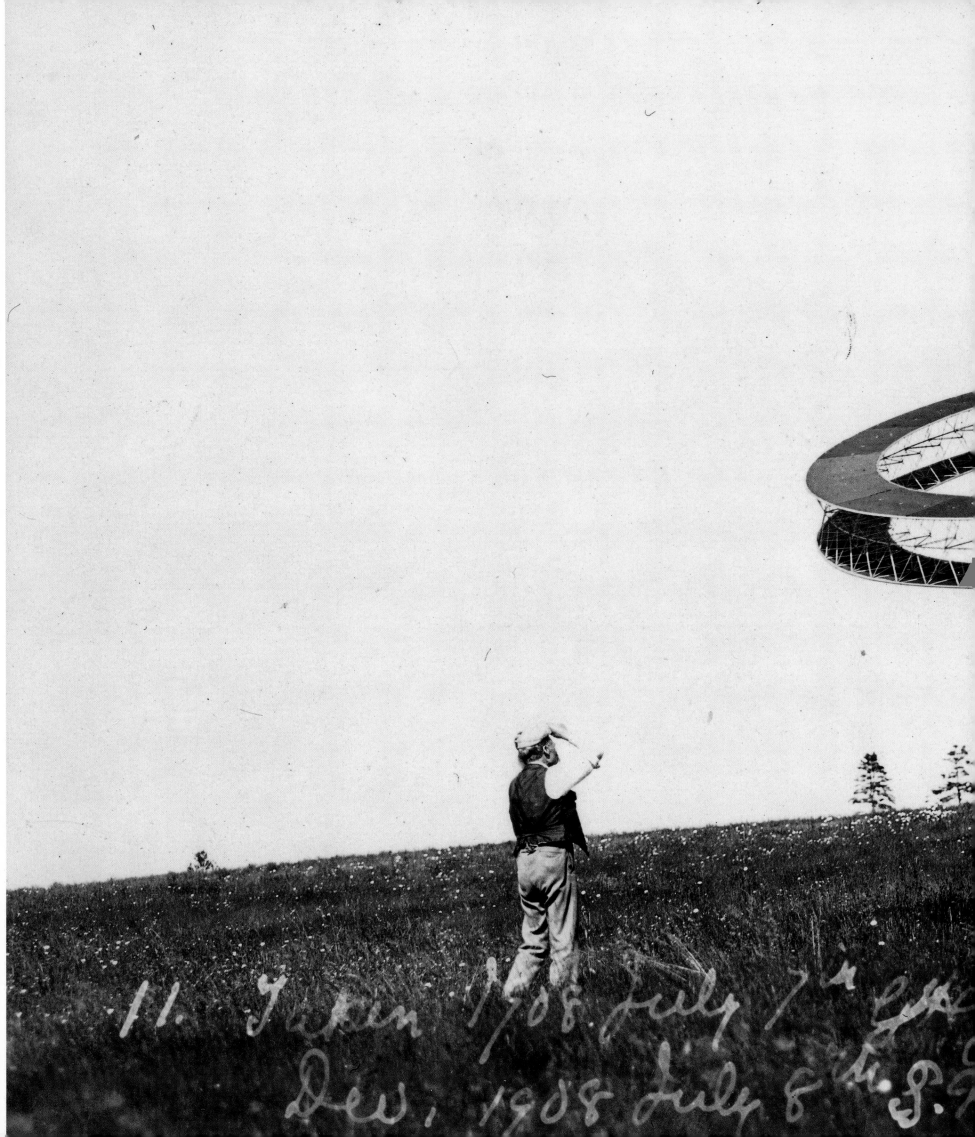

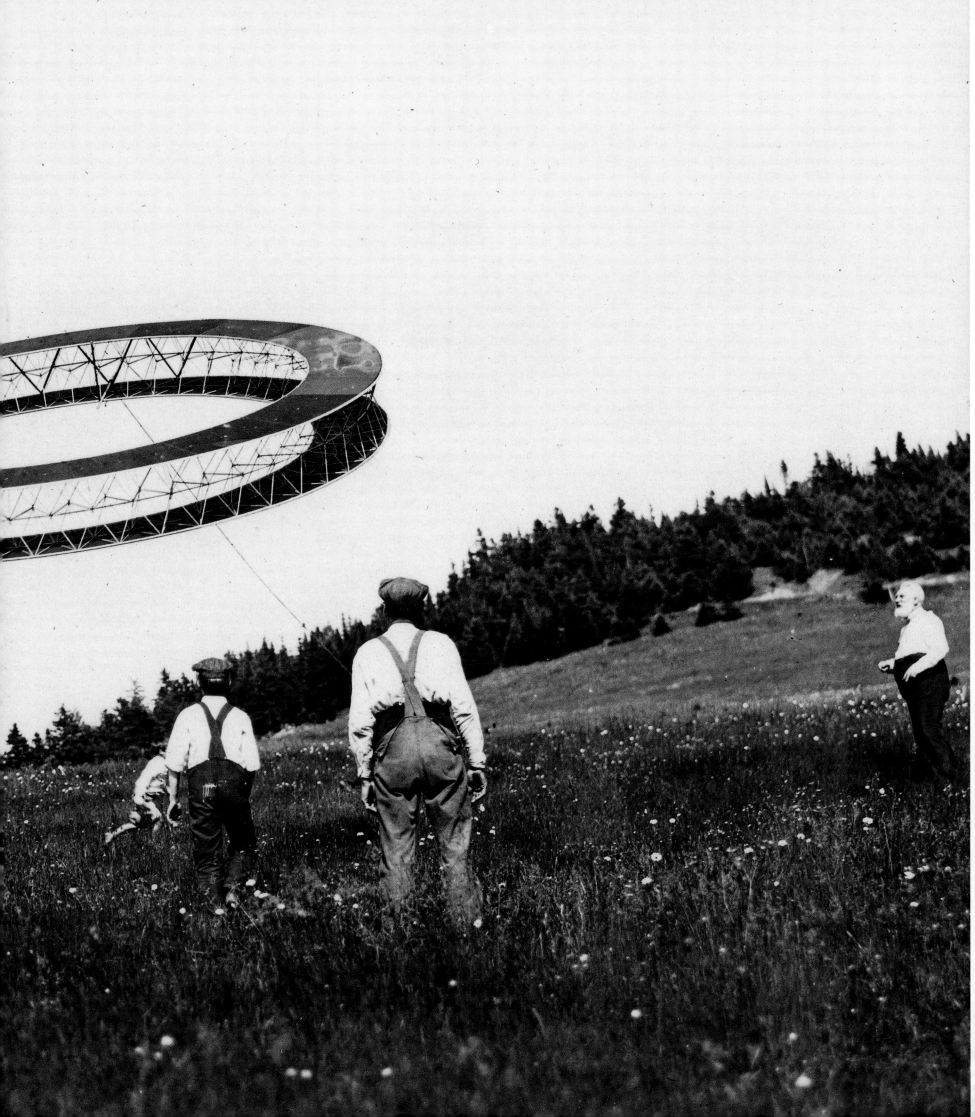

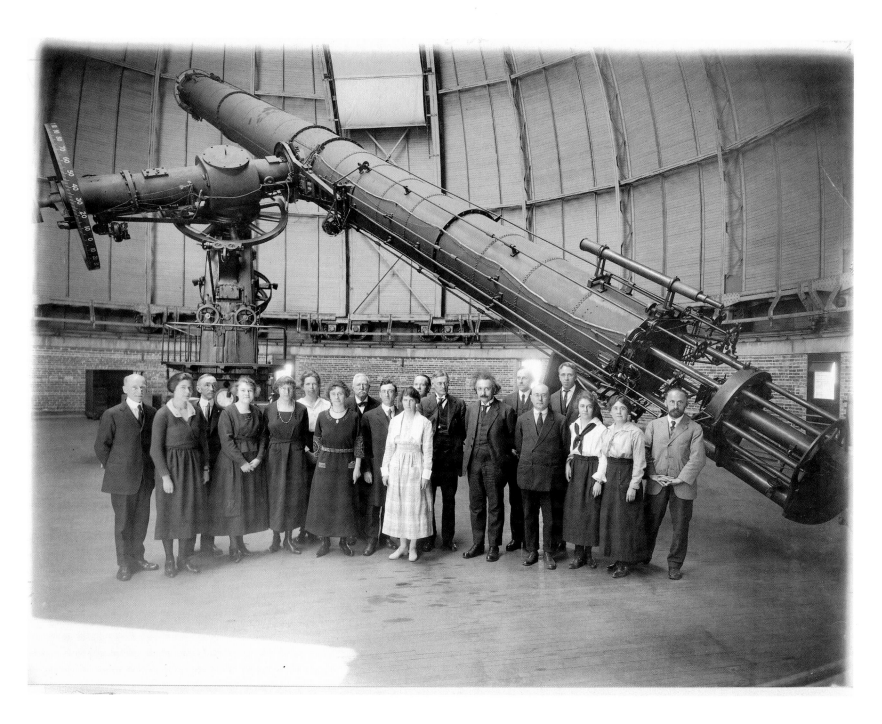

Unknown Photograher

WISCONSIN, 1921 • The staff of the Yerkes Observatory with Albert Einstein, Edwin Frost, Edward E. Barnard, George Van Biesbrock, and their companions, May 6, 1921.

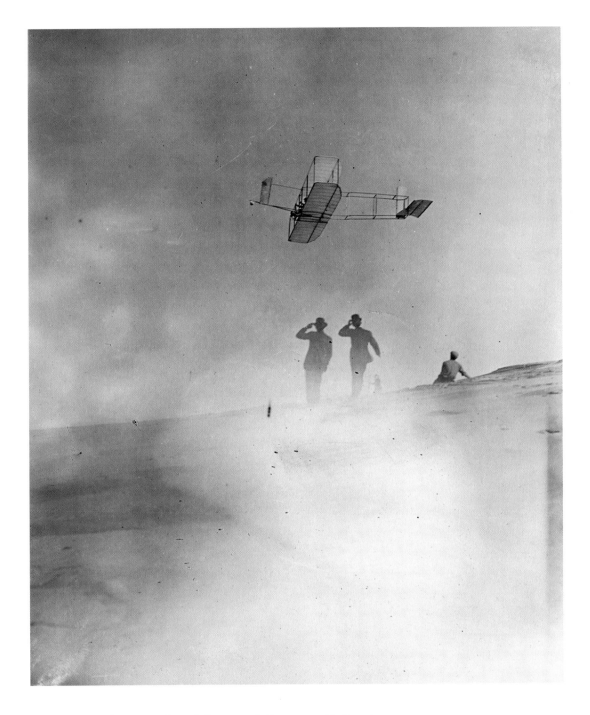

Unknown Photographer, Library of Congress Collection

NORTH CAROLINA, 1911 • Despite having achieved powered flight eight years earlier at Kitty Hawk, the Wright Brothers, Orville and Wilbur, continued to conduct glider experiments to improve the aerodynamics of their *Flyer*, which they had begun to manufacture in 1909.

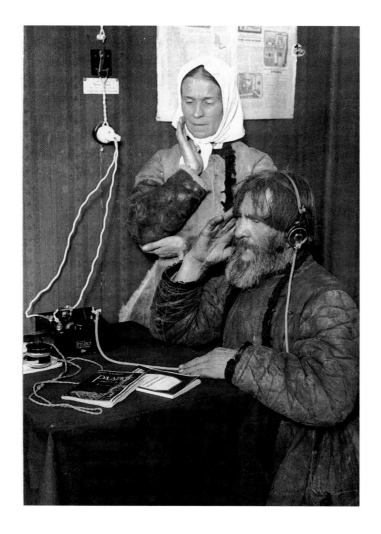

Unkown Photographer, Press-Cliché Russian News Photo Agency

RUSSIA, 1929 • In a series of pictures that show the impact of radio in the U.S.S.R., this one is captioned, "Peasants listening to a lecture transmitted by wireless."

F. Lambert

ALASKA, 1912 • *Right:* Members of the Alaska Boundary Commission, on an expedition to survey the 141st meridian defining the Alaska-Canada boundary, camp on the side of Mount Natazhat at an elevation of about 9,000 feet. They are drying their clothes the morning after a snowstorm.

Donald B. MacMillan

ARCTIC, 1920 • *Following pages:* Rough ice in the Polar Basin, this photograph was offered to GEOGRAPHIC readers as hard evidence of why it took man more than 300 years to reach the farthest North.

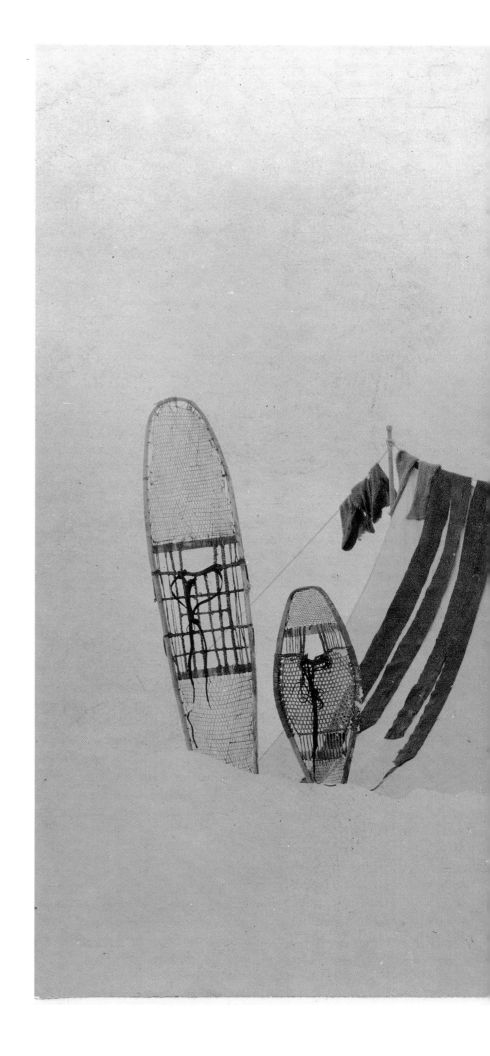

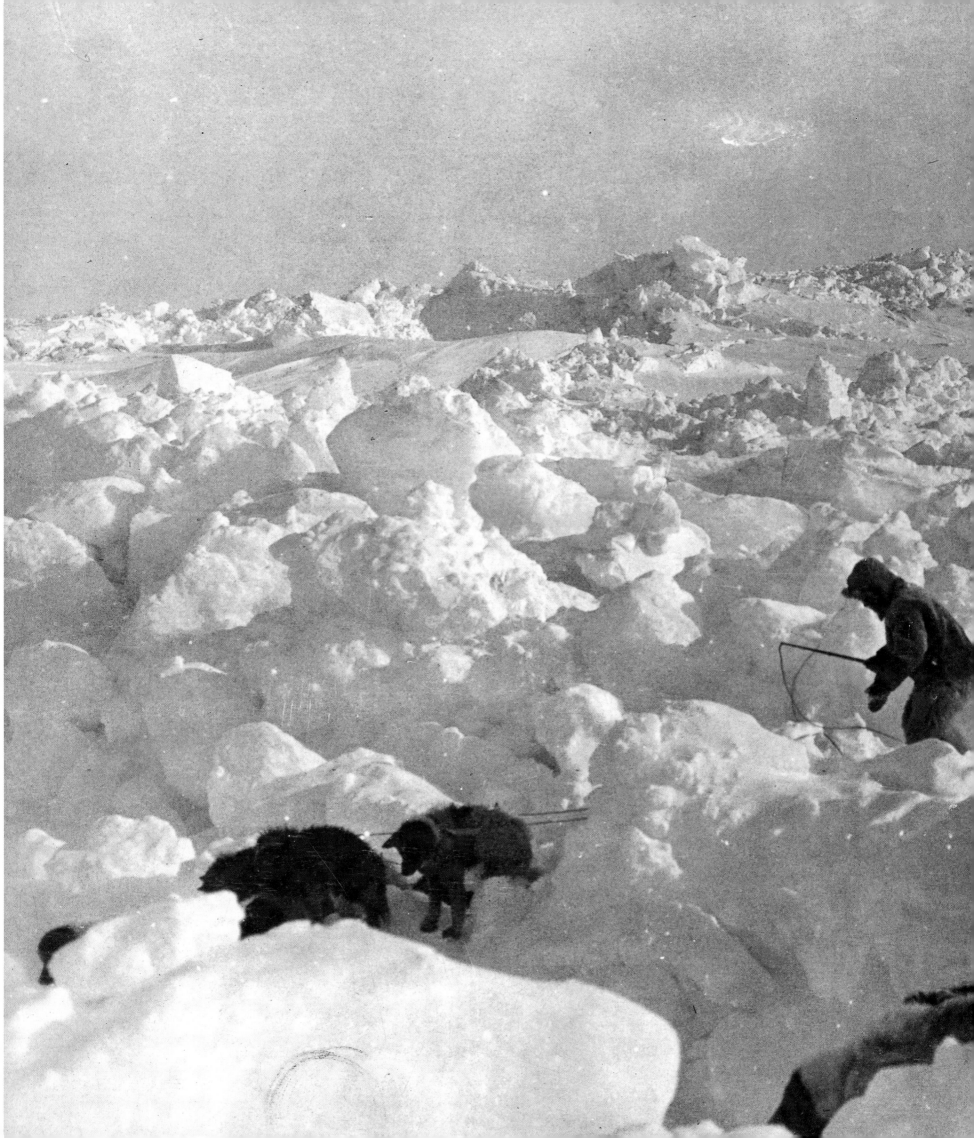

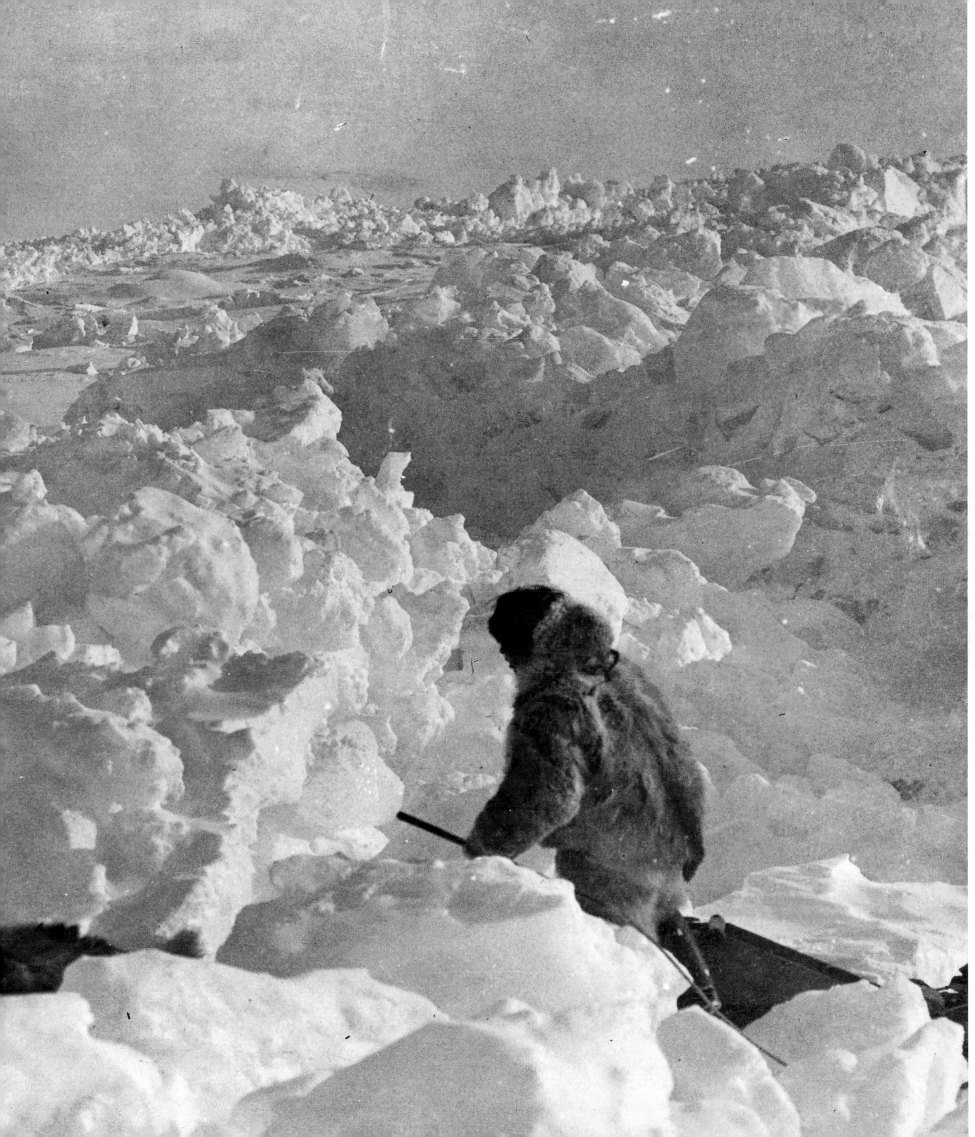

Hugh M. Smith

ALASKA, 1911 • In illustrating an article protesting the decimation of the fur seal, this photographer got too close to a harem and was charged by the bull. He was lucky to escape with his life and his heavy plate camera. Technicians retouched the image for added drama.

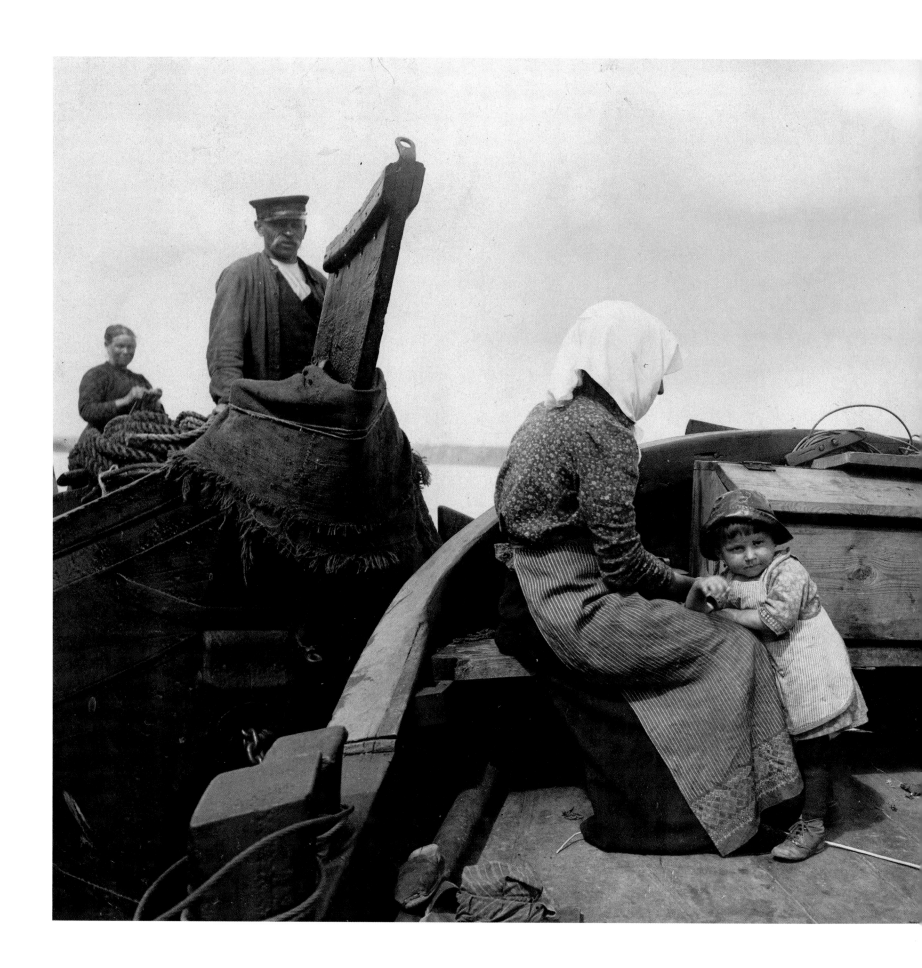

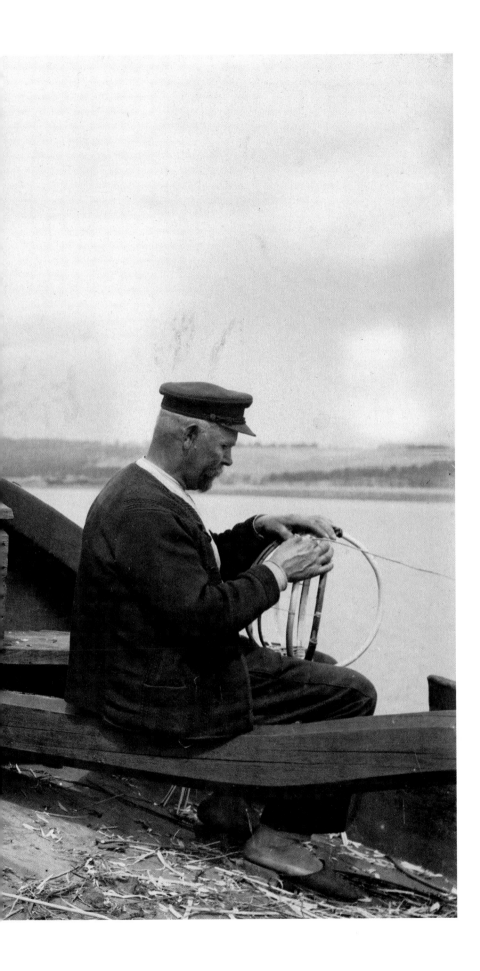

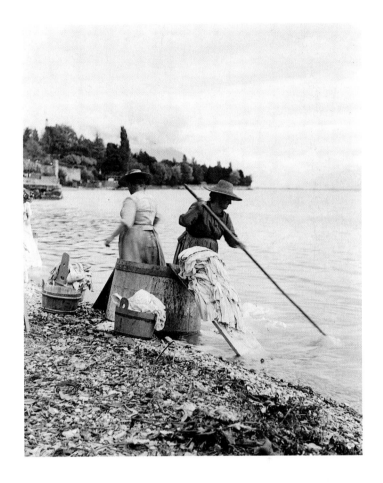

Donald McLeish

SWITZERLAND, 1916 • The laundresses of Vevey Lake, near Geneva, do their wash in a huge tub at water's edge and rinse in the lake, prodding the garments with long sticks.

Keystone View Company

LATVIA, 1924 • *Left:* This skillful photographer, an anonymous employee of a picture agency, demonstrates the kind of "seeing" that NATIONAL GEOGRAPHIC was beginning to value highly.

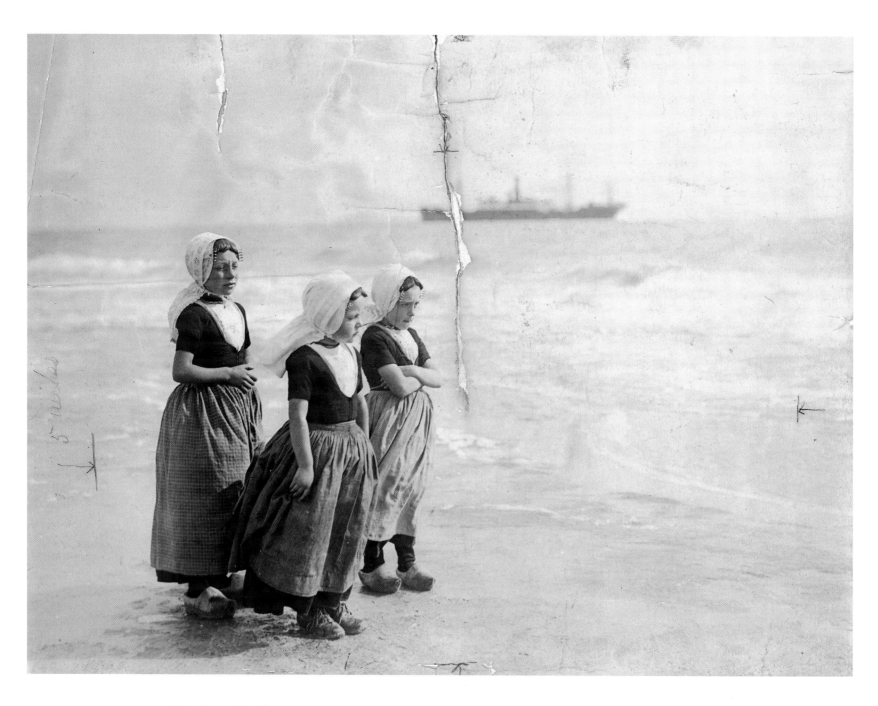

Hugh M. Smith

HOLLAND, 1910 • On the beach at Walcheren, three young girls in traditional dress, including wooden shoes,
stare out to sea in a vintage print still bearing the crop marks from its publication nearly 90 years ago.

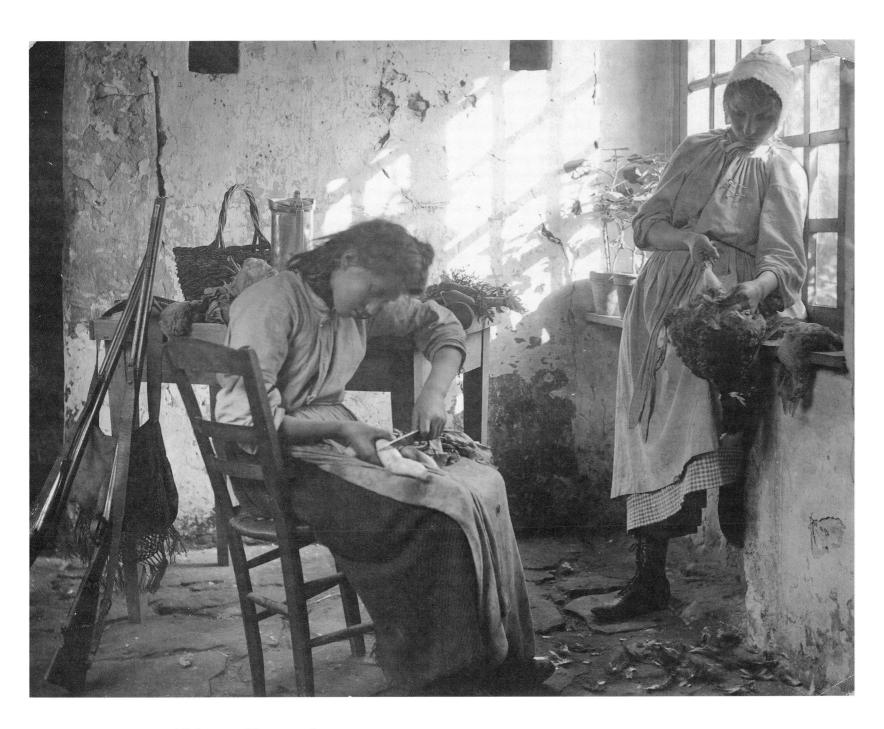

Unknown Photographer

FRANCE, 1918 • NATIONAL GEOGRAPHIC introduced its readers to life in France in an issue that appeared the same month as the Armistice that ended the First World War. This picture was paired with the following quote: "Probably there is not in all the world the equal of the French housewife in economy and efficiency."

A. Segers

CHINA, 1927 • *Following pages:* Accommodations in a small Chinese inn include space on a heated stone bed and a hard millet-filled pillow. Placement of one's queue, which had begun to disappear by this time, and which side to sleep on seem to have followed custom.

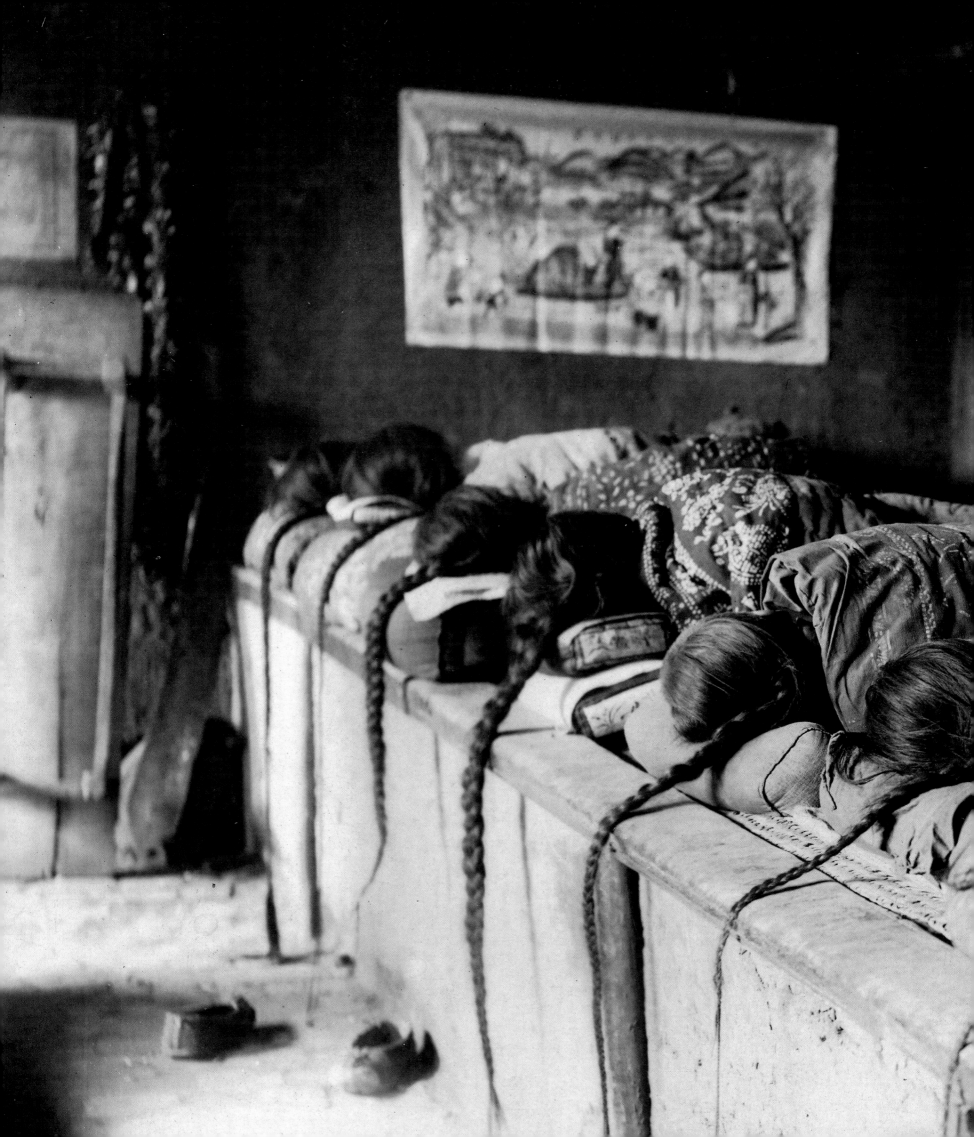

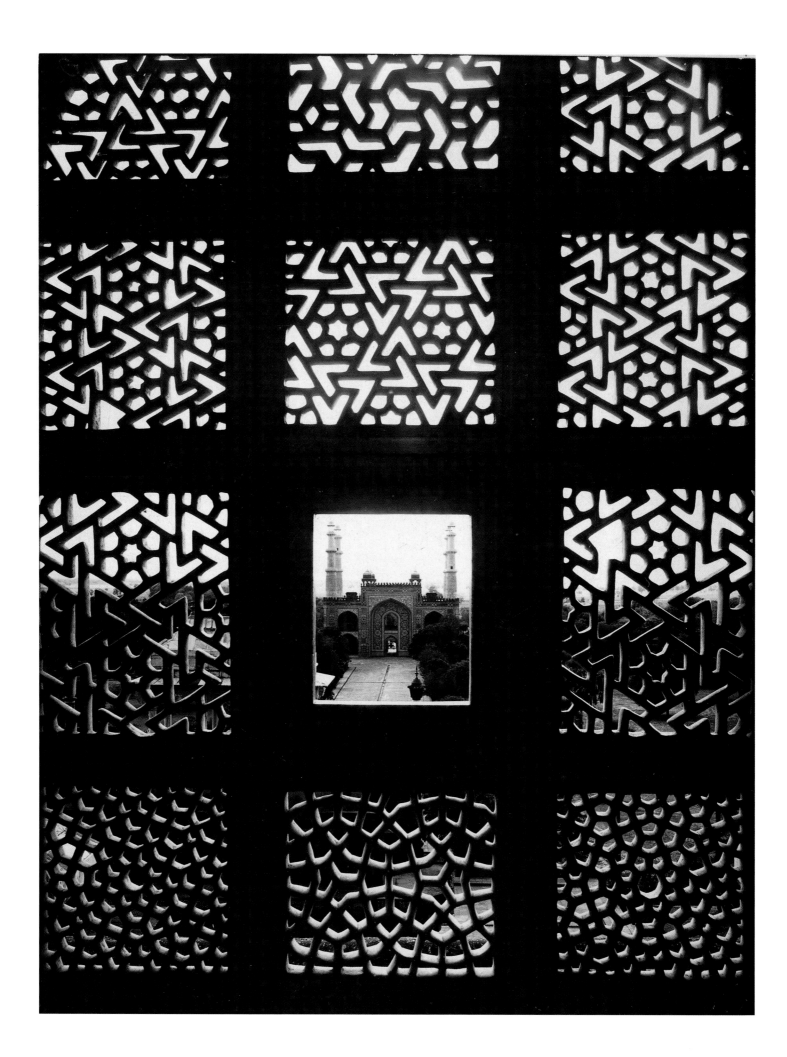

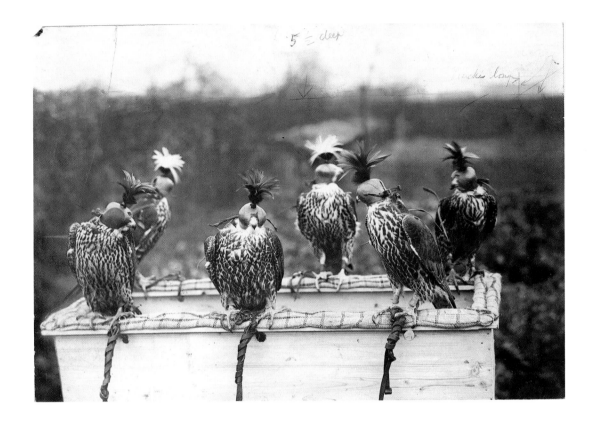

Louis Agassiz Fuertes
MANCHURIA, 1920 • A bevy of hooded falcons awaiting release in one of the world's oldest hunting sports stand captured on film by a photographer who would become a famous bird painter.

Herbert G. Ponting
INDIA, 1924 • *Opposite:* Shot through a screen of marble trelliswork that surrounds the mausoleum, this photograph focuses on the magnificent gateway to the Tomb of Akbar, near Agra. Ponting is best known for his photographs of Roald Amundsen's successful expedition to the South Pole in 1911.

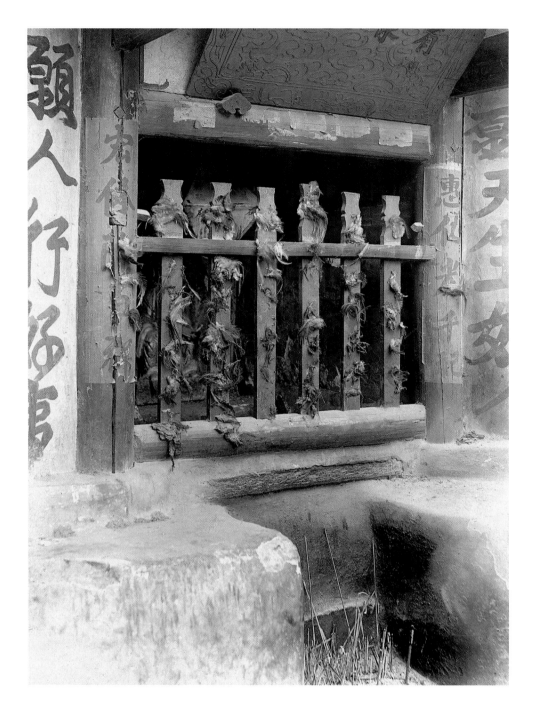

Robert F. Fitch

CHINA, 1927 • A wayside shrine in China, bearing the inscription, at top, "To prayer there is certain response," is decorated by the faithful with chicken feathers, blood, and incense offerings.

William W. Chapin

KOREA, 1910 • *Opposite:* Heavily laden with glass bottles, this Korean porter has found a good place to hang his hat until he reaches his destination.

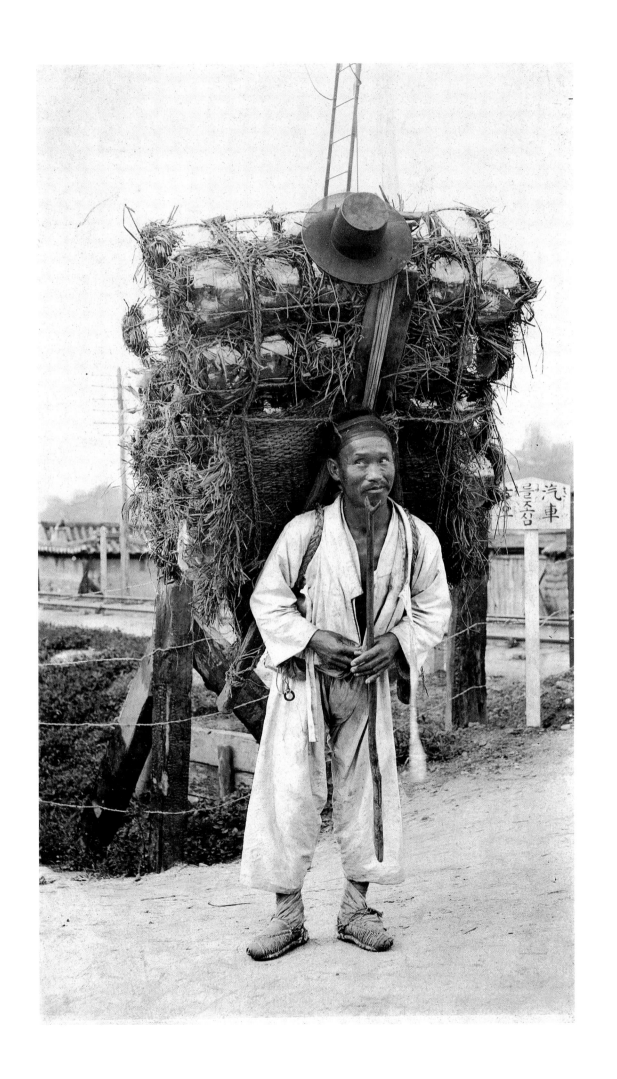

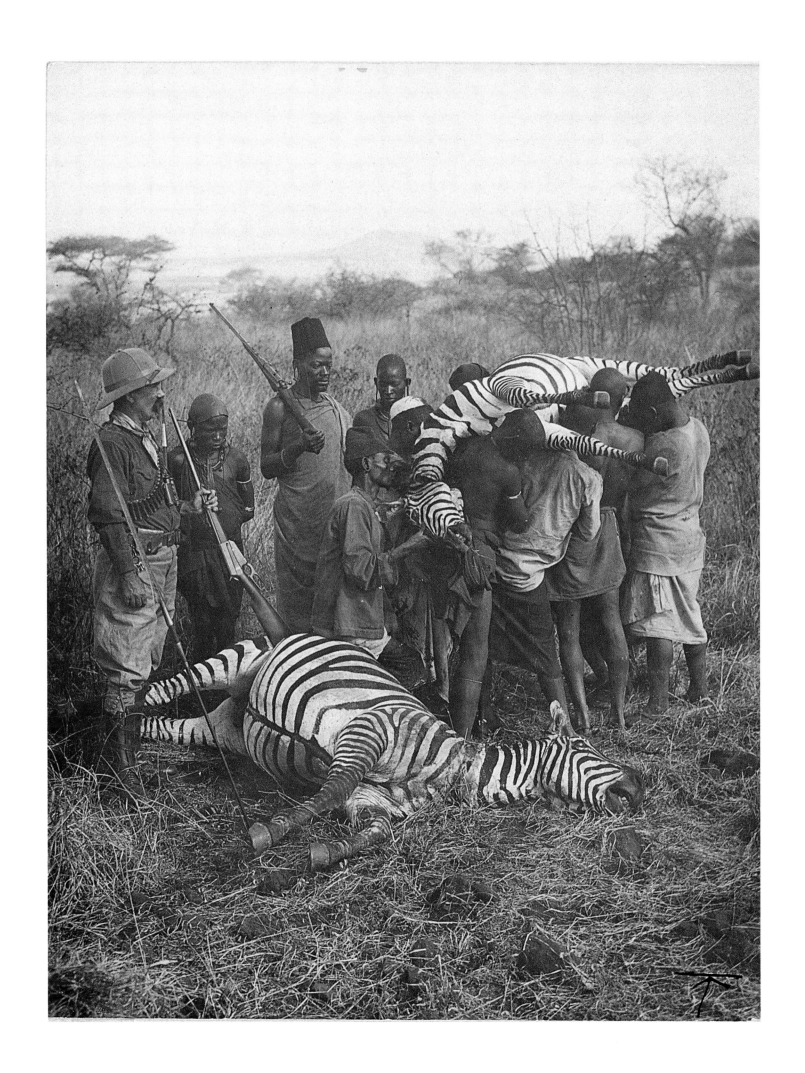

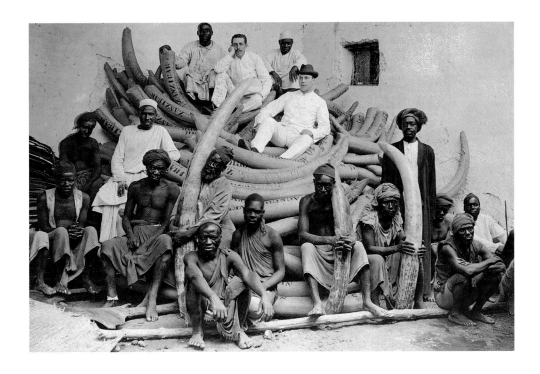

Unknown Photographer

AFRICA, 1912 • In the days before much thought was given to endangered species, a large pile of elephant ivory meant trophies and a good photo opportunity.

Underwood & Underwood

EAST AFRICA, 1909 • *Opposite:* This photograph, taken in the Great Rift Valley of East Africa, was used to illustrate the NATIONAL GEOGRAPHIC article "Where Roosevelt Will Hunt," providing readers with background on the itinerary of Theodore Roosevelt's safari.

Unknown Photographer

EGYPT, 1913 • *Following pages:* This 25-foot-long statue of Rameses II is all that remained of Memphis in its heyday. From the 12th century on, the former metropolis was a source of building stone for other cities.

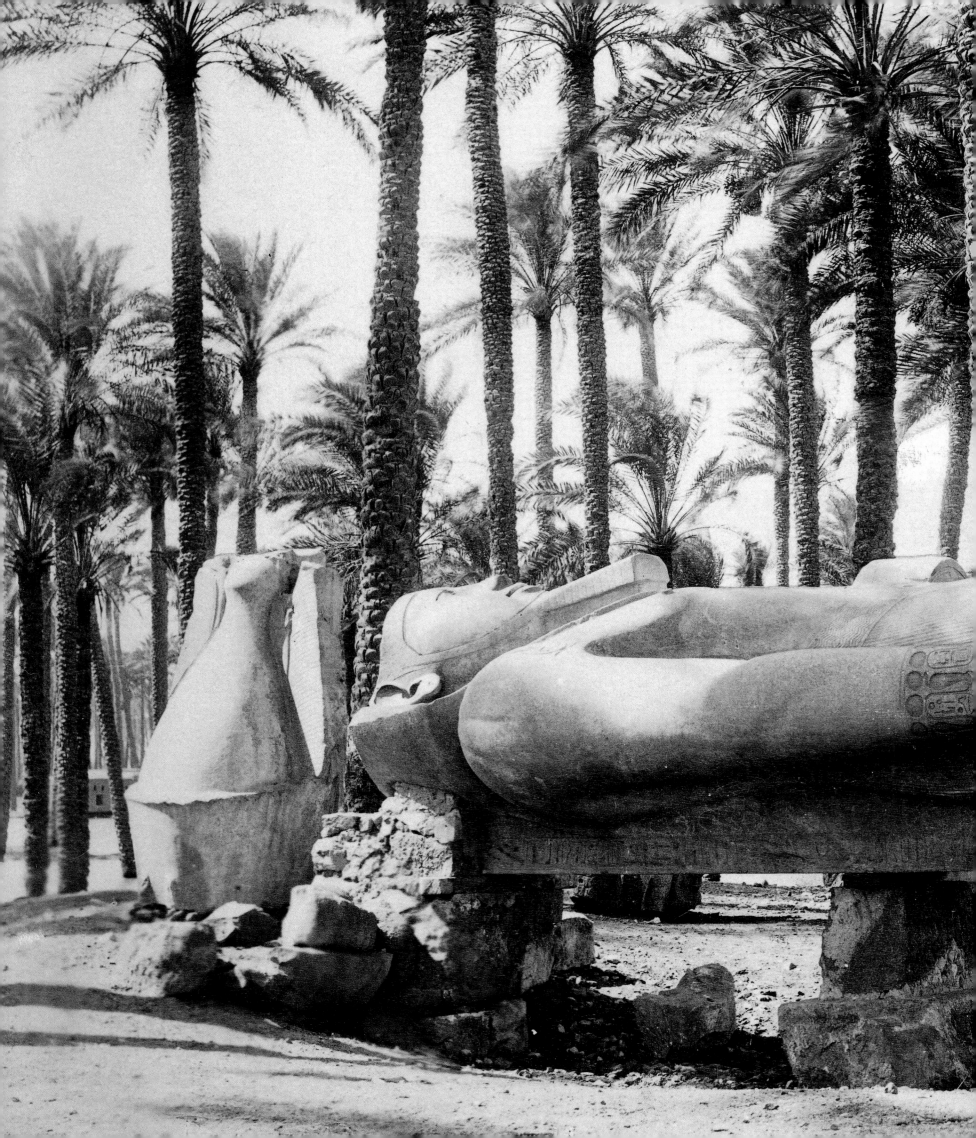

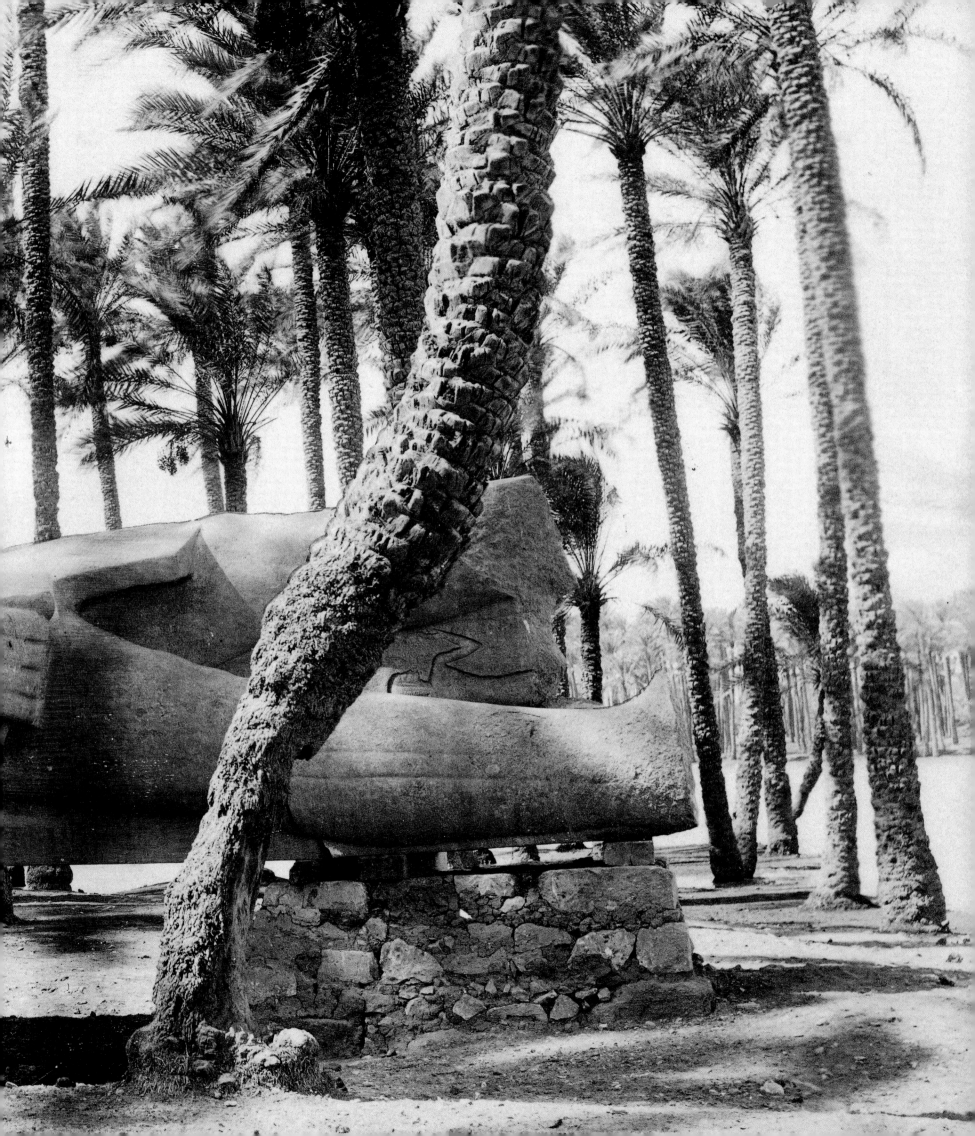

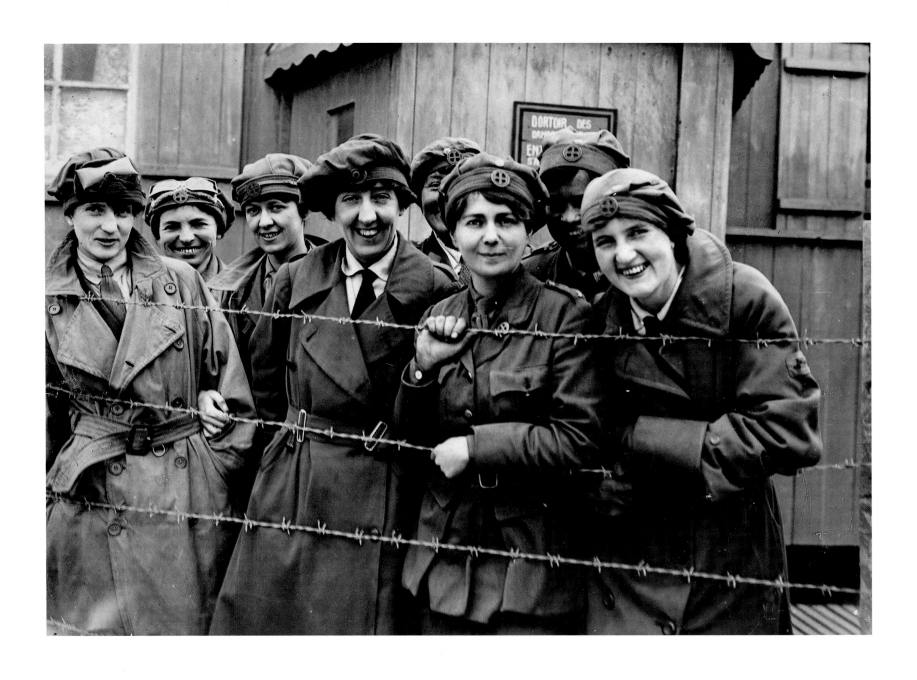

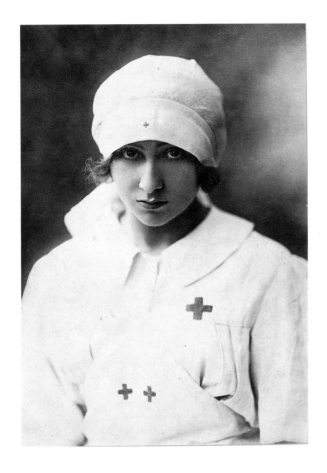

Harriet C. Adams
FRANCE, 1919 • A First World War-era Red Cross nurse manifests in her portrait the dedication of a calling to minister to the needs of the wounded and dying.

Franklin L. Fisher
FRANCE, 1918 • *Opposite:* Labeled "Photo obtained gratis by F. L. F. from British Bureau of Information," this group portrait of British nurses, perhaps newly arrived in war-torn France, exhibits dedication of another kind: to savor the adventure of it all.

Underwood & Underwood
MEXICO, 1911 • *Following pages:* Rows and rows of young girls each make hundreds of cigarettes a day in an enormous factory in Mexico City.

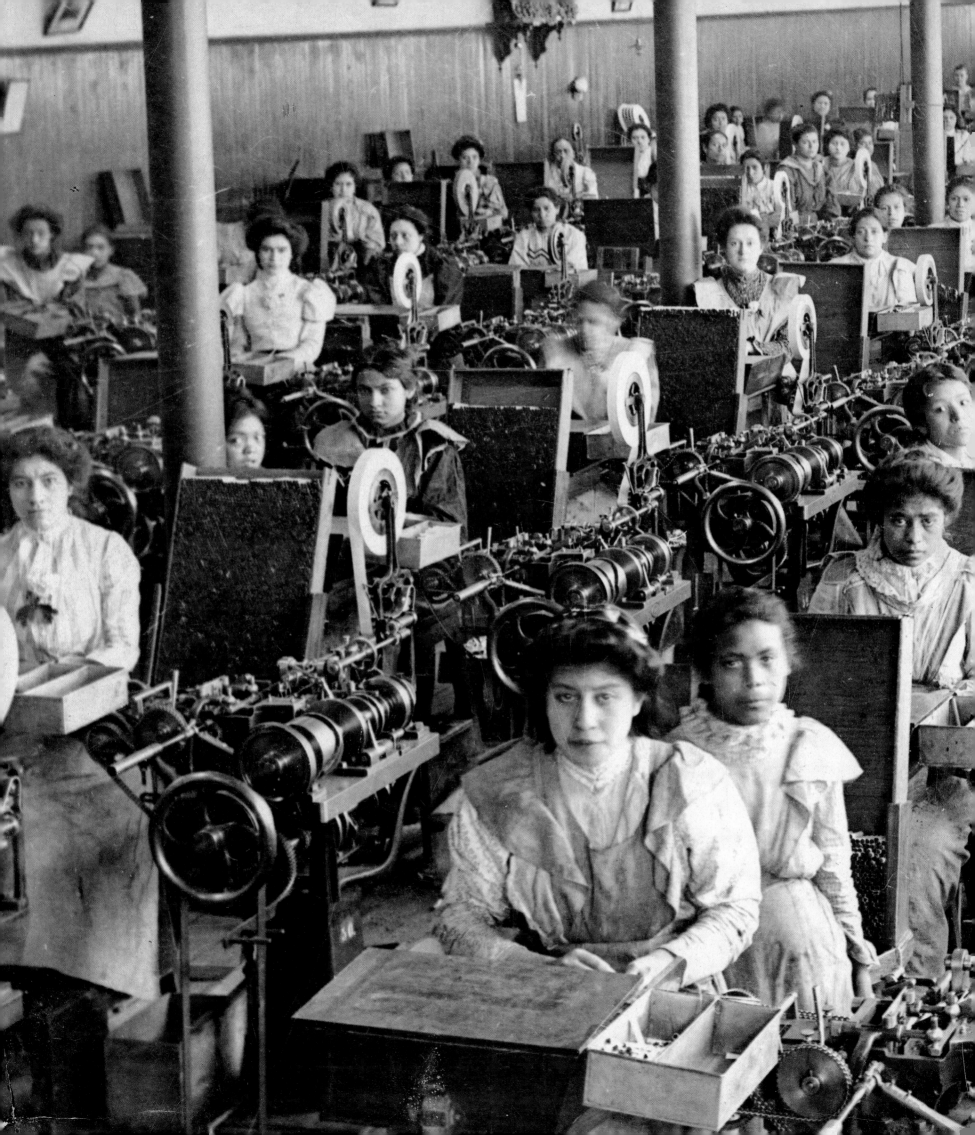

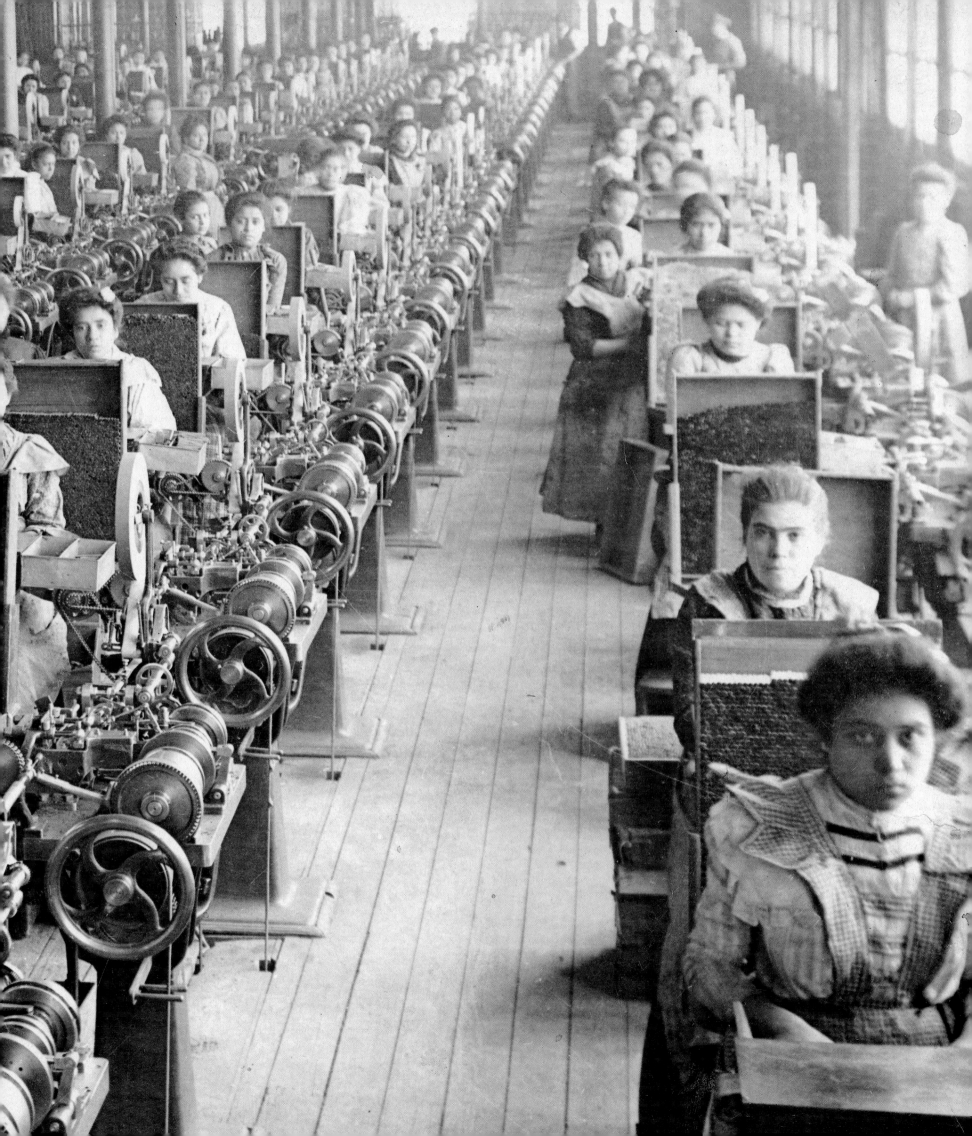

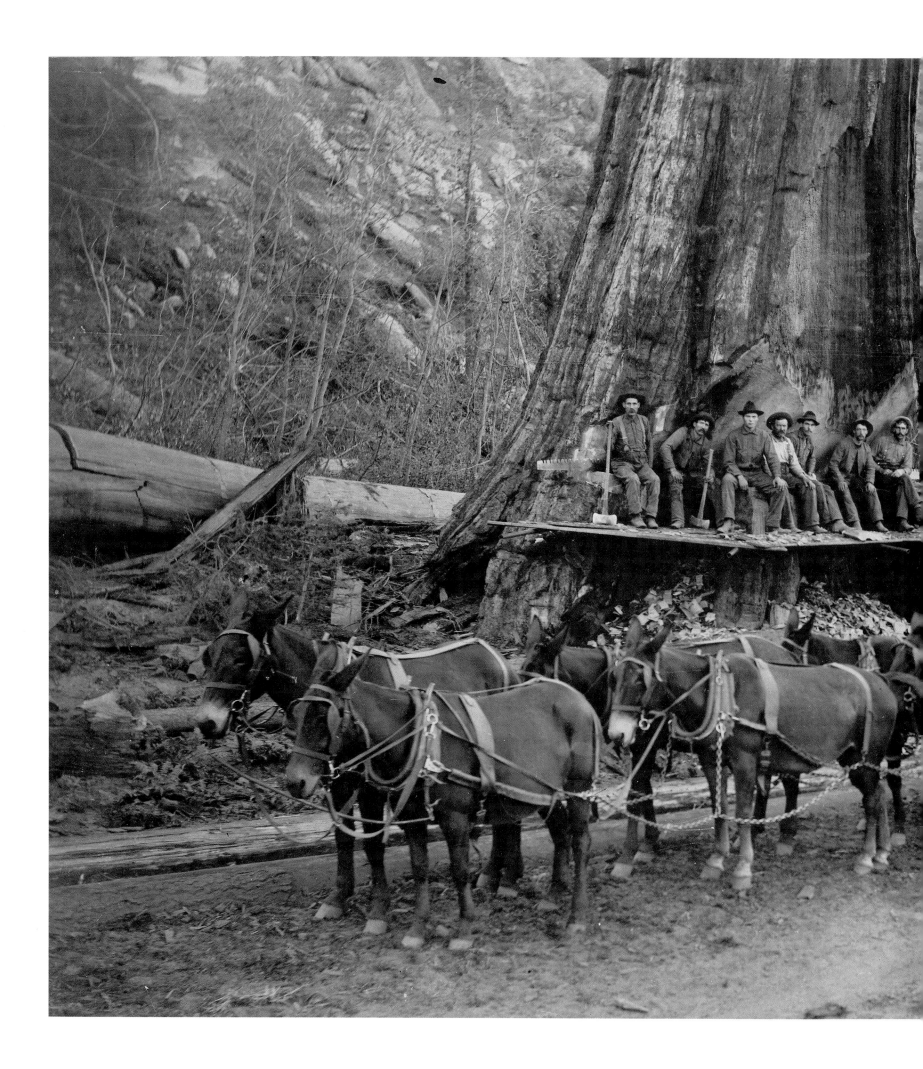

Edward William Nelson

ARIZONA, 1921 • In earlier years, the U.S. government played an active role in protecting private livestock, at the expense of "predatory wild animals," by hiring professional hunters, one of whom displays five mountain lions he killed in just three days.

A. R. Moore

CALIFORNIA, 1917 • *Left:* This photograph and the article it accompanies celebrate the establishment of Sequoia National Park, home of the Giant Forest, "the largest intact body of trees of this species in existence."

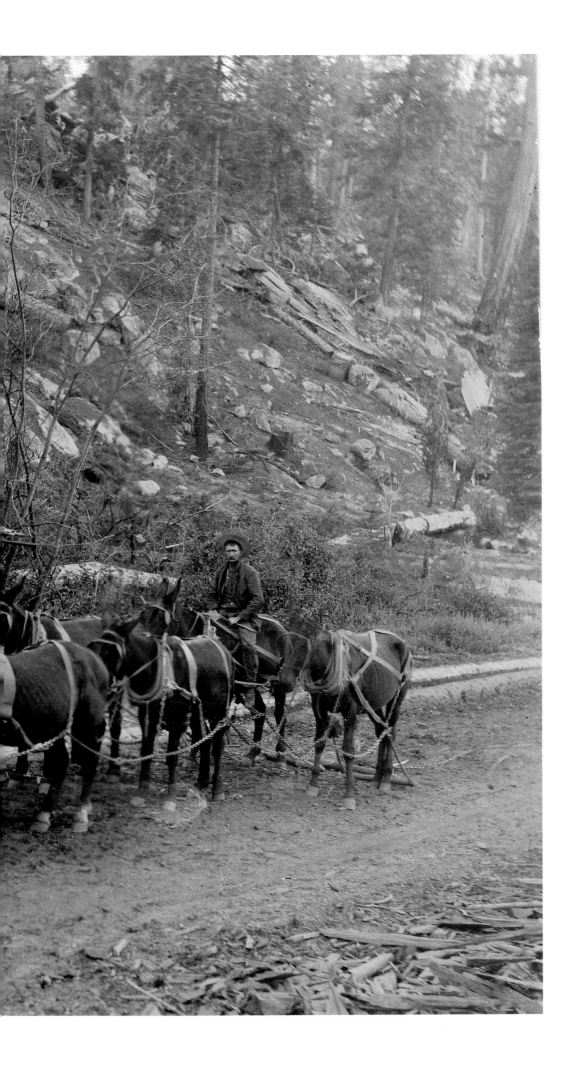

Unknown Photographer, Denver Tourist and Publicity Bureau

COLORADO, 1930 • As Americans headed West to seek a better life, they found facilities along the way to ease the difficulties of their journey, such as the Overland Park Auto Camp Grounds near Denver.

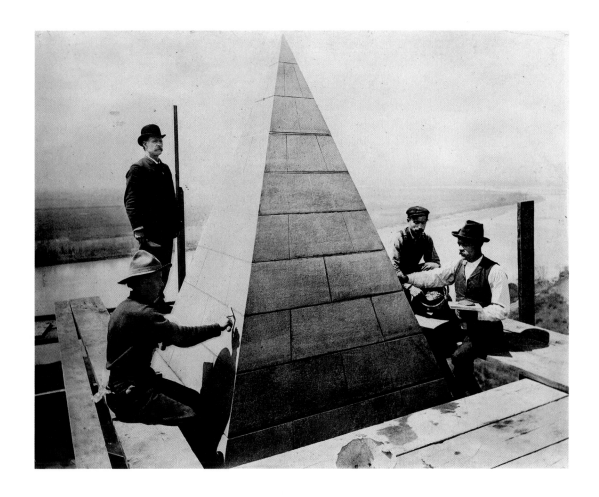

L. C. Handy Studios
WASHINGTON, D.C., 1884 • Masons finish pointing the topmost stones to the 555-foot-high Washington Monument, which, begun in 1848, had experienced a long hiatus in construction during the Civil War.

L. C. Handy Studios
WASHINGTON, D.C., 1905 • *Following pages:* From the Treasury Building's terrace, visitors could view the nation's Capitol at the end of Pennsylvania Avenue and contemplate the dozens of buggies and trolleys at the dawn of the Age of Horseless Carriages.

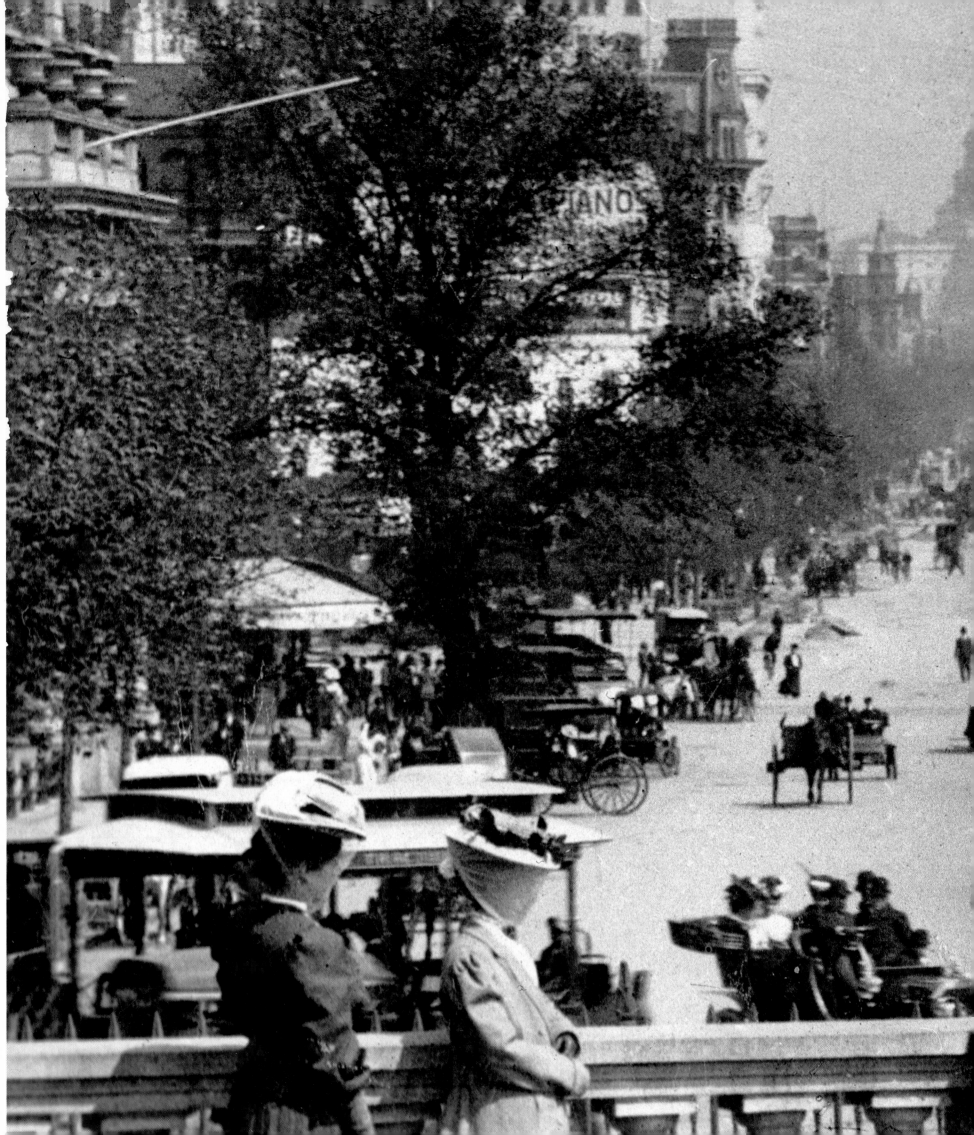

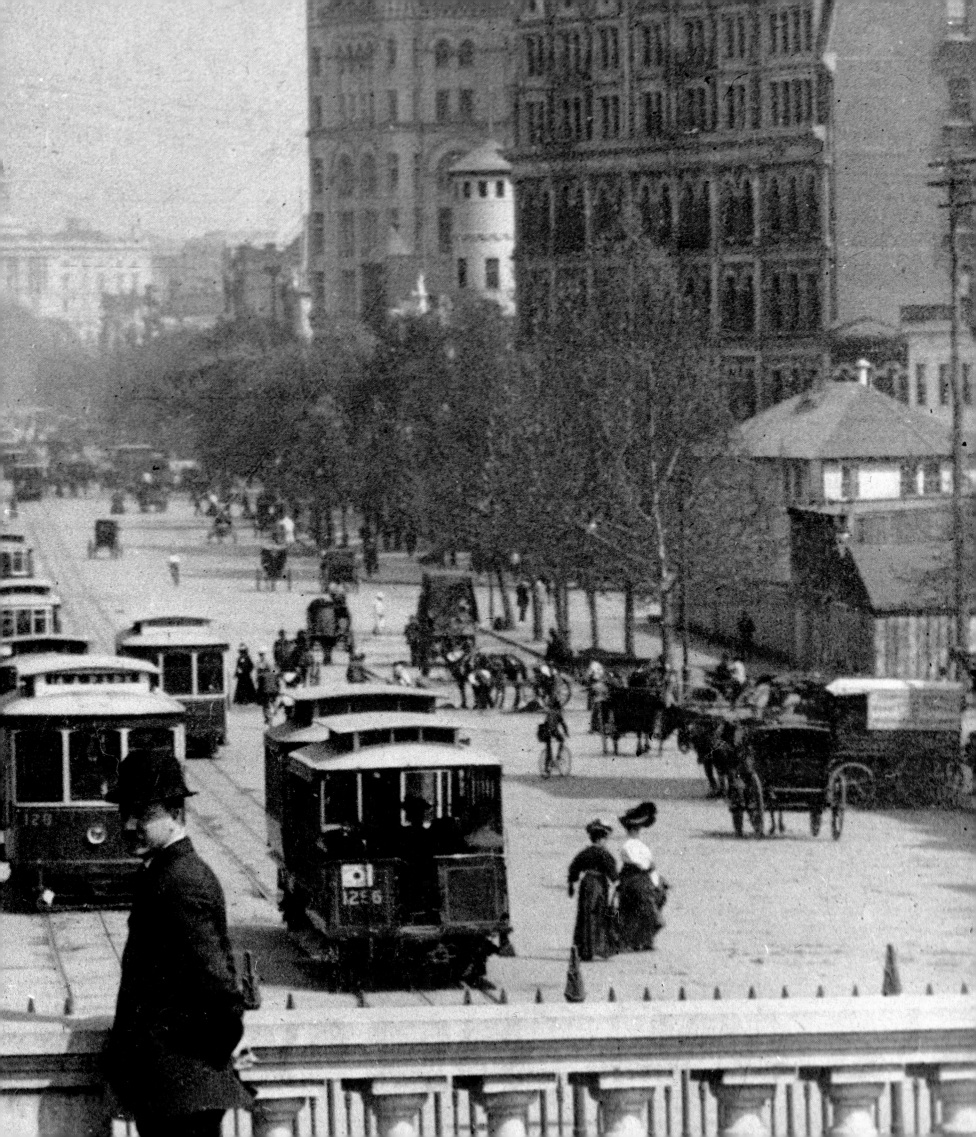

THE SPECIAL COLLECTIONS

Gems in the Gold Mine

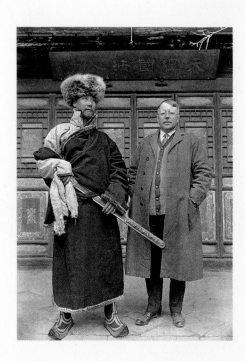

Joseph F. Rock Collection
CHINA, 1925 • Posing here in the heart of Asia with the Prince of Choni, stands Joseph F. Rock, the quintessential GEOGRAPHIC photographer-adventurer of his day. He would drop out of sight and emerge years later with enough film and journals for several GEOGRAPHIC stories.

Considered carefully, the pages of NATIONAL GEOGRAPHIC magazine constitute an incredibly important visual archive of the geographies we all inhabit and of the people with whom we share those spaces. Yet that is merely the tip of the iceberg, as it were, when one becomes aware of the incomparable photographic archive formed and maintained over many decades by the Society. Begun toward the end of the last century by the pioneering efforts of Gilbert Hovey Grosvenor, who became the Editor of the magazine in 1899, and his wife, Elsie, the Society can now claim more than ten million, largely unpublished, photographic records. This archive is at once a testament to the perseverance and diligence of the explorers, adventurers, and geographers who submitted their photographs to the Society, just as surely as it is a monument to the indefatigability of a "visual encyclopedism" that persuasively encourages cross-referencing and comparison through appearance. From the beginnings of natural history museums in the 18th century to the establishment of anthropometric systems of human classification in the 19th, the visual archive assumed the status of a tool for understanding our world. And photography,

with its rendering of fact and detail, served visual encyclopedism all too well. "Photography promised more than a wealth of detail," wrote critic Allan Sekula, "it promised to reduce nature to its geometrical essence."

The dream of amassing something along the lines of a photographic archive is rather old; it even predates the invention of photography by nearly 80 years. In *Giphantia,* a speculative fiction by Tiphaigne de la Roche that was translated into English in 1760, a traveler to an unexplored civilization encounters a vast collection of what could only be described now as photographs on canvas and remarks: "In each picture, appeared woods, fields, seas, nations, armies, whole regions; and all these objects were painted with such truth, that I was often forced to recollect myself." Here, then, was the geographer's dream: to avoid the imprecision of painted pictures, to let nature record herself, to make these pictures the equivalent of reality, and to document all the natural wonders of nature and humankind. If enough people and wonders could be photographed, it was thought, and the images systematically filed and studied, then, and only then, could geographic knowledge be fully attained. The photographs taken by

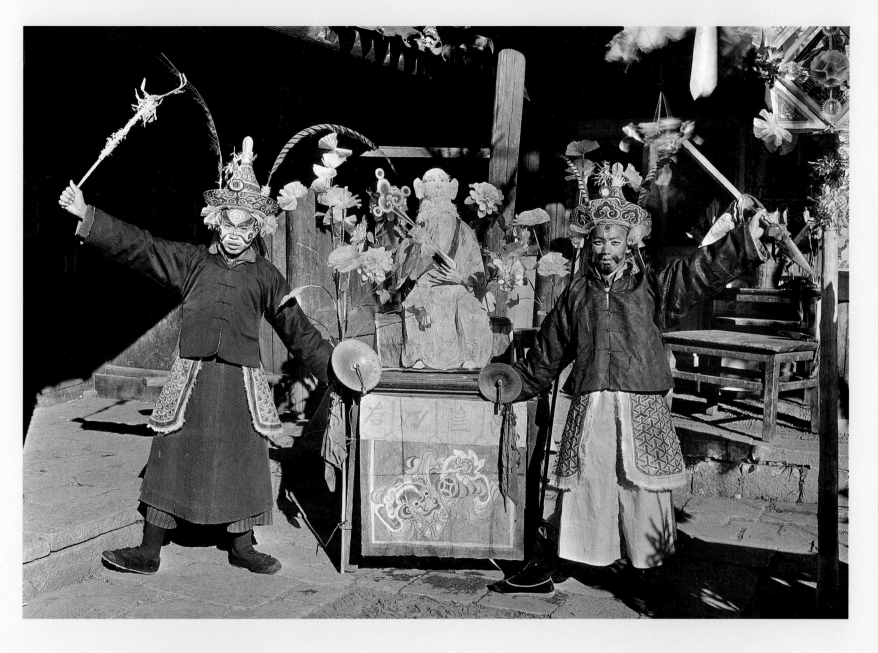

Joseph F. Rock

CHINA, 1927-1930 • In this exotic scene in Yunnan Province, two dancers represent generals who follow the edicts of the god figure seated between them and eventually kill a demon king.

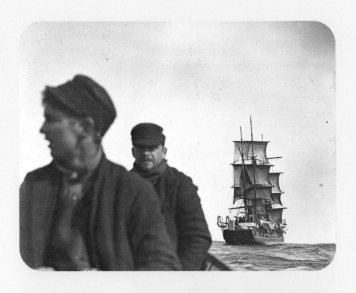

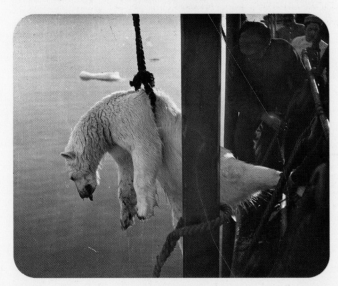

Anthony Fiala

RUSSIA, 1903 • *Top:* Rowing out to their ship *S.S. Amerika*, members of the Ziegler Polar Expedition prepare to set out for the Franz Josef Land archipelago.

FRANZ JOSEF LAND, 1903 • *Bottom:* One of the polar bears that the expedition shot for food is hauled aboard *Amerika*.

correspondents to the Society and stored by it are perhaps the largest such archive in existence. Critically examined, these pictures allow us not only to re-explore the journeys of these intrepid travelers, but also to assess the differences as well as the similarities of the various lands and cultures they document.

Such a photographic archive, of course, presents difficulties and frustrations due to the specificities of each image and the sheer number of images involved. Still, there is a rich and vital trove of historical information and pictorial beauty hidden within the archive. Historians of costume and textile, for example, might well consider the images taken by Charles Harris Phelps of the native peoples of Japan, Russia, and Norway toward the end of the last century. Sinologists interested in Chinese social conventions during the 1920s would be well served by Joseph F. Rock's fascinating photographs. Specialists in Pre-Columbian cultures might easily profit from many of the published and unpublished images taken by Hiram Bingham and others soon after the discovery of Machu Picchu in 1911 and by members of the Society on subsequent expeditions. Marine historians would find that life aboard an exploration craft in the Arctic was amply documented by Anthony Fiala and others during the Ziegler Polar Expedition of 1903-05 and by Robert E. Peary on several Arctic expeditions that ultimately gained him the North Pole in 1909. And photographic historians, as well as those researching Native American culture, would undoubtedly discover rare and exquisitely crafted images by Edward S. Curtis.

The modern traveler, as was every one of the Society's correspondents, contributed immensely to our vision of nature and the world. Writing about pre-photographic geographers, historian Barbara Stafford described what is, in essence, common to all explorers who have been charged with visually rendering their subjects: "At a fundamental level . . . the scientific discoverer promulgated an exploratory way of looking at the world. Penetrating phenomena opened a new perspective on the actual shape of existence, now viewed as an open-ended and intersecting sequence of experiences momentarily 'realized' in concrete fragments of reality and shifting aspects." Out of the fragments and shifting aspects of the scenes encountered by photographers for the GEOGRAPHIC, an archive, or a matrix, of interlocking images "realized" in the moment of a shutter's release has been amassed, organized, and preserved for future generations of scholars and researchers who, in turn, will undoubtedly discover ever more significant visual correspondences and meanings. They will also discover something else in the archive: the images of histories long gone, if not forgotten; and of people and places that once were, yet still remain in these images. Like the images encountered by Tiphaigne's traveler in the 18th century, the photographs in the archive are of things past, and the "most real signs of them are the traces they have left upon our canvases in forming these pictures." That, then, is their subjects' immortality.

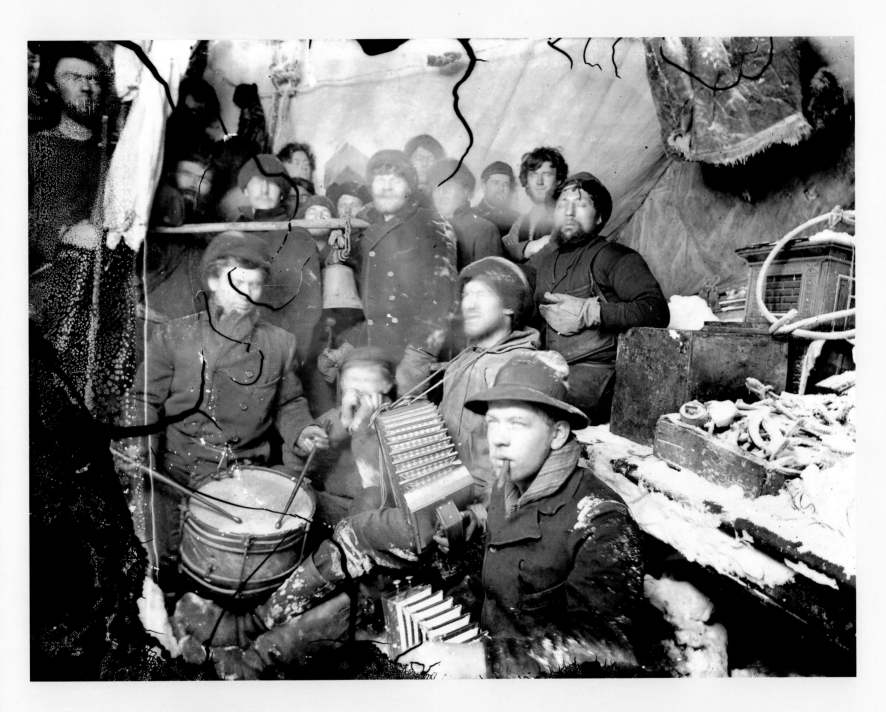

Anthony Fiala

ONBOARD *S.S. AMERIKA,* 1902 • According to Fiala's photo logbook, this flashlight photograph, which he captioned, "Serenaders at Commander's door New Year's morning 12:10 a.m.," was made on January 1, 1902. As for other lantern slides, he produced a positive image on a glass plate.

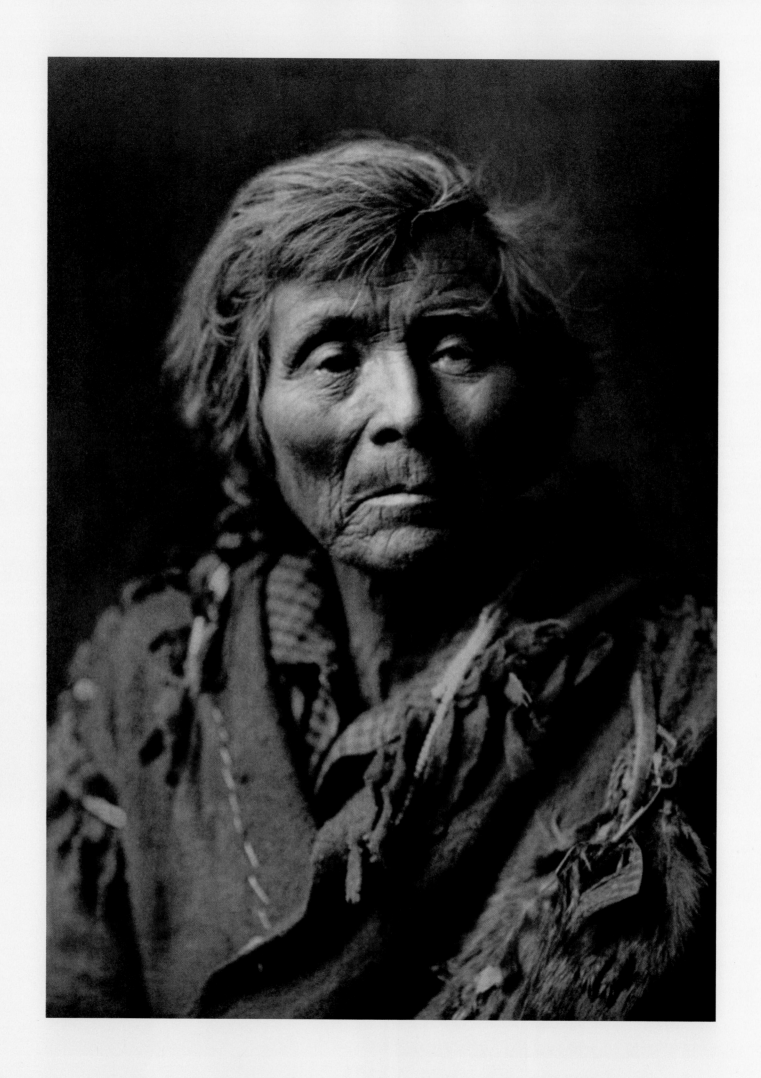

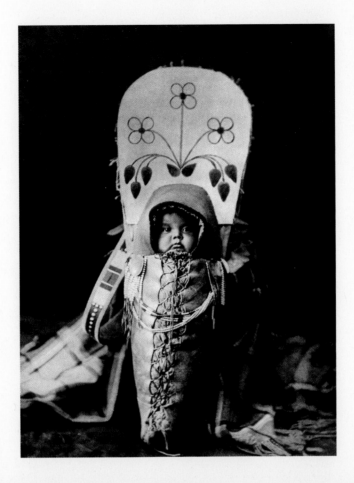

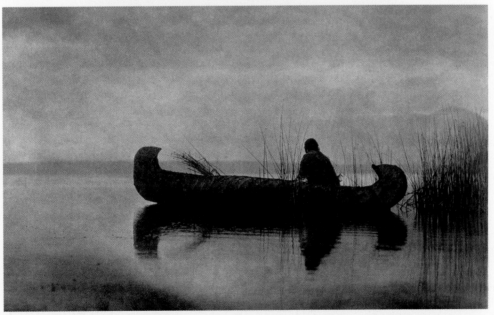

Edward S. Curtis

WASHINGTON, c. 1880 • *Opposite:* Sensitive portraits by Curtis include this elder of the Spokane Indians, member of a community at one time divided, according to Curtis, into three different tribes that lived along separate stretches of the Spokane River.

WASHINGTON, c. 1880 • *Top:* A baby of the Nez Perce people is swaddled in an elaborate papoose backboard for traveling.

WASHINGTON, c. 1880 • *Bottom:* This Kutenai duck hunter sets out in a canoe made of a wooden framework stretched with canvas rather than the traditional bark covering.

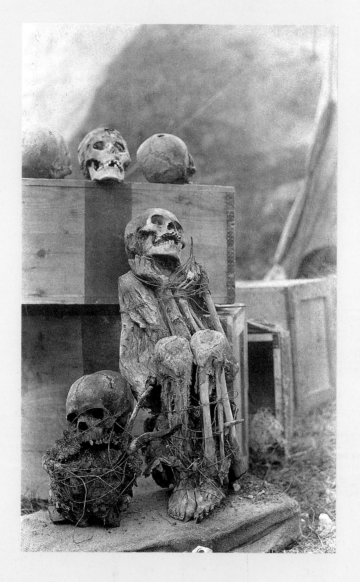

David E. Ford
PERU, 1915 • The National Geographic Society-Yale Peruvian Expedition, headed by Hiram Bingham, discovered these mummies in a cave at Torontoy, Peru.

Hiram Bingham,
PERU, 1915 • *Opposite:* The expedition had returned to Machu Picchu, shown here, which Bingham discovered in 1911, for a more thorough documentation.

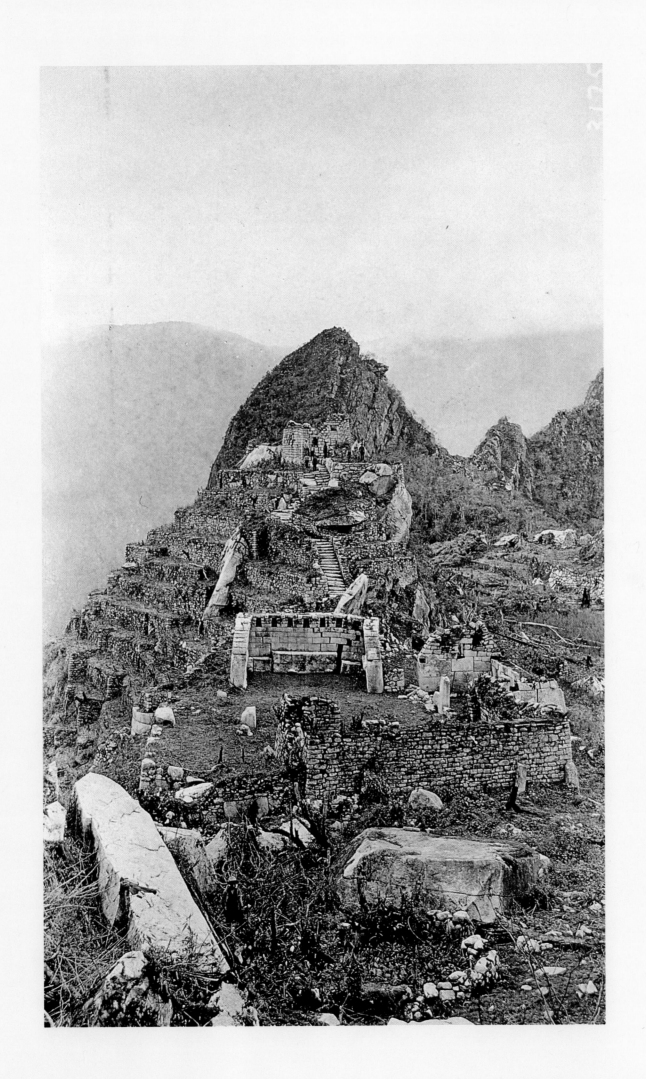

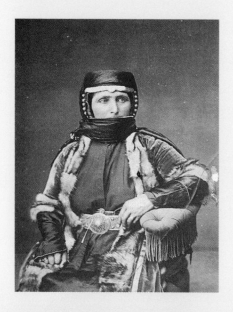

Charles Harris Phelps

RUSSIA, c. 1880 • *Top:* Phelps assembled nearly a hundred pictures of Russia, the Ukraine, and the Caucasus, including this one of an Armenian woman from Leninakan.

Bottom: Among the 28 photographs Phelps collected in Japan while on an extended honeymoon was this one of a prostitute and her maid.

Opposite: A Lapplander couple has to steady one of their reindeer for milking by tying it against a tree.

78

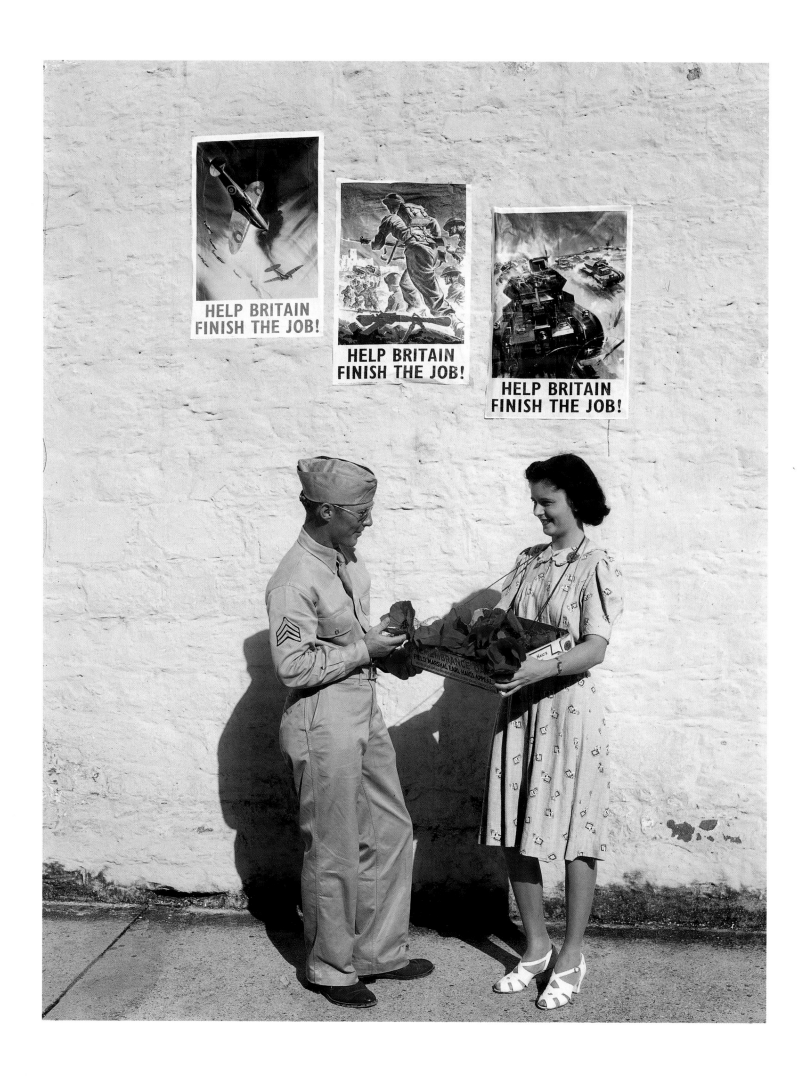

1931-1950

Depression, War, and Color

Carole Naggar

With the Great Depression marking its beginning, World War II stretching through its middle years, and the Cold War well under way at its end, the strife-torn period spanning the 1930s and '40s also encompassed bold stirrings of independence among former colonies in Africa and elsewhere, irrevocable changes in the world's political balance. Yet, in a period so shaken by events, the National Geographic Society continued to hold to its own guiding principles—that its mission was "the increase and diffusion of geographic knowledge." Though a tool of science and education rather than the news, Editor Gilbert H. Grosvenor, in a 1936 article, expressed his view that the society must remain timely in its coverage: "Whenever any region of the world becomes prominent in public interest by reason of war, earthquake, volcanic eruption, etc., the members of the National Geographic Society have come to know that in the next issue of their magazine they will obtain the latest geographic, historical, and economic information about that region." In pursuing this mission, Grosvenor pointed out in 1930, "the NATIONAL GEOGRAPHIC magazine has made the photographic illustration its handmaiden. For more than 30 years, The Magazine's pages have been enriched by the contributions of photographers from all parts of the earth, even from the floor of the sea and, more recently, from the skies above."

Subjects that GEOGRAPHIC editors have chosen to photograph and write about have an incredible range: ". . . from the ant to the elephant, from the humming bird to the trumpeter swan, from tiny tropical fish to the gigantic whale, from the microscopic spores of mold to the mighty eucalyptus and sequoia trees." And nowhere but in the GEOGRAPHIC could one find such intensity and detailed knowledge: from cheetahs in the Indian national park of Bhavnagar and methods of hunting with

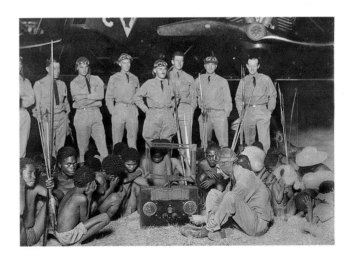

Raymond Stockwell

PHILIPPINES, 1930 • American flyers stationed in the Philippines treat Negrito natives to their first radio broadcast, a concert that produced a combination of pleasure, fear, and fascination.

Luis Marden

TRINIDAD, 1942 • *Opposite:* Even before entering World War II, America had sent thousands of soldiers and civilians to the British West Indies to prepare air and naval bases in aid of Britain. Here an American sergeant buys a remembrance poppy on Armistice Day.

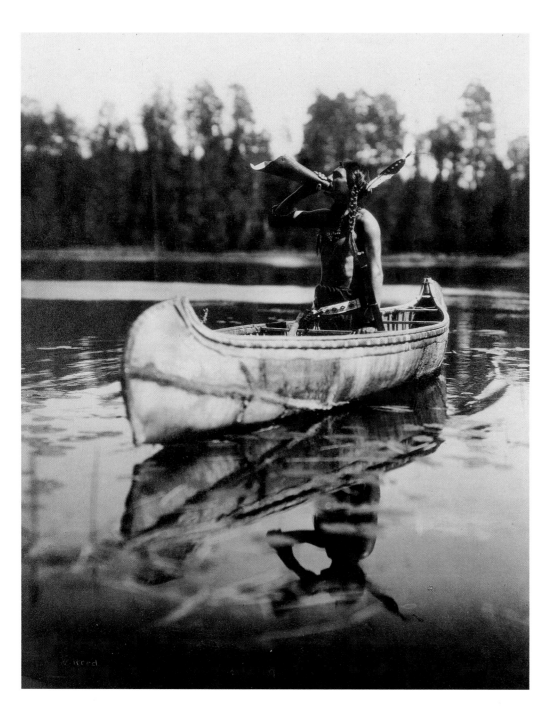

Roland W. Reed

LOCATION UNKNOWN, 1937 • In an article entitled, "America's First Settlers, The Indians," this photograph illustrates how, through simulating the mating call of a moose, this brave draws his prey into the open. The Society maintained its traditional interest in exotic peoples, including those close to home, throughout the years of the Great Depression.

tamed falcons to notations from the first round-the-world airship above Tunguska River of colors in the clouds (coal black with bright streaks) to what it looks like inside the Aniakchak volcano in Alaska.

In the years between 1930 and 1950, and, of course, earlier, NATIONAL GEOGRAPHIC photographers were often trained scientists (anthropologists, paleontologists, geographers, engineers, physicists), and they regarded photography as but one of their activities. They also collected, classified, measured, analyzed, accumulated, and often wrote their own articles, a tradition that lasted well into the 1950s, and beyond.

Their heritage stretches back to 19th-century explorers, both American and European, on expeditions organized by governments, institutions, or even individuals: geographical and geological explorations such as the famous eight-year-long Hayden western survey photographed by William Henry Jackson; anthropology expeditions like Franz Boas's Jesup North Pacific Expedition; or Carl Lumholtz's travels for the Museum of Natural History to study Indian tribes in Mexico.

Another ancestor, in France, was Albert Kahn, who had in common with the GEOGRAPHIC scientific and pedagogic goals, as well as a strong emotional motivation: the realization that certain people, ways of life, and landscapes were disappearing and that it was urgent, therefore, to constitute an organized memory in pictures. Kahn was a philanthropist who believed that world peace could be advanced by knowledge of other civilizations, and he commissioned, for his "Archives of the Planet," 72,000 Autochromes from a team of photographers who traveled the world in expeditions lasting for months or even years. Thirty-seven countries had been covered by the time Kahn went bankrupt in the 1930s, before, unfortunately, he obtained coverage of the United States and the Soviet Union.

As demonstrated by Margaret Blackman in her 1989 article for *Natural History,* "Posing the American Indian," it is often a very thin line that divides the production

of commercial images for popular consumption from those typical of anthropological photography. Indeed, NATIONAL GEOGRAPHIC published a large number of clearly anthropological images between 1930 and 1950 as it routinely financed expeditions led by scientists. However, without artificially separating photography into genres, we can see in the GEOGRAPHIC how image production often blurred lines between knowledge and entertainment. In a time when tourism was not yet widespread, when traveling was not as common as now, intrepid photographers culled from the planet's skin the rare images brought back to readers. Even photographs taken in so non-exotic a place as America, where different regions were repeatedly visited, had that same aura of exoticism and mystery.

The person who, perhaps, best exemplified the tradition of the GEOGRAPHIC explorer was freelance photographer Joseph F. Rock, who worked frequently for the magazine during this period. While climbing in the Amnyi Machen, a mountain range with a peak almost as tall as Everest, he conveyed both in words and pictures his sense of awe at discovering as yet uncharted territory: "No other white men since time began ever stood here and beheld these deep gorges of the Yellow River." The very distant yielded to a sense of going back in time, of Paradise: "Here, in remote, almost inaccessible valleys, I found countless wild animals still unafraid of man, peaceful as in Eden. . . . Here, in July, was ice, and flowers bloomed in the snow."

Rock, like many other earlier travelers, did not travel lightly. His group had a caravan of 60 yaks, plus some mules and horses, laden with cameras, trunks, photographic plates, and, as it progresses, more and more botanical and ornithological specimens. Rock was helped by a team that included local assistants, portrayed in a group picture on their horses.

In his story of another expedition, to the mountain of Minya Konka, on the Tibet–China border, Rock gave an even more daunting list: "We had 46 mules and more than 20 Nashi men, with supplies for seven months. Fur, heavy shoes and warm bedding were provided for the men, as we expected spring snow, especially in the north. We also took five tents, folding chairs, and table, camp cot, and many trunks with photographic supplies, cut film and color plates, developer, coffee, tinned milk, tea, cocoa, butter, flour, salt, sugar, and some tinned vegetables, for the grass-land Tibetans are strangers to vegetables, fruits and sugar." Their equipment also included paper made out of bamboo to be used as blotters for drying botanical specimens, boxes with ginned cotton for bird specimens, plant presses, boxes of white fiber paper to pack dried plants, and medicine. For photographs were to be only part of what the expedition brought back, which would include flora, bone specimens, song recordings, and live and "naturalized" animals: "To celebrate the first view of these gorges, we killed two eagles as natural history specimens. They are now in the Museum at Harvard." From a previous expedition in Tibet, Rock

brought back two Nashi assistants to study in Washington: "While in America, [one] young man studied photography, and his companion learned taxidermy to aid them in their future work for The Society."

Throughout the piece, black-and-white panoramic pictures or large-format photographs alternate with color landscapes. Among the most remarkable examples in black-and-white are views of the Ser Chen Gorge and the Yellow River from the summit of the Amnyi Chungan mountain, evocative of the classic 1873 picture of Canyon de Chelly by Timothy H. O'Sullivan.

Rock's portraits include a beautiful one of the living Buddha of Dzangar Monastery, at 81 years old. On a less serious note, he portrayed nomads of the Tibetan Sokwo Arik tribe listening to a recording of Caruso's "La Donna è Mobile" on a portable phonograph in the author's camp.

Rock accorded no more importance to his Nashis than to his eagle specimens, but I would, however, resist the temptation to reduce this "urussu" (Russian), as Tibetans call all foreigners, to the figure of a smug, humorous colonialist. He was capable of beautiful and poetic observations, such as his description of a solitary lama sitting all day long on the shore of the Yellow River. The lama held a board with five brass molds, of the kind used to imprint the image of Buddha on bricks. All day, he plunged the molds into and out of the water. This was his way, said Rock, of "printing" pictures of the Buddha "on the passing river," thus asserting Buddha's presence in this world.

Many authors working for the NATIONAL GEOGRAPHIC in the 1930s followed a variation of the same anthropological model. W. Robert Moore placed himself, when traveling among Sumatran tribes, in a tradition of explorers ranging from Marco Polo to Ludovico di Carthema of Bologna (1505) to the Dutchman Cornelius Houtman (1509). Except that photography, more than narrative, was now relied upon as solid proof for the reader. Its validity and objectivity were never questioned. Wrote Moore: "Early travelers returning from Eastern tropical voyages once got themselves branded as cheerful romancers when they related tales about indolent natives who had trained monkeys to climb the tall palm trees to pick their coconuts . . . I made some snapshots to prove the tale."

When Ernest G. Holt, four generations later, retraced the steps of Friedrich von Humboldt's expedition of 1800 into Brazil and the Amazon, he stressed continuity rather than evolution: "Though the political map has been altered . . . though astounding progress has been made in every field of science, could Humboldt retrace his Orinoco route to-day he would find little change."

Also in the anthropological tradition, paintings after photographs are often commissioned by the GEOGRAPHIC when the photos themselves are considered not precise enough. A 1937 article about China, "Landscaped Kwangsi, China's Province of Pictorial Art," is illustrated with "camera paintings," the result of a collaboration

between an American photographer, Herbert Clarence White, and two Chinese painters: "Mr. White's photographs of its spectacular cliffs and peaceful temples were specially painted by the artists Deng Bao-ling and Hwang Yao-tso." In fact, some of the photographs mimic Chinese landscape paintings. Several are taken by T. C. Lau.

Barbara Mathé and Thomas Ross Miller, in "Drawing Shadows to Stone," a 1966 article in *Natural History,* have reminded us that ethnographers who saw themselves as recording vanishing cultures often censored from their own pictures evidence of contact and assimilation, just as Arnold Genthe, when he photographed San Francisco's old Chinatown, took out of his prints English-language signs on shops and people in Western dress. Similarly, in Matthew W. Stirling's 1937 GEOGRAPHIC piece "America's First Settlers, the Indians," the author, chief of the Bureau of American Ethnology, Smithsonian Institution, made use of paintings reenacting everyday life in earlier times that strongly resembled 3D scenes suitable for an anthropology museum. They alternate with archive photographs shot in the 1920s, and contemporary panoramic black-and-white photographs by Clifton Adams and Harrison Howell Walker, creating a complex, multi-layered illustrative approach.

Early anthropologists set great value upon tangible cultural data, treating photography as the equivalent of artifacts, anthropometric measurements, sound recordings, head casts, linguistic transcripts, etc. Later on, modern anthropology, starting with Boas and Malinowski, would think of culture more in the abstract. They thought, and we now tend to agree, that a given culture could be appre-hended only through long-term residence and through a deep knowledge of the people's language. In that context, previous visual representations of culture (such as photography) became viewed as partial and insufficient, a view not shared at the NATIONAL GEOGRAPHIC of that period.

In the 1930s, as anthropologists began to publish theoretical books that made less use of photography, the NATIONAL GEOGRAPHIC and, later on, other science-oriented, large-circulation magazines "took over" this abandoned branch of anthropology and developed it into an independent tool, seeking some of the goals that were originally part of anthropology.

Are we to say that the NATIONAL GEOGRAPHIC was untouched by the latest styles in anthropology and photography? That would be only partially true. The best characteristics of the new journalism that emerged in the 1930s and developed in the following two decades appeared in several GEOGRAPHIC stories, often produced by professionals who had lived for a long period of time in a foreign country and had learned to take pictures properly in situ. Their photography reflects a knowl-edge of people that goes more than skin-deep and avoids the picturesque.

Such an essay is "Taming 'Flood Dragons'—Along China's Hwang Ho," by Oliver Todd, published in February 1942. An engineer working in flood control, he remained in China for a year and a half and recorded the people's fight against the

Yellow River's flooding. He also documented the construction of dikes and the effects of famine on families whose crops had been destroyed by rising water. His insights into Chinese psychology in the text are matched by his moving photographs, 35mm and panoramic, mostly black-and-white, that often evoke the work of French photographer Marc Riboud a decade later. In an otherwise mostly picturesque article by Paul Atkins ("French West Africa in Wartime," March 1942), striking square-format photographs by Frenchman Pierre Verger show us the British and Free French forces in Africa, horse races at Ouakam, local belles of Dakar, views of the Dakar slaughterhouses, and Senegalese soldiers who fought for Mussolini.

As for the GEOGRAPHIC's World War II coverage, it is marked by a certain patriotic fervor and an effort toward neutrality. Maps are plentiful, and there is a war-related article in practically every issue. When mistakes were inadvertently committed, such as publishing pro-Hitler or pro-Mussolini authors like John Patric and Douglas Chandler, they were quickly corrected: Chandler was fired when it was discovered that he had received funds from the Nazi Party.

War is generally shown in the GEOGRAPHIC from the sky or from battleships, not close-up. The wounded are safely tucked into hospital beds, good-looking nurses at their side. On their day off, nurses haggle for a necklace with an Algerian salesman. "Fit to Fight Anywhere," a 1943 article, introduced humor as it demonstrated protective army gear, sometimes absurd, such as a gas-protector shaped like a minuscule tent. Also shown were marches under simulated desert heat and sub-zero temperatures. Medals, decorations, ribbons, and badges for both men and women were reproduced in full color.

A 1944 article by F. Barrows Colton, "How We Fight with Photographs," strikes a patriotic chord: "Cameras and film have become as essential in this war as guns and bullets, on some occasions more so. Glass-eyed Mata-Haris, they enter every phase of the war, from X-raying recruits' lungs to making identification badges for factory workers." Movie shorts such as "How To Get Killed in One Easy Lesson" were used to train troops. Some 30,000 pictures from the NATIONAL GEOGRAPHIC'S archive were used to brief flyers on navigational landmarks and to identify enemy targets for bombing. In brief, the archive was part of the war effort.

A unique characteristic of NATIONAL GEOGRAPHIC pictures of this period is their pursuit of the latest technological developments in photography. In the scope of this article, we can mention only a few of the most striking technological devices for which the GEOGRAPHIC, priding itself on all its "firsts," became famous between the '30s and the '50s. One of the most obvious, and certainly the most commented on by other editors, photographers, and writers alike, is the GEOGRAPHIC's use of color. Its reliance upon color photography was what made the Geographic stand apart from most publications.

Jules Gervais-Courtellement

SPAIN, 1926 • In this Autochrome by a regular contributor to the GEOGRAPHIC, a fashionable lady in Segovia steadies herself for a long exposure against an old chest of drawers in her home.

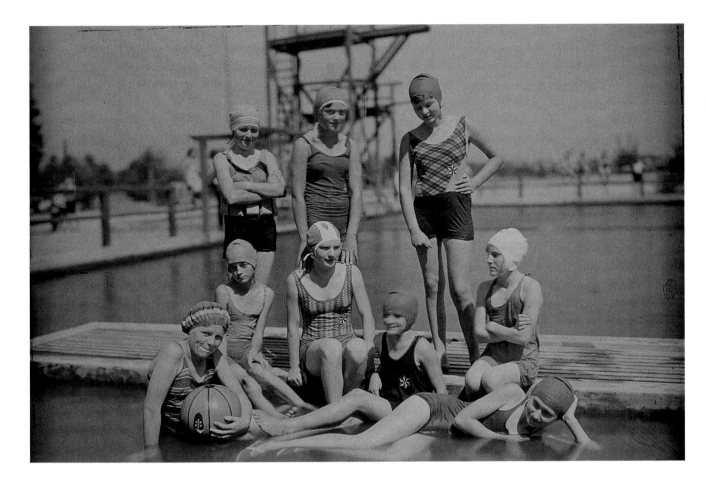

Wilhelm Tobien
GERMANY, 1933 • This
Autochrome captures care-
free pleasures at a pool in
Spreewald, Brandenburg, in
the same year that Adolf Hitler
became Germany's chancellor.

In photojournalism, black-and-white retained its prominence late into the
1950s. Even though Ben Shahn, Marion Post Wolcott, and other highly regarded
Farm Security Administration photographers working from the Depression and on
into the '40s photographed in color, their work could not be used by the FSA or in
most magazines because of the high cost of reproduction. In Europe, color barely
touched avant-garde magazines such as *Vu, Regards, Berliner Illustrierte Zeitung,* or
popular magazines such as *Picture Post.* In the United States, color in the 1930s was
limited to large-circulation magazines such as *Life, Fortune,* and the GEOGRAPHIC
and otherwise was usually reserved for fashion, architecture, and publicity.

In the NATIONAL GEOGRAPHIC of the 1930s, text is given prominent space,
and photography is used in a traditional way as illustration or as highlight. By the
mid-1930s, though, photographs become more significant. It appears, upon close
examination of the issues of this period, that editorial choices were made in assign-
ment of black-and-white to more psychological, intimate, close-up portraits, and
often to scientific subjects—from recent developments such as improved hot-air
balloons and bathyscaphes to modern industries—perhaps to lend more weight

and seriousness. Color was used with obvious delight to emphasize the natural beauties of the world, of animal life, or of exotic aspects of foreign cultures. The American wilderness or an exotic landscape shown in color conveyed a sense of awe, of a world still untouched, and supported the GEOGRAPHIC'S early stance on environmental preservation. In a large number of articles, the picturesque or nostalgic was portrayed, and items such as historic or folkloric costumes were given the lion's share of space.

And, little by little, photography took on an enormous prominence. Editor Gilbert H. Grosvenor routinely tried to turn writers into photographers as well, stressing the idea of the prominence of photography upon sometimes reluctant authors. As he explained to staff writer Maynard Owen Williams: "The illustration made the NATIONAL GEOGRAPHIC, and the magazine's life depends on getting better and better pictures."

At the GEOGRAPHIC each development in color processes defined style, atmosphere, and historical period: the hand-tinted photographs of the 1910s gave way to the Lumiére colors, then to the Seurat-like pointillism of the Autochrome process, still used in the 1930s. The first photograph in natural-color was taken at the North Pole in 1926, shortly followed by the first aerial color photographs of the South Pole, made in September 1930 by Melville Bell Grosvenor from a Navy airship, the ZMC-2, and from a blimp, the *Mayflower*. Other firsts in color included undersea photographs and the first color photograph made in the stratosphere, which have been widely written about.

Over the years, the GEOGRAPHIC experimented eagerly with every new color process, such as Finlay, Agfacolor, and Dufay. But Kodachrome became by far the most widely used film by 1938, two years after it was marketed. By the 1940s, the number of pictures in each issue had soared. In a June 1940 piece, aerial photography was described as not only a tool but as a war weapon, and the U.S. Army Air Corps carried on experiments with the cooperation of Eastman Kodak Company. Maj. Gen. H. H. Arnold praised G. W. Goddard's aerial Kodachromes: "Like a magic eye, the natural-color camera penetrates the veil of camouflage. Variations of shade and tint are clearly defined; natural color also gives a sense of depth, or a third dimension."

In this period, color and black-and-white were often mixed casually in the magazine. There also appeared to have been little concern for design or layout or for scale variations or the relationship between text and pictures, all of which became so important in the 1970s. Strikingly bright Kodachrome pictures often appeared out of context and followed the tradition of 19th-century postcards of small tradesmen and street workers: An April 1930 article on Louisiana by Edwin L. Wisherd, for instance, displayed the inevitable strawberry pickers, basket-weavers, cotton cultivators, and nostalgia for the deckhands who "still roam the Mississippi." Very

often, specific pictures are extraordinary by themselves but lose some of their appeal through lack of care in sequencing.

Largely because of the limitations of Kodachrome film in those years, colors characteristic of Africa or Asia, such as dark green, terra-cotta, saffron, or burnt sienna could only be recorded as emeralds, browns, oranges, and yellows. Kodachrome did not seem capable of seizing the subtly different tonal ranges of diverse countries, and a certain uniformity of color across the board seemed to reinforce the idea of similarities between people rather than their differences. Foreign countries appear to resemble America—except in the sheer number of colors they display.

As C. D. B. Bryan has reported, from the 1930s to the '50s, NATIONAL GEOGRAPHIC editors and photographers felt that they had discovered "a new, universal language that requires no deep study . . . one that is understood as well by the jungaleer as by the courtier, by the Eskimo as by the wild man from Borneo; by the child in the playroom as by the professor in college; and by the woman of the household as by the hurried businessman— in short, the Language of the Photograph."

Economic imperatives—the costs of color film and in printing—restricted the use of color photography primarily to wealthy magazines. For the historian of photography, a dearth of color images has limited its coverage in historical analysis. A history of color photography at the GEOGRAPHIC, however, still remains to be done.

Another area in which the GEOGRAPHIC has clearly been progressive is in its employment of women journalists. By and large, 20th-century female explorers follow an important and often overlooked tradition that began in mid-18-century Europe: Frenchwoman Jeanne Baret, for instance, had sailed with Comte de Bougainville's 1767 exploration in the South Pacific and had boarded the ship *Etoile* in man's attire. Well into the 20th century Isabelle Eberhardt also wore men's clothing most of the time when she lived in the Middle East. In the late 19th century, Englishwoman Gertrude Bell was the first European woman to travel into the Syrian desert, following the example of Lady Jane Franklin, who 50 years earlier had roamed Syria, Asia Minor, New Zealand, Australia, and the Canadian Arctic. Elizabeth Mazuchelli explored Nepal and northern India, while Florence Baker went to East Africa with husband Sir Samuel Baker. By the end of the 19th century female explorers were numerous.

Early on, Gilbert Grosvenor had sent reporter Eliza Scidmore on assignment

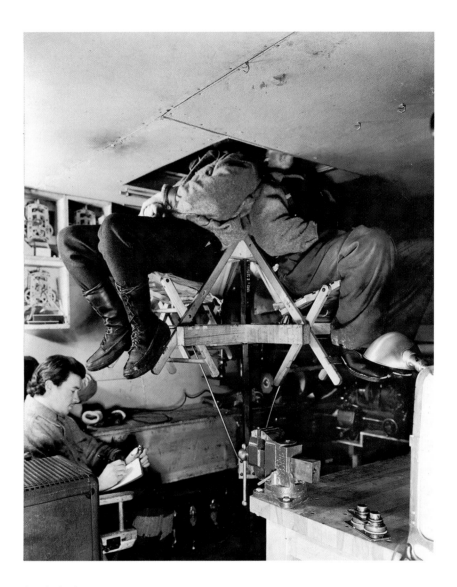

Byrd Antarctic Expedition

ANTARCTICA, 1935 • On Admiral Richard Byrd's Antarctic expedition of 1935, members rigged up a comfortable viewing station for the southern skies, where they counted as many as 60 shooting stars a minute. Exploration and science continued as key subjects through the 1930s.

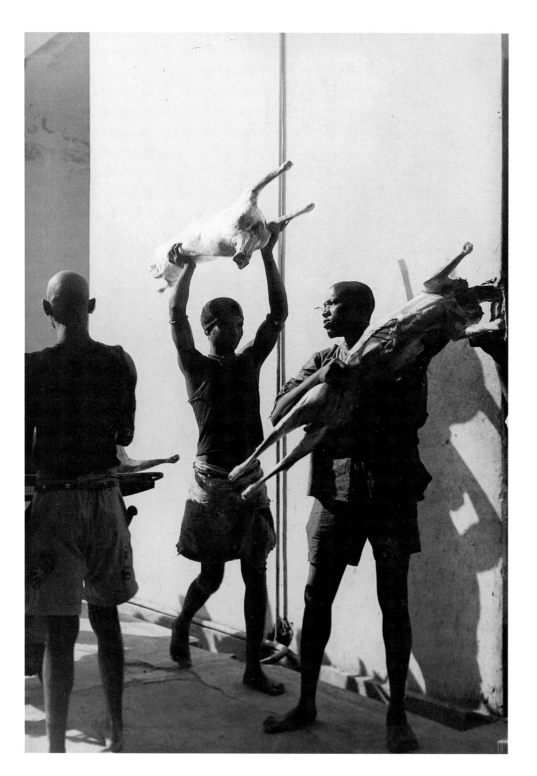

Pierre Verger

AFRICA, 1942 • In Dakar, French West Africa, Moors are enlisted to do the slaughtering in the local abattoir; Muslims will not touch the meat of animals not killed according to their customs.

and by the 1930s had repeatedly urged his editors to find more female writers, noting in 1938 that many best-sellers of that year were written by women. "I am sure there must be some hidden talent," he wrote to Assistant Editor Jesse Hildebrand in 1949. "Men are more forward . . . perhaps that is one reason why the ladies . . . have not received as many assignments."

In the 1930s and '40s, the ladies did receive a very fair number of assignments. Harriet Chalmers Adams, a frequent contributor, specialized in South America and the Mediterranean. In a 1930s trip to the Cirenaica (a part of Libya that was then an Italian colony), she persuaded Muslim women and girls to be photographed without the veil and she established a working relationship with entire families, children included. Persuading women to pose in a period when photography was little known was often a difficulty for photographers, especially in Muslim countries, where there are strong taboos against representation, which is considered *hasuma* (shameful). It could also be difficult elsewhere: W. Robert Moore, for instance, who wanted to photograph Sumatran women in the marketplace noted: "Despite their finery they are exceedingly shy and considerable persuasion is necessary to induce them to pose for pictures."

While many men explorers insisted on stressing the scientific and favor a serious or neutral tone in both pictures and text (maybe to give readers the impression they see an unmediated world), women (except during World War II) could take themselves less seriously, and they often devoted good measure to humor and personal anecdote and reports of unglorified everyday life. Such a tone is obvious, for instance, in Mrs. Richard C. Gill's "Mrs. Robinson Crusoe in Ecuador" (February 1934), which included many everyday-life pictures in black-and-white, reportage-style; and in Ruth Q. McBride's "Keeping House on the Congo" (November 1937), which has a self-deprecating, humorous tone and features amusing stories of her household, which included pets such as a baby crocodile that promptly goes on a hunger strike.

Instead of presenting themselves as isolated and glamorous explorers who fight dangers alone, women often include their family in the trip and in the piece: one example is Cornelia Stratton Parker's "Entering the Front Door of Medieval Towns" (March 1932), subtitled "The Adventures of an American Woman and Her Daughter in a Folding Boat on Eight Rivers of Germany and Austria." In that piece, mother and daughter, as much as what they see, become subjects of the pictures and heroines of the story. A series of striking black-and-white photographs often close-up and taken from another boat at water level, shows them paddling on high waves and passing difficult points on the river, drawing the viewer closer to the event. Ruth Albee collaborates with husband William Hamilton Albee on a May 1942 story, "Family Afoot in Yukon Wilds," a 300-mile trek in the Northwest Canada wilderness, a region, Albee relates, that trappers and prospectors called "a real he-man country." Husband and children are featured in a number of color pictures. That same year Amelia Earhart was the first woman recipient of a National Geographic Society medal, while Anne Morrow Lindbergh received a Hubbard Medal from the Society and gave a first-hand account of her North Atlantic flight

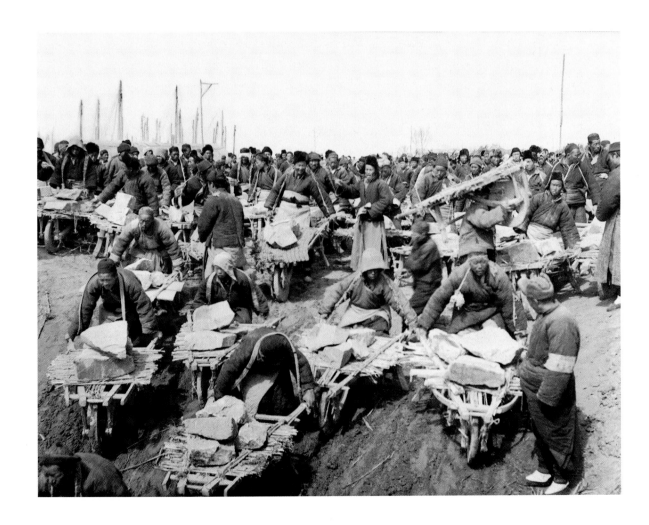

Oliver J. Todd
MANCHURIA, 1942 • Massed human labor is called upon to curb the unruly Hwang Ho, as wheelbarrows by the hundred are used to dump rocks into a break in the dike.

(September 1934). In "The Land of Sawdust and Spangles" (October 1931), Francis Beverly Kelley explored the world of circuses, and her piece is illustrated by modern pictures of acrobats, clowns on stilts, rope-walkers, and trapeze artists with Moholy-Nagy-like perspectives that mix color and black-and-white.

One of the most remarkable pieces is Lilian Grosvenor Coville's "Here in Manchuria" (February 1933), in part because of the author's deep familiarity with her subject: She resided in Harbin, a North Manchurian city, from May 1932, in a climate of general instability where bandit attacks, robberies, and kidnappings are common occurrences. She described in words and pictures ". . . the chaos of China . . . closing in about us," at a time when Japan and China were in dispute over Manchuria. Her article was not only an in-depth exploration of politics and every-day life but also a timely report on the floods that almost destroyed this city of 250,000 people. The piece is illustrated with well-sequenced, modern pictures by Cabot Coville depicting flooded streets, people escaping on boats, Russian and Chinese boatmen rowing across the river to ferry people about.

Among many more women explorers were Mrs. William H. Hoover in Africa, L. Elizabeth Lewis in Singapore, Mabel Cook Cole in Sumatra, Penelope Chetwode in Nepal, Eleanor de Chételat in French Guinea, Ruth Q. McBride in Congo, Eleanor Schirmer Oliver in the Solomon Islands, La Verne Bradley and Mary Nourse on Women's Work before and during World War II, and all deserve to be mentioned.

While we could happily continue reflecting on photography at the NATIONAL GEOGRAPHIC in the years 1931-1950, there is something that analysis will always leave out—and it may be the most important element: emotion, the strong pull, the delighted fascination that keeps me looking and looking through those stacks of magazines, making it difficult to stop writing.

Armchair travelers, we fantasize ourselves next to the writers and photo-graphers and may even plan our own trips as tourists to distant lands because of pictures we have seen.

It is impossible not to mention that the GEOGRAPHIC's countless readers (their number grew from over a million in 1930 to more than two million in the fifties) were pretty much buffered, at least in the magazine, against the Great Depression, World War II's millions of dead, the throes of the end of colonialism, the suspicious climate of the Cold War. So why then does the universal appeal of GEOGRAPHIC photographs, even those that seem somewhat overly-optimistic (or outrageous, colonialist, old-fashioned, kitsch), remain intact?

I think it is because they plug into that part of us that wants to forget the conflicts, wars, and famines of the world at large and to be allowed an escape from everyday drudgeries. It shows us the world as we want it to be.

In all of those countries that, near or far, forever lie between the GEOGRAPHIC's

covers, the dangers may be numerous but the storyteller will nearly always survive to tell us his tale. Even while the stories scrupulously follow the guidelines of the magazine's founders and remain true to facts and eschew the "partisan or controversial," they manifest the GEOGRAPHIC's overwhelming desire to remain faithful to a scientific neutrality and to humanist ideals, ensuring that we look at a world whose appearance and colors are realistic—though somehow penetrated by the sweetest tinge of unreality.

Luis Marden

COSTA RICA, 1946 • Of the thousand known varieties of orchids grown in Costa Rica, this perfumed Swanneck orchid is among the rarest, a thick, waxy flower shown to advantage in this colorful Kodachrome. By the mid-1940s the GEOGRAPHIC was thoroughly enchanted by Kodachrome's vivid possibilities.

Agfa Photographs

NEW YORK, 1930 • *Following pages:* In an article about New York City entitled, "Tempo and Color of a Great City," the GEOGRAPHIC, which had long relied on the Autochrome process for color photos, now introduced an early version of Agfacolor.

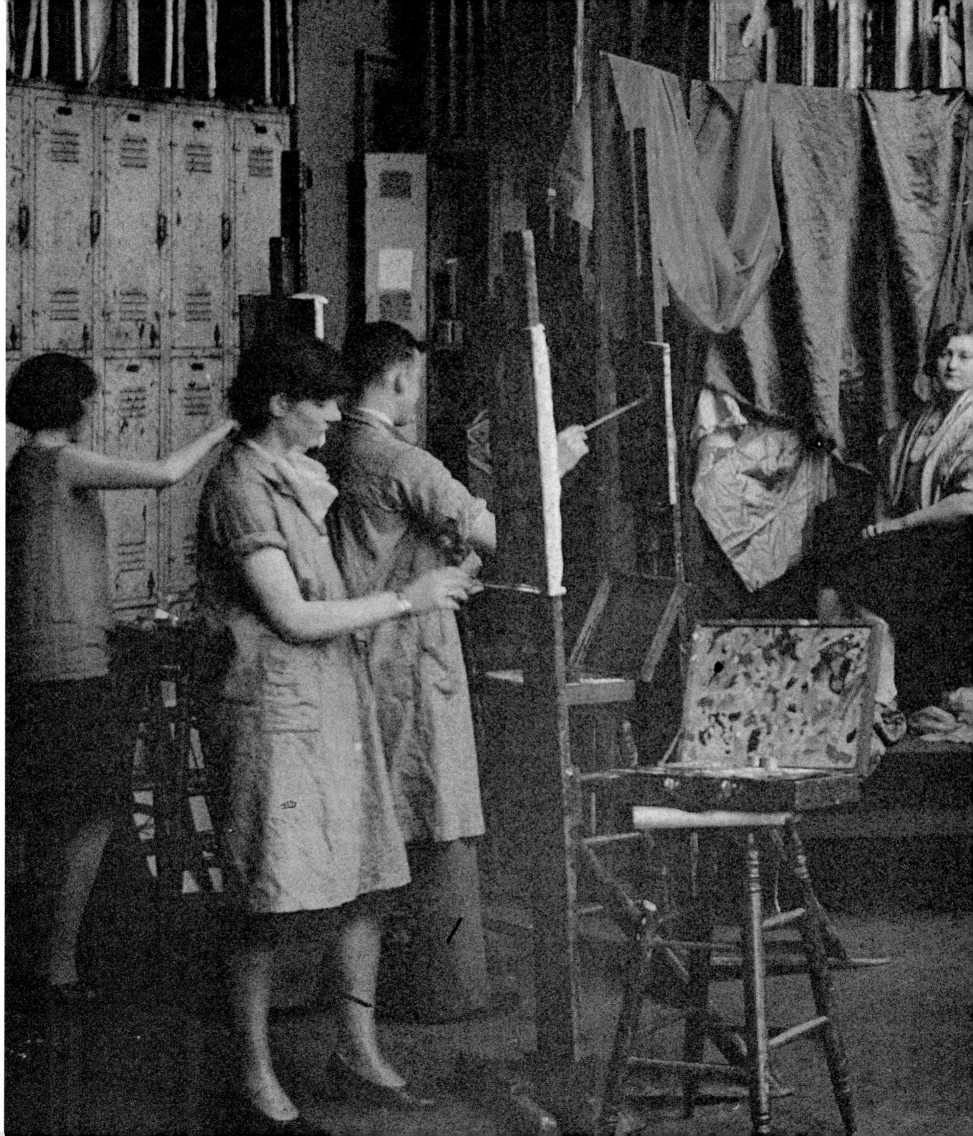

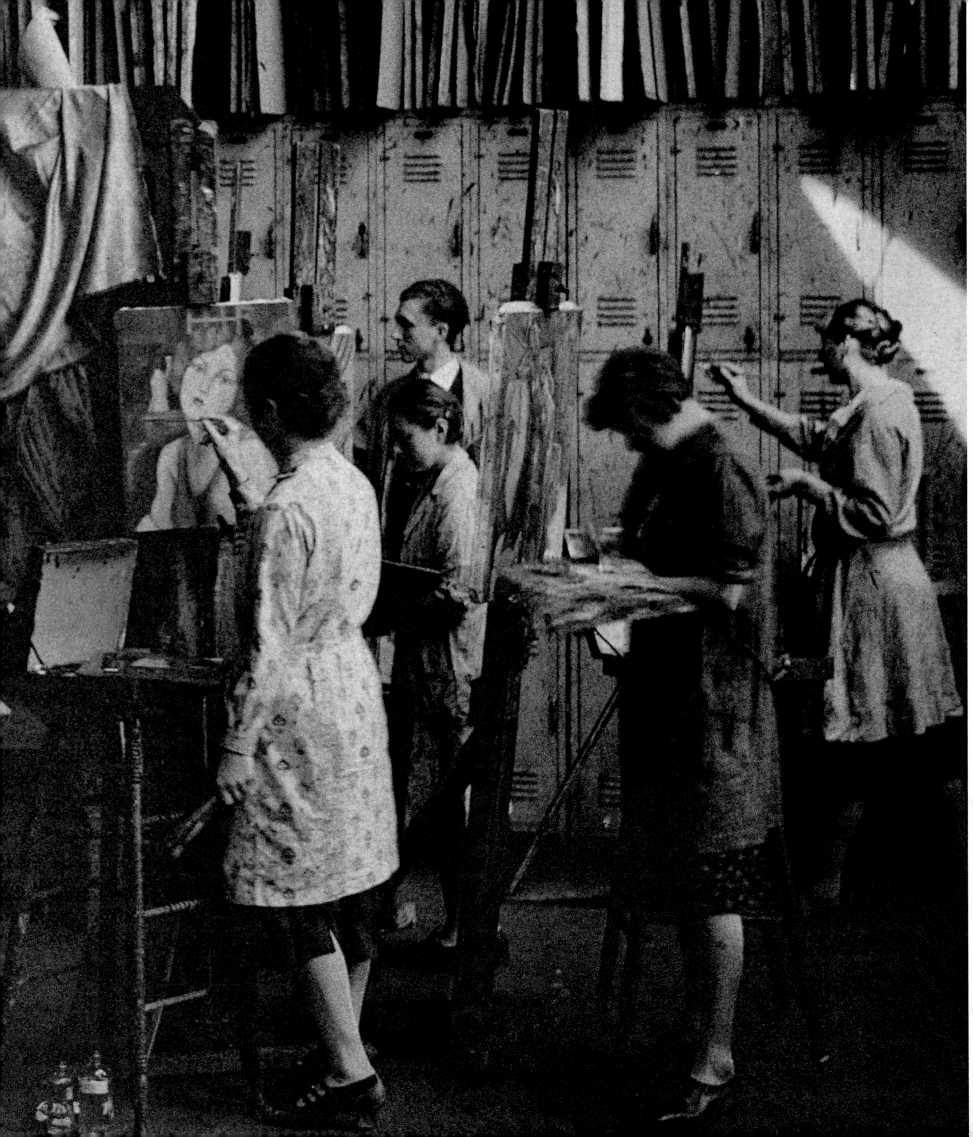

Ewing Galloway
NEW YORK, 1930 • Along Hester Street on the Lower East Side of Manhattan, pushcarts rumble into place each morning, with fruit, vegetables, meat, bread, novelties, and clothing—all that and more.

Unknown Photographer
NEW YORK, 1930 • *Left:* Automobiles and double-decker buses pass in front of the impressive medical center erected by Columbia University at Broadway and West 168th Street in New York City.

Luis Marden

NEW YORK, 1947 • With the Empire State Building on the Manhattan skyline, shad fishermen on the Hudson River drive hickory poles into the mud to support their gill nets.

Unknown Photographer
COLORADO, 1932 • This picture, supplied by the Grand Junction [Colorado] Chamber of Commerce, boasts
half a million pounds of local tomatoes ready for the canning factories.

J. R. Roberts
CALIFORNIA, 1940 • *Following pages:* In the lush semitropical climate of California, entire fertile valleys are
planted with orange trees, whose fruit is shipped all over the country.

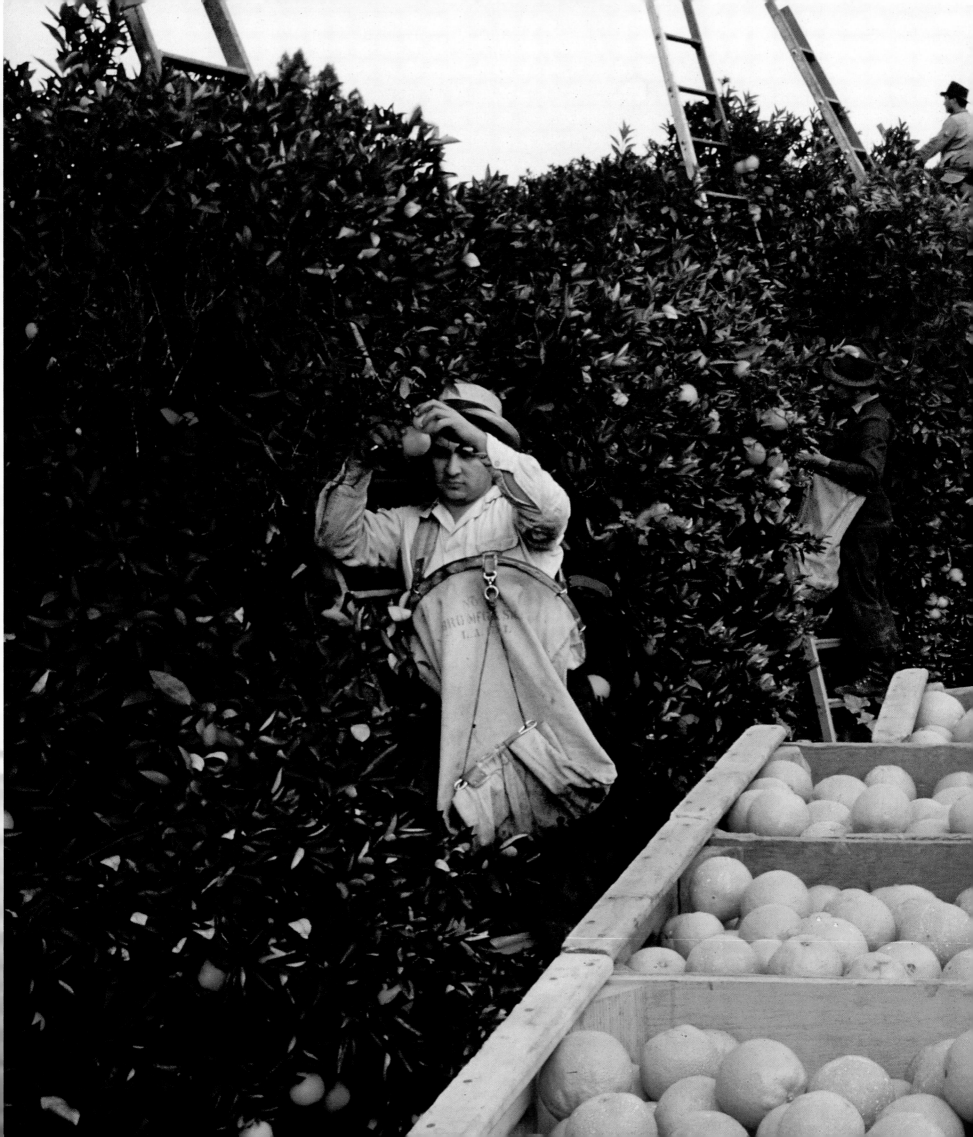

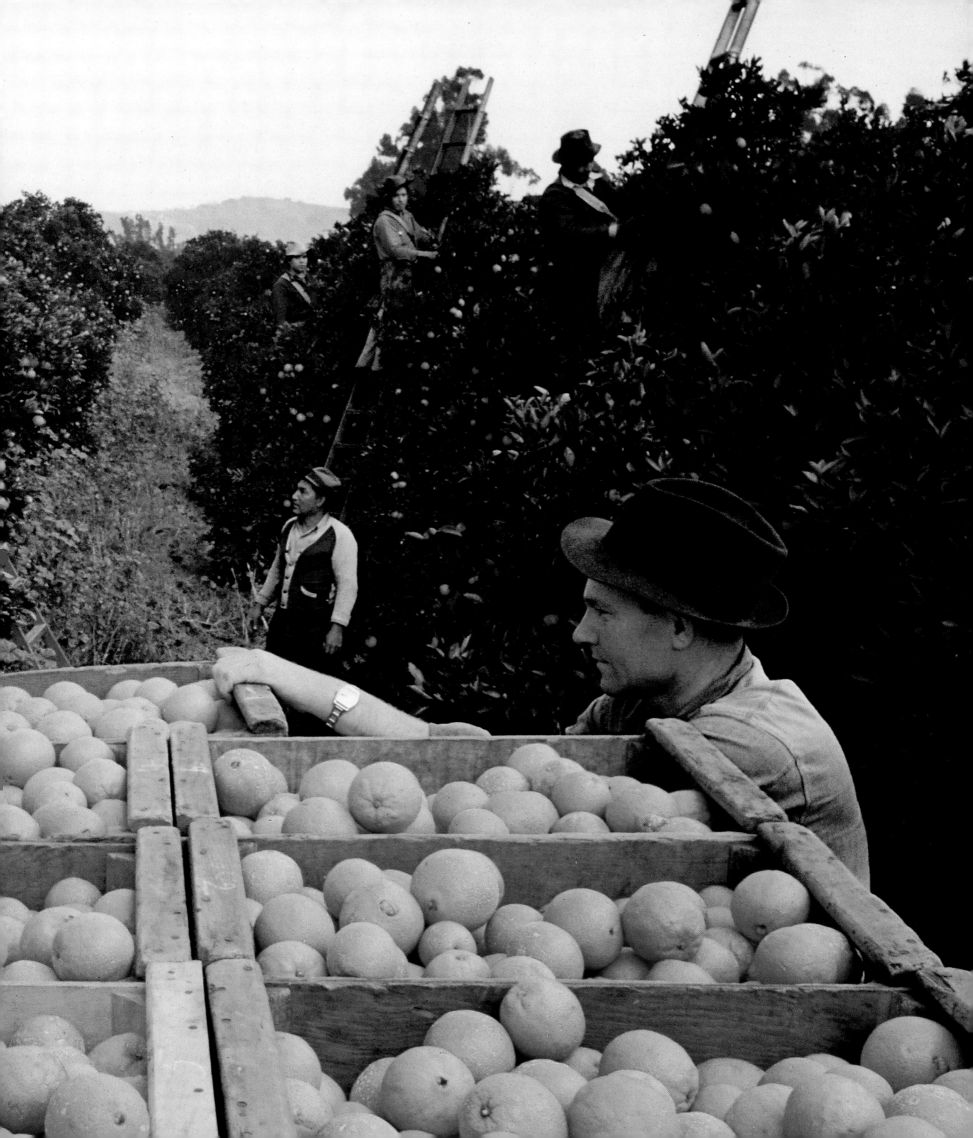

Luis Marden

PANAMA, 1941 • Rainbow trout, orchids, and coffee beans from the Volcán region of the province of Chiriquí are artfully presented in this still life.

Luis Marden

TRINIDAD, 1942 • *Opposite:* In a Trinidad rain forest, hunters flush vampire bats out of a hollow tree into a net, to keep down the number of disease-bearing animals.

Clifton Adams

MEXICO, 1930 • *Following pages:* In this Mexico City arcade, professional scribes do a thriving business preparing documents of all sorts—including love letters—for their illiterate compatriots.

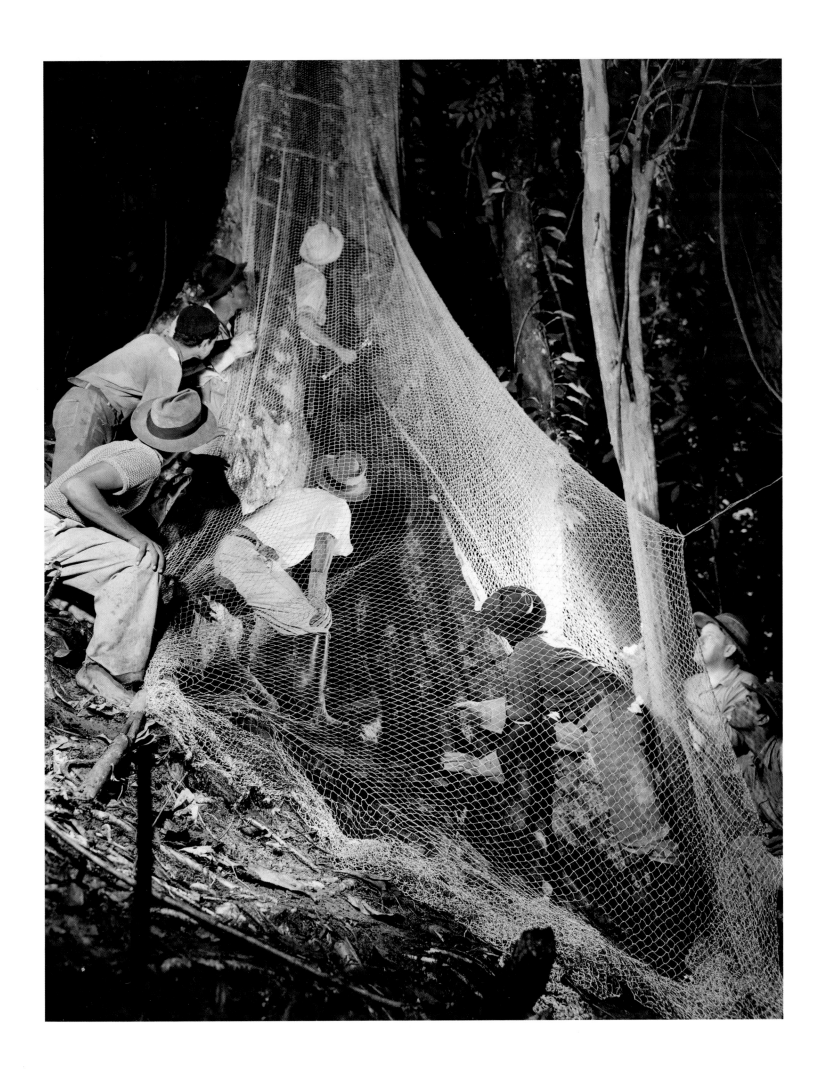

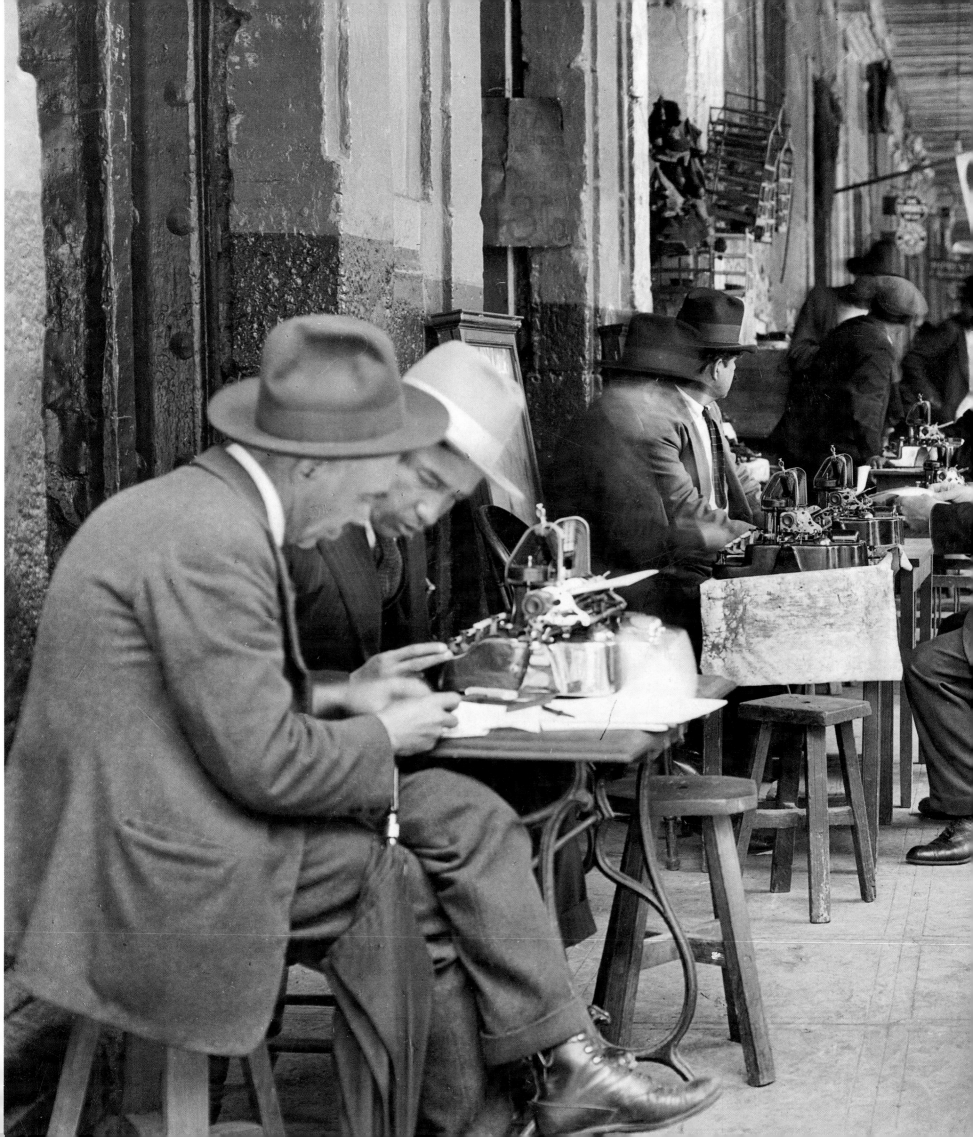

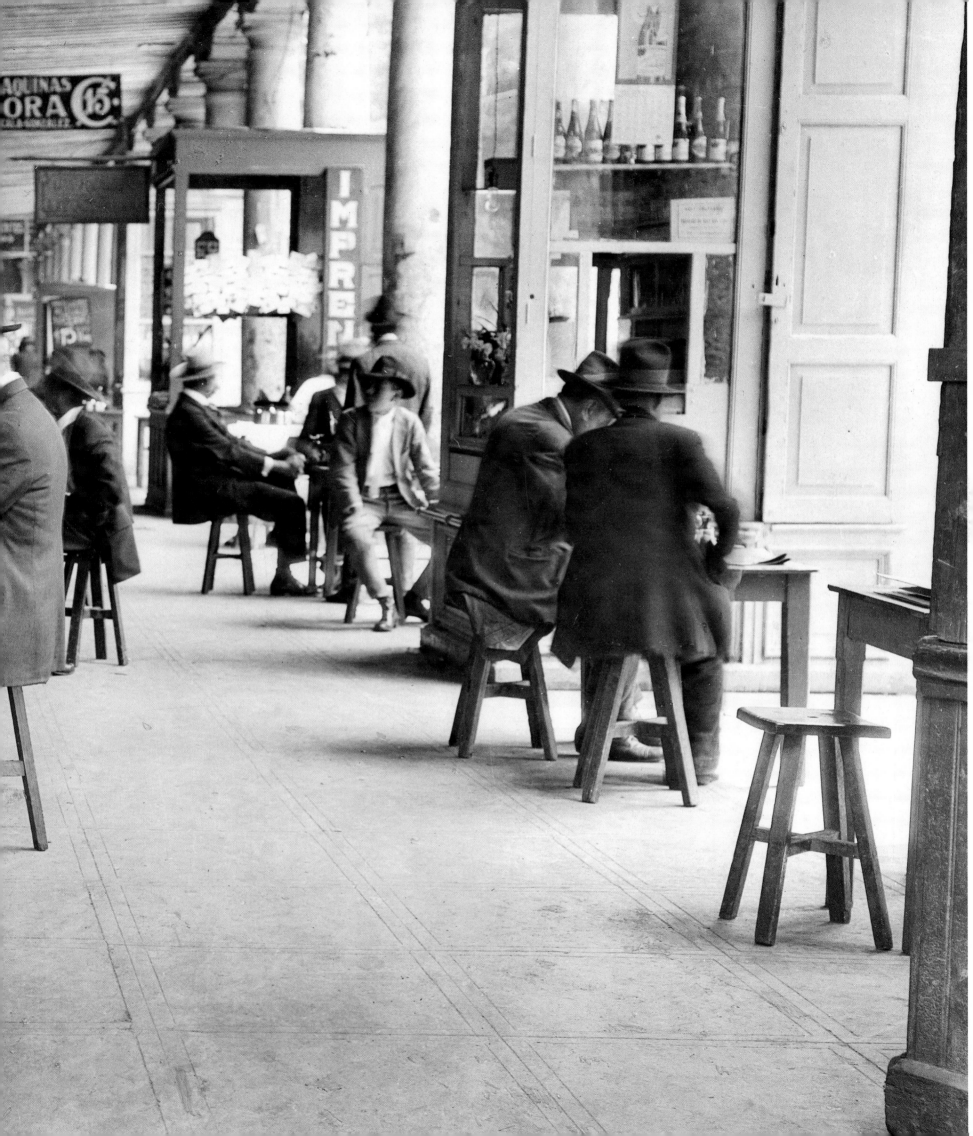

Luis Marden
EL SALVADOR, 1944 • Ripe coffee berries are brought in by oxcart from the plantations and deposited directly into the mill's railcars, just the beginning of a long journey to the cup.

Giles G. Healey
GUATEMALA, 1945 • *Right:* At the base of the mist-shrouded volcano Atitlán, Indians live much as the medieval Maya did, carrying water to their thatch-roof homes in jars balanced on their heads.

Robert Shippee, Aërial Explorations, Inc.
PERU, 1933 • *Following pages:* Six hours by air north of Lima, Peru, where only a few years before barren sands stretched to the horizon, Americans and Canadians developed extensive oil fields.

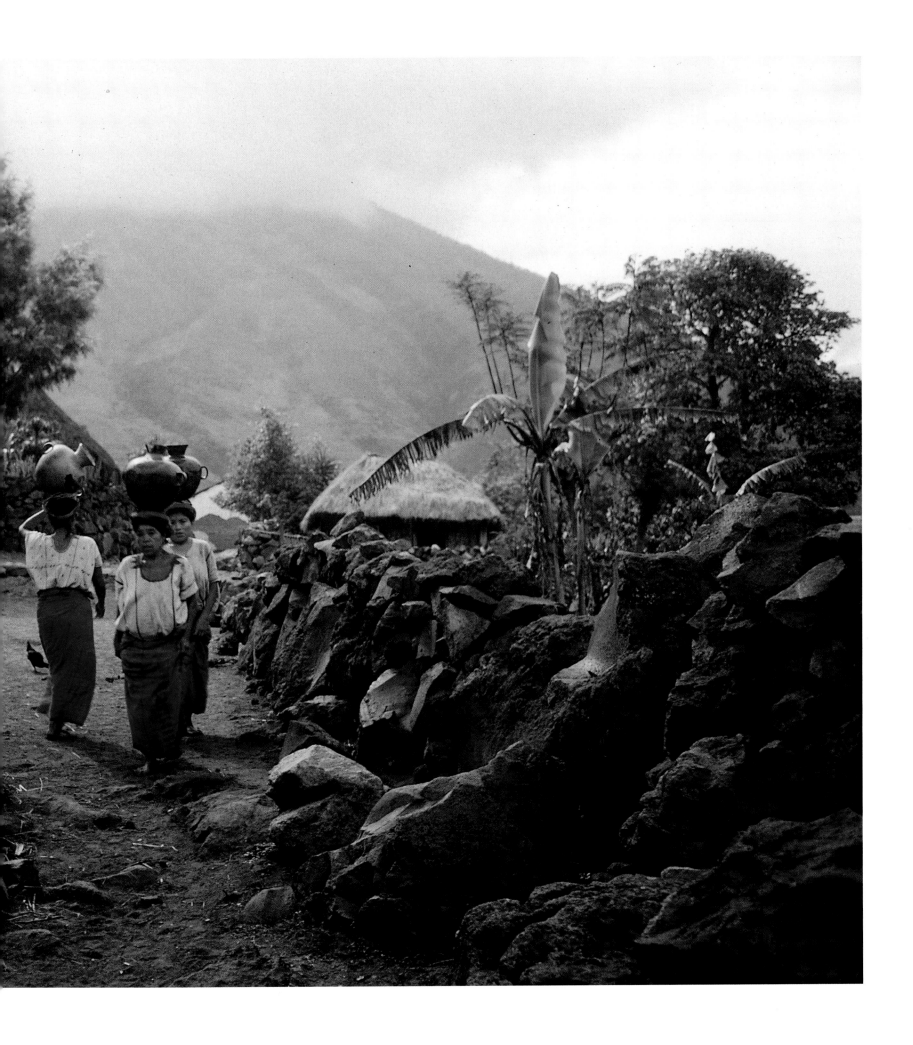

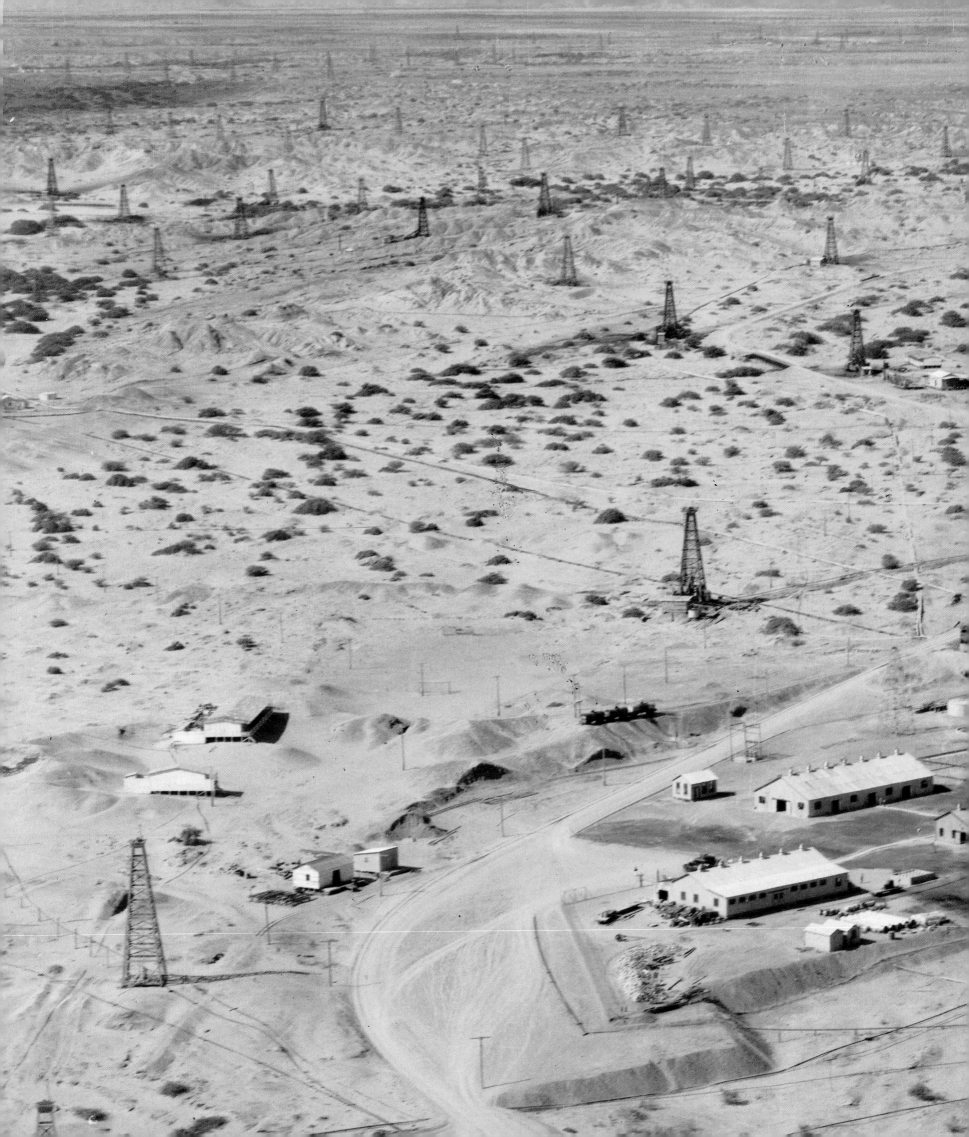

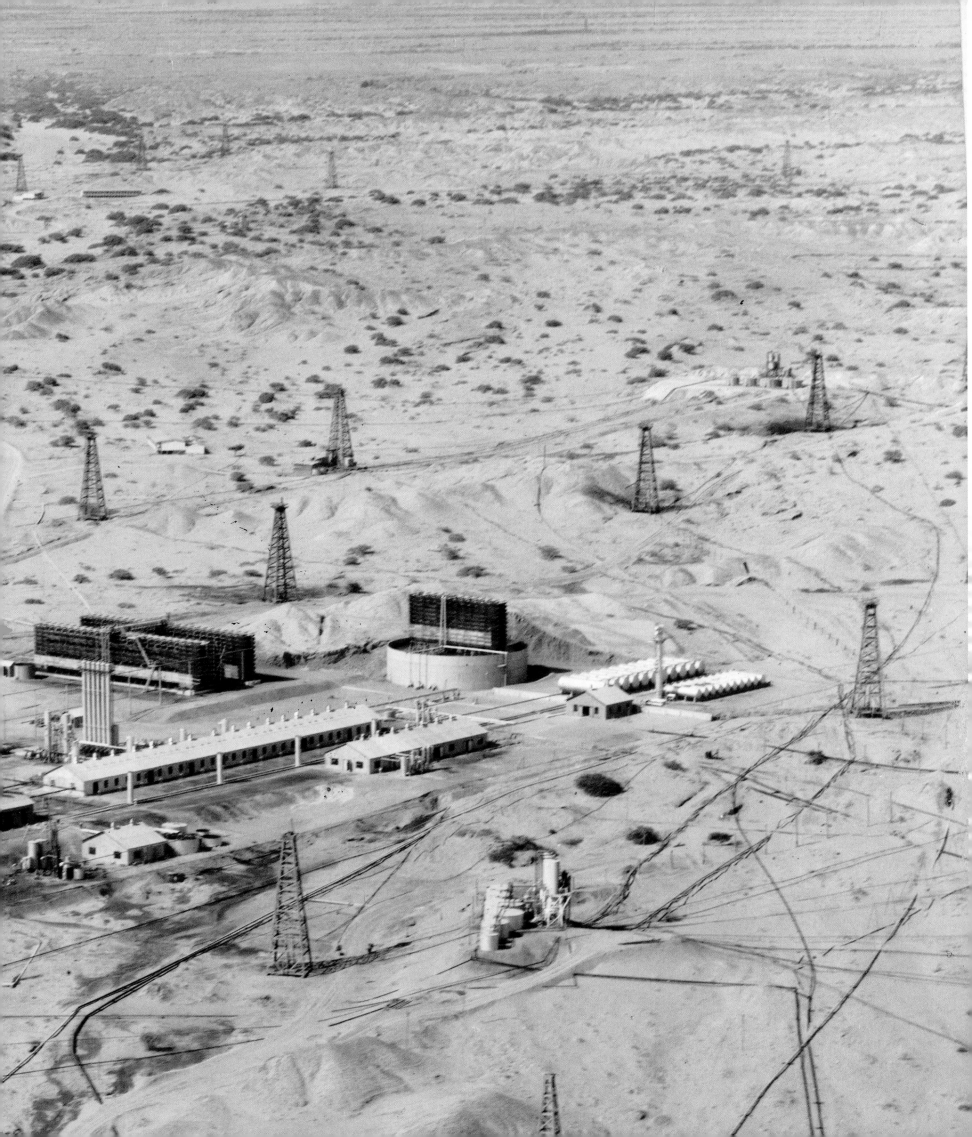

Maynard Owen Williams

TUNISIA, 1937 • Waiting for unprepared motorists to come to grief in the sand dunes, these Berber youngsters earn pocket money by running to the rescue.

William C. Hayes

EGYPT, 1941 • *Right:* These excavations at Thebes reveal more than a thousand years of history and mark the extent of the 1935–36 digging season for New York's Metropolitan Museum of Art.

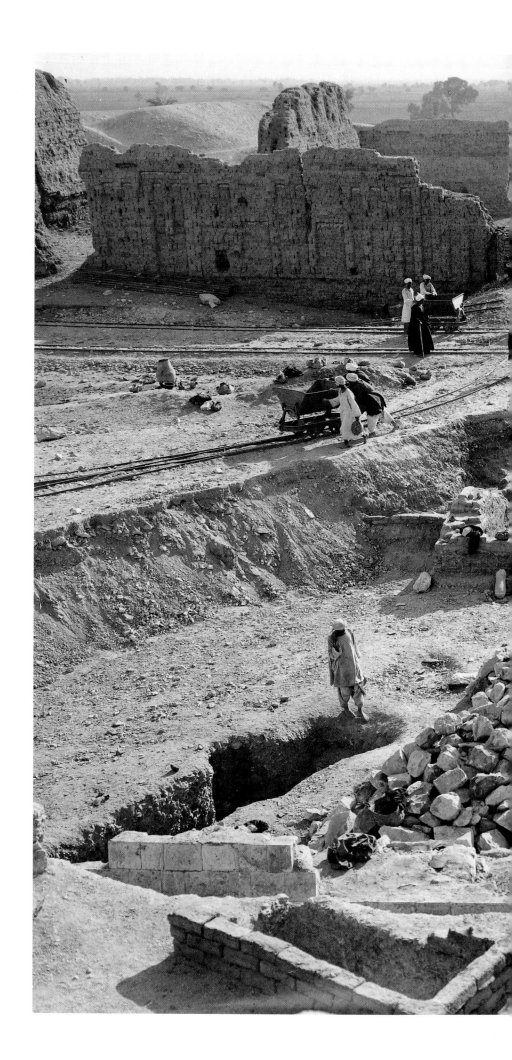

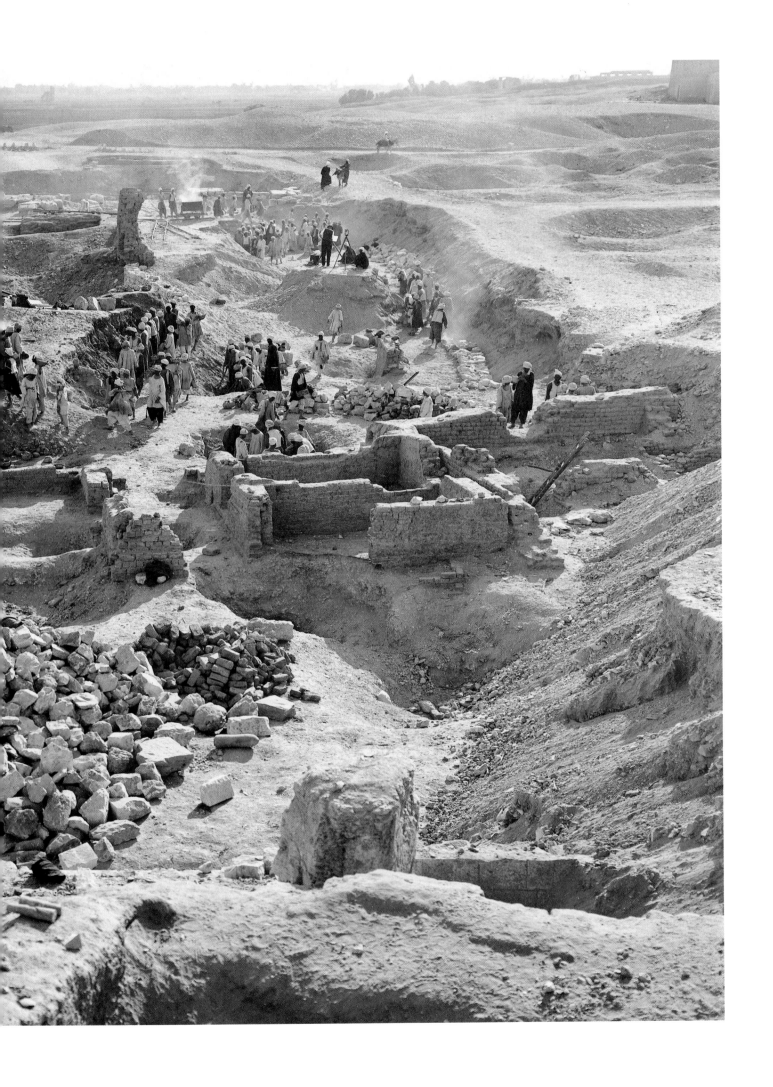

Edward S. Murray

SINKIANG, CENTRAL ASIA, 1936 • In cleaning house, the Kirghiz simply strip off the coverings of a yurt
and move the frame to a new location before putting everything back together.

Renée Gesmar

TUNISIA, 1943 • Male relatives of a Muslim bride-to-be, who has never seen the man she is to marry, pack her belongings for moving to the bridegroom's home.

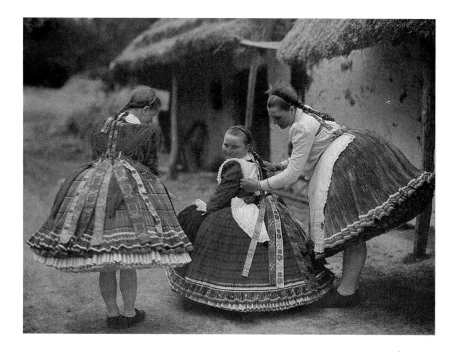

Rudolf Balogh

HUNGARY, 1938 • Captured on a glass-plate Autochrome in their Sunday best, these Mátra Mountain maidens wear seven or eight pleated skirts so stiffly starched that sitting is virtually impossible.

W. Robert Moore

NEW ZEALAND, 1936 • *Right:* In an English country scene transplanted to the South Pacific, New Zealanders enjoy a game of bowls and take the waters at a government-operated spa.

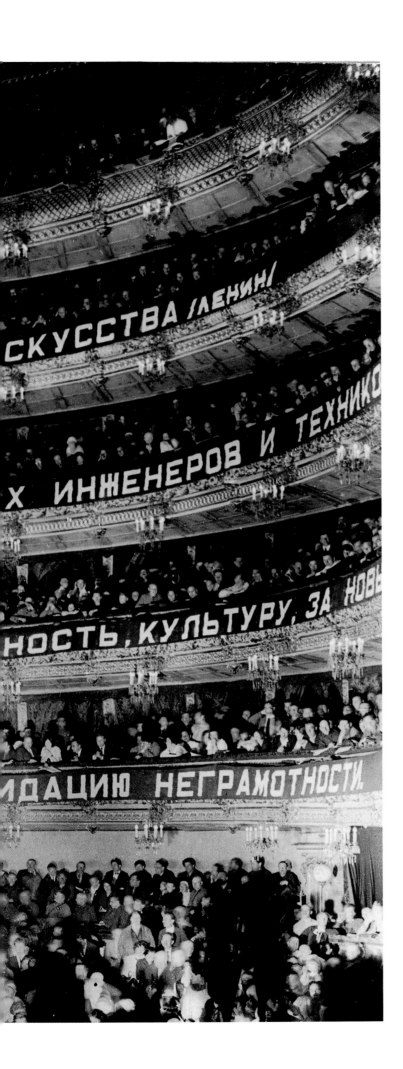

Acme Newspictures

RUSSIA, 1936 • Moscow views a solar eclipse on June 19, 1936, with some perhaps more interested in reading about it than actually witnessing the phenomenon. Very little hard information about life in the Soviet Union was reaching America at that time, but the GEOGRAPHIC obtained whatever was available.

Unknown Photographer
Press-Cliché Russian News Photo Agency

RUSSIA, 1928 • *Left:* In the Great Imperial Theater, the Moscow Soviet met in plenary session on May 31, 1928, to honor Maxim Gorki, author of *The Lower Depths* and literary spokesman of the working class.

Unknown Photographer, U.S. Army Signal Corps
ITALY, 1944 • In an article entitled "Infantrymen—The Fighters of War," this combat photograph shows soldiers firing on Nazi advance units near Anzio, Italy, with much coveted submachine guns.

Aaron S. Miller
WASHINGTON, D. C., 1945 • *Opposite:* On the morning after perhaps excessive V-J Day celebrations, these two servicemen take a little rest, oblivious to their surroundings.

Willard R. Culver

MESA VERDE, 1949 • Taking full advantage of his Kodachrome film, this photographer captures a range of contrasting colors on the road that spirals down from Mesa Verde Summit, past the Knife Edge, to Montezuma Valley.

David Douglas Duncan

PERU, 1941 • *Following pages:* Cormorants by the hundreds of thousands come to roost upon San Lorenzo, where in two years this side of the island will acquire a guano deposit nearly 18 inches deep.

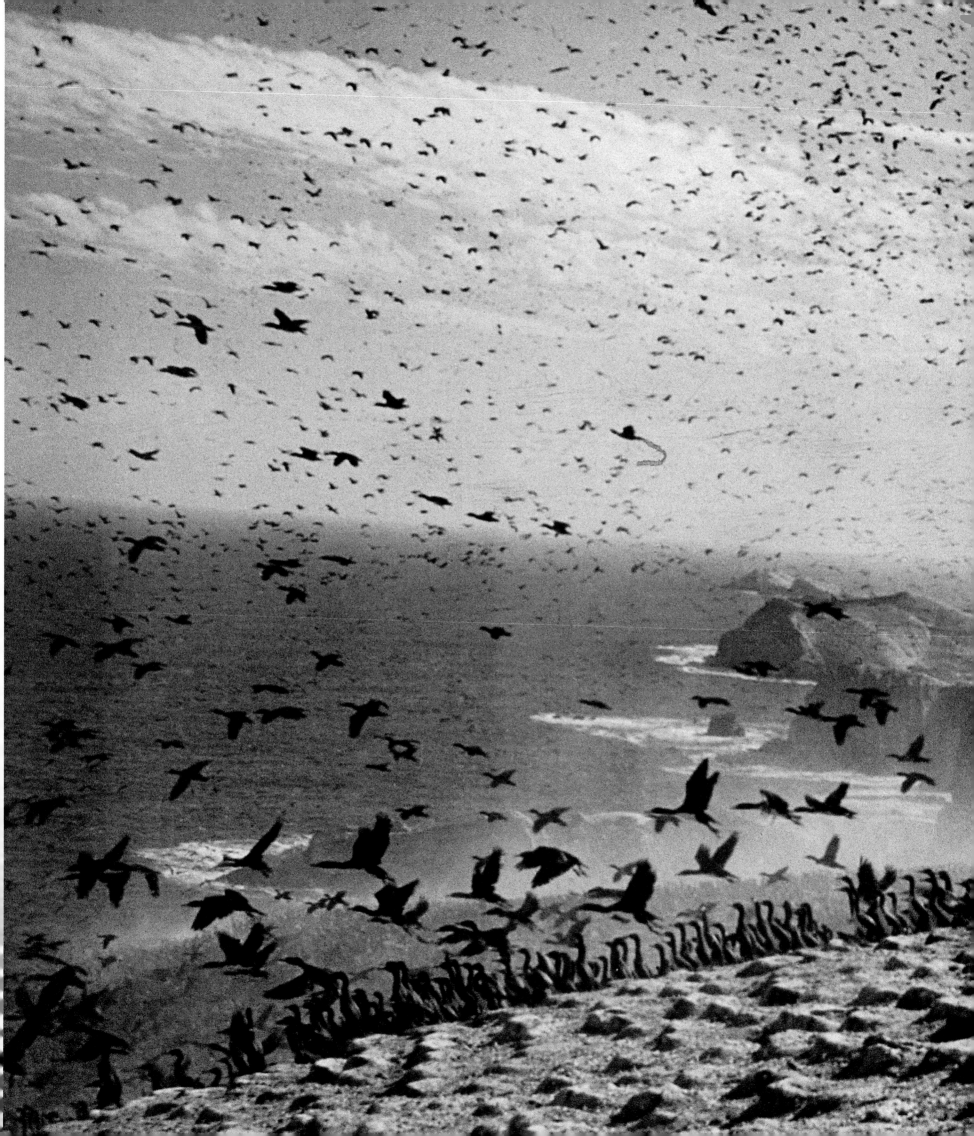

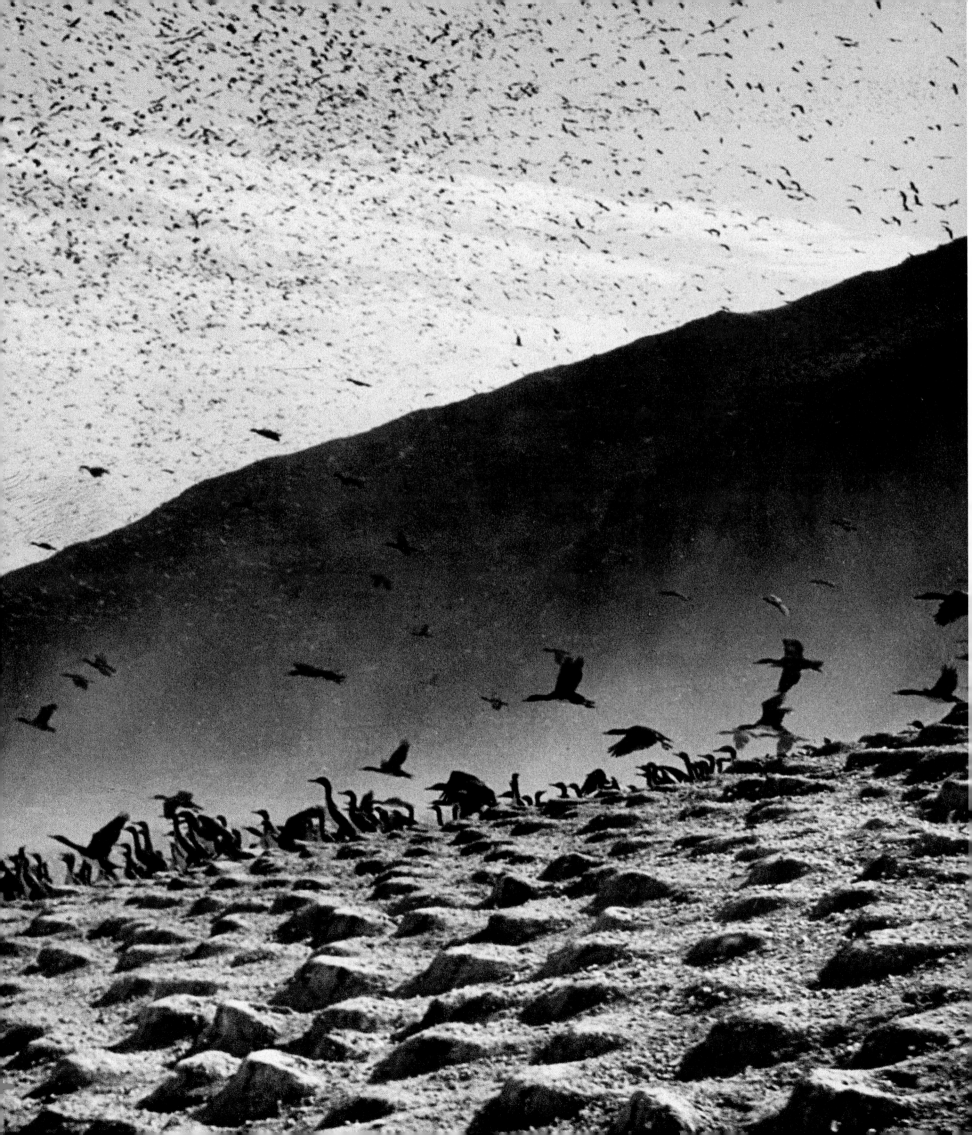

Breakthroughs with Color Film

William Wisner Chapin
KOREA, 1910 • This Korean farmer dressed for rain, in a hand-tinted black-and-white photograph, was part of a 24-page color section in NATIONAL GEOGRAPHIC that was a sensational milestone: No magazine had ever run so many color pictures before.

A. W. Cutler
PORTUGAL, 1922 • *Opposite*: A Portuguese peddler wears her wealth upon her head in this hand-tinted image. Hand tinting was one typical approach for getting color into published photography in this early period.

At the time of photography's invention, just before the middle of the 19th century, capturing color was more or less a dream, although several photographers before the century was out had discovered ways of adding color to their pictures. Initially it was by the hand-tinting of photographs that natural color was simulated, but other ways were soon discovered to introduce pigments into positive prints or into film emulsion to produce pleasing overall tones. In addition, it was learned that lifelike color could be duplicated by projecting a black-and-white subject through three different color filters and combining the images. Technically this was the direction the future took, but it was not viable until the first decade of this century when a practical method of duplicating this additive filter process on a glass plate was finally invented by the Lumière Brothers of Lyon, France. Christened Autochrome, these plates combined filters of very fine potato-starch grains dyed orange, green, and violet, which were coated, as for black-and-white pictures, with a gelatin-silver emulsion. The process, though easy to use, required a long exposure time, and was best viewed as a transparency since there was no immediate, satisfactory way of producing the image as a positive print for use in publications; but that would come.

In the meanwhile, perceiving that the future of the GEOGRAPHIC was joined to photography, Editor Gilbert H. Grosvenor had ventured to print 11 pages of photographs in the January 1905 issue, and then 32 more in April of that year. By 1908 more than half the pages of the magazine were devoted to photographs. In the November issue of 1910, Grosvenor printed his first color pictures, 24 pages of hand-tinted photographs of Korea and China taken by William W. Chapin. The results were sensational and prompted Eliza Ruhamah Scidmore, the first woman on the Society's Board of Managers, to offer her own hand-colored pictures of Japanese children so that Grosvenor could cover himself "with glory with another number in color and thereby catch a few thousand more subscribers." When Scidmore's photographs appeared in the GEOGRAPHIC of July 1914, Grosvenor

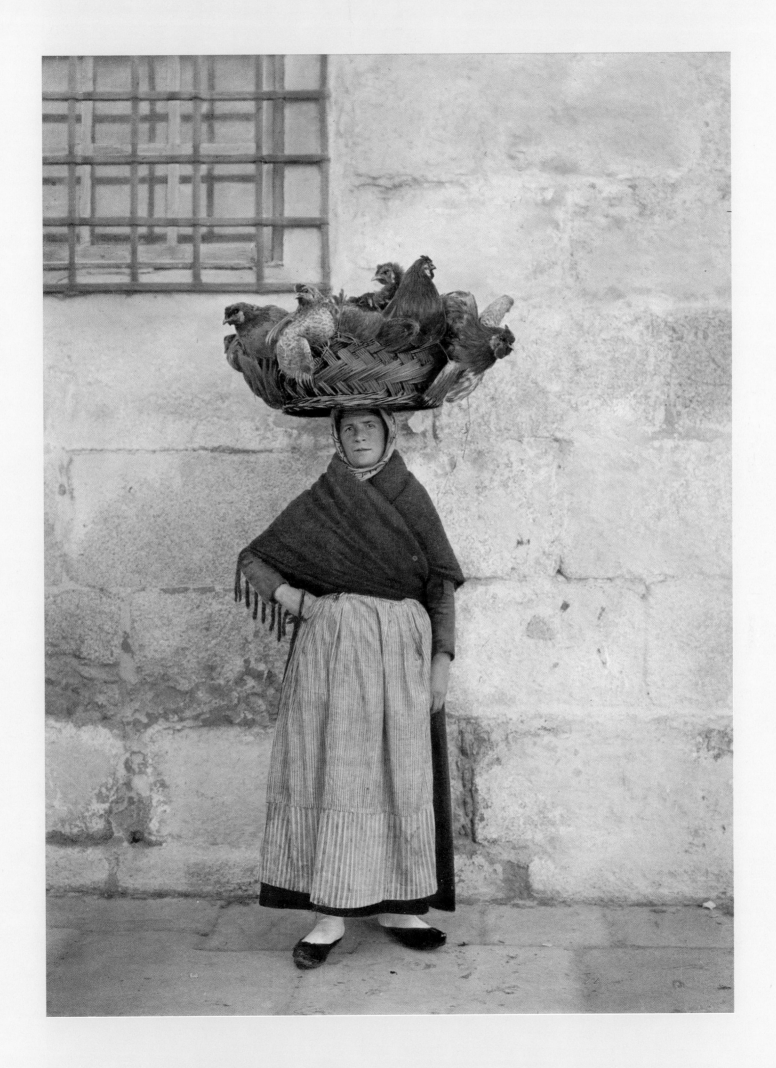

had another ace up his sleeve and also published his first actual color-film photograph, a Lumière Autochrome taken at a Belgian flower show.

Although Autochromes lost in print some of their luminous colors as glass plates, they were a mainstay of the GEOGRAPHIC into the 1930s—some 12,000 originals are archived, the work of photographers such as Clifton Adams, Luigi Pellerano, Wilhelm Tobrien, Charles-Edward Heag, and Jules Gervais-Courtellemont. In 1927 the GEOGRAPHIC achieved a historic first with Autochrome by publishing the first natural color photograph of fish taken underwater. There were, however, rival processes also popular with GEOGRAPHIC photographers, including Finlay, which consisted of a screen of bichromated gelatin, a technique derived from the half-tone process. Grosvenor kept track of the newest developments in color photography and filled the pages of his magazine with images representative of each new process. From 1925 on, there were color photographs in every issue of the GEOGRAPHIC. Grosvenor's son, Melville, in September 1930 shot an unprecedented series of color pictures from a Navy airship with an 8x10" camera.

The 1930s saw a huge development in

Unknown Photographer

NEW YORK, 1930 • This fashion show on New York's famous Fifth Avenue is captured, as the credits indicate, in Finlay Direct-Color, one of the newer color processes with which GEOGRAPHIC constantly experimented.

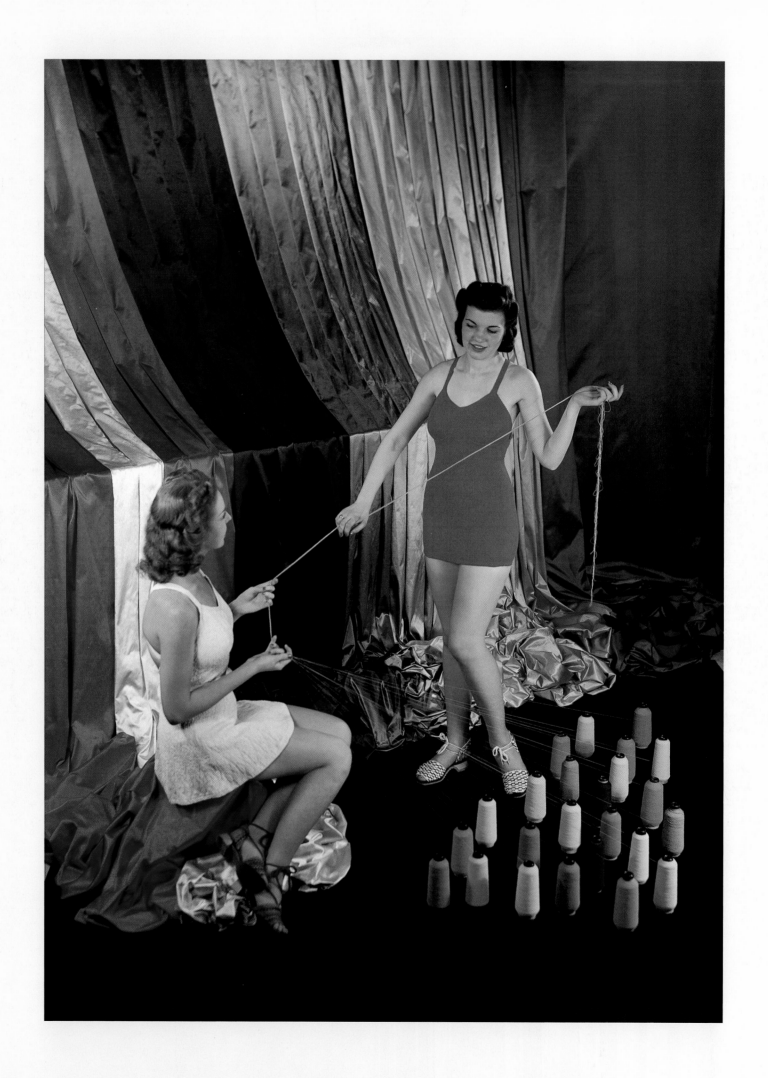

color photography materials and equipment, as the industry responded to the demands of Hollywood, for which these were produced. (Walt Disney's first color feature, "*Snow White and the Seven Dwarfs*," came out in 1937, using Technicolor, a film with three separate, superimposed emulsion layers sensitive to blue, green, and red.) In 1932 the Agfa process, using emulsified shellac in turpentine, had been introduced by the German I. G. Farben Industrie as Agfacolor, a credit often seen on GEOGRAPHIC photos in the period, especially after 1936 when a new version was marketed. By 1938 Autochrome was readily available with celluloid backing rather than glass, under the brand names Filmcolor and Lumicolor. But it was Kodachrome, invented in 1935 as a five-layer film, then perfected and simplified in 1938, that went on to overtake all competitors and become the film of choice for photographers—until Ektachrome was launched by Kodak in 1946.

NATIONAL GEOGRAPHIC, along with *Life* and *Fortune* in the U.S. and *Sunday Mirror* and *L'Illustration* in Europe, was one of the very few magazines not dedicated to fashion, advertising, or interior decorating that could afford a steady and consistent editorial use of color photography. However, GEOGRAPHIC made more use of color than any similar magazine and devoted more of its resources to staying in the forefront both artistically and technologically. Throughout World War II, the GEOGRAPHIC kept abreast of the experiments conducted by the military using Kodachrome, in cooperation with the Eastman Kodak Company,

especially in connection with aerial photography from reconnaissance planes. Also during and after the war, color negative film for prints was produced by several companies, but the GEOGRAPHIC remained faithful to transparencies.

As the century progressed, a number of different technologies were introduced, all with the aim of duplicating "natural colors." But in looking back at pictures produced on up into the 1960s, it is apparent that none of the processes was really "natural"; the photographer's view of reality had been filtered by the process used, and each process came to define a particular period. In the last two decades, NATIONAL GEOGRAPHIC has become known for the vast array of its color work, ranging from such scientific images as the NASA pictures of Jupiter and her moons to strobe camera incursions into life in the animal world to photo-illustrations to computer enhanced photographs and even to three-dimensional pictures.

Since the 1980s, the GEOGRAPHIC's editorial spectrum has broadened in terms of combining first-rate text with full-color coverage of many subjects, including multicultural concerns, preservation of the environment and wildlife, and a regard for current events or even global challenges. Also, the magazine has been quick to seize upon the growing significance of a particular subject, such as Cuba, which recently received special coverage, or the aftermath of dramatic events, such as the reconstruction of Beirut.

Although, in the 1990s, the GEOGRAPHIC has continued in its arti-

Thomas J. Abercrombie
AFGHANISTAN, 1968 • Stains of his trade color a boy's hands, which clutch a bright skein of yarn at a dye works in Tashkurghan.

Willard R. Culver
UNKNOWN LOCATION, 1939 • *Opposite:* In a pre-World War II article celebrating rubber, "Our Most Versatile Vegetable Product," this advance look at next season's swimsuits pays tribute to the wide range of colors that the elasticized yarn came in.

cles to make use of a traditional color portfolio in combination with illustrated text, color photography has been showcased on its own in articles such as Bruce Dale's "Shanghai Portfolio," where there is very little text. Other new kinds of layouts are being tried, notably in the series *Americana,* which was launched in September 1997. For example, David Alan Harvey's North Carolina shots of stock cars are presented as a diary-like series of captioned postcards over a colored background, while in another article Michael Yamashita sequences postcard-size pictures of the same Vermont landscapes through the four seasons.

In contrast with the early years, when color was often hedged in by the black-and-white that was preferred for more in-depth, psychological or scientific subjects, color long ago took on an autonomy. As picture editors and designers, in collaboration with photographers, become increasingly sensitive to the scale, sequence, and layout of an article's images, color photography can certainly be said to have achieved its own articulate language.

Peter Essick

JAPAN, 1994 • The keeper of the flames makes his rounds at the Kamakura festival in Yokote, where each tiny "igloo" is a shrine to the water gods, who bring about a bountiful rice harvest.

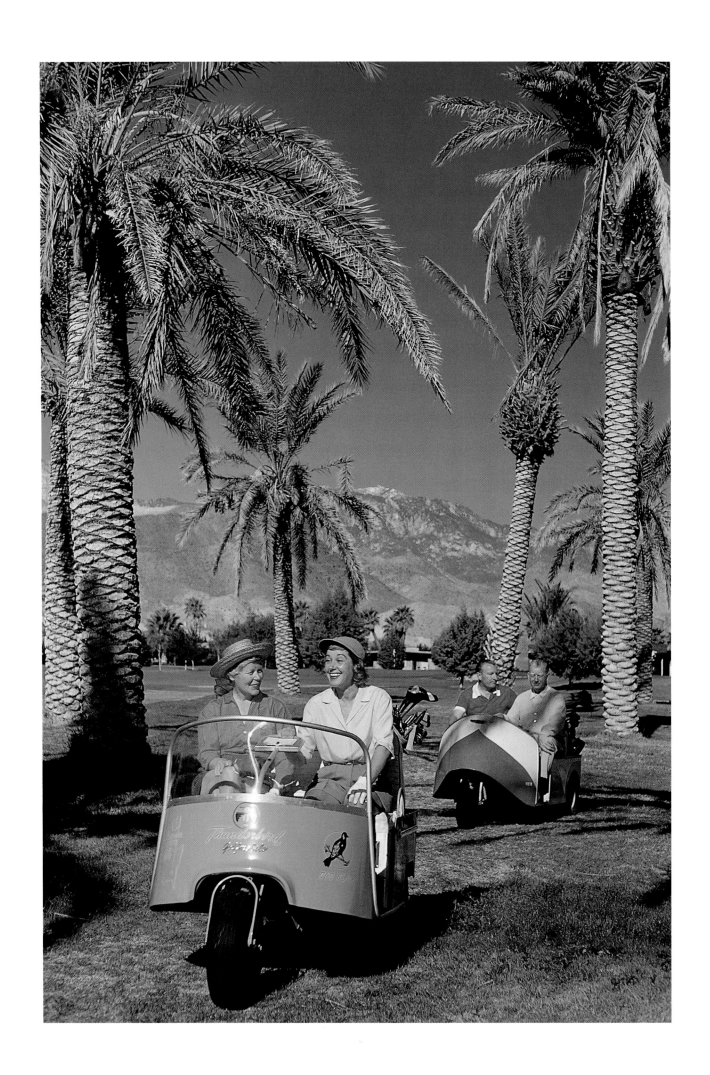

1951-1970

Cliché and Change

Anne H. Hoy

Color is "vulgar" wrote Walker Evans in 1954. Many "color photographers confuse color with noise," he went on; they blow you down "with screeching hues alone . . . a bebop of electric blues, furious reds and poison greens." He meant photography in the advertising and editorial pages of national magazines—including NATIONAL GEOGRAPHIC. Black-and-white was the chosen medium for photojournalism and art photography that critics regarded as the most serious at mid-century. No color photography appeared in *Family of Man,* the book that accompanied the epic exhibition Edward Steichen organized for the Museum of Modern Art in 1955, or in the pages of *Aperture,* Minor White's forum for ambitious camera art, which had been founded in 1952. Color was even rare in the editorial sections of mass news magazines. At NATIONAL GEOGRAPHIC, the staff and over two million readers were apparently unconcerned with the critics.

The magazine was riding the boom in travel and its correlative, amateur photography, that followed World War II. Its readers wanted color—in their own photographs and in the photographs they saw. Though Editor Gilbert H. Grosvenor shared Steichen's family values and belief in firm editorial control, he was committed to conveying masses of information—"geographic knowledge" broadly defined—to a mass audience. Making it comprehensible was crucial. Making it visually appealing was important. Making it into exciting and innovative photojournalism, on a par with *Life* magazine's contemporary photo-essays, mattered less at that point.

The paths and fortunes of the GEOGRAPHIC and *Life* were to diverge and then cross in the fifties and sixties, revealing some of the significant changes in photojournalism in those heady years.

J. Baylor Roberts

CALIFORNIA, 1957 • A pictorial gazetteer of the state's most prominent sites bedecks the rear window of a tourist's car in California. Such decoration—a fad of postwar America's newly mobile middle class—was documented by the GEOGRAPHIC with Kodachrome.

Charles Herbert

CALIFORNIA, 1957 • *Opposite:* Life was all Kodachrome for Americans in the heady years following World War II, where even deserts could be made to bloom like oases—if a bountiful-enough underground lake could be siphoned to overcome nature's aboveground shortcomings.

133

Geographic Guide to Basic Photography

WASHINGTON, D. C., 1966 • Intended for the first-time camera-
man in the field, this booklet advises that GEOGRAPHIC pictures
are intended to "give information" and "illustrate the story."

At mid-century *Life* was the closest thing to a national magazine that America would ever have. No other magazine would ever give photographs more visibility or influence. Some have claimed that *Life* editors perfected the photo-essay, a persuasive, even tendentious narrative form woven of words and images that originated in print-hungry prewar Europe and England. Stories such as W. Eugene Smith's "Maud Callen, Nurse-Midwife" (1951) and Gordon Parks's portrait of Flavio, a selfless 12-year-old in one of Rio's slums (1961), gripped hearts and through them, pocketbooks. Readers quickly responded to a caption stating that Callen could only dream of finding the $7,000 to build a well-equipped clinic: within three years they had mailed *Life* $28,500 to help the black South Carolinian. Reaching from one-third to half of the American population in any three-month period (depending on which survey you read), *Life* had undeniable power. It may not have intended to fund-raise, but its readers wanted a constructive outlet for the feelings that Smith's and Parks's photographs had aroused.

Arousing feelings was not the GEOGRAPHIC's goal. "GEOGRAPHIC pictures give information about people, customs, natural history, geography, and any other subjects related to the story." So said the 1966 *Geographic Guide to Basic Photography,* a booklet intended for its first-time cameramen in the field. "The photograph should be a dramatic visual image that will hold the reader's interest and illustrate the story." In *Life* the photographs *were* the story.

The differences in the magazines derived not just from editorial direction and culture but from practical matters: the perfect-bound, modestly sized (7x10") monthly was mailed only to members of the National Geographic Society; the stapled, tabloid-scaled (11x14") *Life,* on the other hand, relied in 1950 for its 5.3 million weekly readers on newsstand sales as well as subscriptions. *Life* offered less than a hundred pages; the GEOGRAPHIC averaged 50 percent more—not counting advertising pages, which it did not deign to number. With its thorough texts and detailed maps, the yellow-bordered journal was a keeper, as cartoons, jokes, and yard sales continue to prove. Indeed, as Gilbert Grosvenor has written, the GEOGRAPHIC was permanently bound more often than any other magazine. The one with the distinctive red logo, however, had to sell itself every week to bring in some of its revenues.

Color and instruction were the square meals that the GEOGRAPHIC offered its members. Drama, news, and entertainment were *Life's* cocktails for its readers. "In its presentation of humanized geography," the GEOGRAPHIC told prospective picture contributors in 1951, it sought "physical features of a locality, including aerial views; people at work . . . and their amusements; typical dress, festivals, customs, and way of life; industries, handicrafts, commerce, transportation; art and architecture of unusual or characteristic design; important public institutions and public works; scenes of historical significance; natural history—animals, birds, plants, insects, fish; the 'strange

and curious.'" At its founding in 1936 *Life* had announced that its goal was "to see life; to see the world; to eyewitness great events; to watch the faces of the poor and the gestures of the proud; to see strange things. . . ; to see and take pleasure in seeing; to see and be amazed; to see and be instructed." No wonder that funds sent to *Life* brought Flavio to America, and that the GEOGRAPHIC became a classroom tool in the age of Sputnik.

In the fifties the differences between the two major mass-circulation magazines were notable because their goals had begun to converge. Both appealed to the middle and upper classes of the richest and most powerful military nation in the world. Those classes had new leisure and money (the GNP rose 250 percent between 1945 and 1960, and consumer credit rocketed 800 percent in the ten years after the war's end). Exposed initially to Europe and the Far East by war coverage but now free of wartime restrictions on travel, Americans looked outward and at their own country with pride, or perhaps complacency—despite McCarthyism and the anxieties of the Cold War. Measuring democracy, capitalism, and current technology against foreign alternatives preoccupied opinion-makers and thoughtful travelers. The story about a foreign country or capital or an exotic people became a staple in picture magazines worldwide. While travel magazines mushroomed, led by the glamorous *Holiday* (reborn as a Curtis publication in 1946), *Look, Paris-Match, Der Spiegel, Heute,* and the *Picture Post* fed the appetite for such articles among prospective tourists, amateur anthropologists, and adventurers with the new international currency, the American Express traveler's check. In the fifties the GEOGRAPHIC, too, gave a few new sparks of life to what was traditionally one of its special genres.

Magnum, the legendary photographers' cooperative agency founded in 1947, undertook to illustrate such stories, among others, and from self-assigned expeditions its members sent back images that Magnum shopped to likely publishers. Thus George Rodger, a Magnum founder, is represented in a February 1953 GEOGRAPHIC article on the Sudan with a crowd scene of dancing, dust-swirling tribesmen. But this image contrasts stylistically with the tightly knit composition of a tribesmen's club, complete with ostrich, and also with a pair of patrolmen on camels posed before a man-on-camel statue, Khartoum's memorial to Chinese Gordon—an article illustrated by three different photographers.

For a story on Poland in September 1958, however, the editors assured stylistic unity by assigning the photography to Magnum's Erich Lessing. His unsmiling women hauling coal and laying track are grim images in black-and-white among the pretty travelogues of earlier fifties articles: by contrast they implicitly support the American Way. Here Lessing's monochrome functions expressively, but it was unusual in the GEOGRAPHIC and would soon disappear, despite the esteem in which most photojournalists elsewhere held the medium. Black-and-white would occupy the GEOGRAPHIC's few freelancers, who provided filler pictures. Color, on the other

Erich Lessing

POLAND, 1957 • Grim monochromes of this nature were highly unusual in the GEOGRAPHIC of the 1950s and would soon give way to full color, which guaranteed the magazine's uniqueness.

hand, guaranteed the magazine's uniqueness. Since the forties the GEOGRAPHIC has been the largest user of color of any magazine.

Color illustration before the late 1950s required too much time-consuming preparation for the deadlines of a weekly magazine, and it was unthinkable for newspapers. Thus black-and-white was the only language for breaking stories. Most photojournalists made an aesthetic virtue of this practical necessity, but with longer deadlines the GEOGRAPHIC had no such motivation. In fact, assignments could enjoy gestations of many months if not years and, when completed, might join a large stockpile of articles. "Permanent value" was close to first among Gilbert Grosvenor's "Seven Guiding Principles" for publishing the GEOGRAPHIC while "maximum timeliness" was last. "Everything printed in the magazine [should be as] pertinent one year or five years after the publication as it is on the day [it appears]," wrote the editor of 1903-54.

The editorial deliberation this credo fostered reinforced the magazine's absorption with color and photographic technique. Color illustration was a point of pride from 1910 when Grosvenor first reproduced hand-tinted photographs of China and Korea. With in-camera color in every issue from 1925 on, the first successful aerial photographs in color (by Grosvenor's son Melville in 1930), the first undersea photographs in natural color (by Charles Martin in 1927), and articles between the wars such as "Through Germany with Color Camera" (1928) and "Carrying the Color Camera through Unmapped China" (1930), readers came to expect the information and appeal of full color, as well as technical models for their own camerawork. Although how-to data appeared only with pictures notable for their unusual execution, standard captions did identify film types, and from the forties through the sixties readers could see how quickly the magazine adopted the photography industry's latest inventions—Kodachrome (first in print in 1938), Anscochrome (1946), Ektachrome (1947), Super Anscochrome (1958), High-Speed Ektachrome (1960)—and possibly be encouraged to try them out themselves.

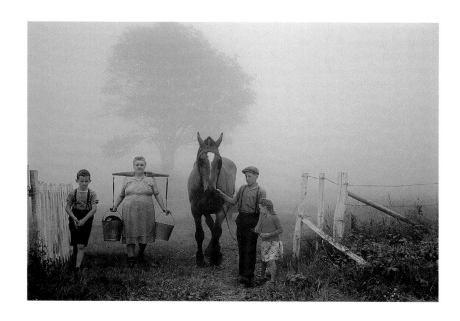

B. A. Stewart and J. E. Fletcher
PROVINCE OF QUEBEC, CANADA, 1950 • On a misty morning, a French-Canadian family starts out early on chores that sustain their way of life, which differed little from that of their rural Francophone relatives on the other side of the Atlantic.

Most readers could not, or course, match the technical mastery of the GEOGRAPHIC photographer. That man (there were almost no women photographers before the sixties) routinely traveled with at least four cameras, with all the usual lenses and extra-short and extra-long ones as well. Although the GEOGRAPHIC adopted 35mm cameras in the thirties, paralleling the daily press, it also insisted on the range of view cameras and sheet film, requiring tripod and film holders to ensure full detail in any situation. Though this mountain of gear made spontaneity impossible in the field, photographers did not object. They reported to the chief of

the photographic laboratory, a vast, state-of-the-art, in-house facility. There was no editor of photography until 1958.

The lab chief "was enough of a dictator we didn't have time to look left or right," longtime GEOGRAPHIC photographer Volkmar Wentzel recalled. "The emphasis was on illustrations; there wasn't much of 'looking for a message.' *Life* didn't exist as far as we were concerned." Such insularity was reinforced by the Society's refusal to allow photographers to enter national competitions in the 1950s (when *Life* was running an annual Young Photographers contest and hiring the winners). The GEOGRAPHIC, its dignity intact, its attention more fixed on color technique than vision, unwittingly encouraged advancement from within, minimum turnover among photographers, and maximum homogeneity in their photography.

Color, introduced to enhance actuality, had become a cause by the early fifties, pursued for its own sake, with high intensity and contrast and perfect reproduction required. Stories were sometimes chosen as much for their color possibilities as their content. Though *U.S. Camera* gave the GEOGRAPHIC its Golden Achievement Award for color in 1951, by 1962 the same magazine was complaining that GEOGRAPHIC pictures, "with rare exception, were all pretty much of the picture postcard type of idealistic beauty, rather than photojournalism."

The need to enliven the often sandy or greenish monochrome of the typical nature scene, for example, had led many photographers to pose assistants as foreground yardsticks in items of red clothing, generally pointing at the beauty spot that motivated the photograph. Though the practice, encouraged by editors, was ancient at the magazine—one Autochromist traveled with a trunkful of bright scarves—the results by the fifties were static, overdesigned, and dull. Outsiders identified the magazine with "the Red Shirt School of Photography."

Still, many of the GEOGRAPHIC's photographs through the fifties have the innocent charm of Disneyland, which opened in 1955, an event that triggered two stories on Disney in the magazine. Like the park, the magazine's illustrations offered reassurance and escape. While weeklies covered the Korean Conflict and the Cold War, with their aura of irresolution and bitterness, and the civil rights struggles in the South, readers of the GEOGRAPHIC were left undisturbed. Indeed, they could admire the march of human discovery, learn about a freshly mapped far-off place, imagine a trip, say, to the City of Light, and enjoy the amiable diversity of the world's peoples, sometimes including a bare-breasted native, in every color-packed issue. "New Guinea's Rare Bird and Stone Age Men" (April 1953) even had eight such "belles," as well as one of the GEOGRAPHIC's classic, now politically incorrect juxtapositions, a view of the befeathered tribesmen of Kup marveling at the author-photographer's small plane.

The wire services rented the magazine black-and-whites for more topical stories, such as "Here Come the Marines!" (November 1950), while staff photographers

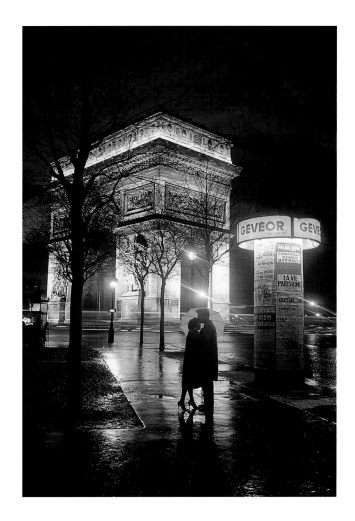

Thomas Nebbia
PARIS, 1960 • In a combination of Paris symbols, young lovers embrace beside an advertising kiosk amid wet-sidewalk reflections of the floodlighted Arc de Triomphe.

were free to concentrate on color. Picturesque hometown stories followed and neutralized the few features on politically tense regions. After "Eyes on the China Coast," for example, pertinent to U.S.-protected Taiwan, came "Washington's Historic Georgetown" (April 1953). United Press action shots and Rodchenko-like close-ups yielded to yearbook-style photographs—in color. It was time for a change.

The mix of ingredients did not alter in 1957, but the magazine's leadership, editorial emphasis, and visual quality did. That year Gilbert Grosvenor's son, Melville Bell Grosvenor, became editor and Society president, ending the 1954-57 interregnum of John Oliver La Gorce. Staffers with experience and distinction in photojournalism were hired, notably James Godbold, an active member of the National Press Photographers Association, who became the magazine's first editor of photography. Godbold in turn imported a fresh generation trained in news coverage, photographers such as Thomas Abercrombie, Dean Conger, Albert Moldvay, Thomas Nebbia, and Winfield Parks, who had already earned Magazine Photographer of the Year awards or would do so for their sixties work for the GEOGRAPHIC. Wilbur E. Garrett, an intrepid photographer and future Editor of the magazine, assumed layout supervision and eventually established the layout department: he made double-truck openers a standard for articles and used frequent full bleeds for gripping photographs, as well as other graphic devices that visually expanded the monthly's relatively small size.

When Robert Gilka, also a newspaperman turned staff member, succeeded Godbold in 1964 and took charge of all still photography for the Society, the direction encouraged by Grosvenor was clear. *Holiday,* never taken seriously, was dismissed as entertainment, scorned for its set-up photographs and artificially hot color. Photojournalism would reign. "I told the bean counters we could have as good a staff as *Life,*" Gilka said recently. More stories would respond to current events. Photographs would seize attention with action subjects and visual energy. Layouts, type, and captions would make articles into page-turners. The pulse of the weekly gave heart to the monthly. Yet, Gilka pointed out, "Our mission was different. We were not so bent on stories of social significance, but we didn't duck issues either. Grosvenor's word was *balance*—in a story, and in an issue as a whole." Melville Grosvenor's successor, Ted Vosburgh, remarked that he intended "to hold up the torch, not to apply it."

Perhaps it is not surprising, then, that a story on U.S. national parks in July 1966 should open with a spectacular full-bleed, two-page spread of water-skiers jetting toward the camera in giant manmade Lake Powell, "in the new Glen Canyon National Recreation Area, spanning the Arizona-Utah border." The flooding of Glen Canyon, to increase electric power to several Western states had aroused passionate antagonism from the Sierra Club and inspired its publication of an elegiac, beautifully printed book of photographs of the antediluvian canyon. The

GEOGRAPHIC's upbeat image, by contrast, upheld one of the publishing principles laid down by Melville Grosvenor's father, Gilbert: "Nothing of partisan or controversial nature is printed." The GEOGRAPHIC had covered ecological matters starting in the 1920s, and in 1966 it had urged readers to support creation of Redwood National Park in California. But such projects were not so embattled. The GEOGRAPHIC would confront the complexity of ecological issues head-on in 1970.

When the Sierra Club launched an all-out campaign in 1969 to stop flooding in the Grand Canyon, it lost its tax-exempt status. The National Geographic Society took no such risks. It thus preserved a lower postal rate for the magazine's distribution to Society members and a membership fee (aka subscription rate) that still challenges competition. In the mid-sixties, the Society used its longtime inside-the-Beltway status to get Robert Kennedy to write about his climb of Mount Kennedy, named in memory of his slain brother; General Curtis LeMay to cover the new Air Force; and Lyndon Johnson to describe his official travels while vice president to Scandinavian countries. Hot current topics were often imbedded in broader, positive stories describing endangered places and peoples. Thus the magazine tackled Vietnam, perhaps the defining issue of the LBJ-Nixon years, with its classic, text-rich, first-person approach, including maps. Attempts to give a face to the guerrilla war and the murky loyalties of the Vietnamese were parts of extensive stories photographed by Bill Garrett and Winfield Parks (teamed with author Peter White) and filed by photographer-writers Howard Sochurek and Dickey Chapelle, whose last contribution appeared in 1966 beside her obituary in the magazine: she was the first woman correspondent to die in Vietnam.

At a time that American involvement was still termed "advisory," Chapelle's photographs in a November 1962 article were among the earliest published anywhere that showed U.S. servicemen fighting in Vietnam. A freelancer, Chapelle herself was a hawk, which made it difficult for her later to place stories elsewhere as the war's escalation and American failures increasingly alienated this country. Whatever the politics of the Society, however, the GEOGRAPHIC, with its first-person voice, allowed her to write that "the little boats [on the Mekong] are trying to keep for the free world the coveted rice bowl of Southeast Asia," while also giving ample space to Sochurek's and Garrett's more deliberated reporting.

Garrett in the fifties had already learned something of the region: For "Life Under Shellfire in Quemoy" (March 1959), he produced black-and-whites of backlit women running with children in their arms—that camera icon for war's

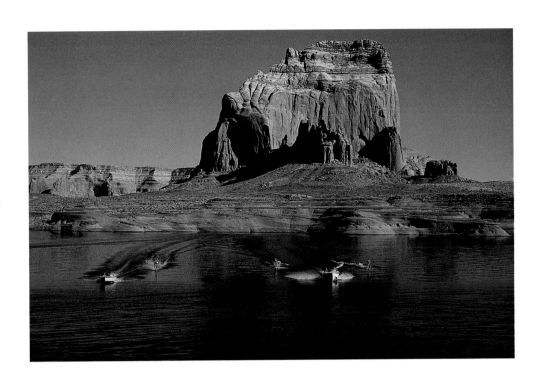

J. M. Edwards

LAKE POWELL, UTAH, 1966 • In the days before the GEOGRAPHIC confronted complex ecological issues head-on, this photograph celebrates the recreational values of this giant manmade lake.

inhumanity—and of old women and boys holding candles in their bomb-shelter caves. These powerfully graphic images showed his respect for Robert Capa's and W. Eugene Smith's coverage of war; now he used their devices to condemn the Communist bombardment of Nationalist Chinese civilians. "Bill and I were not concerned with the politics of the situation," wrote Franc Shor a bit disingenuously. "Our job was to find out how the people of that beleaguered island were living. . . ."

Similarly in Vietnam, the crucial role played by ethnic groups and geography justified coverage, apart from the fact that half a million Americans saw duty there. Thus for the January 1965 issue, Sochurek described how a tiny group of American Special Forces faced down a rebellion of their Montagnard allies against the

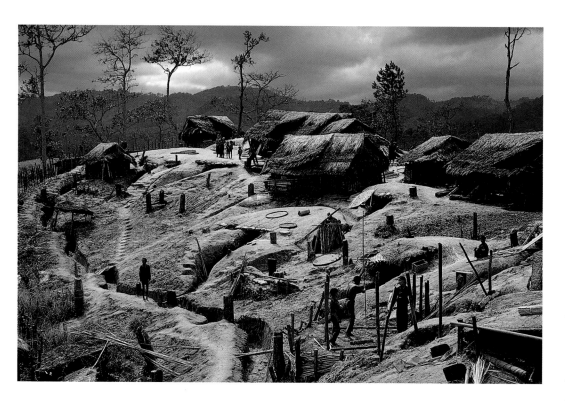

Vietnamese government: The hill people's uprising had cause but the Viet Cong had fanned it. This time the Americans prevented crossfire. "Our situation here mirrored the complexity of the problem that the U.S. faces in Viet Nam," Sochurek wrote.

For an April 1968 article, he returned to the Montagnards and photographed a blasted hillside village-fort, a two-page spread of dun-colored, Stone Age desolation, and he quoted an old refugee: "'No matter which side wins, we must go on living.'" Facing this text, the article ended with pictures of a Montagnard boy-soldier and a barracks town built by the Special Forces for Montagnard families. In the brown and green landscape, the "red shirt" was supplied by the dispensary's Red Cross symbol.

Among the thousand-plus reporters in Vietnam over the same years, *Life's* Larry Burrows is credited with making the most

Howard Sochurek

VIETNAM, 1967 • Deceptively calm and beautiful in this light, a Vietnamese village-fort, honeycombed with tunnels and bunkers, sheltered more than 250 Jeh refugees from Viet Cong attacks.

indelible photo-essays. In color and black-and-white, he shot the weekly's first cover story on the war, in the January 25, 1963, issue, two months after Chapelle's story in the GEOGRAPHIC. His cover story "One Ride with Yankee Papa 13" (*Life,* April 16, 1965) may be the war's most memorable. The message of both stories was bipartisan: The war was brutal and America was losing—facts that the GEOGRAPHIC was perhaps less willing than *Life* to show. Further, the Yankee Papa story, following one Marine on a bloody helicopter mission, had the simplicity, unity, and close-up horror of Greek tragedy. An American hero was reduced to tears, unable to save his men.

Burrows's gripping images, as well as those captured by GEOGRAPHIC photographers, proved the old saw that photographs only describe, they cannot explain.

The GEOGRAPHIC attempted to explain with text—lots and lots of it. And because it was like all mass magazines in refusing to antagonize a large part of its readership in a politically divided era, it attempted to explain evenhandedly. In relying on photographs in shorter stories, however, *Life* chose not to dilute their visual potency. Giving emotional impact to news had always been its goal.

Married to news photography, *Life* suffered a loss of readers to television in the sixties, while the GEOGRAPHIC did not. In fact, Melville Bell Grosvenor ("MBG" to staff) was quick to see and exploit the benefits of allying the magazine with the ubiquitous new medium. Though Grosvenor's father abhorred television, as well as the notions of GEOGRAPHIC globes and atlases, the Editor of 1957-67 embraced them and made these spin-offs of the magazine into self-sufficient, profitable, and respected publishing entities. The National Geographic Television Special, preceded and followed by magazine features and sometimes books from the expanded Book Division, would give exploration and natural history charismatic stars.

The Society's first venture into video, "Americans on Everest," was screened in 1965 and won eight significant awards. Several documentaries, including one about Captain Jacques-Yves Cousteau in 1965-66, introduced a new generation to the hawk-nosed inventor and deep-sea explorer, whose adventures the magazine had begun chronicling in 1952. Even more charming was the nymphlike naturalist Jane Goodall, introduced to the Society by others of its grantees, Louis and Mary Leakey. The Leakeys had found the fossils of the world's earliest known human in Tanzania, a story they told in the September 1960 magazine. The Geographic's television special about them, in 1966, had been preceded by a series on Goodall, whose study of wild chimpanzees in Kenya enchanted viewers as it revealed social patterns and tool use among the primates to whom she gave names.

GEOGRAPHIC readers first met Goodall in the August 1963 issue. The photographs of her by her husband, Baron Hugo Van Lawick, were serviceable, but the idea of one family of mammals living among and recording another outweighed aesthetics in importance. Likewise on top of Everest, the fact that photographs could be taken at all nullified questions of how they looked. The pioneering climber and aerial photographer Bradford Washburn had earlier made more heartstopping pictures of Mount McKinley for the GEOGRAPHIC of August 1953. But in the 75th anniversary issue, November 1963, Barry Bishop told how he and his Society-funded team reached the top of the world, the first Americans to do so, and he showed it. Ironically the peak in his picture resembles a slab of frosted cake with a little Fourth of July flag stuck in it. It could not show what it cost to take the photograph—including Bishop's frostbitten fingers and toes.

These stories of undeniable human achievement transcended the era's dissent. The GEOGRAPHIC also gave generous coverage to the U.S. space program: Grosvenor saw that the few areas left unexplored in the world were the sky, the sea,

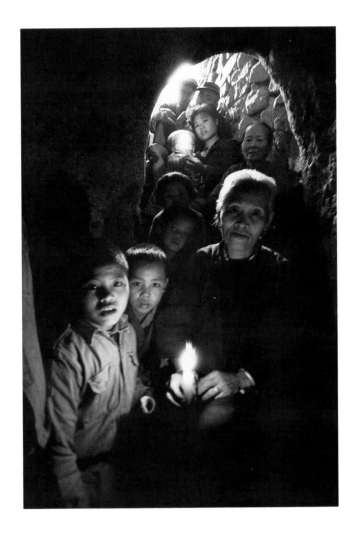

Wilbur E. Garrett
QUEMOY, 1959 • Forced by bombardment to live in caves, the inhabitants of this contested island off mainland China bed down in cubicles carved out of tunnel walls.

and the animal kingdom. To convey the excitement he found in them, the GEOGRAPHIC now used the highest quality color to appear in any mass magazine.

Life had first reproduced color in 1954 and moved production to giant web presses, able to print and fold on the same machine and roll off more than ten thousand pages a minute. In 1960 the GEOGRAPHIC followed suit, and it adapted *Life's* electronic quality controls to special coated paper, making color covers and all-color issues standard (which *Life* never did). It was a serious financial gamble, but GEOGRAPHIC readers loved color. Costs were more than covered by the subsequent membership growth rate of nearly 10 percent a year.

While first-person pieces had always been a GEOGRAPHIC norm, by the sixties photojournalism elsewhere was becoming more personal. On the heels of the admired photographer Robert Frank, who hated "those goddam stories with a beginning and an end," practitioners such as Bruce Davidson, Burk Uzzle, Danny Lyons, and Larry Clark denied the concept of group journalism implicit in the studiously optimistic *Family of Man,* as well as the artistic ideals of clearly resolved pictorial structure embodied in Henri Cartier-Bresson's concept of "the decisive moment." They became as involved with their subjects as W. Eugene Smith had, but they followed Brooklyn street gangs, teenage drug users, bikers, and Texas prisoners—the outcasts of a society in flux. Their stories, difficult to place in magazines, in some cases saw book publication and museum exhibits.

The differences between concepts of photojournalism and art practices in the fifties and sixties were announced in the Museum of Modern Art's "New Documents" exhibition of 1972, a modest but telling title for the black-and-white imagery of Diane Arbus, Lee Friedlander, and Garry Winogrand. Distanced, often disturbing, stylistically idiosyncratic, this work referred to no common body of values and shared no formal sources. All this indicated the number of new branches within photography, visible at the same time that the GEOGRAPHIC had confidently entered mainstream photojournalism.

It had mastered action camerawork: not just striking trout or hummingbirds frozen in Harold Edgerton's strobe, but wildlife caught with the blur, the camera tilt, or the cinematic sequence that contemporary readers accepted as photographic equivalents for the sensations of being there.

With a new frankness in the late sixties, the GEOGRAPHIC reproduced such scenes as lions battling and bloodily feeding, a sequence of hyenas chasing and killing zebras, and a black eagle attacking a zoologist, tearing her jacket to the skin. If the signature photograph of the fifties was a time-delayed night shot of a European capital with traffic turned into rivers of light, the photograph of the sixties showed a wild ride down the Colorado River from raft level, apparently through a mud-spattered lens.

As the civil rights struggle was turning violent, the GEOGRAPHIC printed Victor Englebert's "I Joined a Sahara Salt Caravan" (November 1965) and showed

the Belgian photographer-writer, who had learned the Tuareg language, in Tuareg desert dress expertly riding a camel. In October 1968 during peak opposition to the Vietnam War, the magazine presented the first of three articles by a California high-school boy who, starting out in a 24' sloop, would spend five years to sail around the world alone. Full of escapist thrills, such stories also offered alternative models of physical courage, resourcefulness, and racial sensitivity. The GEOGRAPHIC was reaching the mainstream of America, and with new success.

Meanwhile, American art photographers of the seventies and eighties would scavenge the GEOGRAPHIC and other mass magazines, in addition to their memories of them, to come up with material for often ironic reflection. Did Garry Winogrand see such pictures of paparazzi as Lessing's of cameramen circling a Polish pinup girl (September 1958), before he embarked on what would be *Public Relations,* 1969? Did Laurie Simmons remember the snorkeling bathing beauties of the January 1955 number when she began to pursue feminine stereotypes in her work of the early eighties? Did David Hockney recall NASA's remote photographs of the moon, including the one in the October 1966 issue with an Atget-like shadow of the photographer (the Surveyor's TV camera), when he started making his space-embracing photo-collages in 1982? Probably not. But the similarities between these vanguard projects and GEOGRAPHIC camerawork reflect the magazine's contributions to a popular visual culture that proved fertile for many.

The exchanges were mutual. In the late sixties the GEOGRAPHIC ran more pictures that seemed to accept the world's visual complexity, homely people, and

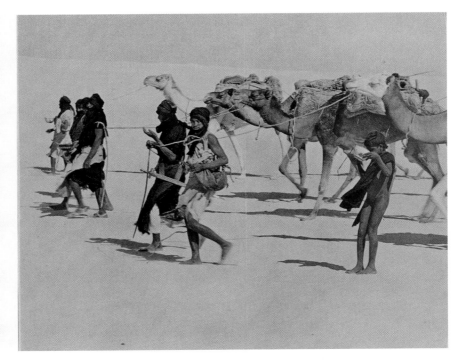

Victor Englebert

SAHARA, 1965 • Reminiscent of GEOGRAPHIC adventurers of decades earlier, this Belgian writer-photographer immerses himself, through dress and language, in the everyday life of the legendary Tuareg. The result was coverage with a depth not undertaken by other publications.

143

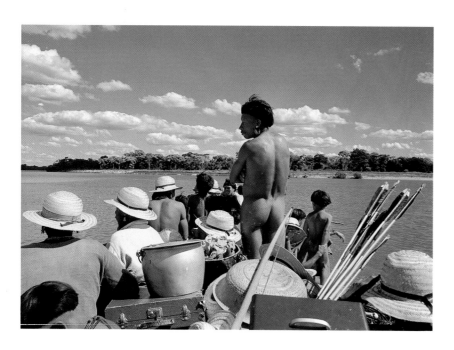

W. Jesco Von Puttkamer
BRAZIL, 1968 • In this Ektachrome, Tchikao Indians warily eye their new home in Xingu National Park, a preserve set aside for the protection of Brazil's indigenous peoples.

sometimes subtle hues—the qualities being discovered by museum-favored "street photographers" such as Joel Meyerowitz, William Eggleston, and Stephen Shore. Cultural collisions in the magazine's photographs no longer favored first-world values: The TV set in unlikely places—a middle-class Peruvian living room or a Seminole *chikee*—was not shown for celebration but sarcasm, as in Robert Frank's *The Americans,* 1959.

Stories could be more evocative than descriptive. And staff photographers were encouraged to do both kinds of work. Thomas Abercrombie, in 1957 the first civilian cameraman to reach the South Pole, had photographed and been pictured at the world's coldest spot for the magazine. But with a story about Captain John Smith, he also helped create the article type that followed in the footsteps of the great explorers. "Tom made subjective, poetic pictures of the places that Smith might have seen in Virginia then," Bill Garrett recalled, "not the skyline of Richmond." When William Albert Allard chose to motorcycle the length of the U.S.-Mexico border for a story, the GEOGRAPHIC not only bought him a Triumph but also ran his moody, often poignant pictures of the old cowboys and other marginal characters he found. Such work forecast the more personal idiom of the magazine's subsequent photography.

More significantly, the GEOGRAPHIC reflected a new sophistication and sobriety in its self-definition. "Saving Brazil's Stone Age Tribes From Extinction" (September 1968), for example, begins with a view of naked Tchikao Indians being ferried to a government preserve established for the protection of the country's "primitive peoples." But the story ends with the authors' admission that the relocation had failed: the Tchikao were warring with rivals and would have to move again.

Such somber conclusions evidently did not alienate readers. When Melville Grosvenor retired in 1967, he could savor a 90 percent renewal rate (sixty-five percent was respectable among mass magazines) and a readership he had brought from 2.1 to 5.5 million in ten years. When *Life* died as a weekly in 1972, its photographers would be attracted to the GEOGRAPHIC. The budget for photography had tripled under Grosvenor. The foreign desk, two people before World War II, now numbered 65 photographers and writers. They could travel farther and enjoy more freedom than any mere news editor would allow. They had the best pay, equipment, and field services (from translators to guides), the longest lead times and largest space for stories of any journalists. They were winning prizes and in some instances seeing their photographs put on the wire services to report daily news. Many insiders called Grosvenor's tenure "the golden years."

By the seventies the GEOGRAPHIC seemed ready for the fragmentation of the magazine market into special interest groups. Wildlife and ecological concerns,

mountain climbing and deep-sea diving, "rough travel" to the world's most remote sites and the photography capable of bringing it all back in living color: The magazine knew these niches and had colonized them for half a century. Insofar as Goodall, Cousteau, and their like were celebrities, the GEOGRAPHIC also had "People." And since Grosvenor's editorship, it had competed for the best photojournalism. "Before, our photographers could get into strange places, but now that wasn't enough," Robert Gilka remembered. "The photograph of record now had to be a great photograph."

Wilbur E. Garrett

MEXICO, 1968 • For GEOGRAPHIC photographers, "seeing" became an indispensable attribute that brought about this perfectly composed aerial shot of harvesting marigold blossoms in Mexico.

Robert F. Sisson

ARIZONA, 1960 • *Following pages:* A federal agent is surrounded by friendly Indians on a Navajo reservation, where the FBI is used to investigate major crimes.

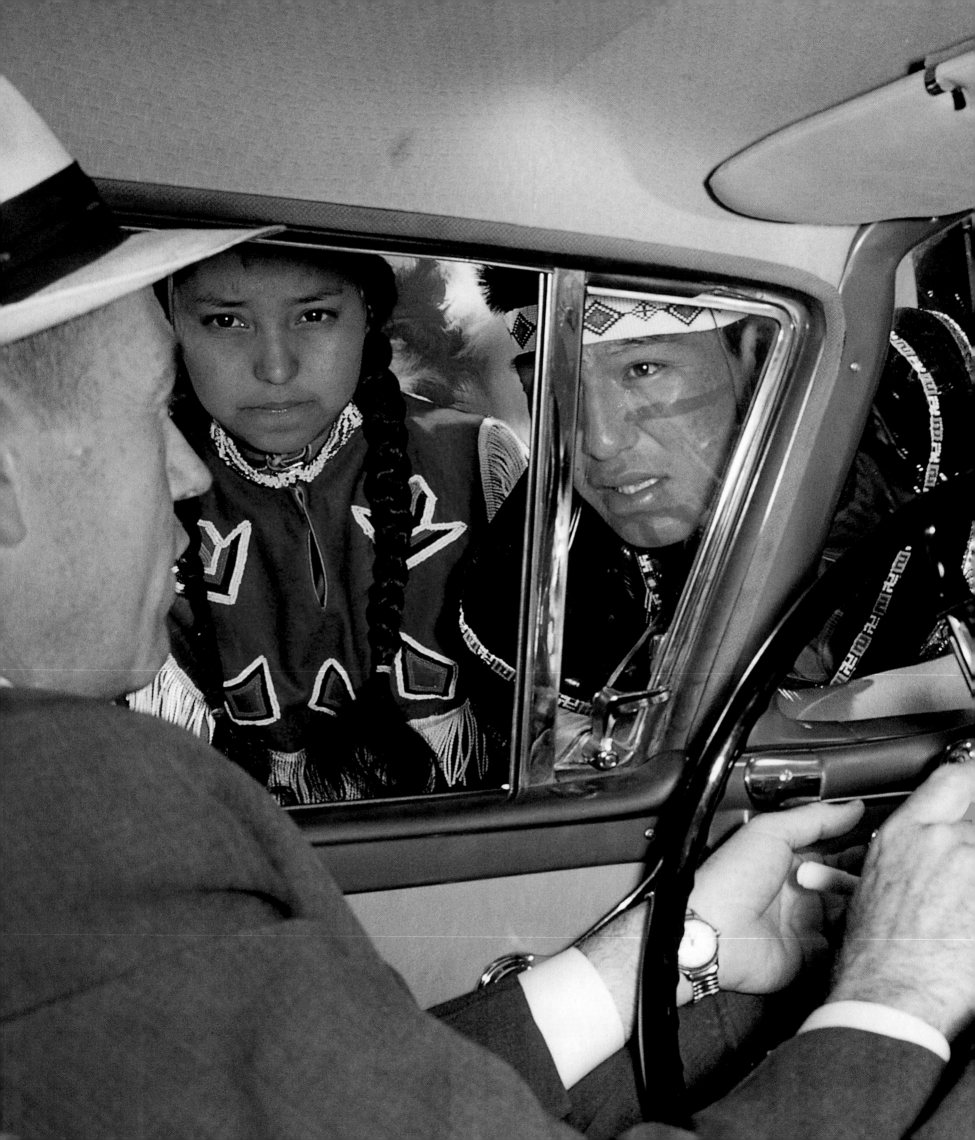

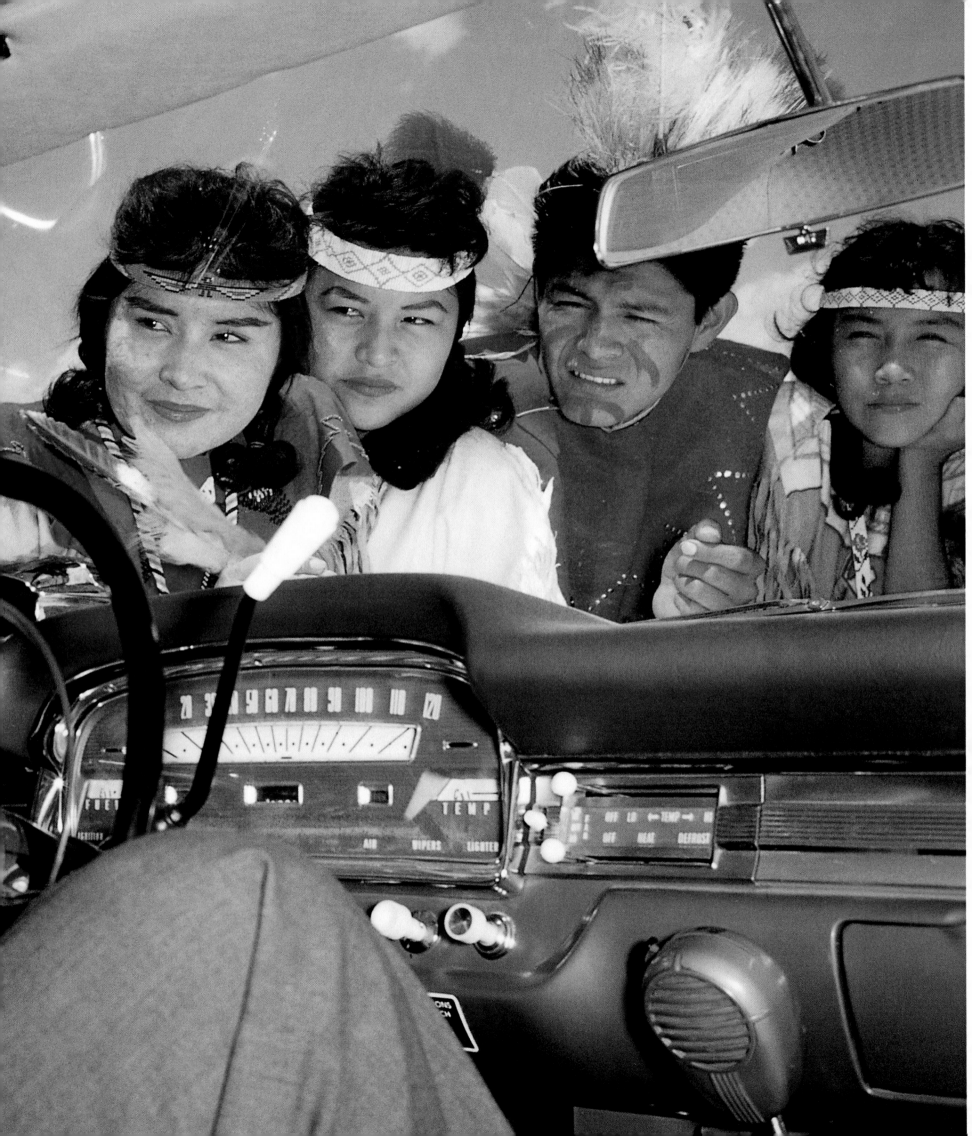

Thomas J. Abercrombie

JUNEAU, ALASKA, 1959 • Warmed by Pacific currents and long hours of sunlight, the panhandle of Alaska belies the region's traditional image as a frozen wasteland of igloos, ghost towns, and grizzled sourdoughs.

David Boyer

CALIFORNIA, 1956 • *Opposite:* A San Franciso couple in fifties finery, including pert hat and white gloves, hungrily eyes Pacific market crabs just lifted from the boiling cauldron and ready to eat.

Bates Littlehales

FLORIDA, 1955 • Way down upon the Suwannee River, the haves and the have-nots alike cast their lures for the wily and succulent catfish that inhabit the slow-moving stream. GEOGRAPHIC photographers took pleasure in recording American regional lifestyles otherwise little noticed by the reading public.

Willard R. Cutler

LOUISIANA, 1958 • *Right:* In bayou country, where land is despairingly described as liquid mud, transportation needs are met by shallow-draft skiffs that can "ride a heavy dew," traditionally paddled standing up.

Thomas J. Abercrombie

MINNESOTA, 1958 • An ice-fishing contest on White Bear Lake draws a record crowd. "No fish in his right mind would swim within a thousand yards of this mob," one contestant said, wondering how the ice supported them all.

Joseph Modlens

PARIS, FRANCE, 1950 • Mother Catherine's Restaurant, founded in 1793 on the Place du Tertre, at the crest of the highest point in Paris, distills the essence of old Montmartre. It may have served notables of the French Revolution.

David Seymour

NAPLES, ITALY, 1957 • *Opposite:* Taking advantage of the Neopolitan sun and air, a busy seamstress has moved her worktable out into the doorway of her shop, which seems to specialize in the D-cup bra. The photographer found the humble scene worthy of the GEOGRAPHIC.

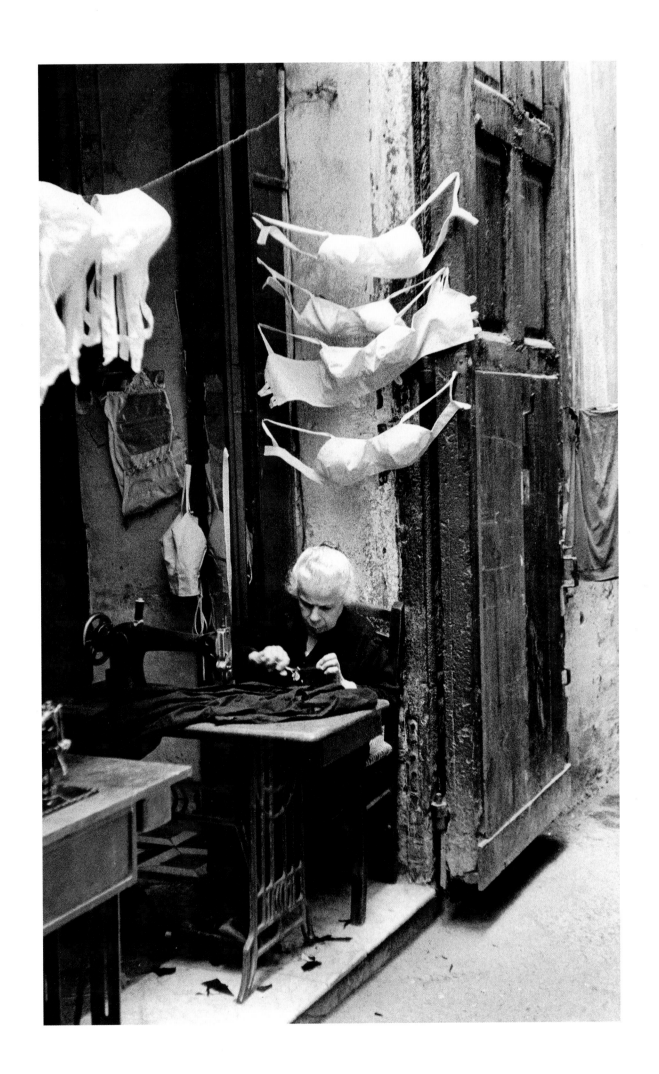

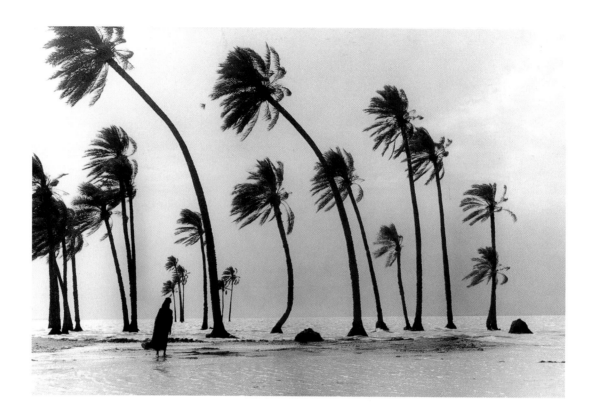

Wilfred Thesiger

IRAQ, 1953 • Date palms bow their tattered plumage to the fury of a howling gale, as flood waters, relentlessly driven by the wind, turn the desert into a lake.

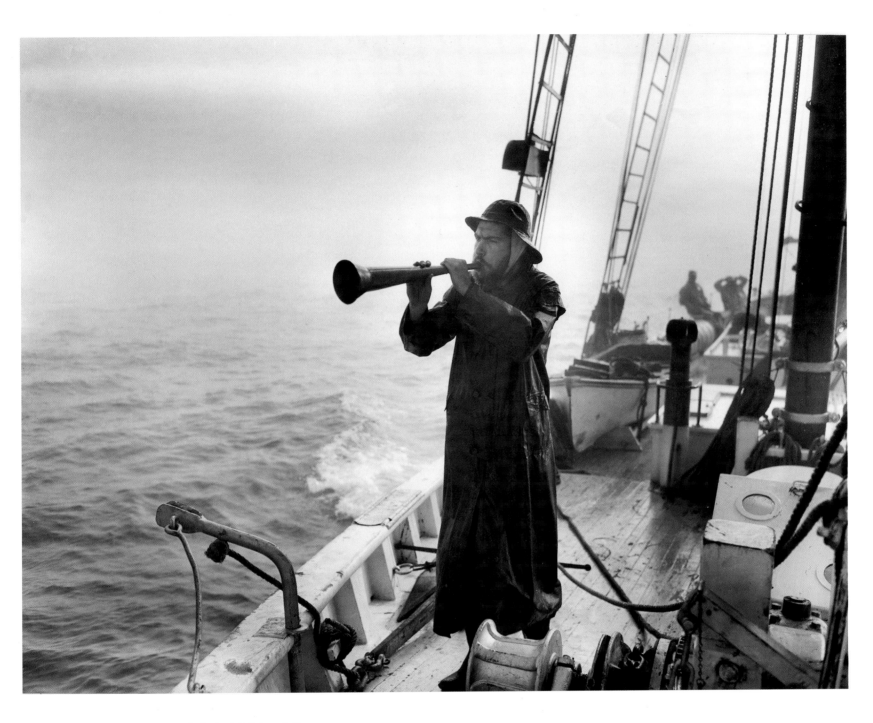

Ralph B. Hubbard, Jr.
ATLANTIC OCEAN, 1951 • Off Newfoundland, a lung-powered horn sounds once a minute as the *Bowdoin* feels her way through heavy fog. Other fishing boats follow *Bowdoin*'s horn blindly, knowing she'll lead them safely to harbor.

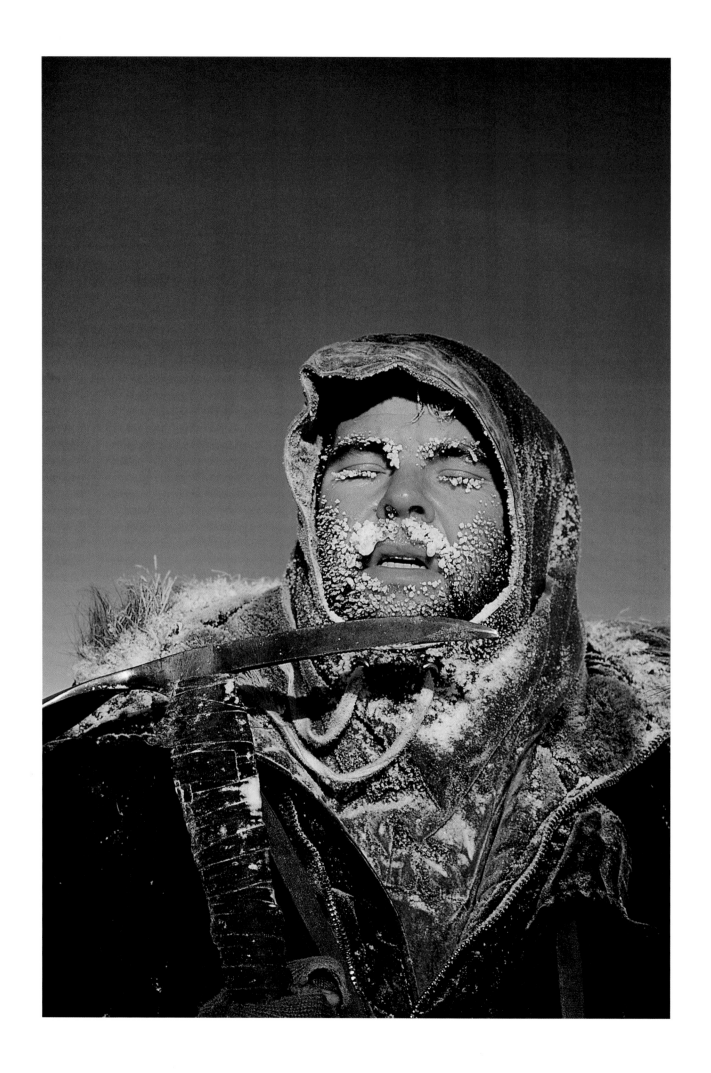

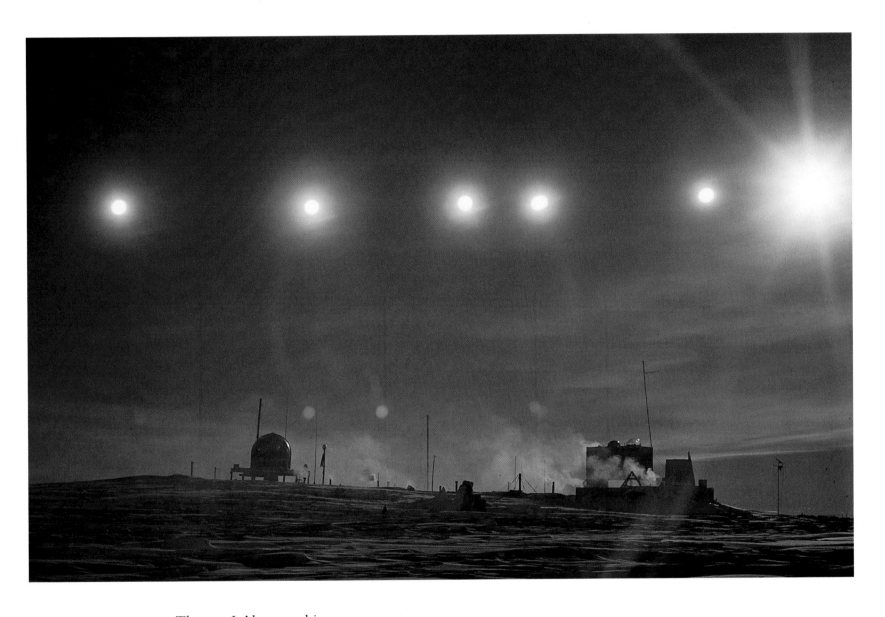

Thomas J. Abercrombie

ANTARCTICA, 1957 • At South Pole Station, six exposures of the sun taken over a three-hour period make an extraordinary panorama. To minimize the sun's intense glare, the picture was shot through a filter from a welding mask.

Thomas J. Abercrombie

ANTARCTICA, 1957 • *Opposite:* After four hours outdoors at the Earth's coldest spot, photographer Abercrombie, the first correspondent to stand at the South Pole, is coated with frost. On the evening of September 17, 1957, the temperature plunged to a record 102.1°F below zero.

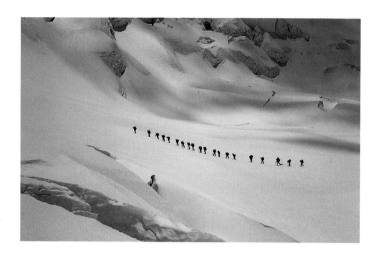

John Harrison
HIMALAYA, 1951 • Climbers inch up through rarified air, without oxygen equipment, along the southwest flank of Makalu, at 27,824 feet the fifth highest mountain in the world. This party, which included Sir Edmund Hillary, was turned back 370 feet from the summit. Such heroic fare continued to be the backbone of NATIONAL GEOGRAPHIC photography through the post-war decade.

Samuel Silverstein
ANTARCTICA, 1967 • *Right:* Invading a no-man's-land above the clouds, climber Nicholas B. Clinch reaches the summit of Vinson Massif, at 16,860 feet the highest mountain in Antarctica. Behind him rises the pyramidal peak of Mount Tyree, only 570 feet lower.

F. Kazukaitis
ANTARCTICA, 1963 • *Following pages:* Emperor penguin chicks huddle for warmth at Cape Crozier. Born in winter, they complete their growth in time for summer's ice break up, when they fend for themselves.

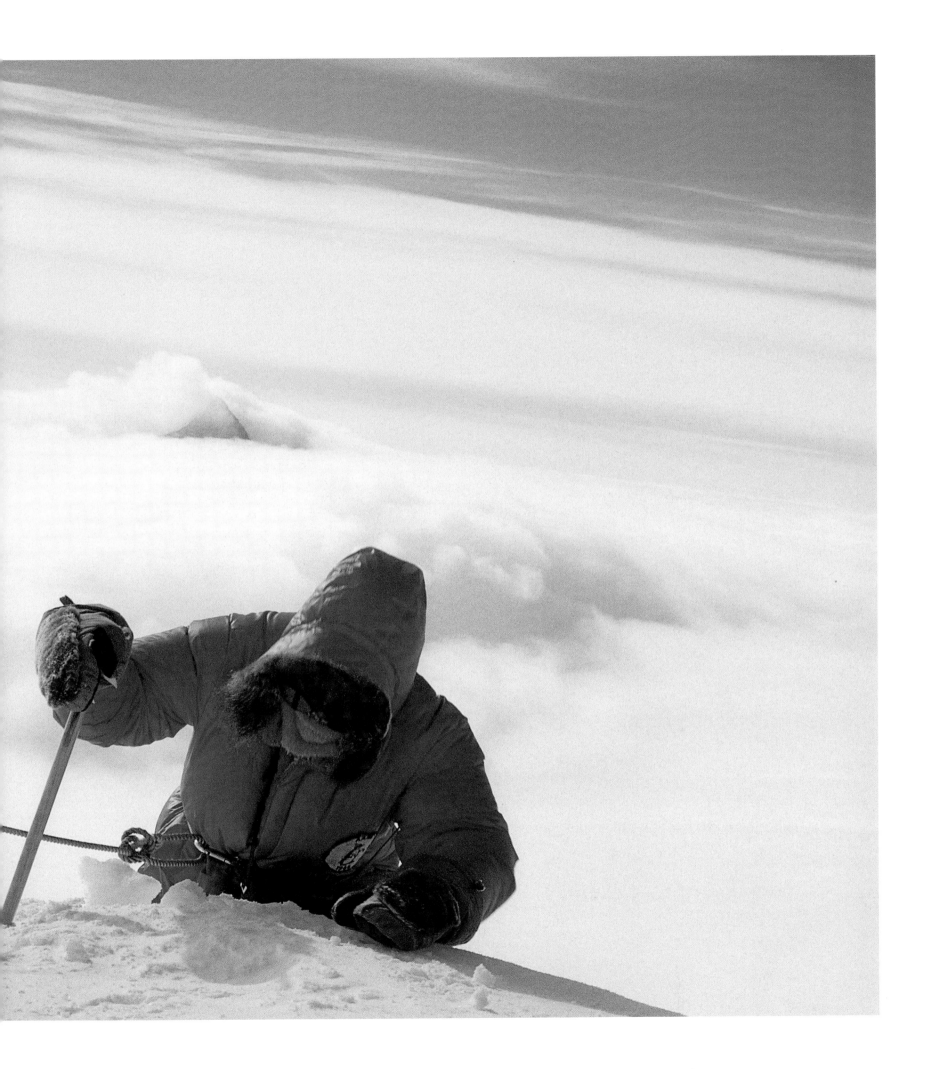

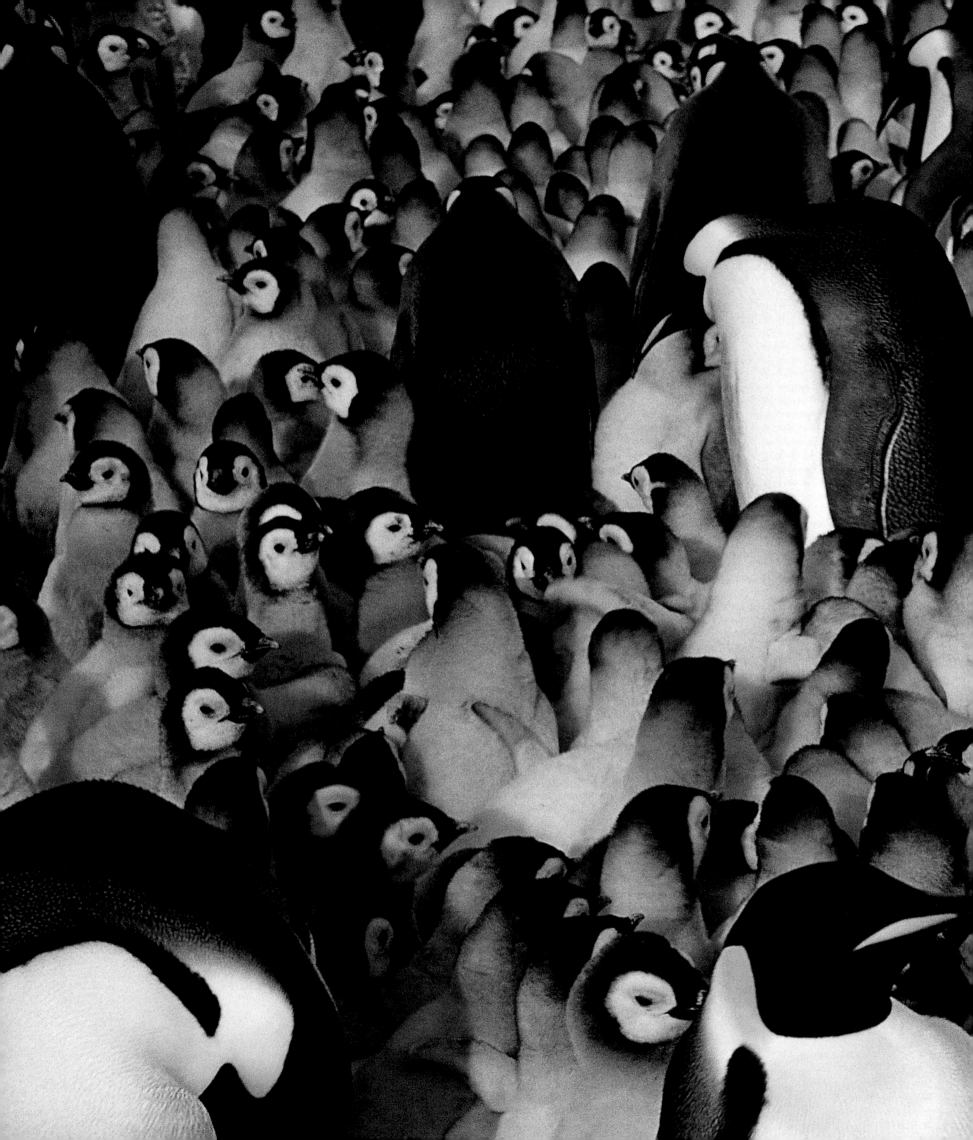

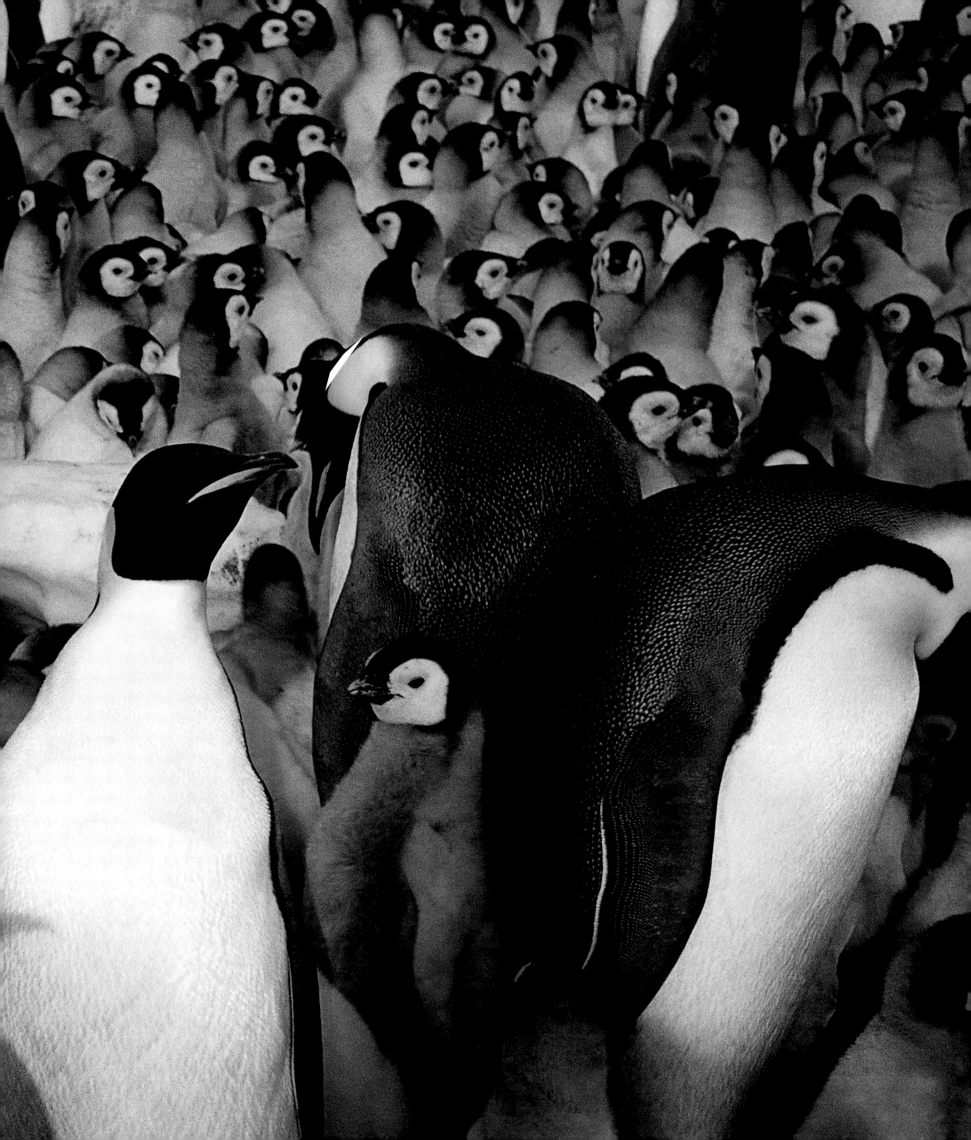

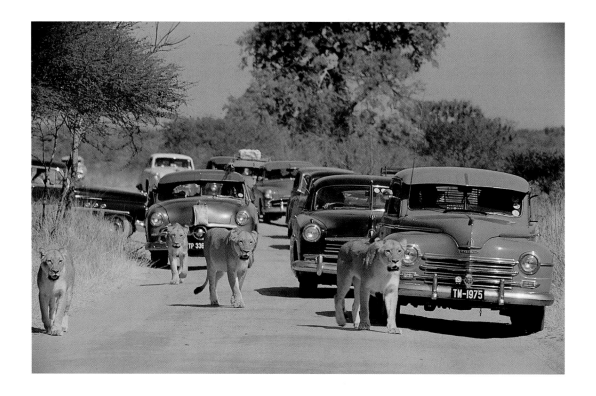

Dick Wolff

SOUTH AFRICA, 1960 • In Kruger National Park, lions take a leisurely midday stroll along the trail, oblivious to the growing traffic jam of tourists stalking them, as well as other wondrous beasts in this game preserve. GEOGRAPHIC photographers documented the often seen along with the seldom.

Hugo van Lawick

AFRICA, 1965 • *Opposite:* Little Flint introduces himself to famed chimpanzee student Jane Goodall, but Mother Flo keeps a protective hold on him, as the ten-month-old infant investigates the scientist's hand with his lips. National Geographic funded Goodall's research and GEOGRAPHIC photographers made her famous.

Helen Schreider

IRAN, 1968 • *Following pages:* Across a vast and desolate emptiness where Alexander the Great's army trod in 330 B.C., sunset's parting glory signals the approach of night along this desert trade route.

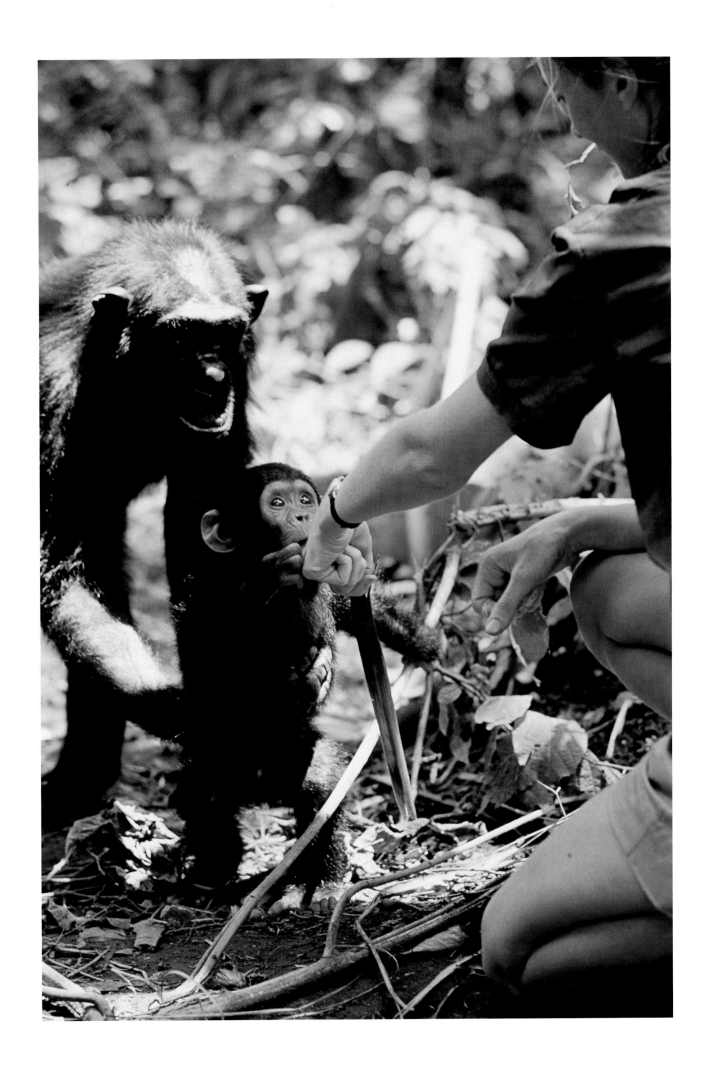

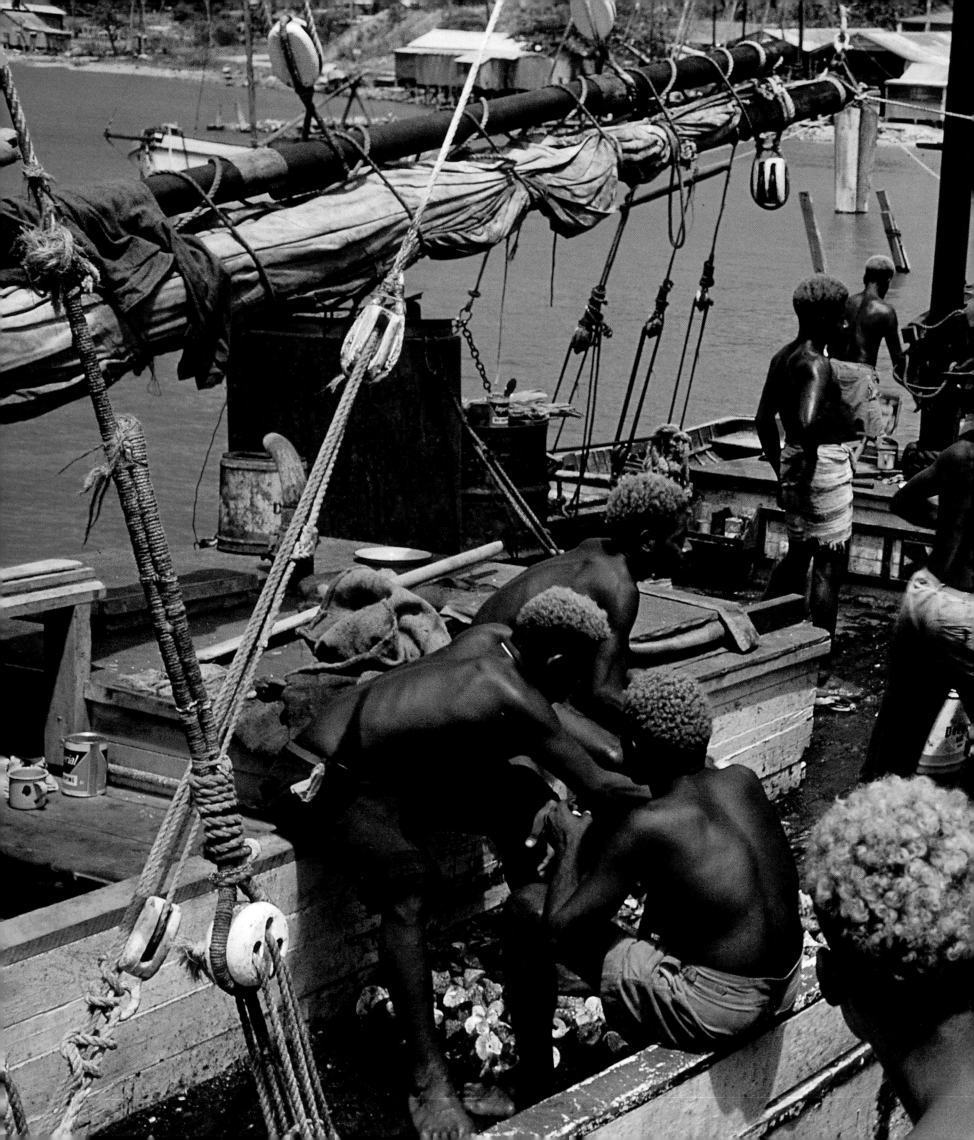

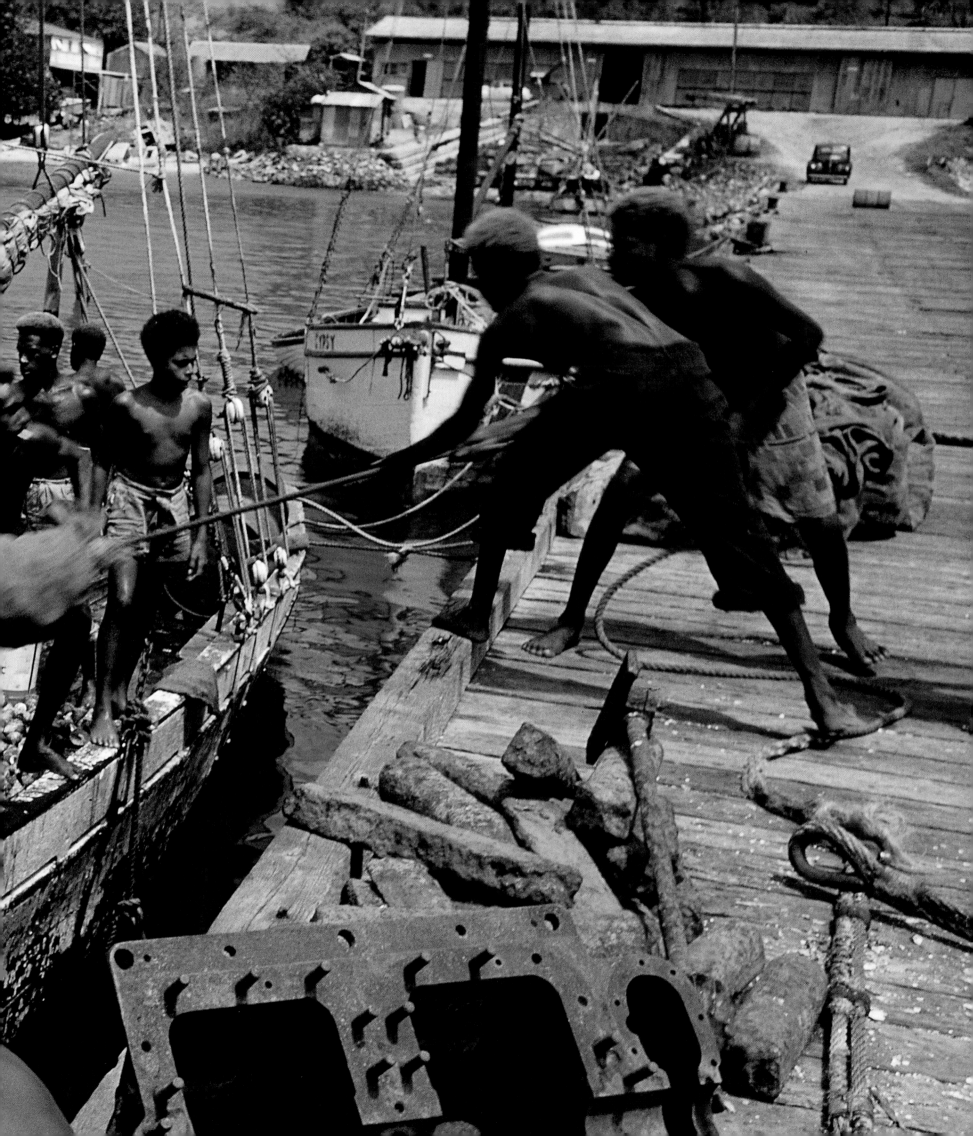

Paul A. Zahl

PORT KENNEDY, AUSTRALIA, 1957 • *Preceding pages:* Bleached hair a badge of their trade, trochus shell divers from Thursday Island unload the results of six weeks' diving for this mollusk valued for mother-of-pearl. Late in the 1950s, a looser, more journalistic style was emerging in the GEOGRAPHIC.

Bruce Dale

KENYA, 1969 • *Above:* Beating out a rhythm on an empty gasoline can, a young Kenyan scares grain-gobbling birds away from his family's rice field.

Bruce Dale

AFGHANISTAN, 1969 • *Left:* His pet mynah perched atop his head, a Jat tribesman hangs caged fighting quail, covered to keep them quiet, along a tree branch, near Kabul.

Thomas Nebbia

ISRAEL, 1967 • *Following pages:* Carefree innocence leads children to a sunlit meadow outside Nazareth, where Jesus spent his childhood and learned, among many things, about the fig tree and the mustard seed, which would figure in his teachings.

171

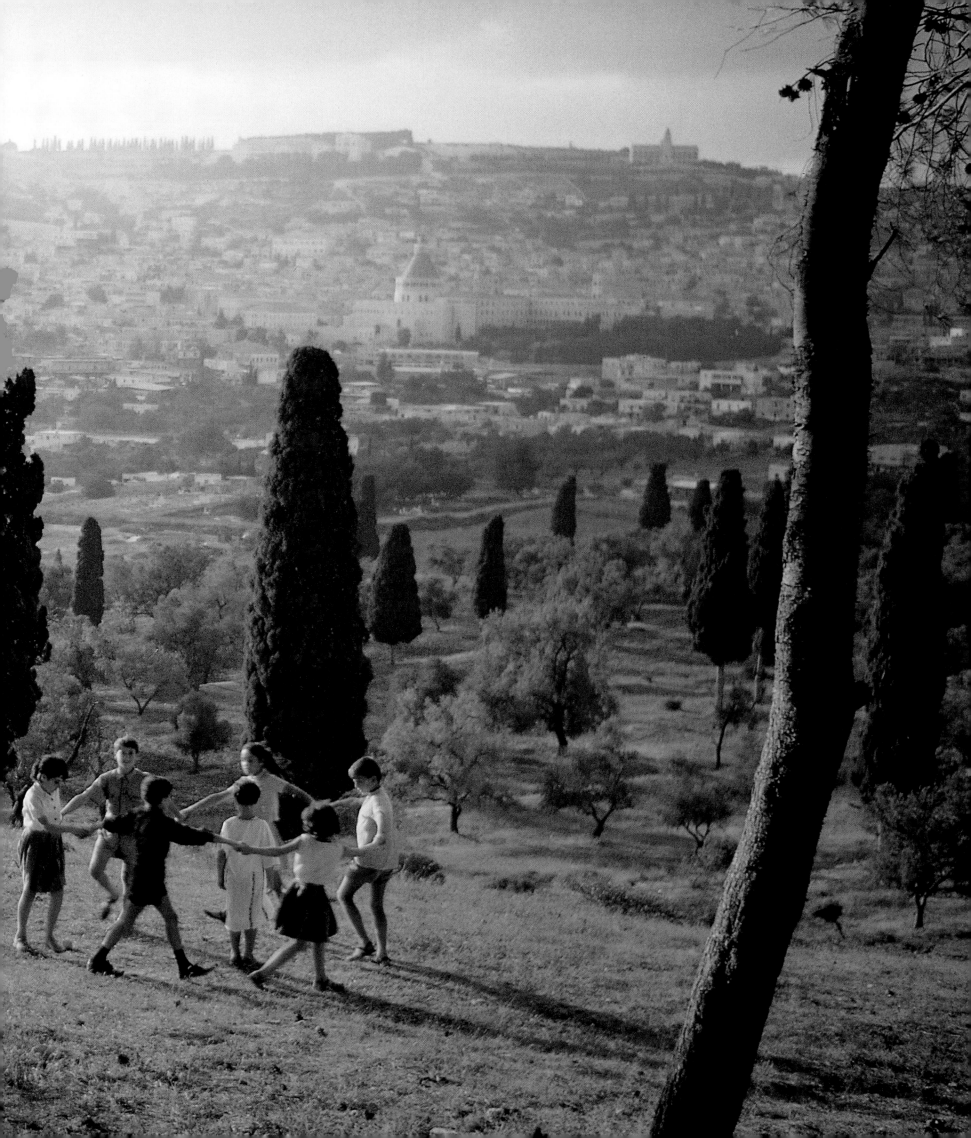

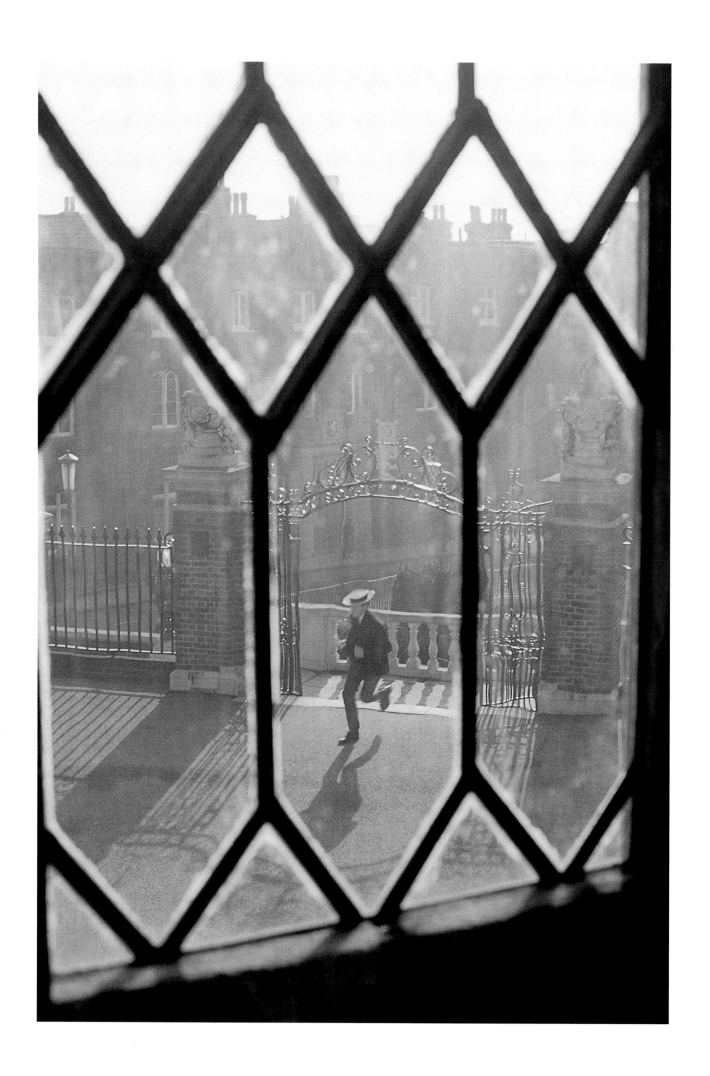

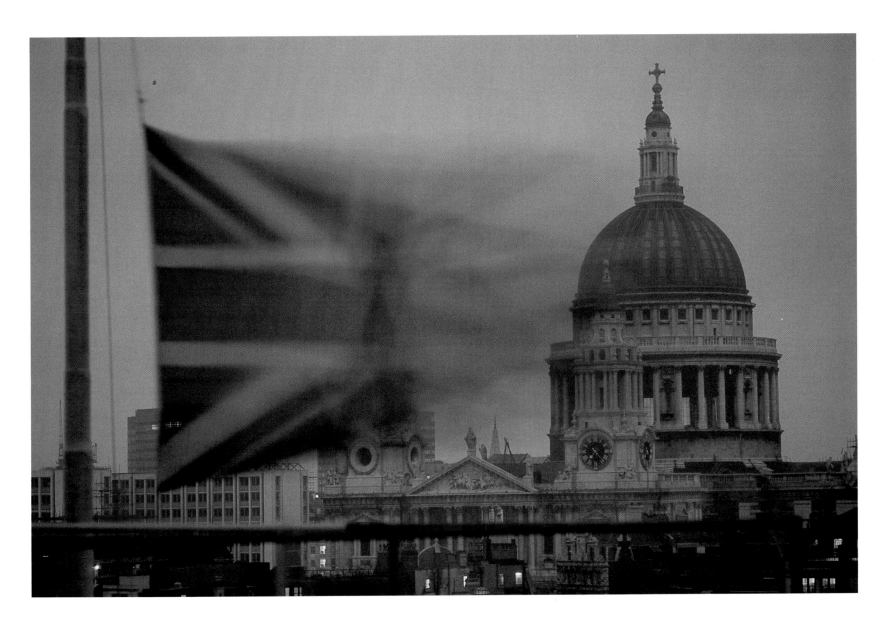

Bates Littlehales

ENGLAND, 1965 • The Union Jack flutters at half-staff, with London's St. Paul's Cathedral in the background, signifying a nation mourning for statesman Sir Winston Churchill. The GEOGRAPHIC sent a team of photographers to cover Churchill's funeral. Director of Photography, Bob Gilka, was on the scene to oversee the coverage.

Bates Littlehales

ENGLAND, 1965 • *Opposite:* A "ten o'clock scholar," in traditional straw boater and formal attire, races to class at Harrow, much as young Winston Churchill, both precocious and backward, must have done.

John Schofield

HONG KONG, 1962 • *Following pages:* Testament to British influence, a facsimile of the double-decker London bus navigates Kowloon's Nathan Road, with help from a policeman in his neo-oriental kiosk.

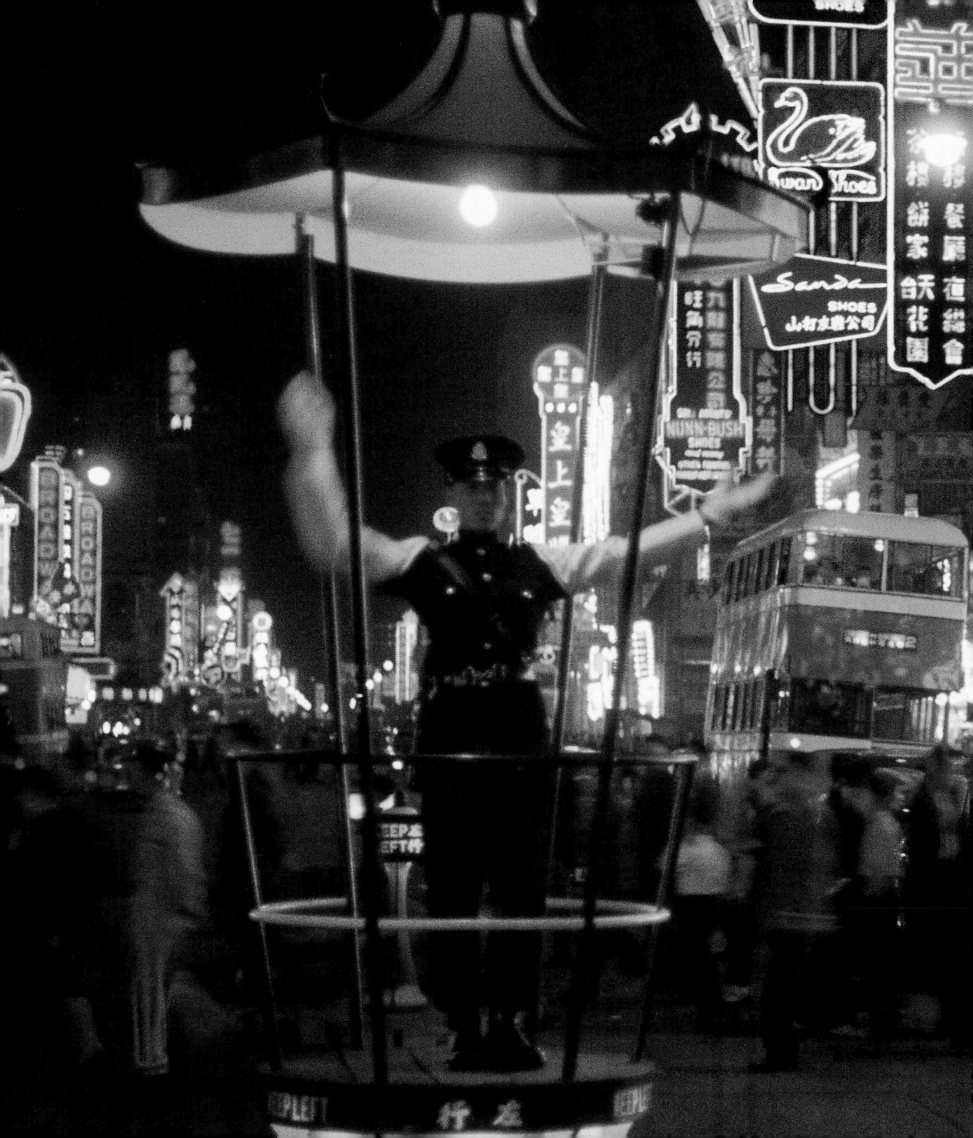

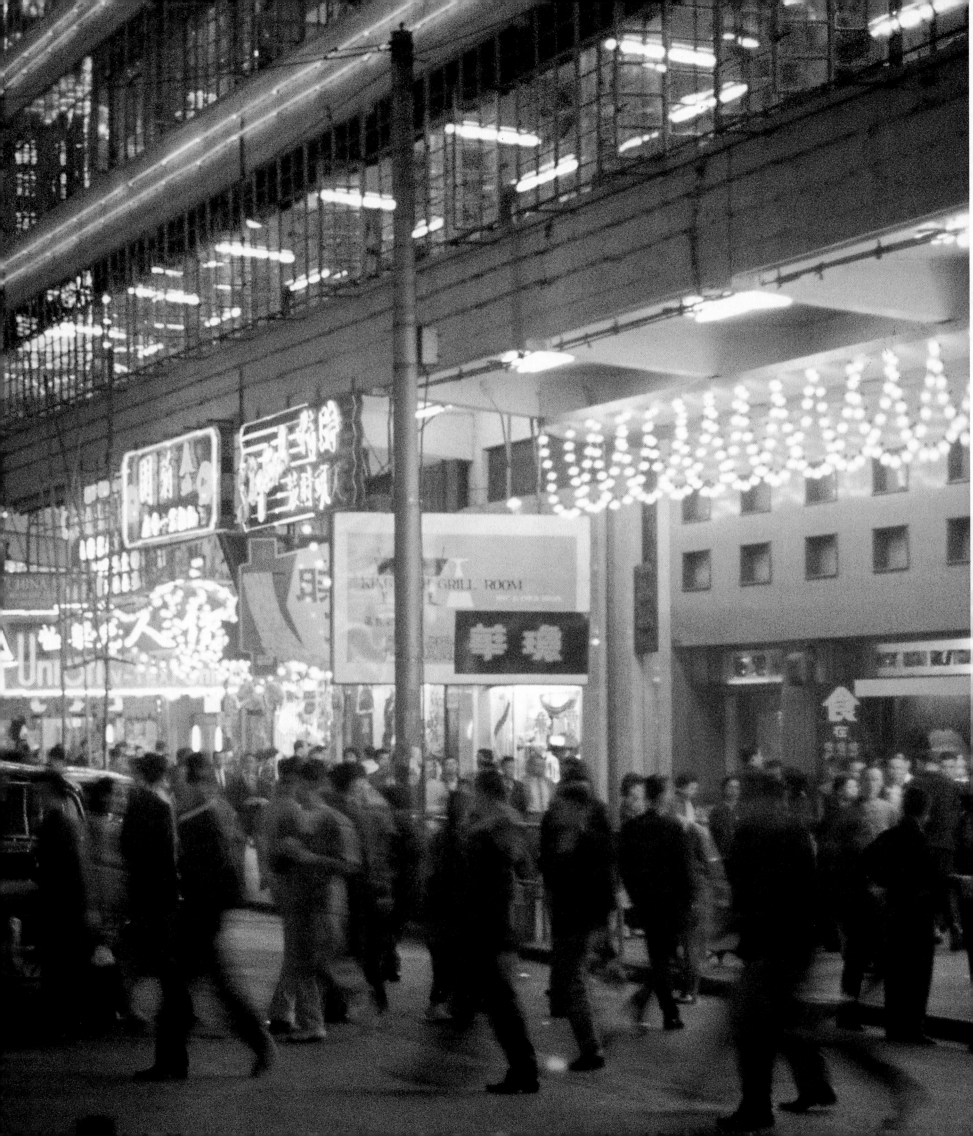

Dickey Chapelle

VIETNAM, 1965 • A veteran reporter of many wars and a contributor to NATIONAL GEOGRAPHIC since 1953, Dickey Chapelle was the first American woman correspondent to die in action when she fell victim to a booby trap in Vietnam on November 4, 1965.

Dickey Chapelle

VIETNAM, 1965 • *Right:* Awaiting publication at the time of Chapelle's death, her last story, "Water War in Viet Nam," opened with this startling picture of a flaming inferno, as South Vietnamese set fire to a Mekong Delta hut to flush out the Viet Cong. With Chapelle's work, the GEOGRAPHIC ventured into photography outside its perceived mission at the time.

PROBING THE DEPTHS

Photography Dives Beneath the Seas

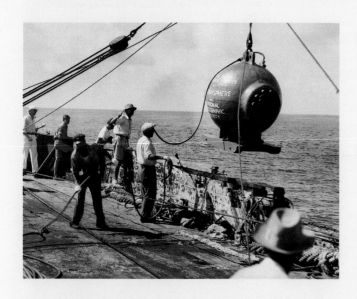

David Knudsen
WILLIAM BEEBE EXPEDITION, 1934 • Captioned "Overboard and down for the deep dive," this National Geographic-sponsored bathysphere takes William Beebe to new depths in undersea exploration.

Charles Martin
DRY TORTUGAS, 1926 • *Opposite top:* A magnesium-powder apparatus rigged to supplement sunlight in making the first color undersea photographs explodes with a great flash.
Opposite bottom: The result: Gray snappers and a yellow goatfish are captured in their habitat in natural color for the first time.

To make a fuzzy pastel Autochrome of a hogfish 15 feet underwater off the Dry Tortugas, W. H. Longley nearly lost his life. But in 1926 the scientist and the NATIONAL GEOGRAPHIC staff photographer Charles Martin had made the first natural-color photographs under the sea. Autochrome, a direct-positive process involving color-dyed potato-starch granules on glass plates, was the only color photography then available. And the necessary flash came from igniting an ounce of loose magnesium powder as the photographer tripped the shutter. To illuminate the depths, Martin rigged a reflector on a raft stocked with a pound of magnesium. By accident it all went up at once.

The magazine's next significant foray into the deep was even more electric. "The best way to observe fish is to become a fish," Capt. Jacques-Yves Cousteau wrote in the October 1952 issue. And wearing Aqua-Lungs, his wartime co-invention, the wiry Frenchman and his research team for

limited times did just that. On dives then up to 220 feet, they coped with atmospheric pressure, limited visibility, and sharks—the usual challenges to warm-water undersea photographers. But using filtered sunlight for eerie black-and-white photographs and pressurizing flashbulbs with their own Aqua-Lungs for color, they caught the allure of free diving as they provided evidence for Cousteau's article, which argued persuasively and poetically for the importance of deep-sea exploration and of photography as its tool.

The Society was convinced. With its support, the captain and Harold Edgerton, inventor of the strobe, collaborated on the development of an electronic flash for marine photography. Further, Society-funded Cousteau projects were documented in articles and award-winning television specials throughout the sixties, winning a national audience for the field. That living underwater could become ordinary is illustrated in an image of Cousteau's chess-playing scientists

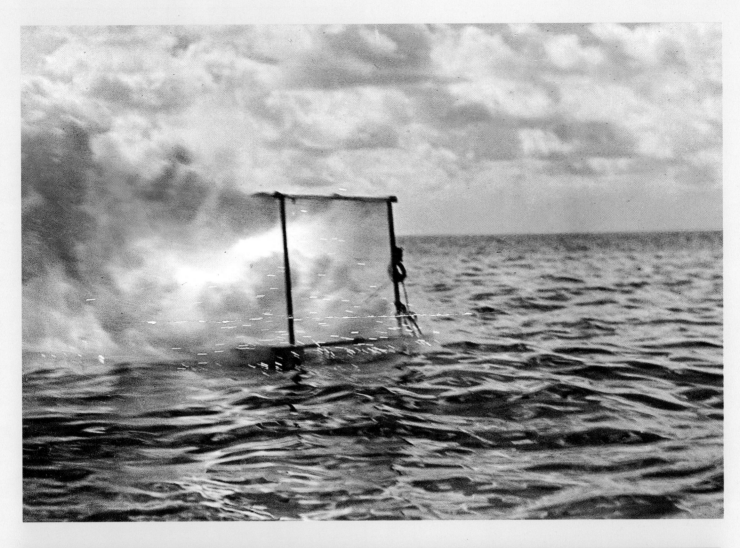

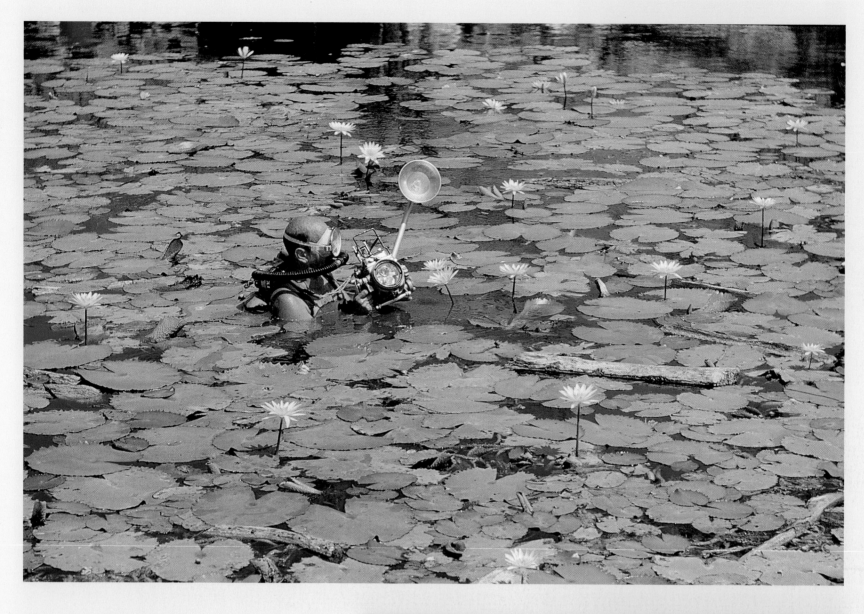

William W. Campbell III

MEXICO, 1958 • Staff photographer Luis Marden, with his special underwater camera equipment, surfaces among the lily pads that cover a cenote, a natural well, in the Yucatán, where he was diving.

Luis Marden

MEXICO, 1958 • From the murky, 80-foot bottom of a Yucatán cenote, a diver brings up an unbroken jar perhaps a thousand years old.

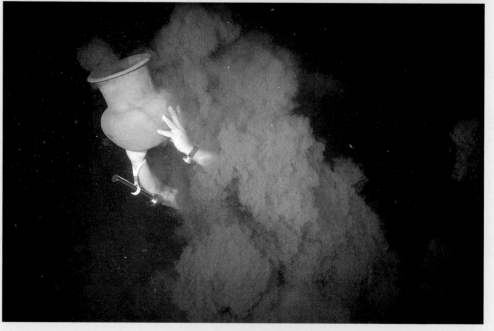

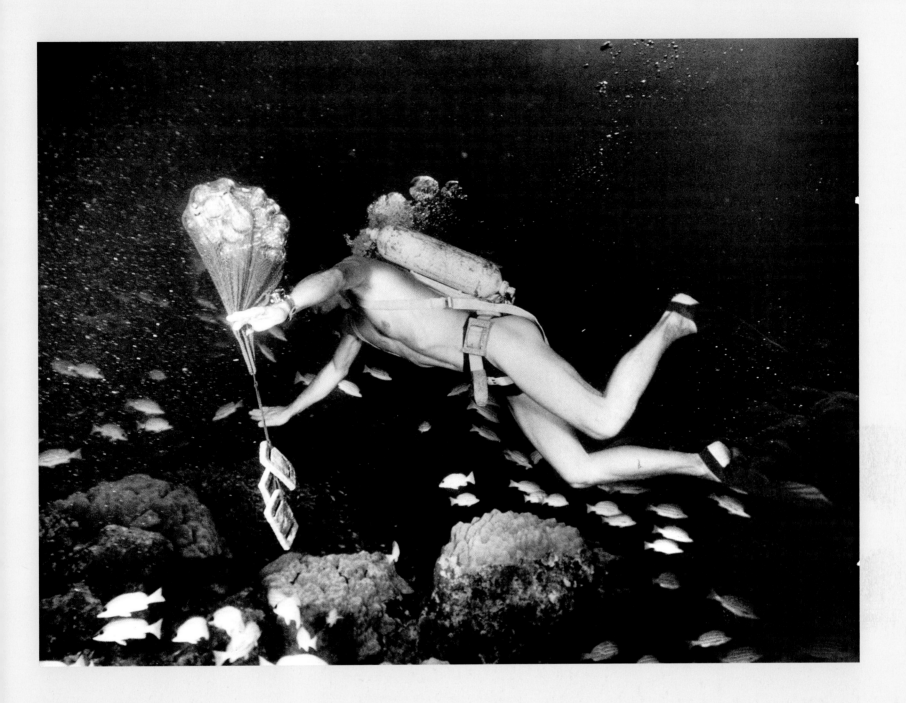

oblivious to a fellow diver feeding fish outside, 36 feet down. That was the point: residing for a month on the Red Sea's continental shelf, they proved the viability of long-term underwater colonies. (Such photographs forecast the droll housekeeping scenes inside the six *Apollo* spacecraft on their lunar missions. And they were not the only parallels between undersea and outer-space exploration, subjects that engrossed readers worldwide.)

By the early sixties, diving gear and underwater cameras were standard equipment for five staff photographers. Their dean was Luis Marden, ultimately a veteran of four decades as a NATIONAL GEOGRAPHIC cameraman and writer. An early advocate of 35mm cameras at the magazine, he may have been the first photojournalist anywhere to realize the potential of Kodachrome, first available in 1935. Using the fast, grainless, brightly hued roll film from then on, he provided images and text on assignments around the globe, including the first all-color underwater

Luis Marden

RED SEA, 1956 • This diver had to weight down his supply of flash bulbs with lead to keep them from rising to the surface.

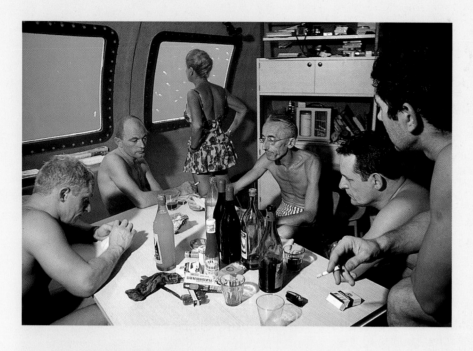

Robert B. Goodman

RED SEA, 1964 • To avoid the tedious and time-wasting need to decompress after each dive, SCUBA inventor Jacques Cousteau decided to maintain a sea-bottom station to which divers could repair between dives—and perhaps share a bite to eat.

Robert B. Goodman

MONACO, 1964 • *Opposite:* Live fish gathered from the depths for study in plastic bags attract hungry predators, who soon learn to rip open the transparent sacks to reach their victims.

article, the most extensive such photo-essay to date. His tandem skills were at their peak in "I Found the Bones of the *Bounty,*" his discovery of Captain Bligh's mutineered and sunken ship, and in his report of his 160-foot dive into a Maya sacrificial well in the Yucatán. His images from both adventures record achievements in underwater archaeology, but also induce a grave-robber's shiver. Together he and Cousteau refined the Aqua-Lung for deeper dives and the equipment essential to undersea photography.

From Marden, the NATIONAL GEOGRAPHIC family tree of marine cameramen branches to include such figures as Bates Littlehales, the deep-water specialist Emory Kristof, David Doubilet, and Charles "Flip" Nicklin. In the sixties Littlehales co-designed the Ocean Eye, an underwater camera housing that corrects the distortion of light-waves underwater. Nicklin began swimming with whales in the late 1970s. For the range and aesthetic mastery of his animal and marine photographs, Kristof calls Doubilet "the Audubon of this century."

While striving for firsts as underwater journalists and divers, these pho-tographers face a subject of unique artistic challenge. They document and sometimes make advances in biology, geology, archaeology, and other undersea sciences and also contend with what Robert Ballard, the Society-supported discoverer of the wreck of the *Titanic,* calls "Earth's last uncharted frontier." In this unbounded, generally blue-green world, man-made remains are barely readable, while nature's most extravagant inventions and most savage hunters flourish free of gravity. To make an informative underwater photograph is difficult enough; to make one with the marks of individual style is rare indeed. Nonetheless, if there is a school of underwater photographers, with pioneers to the third generation, technical breakthroughs and near-death experiences, the NATIONAL GEOGRAPHIC can largely take credit for having created it.

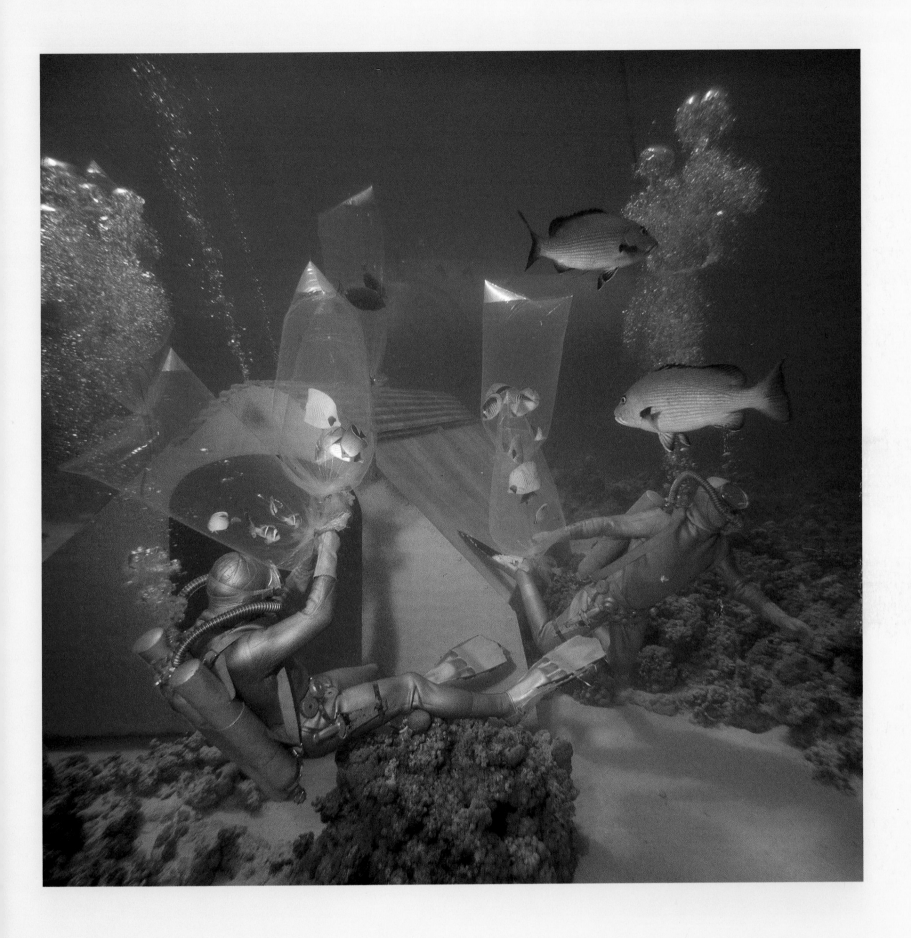

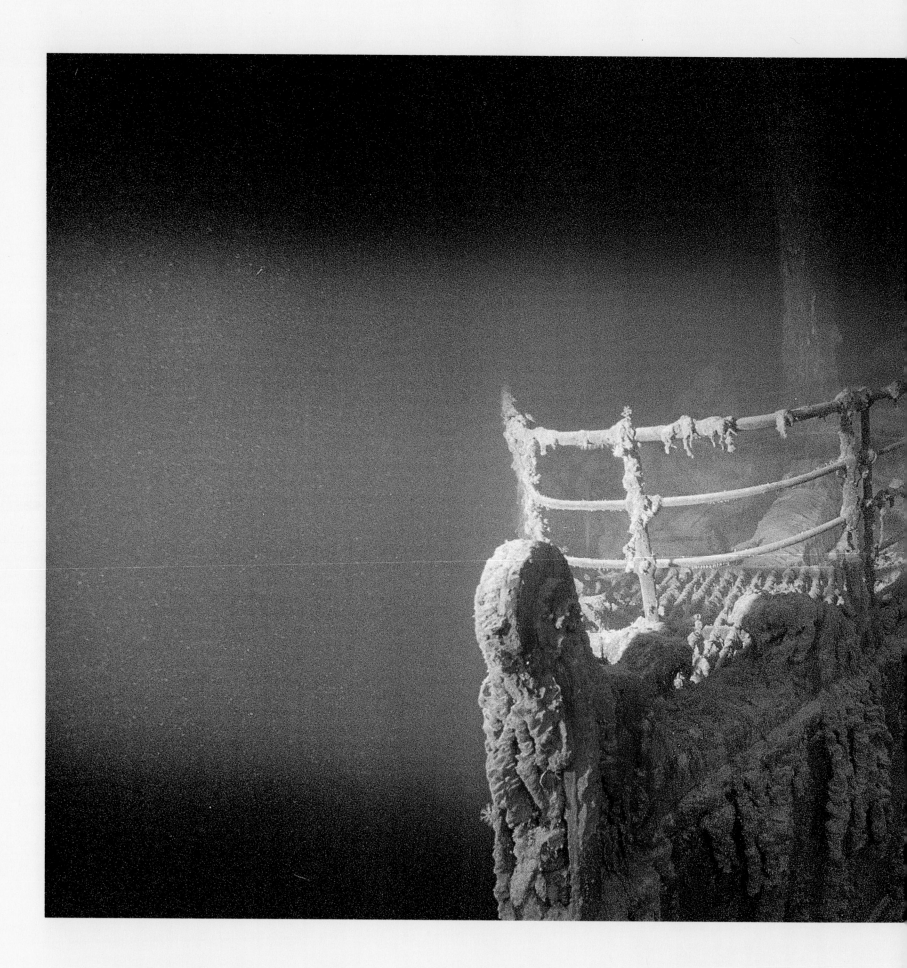

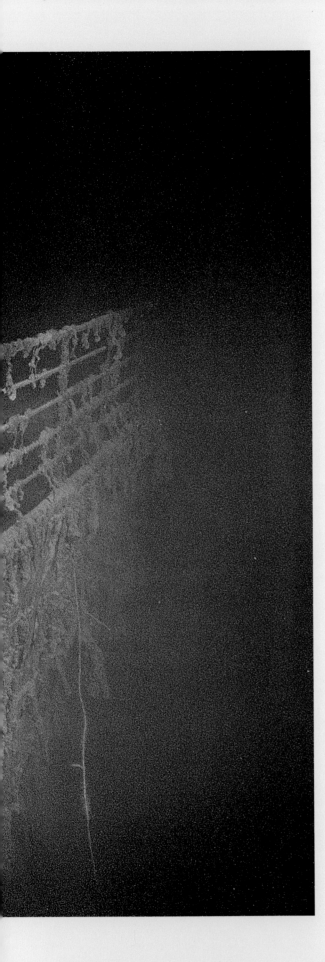

Emory Kristof

SOUTH CHINA SEA, 1993 • A blue-spotted rock codfish skims close to a gleaming Chinese blue-and-white vase, one of more than 800 pieces of intact Ming dynasty porcelain found in the wreckage of *San Diego* off Luzon in the Philippines.

Emory Kristof

NORTH ATLANTIC, 1991 • *Left:* Eluding all searchers for nearly three-quarters of a century, the R.M.S. *Titanic* was finally discovered in 1985 at a depth of two miles. On a return trip, the great ship's remains were illuminated by submersible vehicles and memorably photographed.

Bill Curtsinger

CANADA, 1996 • Sprinting near the summit, a Steller sea lion streaks by while patrolling the rich feeding grounds of Canada's Bowie Seamount, a 10,000-foot volcanic mountain beneath the Pacific.

Flip Nicklin

CANADA, 1994 • *Right:* During the ice-free months of July and August, hundreds of belugas crowd into the estuaries of Somerset Island to molt and to nurse their young.

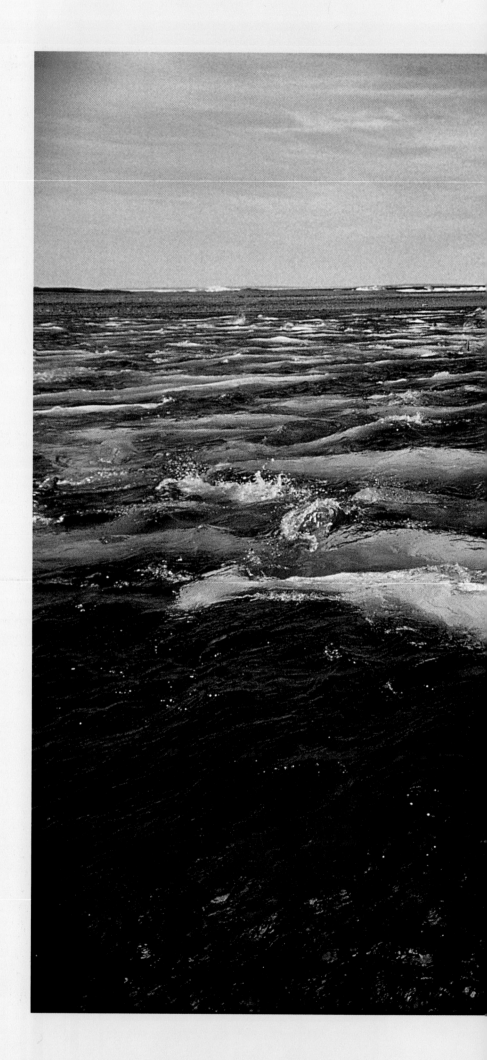

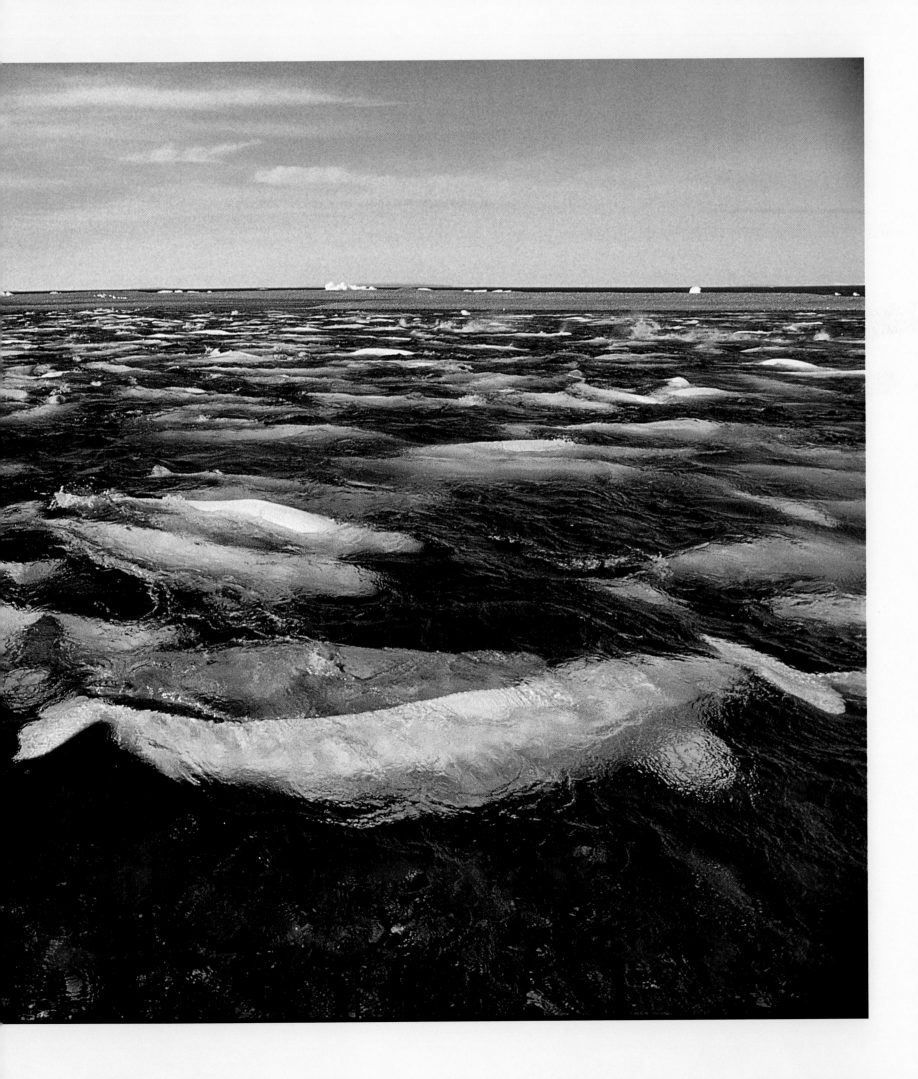

David Doubilet

CHANNEL ISLANDS, CALIFORNIA, 1998 • A towering grove of giant kelp, which can grow two feet a day, provides sustenance and shelter for grazing señorita wrasses and orange garibaldi.

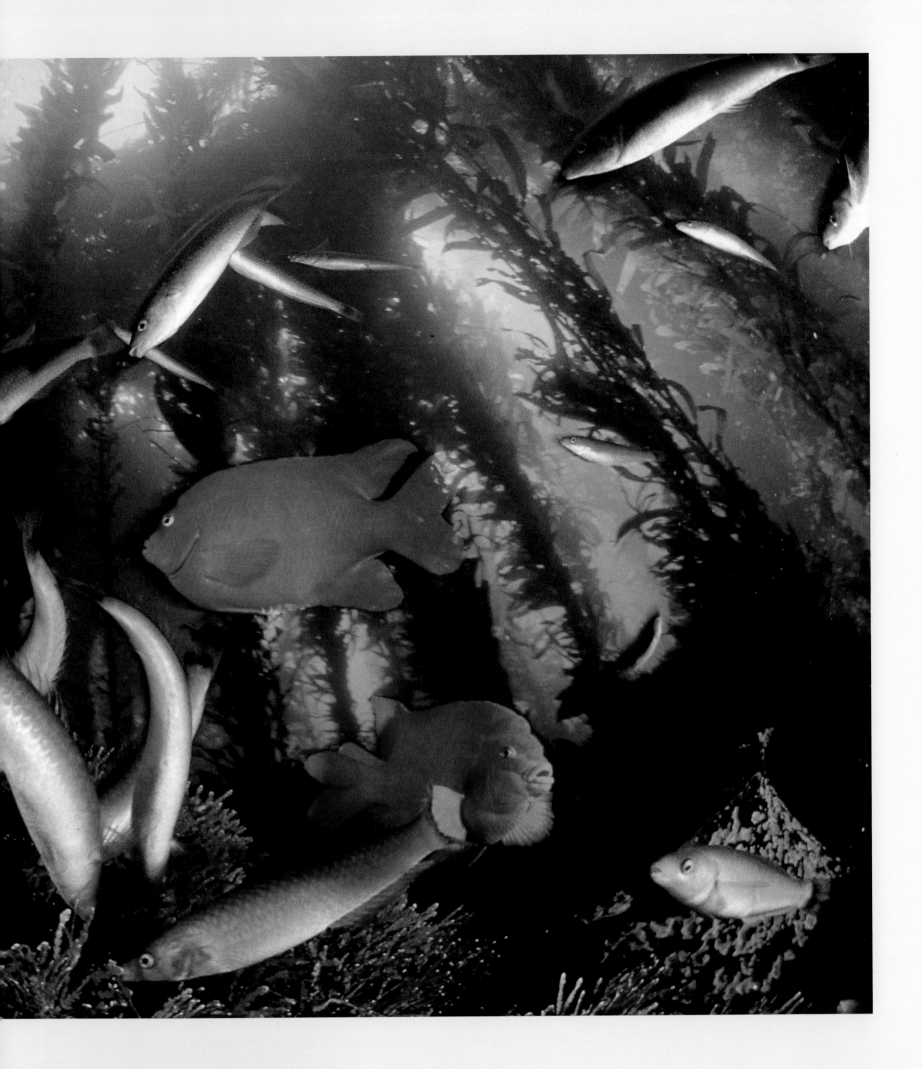

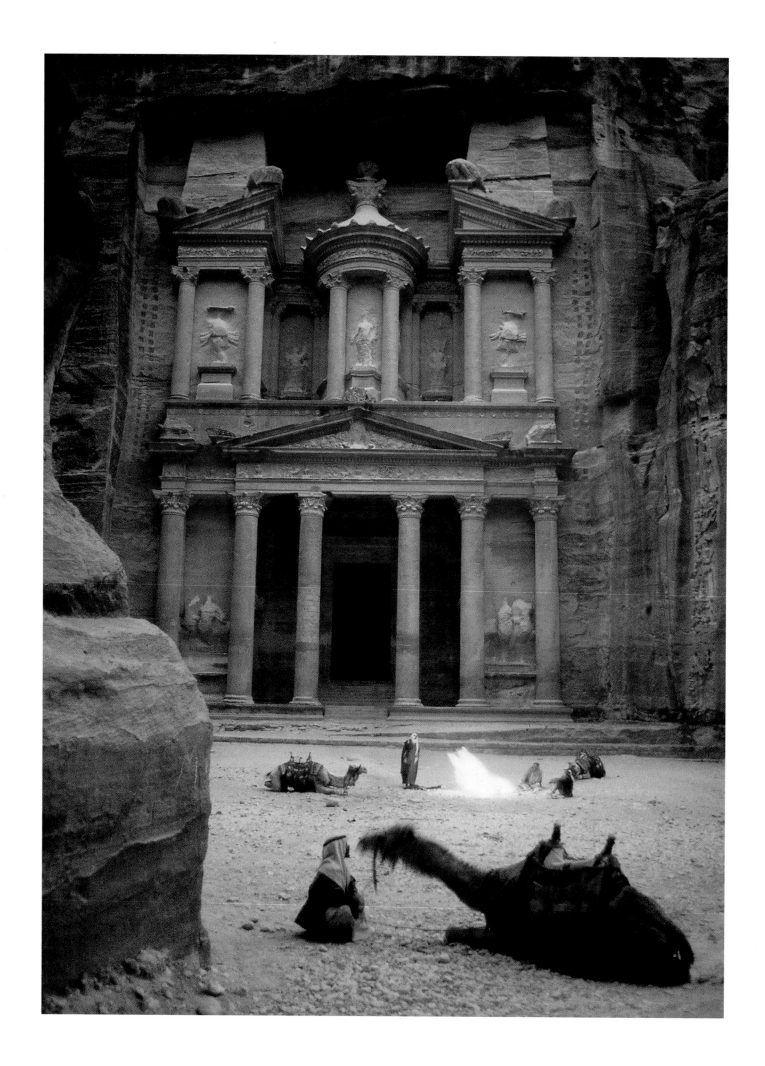

1971-1990

Realism and Individuality

Ferdinand Protzman

Artists weren't what Bob Gilka was seeking to hire when he became National Geographic's director of photography in 1963. "Go out and get some young photographers in here," editor Melville Bell Grosvenor told him. "I want our magazine to show what photography is today, not what it was 20 years ago." The mandate for a youth movement was prompted by the realization that times were changing rapidly and that the GEOGRAPHIC needed to change, too, if it was to flourish.

"When Grosvenor handed the job over to me, he made it clear that he understood photography and knew that the status quo wasn't what was needed," says Gilka, who had been photo editor of the *Milwaukee Journal* before joining the magazine. "He saw the GEOGRAPHIC's photography was stilted. The 'Red Shirt' days were ending and realism was gaining ground, but the notion that it was okay to pump up a picture by adding some color wasn't entirely gone in some quarters. Melville Grosvenor knew that had to change."

Charged with bringing in fresh blood to complement the nucleus of talented young photographers and picture editors already there, such as Dean Conger, Winfield Parks, Tom Nebbia, Al Moldvay, Jim Blair, and Bill Garrett, Gilka turned to the source he knew best: newspapers. He was searching for gifted generalists, photographers capable of taking first-rate pictures of everything from car wrecks to coronations. Versatility was high on his list of prerequisites. Art and aesthetics weren't.

"I wasn't looking for people with an artistic bent," he says. "I was after seeing ability. It's the critical factor in photography. Some people have it; some don't. When I was building the staff, I went largely by instinct. It was an emotional, gut-driven process. What I wanted were classic photojournalists."

Bruno Barbey
MOROCCO, 1988 • Handprints of the Islamic faithful decorate a wall in Morocco, the land from which the Moors launched their conquest of Spain in A.D. 711.

Thomas J. Abercrombie
JORDAN, 1985 • *Opposite:* In front of the nearly 2,000-year-old Nabataean Khazneh in Petra, Bedouin cameleers rest their mounts as their ancestors must have done centuries ago when they passed through this ancient caravan crossroads.

The photographers he hired, among them William Albert Allard, Sam Abell, Jodi Cobb, and David Alan Harvey, would prove to be that and much more. As a group, they would blossom during the 1970s and '80s, changing the GEOGRAPHIC's photography by developing individual styles that combined unflinching realism with a fine art aesthetic. They would also become specialists, devoted to covering particular subjects or parts of the world.

Those accomplishments grew from their personalities and life experiences. Unlike for previous generations of GEOGRAPHIC photographers, the values, goals, and thinking of Gilka's young protégés were the products of postwar prosperity, as well as the Cold War, the nuclear era, the flowering of American photojournalism, and the advent of television. Thanks to vibrant economic growth and technological advances by companies like Leica, Nikon, and Kodak, it was a world in which the 35mm camera and color film were staples of amateur and professional photography rather than prohibitively expensive novelties.

Coming of age during the turbulent sixties would be a powerful force in shaping the ideals and the visual consciousness of Gilka's hires. During that decade, the parameters governing the kind of photos that could be published in the mainstream print media expanded dramatically. From TV and *Life* and *Look,* the young talent coming to the GEOGRAPHIC had been exposed to close-up views of the assassinations of John F. Kennedy and Martin Luther King, Jr. Graphic images from the civil rights struggle and the war in Vietnam—such as the infamous photograph of the chief of South Vietnam's secret police shooting a Vietcong suspect in the head— were ingrained in the national psyche. As college students, countless young people began questioning authority and protesting against the war and social injustice. Sex, drugs, rock-'n'-roll, and "doing your own thing" were an accepted part of their generation's culture.

The tenor of those times manifested itself in the ways Cobb, Abell, and others worked and in the images they produced. They were willing to take risks, spend weeks becoming intimately familiar with their photographic subjects, try strange shooting techniques, and flirt with failure while searching for something new. The GEOGRAPHIC's resources and Gilka's willingness to do whatever it took to get good pictures gave them the time, money, and logistical support needed to pursue their goals as photojournalists.

Jodi Cobb's experience on a 1979 story

Jodi Cobb

FLORIDA, 1977 • In a series on wild and scenic rivers, the GEOGRAPHIC concentrated on the largely undeveloped Suwannee River, already famous as the setting for Stephen Foster's "Old Folks at Home," which could also characterize this photograph. In her reportage, Cobb displayed, at a young age, her ability to understand people and their settings.

about the Suwanee River is typical. For weeks she slept in a funky cinder-block motel in Florida's backwoods. But almost every waking minute was spent with her subjects. Her picture of riverman John C. Colson, Sr., at the end of a hard day, slumped on a sofa in his family's shack in staring exhaustion, while domestic life swirls around him, is so intimate it could have been taken by one of his children.

"You hang out until you become invisible," Cobb says of her days with the Colson clan. "But you're always looking for the telling moment." To capture such a moment obsessed Gilka's hires, and their success in doing this resulted in photos with compelling psychological as well as visual presence, something rarely seen in the GEOGRAPHIC of old. It came from an ethos rooted in journalism but nourished by art. Cobb and most of the other photographers who would reshape GEOGRAPHIC photography in the 1970s and '80s had gone to journalism school and honed their skills on newspapers. But many of them also had some fine art training and working knowledge of art history. They accepted and understood photography as an art form. The great poets of the black-and-white, natural-light photographic image—Ansel Adams, Paul Strand, Dorothea Lange, and Henri Cartier-Bresson—were their idols.

Such photography wasn't part of Grosvenor's or Gilka's agenda. Content and color were their main concerns, but that didn't deter the newcomers. "When I took the summer internship, Gilka asked me how I felt about color," Allard says. "I told him it doesn't bother me a bit. And it didn't, because I'd never done it before."

Allard and the others eagerly accepted the GEOGRAPHIC's requirement that they photograph in color and shoot blind—meaning that the photographers took their pictures, sent the film back to Washington, and didn't see the actual pictures until they returned from the field—because working for the magazine was more than just a good job. It was an entrée into a coveted lifestyle, a ticket to see, experience, and photograph the world. As Sam Abell puts it, "When I was a summer intern in 1967, I saw a way of life and an opportunity I wanted to be part of. I didn't want to lead a businessman's life or a corporate life. I wanted the photographic life. Photography flowed from the life experience at NATIONAL GEOGRAPHIC. I saw that was what they were all about, and it inspired me."

Thrilled as they were to join one of America's premier publications, the young photographers nonetheless brought their own ideas about how to do the job and, in some cases, their own agendas. Abell, Allard, and the others were indeed generalists of uncommon ability. But they were devoted to honing their personal styles and pursuing areas of special expertise or interest. Such notions were unprecedented and borderline heretical at the National Geographic Society.

Precedent didn't cow the new photographers. Within the context of staying employed at the GEOGRAPHIC, they were going to do their own thing. Through the sheer force of talent, intellect, energy, and resolve, they would make journalistic photos that told a story but were as well works of art clearly marked by the artist's

stylistic signature. In addition to changing the style and substance of GEOGRAPHIC photography, their ideas would alter the way its stories were conceived, authored, edited, and presented. The changes would be gradual and subtle but significant. There would be no revolution at the GEOGRAPHIC. "The real evolution started ticking in the 1970s and '80s and continues to this day," says Allard. "It's an evolution, not a revolution. There's never been anything revolutionary about this place."

As that evolution gained steam, Allard and others would often chafe at the slow pace of change. There would be struggles, some bitter, particularly over the selecting of pictures to illustrate a given story. But from 1970 to 1990, realism, personal styles, and specialization would thrive under Bob Gilka. The man who wasn't looking for artists had filled his staff with them. His successors, Rich Clarkson and Tom Kennedy, would add even more.

Allard, Abell, Cobb, and Harvey are now middle-aged, established professionals with sterling lists of accomplishments. Their photos are exhibited at museums, universities, and commercial galleries. Books, such as *William Albert Allard—The Photographic Essay,* are devoted to their work. When time permits, many of them teach photo workshops at colleges and arts centers. They still roam the world on assignment for the GEOGRAPHIC, and photography remains their burning passion.

Despite busy schedules and long, assignment-related absences from the Washington office, the photographers exhibit a strong sense of community and camaraderie, not just evident among Gilka's hires but encompassing relative newcomers, such as Michael "Nick" Nichols, who joined the staff in 1990, as well as contract photographers. Those bonds were forged through their shared experiences of the photographic life and strengthened by the respect and support they give one another. On the rare occasions when the photographers are all in the office, such as the GEOGRAPHIC's annual photo seminar, one of their favorite pastimes is viewing and critiquing each other's work.

"The seminar was a very critical thing," Abell says. "To see the best of each other's work, to have it shown to the editors, and to interact with the older photographers, that was all very influential. It gave you a sense of belonging and a renewed sense of purpose."

Looking at the 1970s and '80s from midlife, Gilka's hires speak with undiminished enthusiasm about their favorite photographs, assignments, and areas of special expertise. The difficulty of changing things at the GEOGRAPHIC and the battles they fought to gain acceptance for their journalistic and aesthetic ideas are not forgotten. Some old wounds still ache. But even during the days when they were deeply frustrated over the magazine's laggardly pace of change, none doubted its commitment to photography. For the GEOGRAPHIC gave them two things all photographers crave: unstinting logistical support and time. Then as now, GEOGRAPHIC photographers often spend months in the field for a single story, shooting hundreds of rolls

of film, totaling as many as 30,000 frames. At the National Geographic Society's headquarters in Washington, that output gets winnowed down to a single slide tray with 80 slots, from which photos are chosen for a given story. Once typical of some American magazines, such as *Life* and *Look,* that approach to photography is now practiced regularly only by the GEOGRAPHIC. It has become the bastion of long-form photojournalism in America.

"I never heard the word "budget" for my first 20 years here, not in terms of time or finances," Abell says. "It was about whatever it took to get the story. You were expected to be responsible. There was a creative tension between ultimate responsibility for the photograph and unlimited opportunity." In that context, Abell says, if he failed as an editorial photographer or an artist he had only himself to blame. He couldn't say the GEOGRAPHIC hadn't given him enough time or money.

"As a consequence, so total was my involvement in the field, so totally were you the author of the experience in the field, that you felt you were the author of the article," he says. "But in truth, your contribution went into an editorial process, it was just part of that process. Some photographers couldn't give up the energy of the field. They came back and hit the wall of the building."

Bill Allard, a forceful, driven man, was one of Gilka's early hires. Over the years he would become the staff's preeminent wall-hitter. His career at the magazine began in 1964, as a summer intern fresh from the University of Minnesota's journalism school where he had concentrated on photography and writing. "I'd sit up late at night looking at pictures by Capa and Cartier-Bresson when I should have been studying Spanish," Allard says of his student days. "They just seemed to say to me, 'This is what you can do. This is a means of communication.' It was the first thing I'd ever found that I really wanted to do."

When he arrived at the GEOGRAPHIC, he was 26 years old, married, father of four children, and a former blue-collar worker. In college, Allard produced photo-essays on a racially mixed couple, a black evangelical church, and a six-year-old girl dying from cancer. Those were not GEOGRAPHIC-type subjects. But the pictures were immensely evocative and distinguished by a sophisticated use of chiaroscuro, which turns his pictures of ordinary people into impressionistic psychological portraits painted in light and shadow.

"I came here as a people photographer, but not with an agenda," Allard says. "I'd still describe myself as that. My color work evolved out of my black-and-white work in college. I was used to shooting in very limited light, real Hail Mary."

Adapting that style to color photography proved a bit tricky, but Allard's art background helped smooth the transition. "I've probably been influenced more by painters than photographers," he says. "From Matisse, Hopper, and the early Flemish painters, I learned how to divide space and see the light. But working with film you don't have control of the palette, you don't have the ability to exclude colors or shapes."

Writing was another of Allard's talents. Between 1967 and 1977, he wrote six of the eight stories he did for the GEOGRAPHIC. His first photo spread, shot during the internship, was a remarkably intimate look at the lives of the notoriously camera-shy Amish of Pennsylvania Dutch country that was published in August 1965. It was a brilliant start, and he was put on staff.

But Allard quickly grew restless with life at the GEOGRAPHIC. On August 7, 1967, he sent a letter of resignation to Gilka. "I feel the time has arrived when I must move on," he wrote. "There are problems in our country today that cannot be ignored by either the artist or journalist. Although I hope to continue to create images of beauty, I must also attempt to fulfill my obligations as an observer of our society and its conflicts." As a freelancer, his first job was documenting the civil rights struggle in Mississippi and Alabama for *Life*. He also continued to accept assignments from the GEOGRAPHIC.

"You always had to push and fight for things at the GEOGRAPHIC," Allard says. "We should be publishing the very best, but in the 1960s and the '70s I had the feeling that we weren't. There was a period when we underestimated the reader. The people who read this magazine aren't stupid. They didn't need or want simplistic images. We have an even more visually literate audience now."

Gilka offers a different perspective. "Allard had good seeing ability and a lot of determination," he says. "But he could be difficult to work with because he got so emotionally involved with his stories that he would lose perspective." While his editors and colleagues sometimes questioned Allard's self-control and judgment, no one doubted his creativity or commitment to excellence. Once involved with a story, he immersed himself. That approach could cause problems. But it also produced the work for which Allard may be best-known: his photographs of the American West.

In 1969, Gilka assigned him to do a story on the Hutterites. Like the Old Order Amish, the Hutterites are a German-speaking, Anabaptist sect. Strict Protestants, they live communally on sprawling farms in Montana, the Dakotas, and western Canada. Like the Amish, they generally shun photography. The assignment played directly into Allard's journalistic and aesthetic strengths: his ability to win his subject's absolute trust and his talent for organizing light and space in his pictures. And the sweep and grandeur of the West touched something in his soul.

"I felt like the West was where I belonged," Allard says. After the Hutterite story, which he also wrote, Allard photographed people, places, and life from the Canadian border to the Rio Grande and the Mississippi to the Pacific. Some of the stories, such as his photo-essay about the U.S.-Mexican border, were radical departures from the kind of journalism and photos for which the GEOGRAPHIC was known. Allard cruised the border on a Triumph 650 motorcycle paid for by the magazine and says it gave him an especially close feel for the land. His pictures gave readers a visceral feel for the landscape, the people, and the harsh socioeconomic

realities of border life, including illegal immigration and drug smuggling. In *Life,* such gritty, close-up coverage wouldn't have been exceptional. At the Geographic, it was.

The story didn't signal a sea change in the Geographic's style. It was not turning into a weekly news magazine. But it demonstrated a new openness to "what photography is today," as Melville Grosvenor had put it. A different kind of journalism and aesthetic were slowly making themselves felt. Gilka, an old-school photo editor, was helping Allard develop a personal style and pursue personal interests as long as they coincided with what the magazine needed. It was a clever move, and its significance registered immediately with the staff. Young photographers who came to the Geographic in subsequent years would benefit from the battles Allard fought over picture selection and assignments.

William Albert Allard
MEXICO, 1970 • Tracing life on the U.S.-Mexican border via an erratic course from the Pacific to the Gulf Coast, Allard racked up nearly 8,000 miles on his motorcycle. "I like to wander when I travel," he says.

"What happened here was partly due to evolutions in individual ways of seeing," Allard says. "With the best work, there was a signature on it. Photographers, if they contribute a lot to a particular magazine, can be picked out without seeing the credit line."

From those ways of seeing, an aesthetic was developing. "The magazine didn't have much of an aesthetic," Allard says. "Just using that word in the office made you suspect. Grosvenor wanted a gold-plated picture postcard. We realized we weren't going to go into the downside of things. That approach excludes a lot of life. I left because I didn't think this place would go in the direction I felt obligated to go in. I came back because things had changed for the better."

While Allard was fighting his battles, his colleagues were, with Gilka's support, quietly developing their own individual styles and specializing in certain areas. Dean Conger was making the Soviet Union his photographic turf. Emory Kristof was taking readers to the depths of the ocean. Wildlife photography became Jim Brandenburg's forte. Young photographers who joined the staff from the mid-sixties on did the same individualizing. But some of the newcomers also brought a different mindset to the magazine. They thought of themselves first and foremost as artists.

"I think anybody would tell you I was coming from an artistic direction, and that wasn't always healthy for me here," says Sam Abell. "But like a lot of people in my generation, I left college flying on the wings of idealism, not careerism. We were going to change the world, and that included National Geographic."

Abell was an unlikely agent of change. His family background was made-to-order for a GEOGRAPHIC photograper: His father was a high school geography teacher, and his mother taught modern languages in a suburb of Toledo, Ohio. He got his first taste of photographic life at the GEOGRAPHIC in 1967 as a summer intern from the University of Kentucky, where he majored in English with a minor in journalism. After graduation, he did a stint as a color photographer for the *Louisville Courier-Journal*'s Sunday magazine before moving in 1970 to Washington to be a contract photographer for the GEOGRAPHIC. He remained on contract until finally joining the staff in 1990. The prolonged courtship resulted partly from Abell's steadfast belief—shared by virtually all the photographers who came to the GEOGRAPHIC during those years—that "you could combine journalism and art, that out of editorial photography art could emerge."

Unfortunately, that wasn't the prevailing opinion at the magazine when he arrived. His main artistic influences—the black-and-white photo documentaries of Dorothea Lange and the pictures of Paul Strand that found the art in machinery or buildings all over the world—were also not the stuff of GEOGRAPHIC photos. Neither were Abell's photojournalistic influences.

"The biggest influence on me as a photographer was *Life,* not NATIONAL GEOGRAPHIC," Abell says. "Their photography was very compelling, and they ran photo-essays at great length. *Life* set this incredible standard for photography. They took on tough subjects—the war in Vietnam, race riots in America—and really told a story through these amazing pictures. I wanted some of that character to be in my work and in the NATIONAL GEOGRAPHIC."

Getting that character into his work was sometimes problematic, particularly during his early days with the magazine. Gilka was wisely nurturing his young photographers' ambitions, and the GEOGRAPHIC's editorial process gave them a say in how their work would appear in print. But many editors still took a conservative approach to photography that favored literal interpretation of a subject over more imaginative treatment.

"Photographers pushed the edge faster, harder, and more consistently than the editors wanted to," Abell says. Inevitably, that led to some conflicts and tensions. "I don't remember any great coverage from the 1970s where the photographer wasn't disappointed about some picture that was left out. Space wasn't an issue. There was plenty. It was picture choice. Literal interpretations usually won out. That could get frustrating. We wanted rolling thunder, photo-essays that built up internal momentum, with one strong picture leading to another and ending with a climax. The editors often had other ideas."

The safe choices were particularly galling to Abell, Harvey, and others because the editors routinely published tough, graphic photo-essays about natural history. Brutality in the animal kingdom was accepted as perfectly normal. So was human

nudity—if the subjects were indigenous peoples. Although Europe's beaches abounded with nude or topless bathers, they never showed up in the GEOGRAPHIC. In the 1970s, social or cultural subjects received equally reserved treatment, particularly if they had to do with the United States.

"Because of those attitudes, the victories the photographers had in getting progress in the use of pictures were big victories, even if the changes seemed incremental to people outside the magazine," Abell says.

Developing an individual style may have seemed like a minor matter to people outside the magazine. But for Abell and the others, it was essential. His style emerged in one of his first major stories, a photo-essay about hiking through Yellowstone National Park's backcountry with members of the Craighead family, who had done research in the park for several generations.

The pictures told the "people" story of the trip—the mix of solitude, camaraderie, reverence for nature, as well as of eating dehydrated food, hiking in wet boots, and watching out for bears—with wit, warmth, and flair. But what made the pictures so compelling was Abell's unique way of seeing the natural world. The color in his photos is subtle and subdued. There is a serene, poetic sense of the Earth's vastness in almost every photo, of majestic horizons beckoning, of nature's power and scope. That quality, which puts man's endeavors into context, became the hallmark of his photographic style.

"If there isn't a horizon line in the picture, then I didn't take it," Abell says. "It's there because I grew up in the Midwest. Ohio has some of the flattest terrain in North America. That's the basis of my photography. I always felt anchored there. That horizon line is always an anchor to the perspective, but then it goes to infinity. My eye always seeks the horizon. Once I find it, I can build a response." On GEOGRAPHIC assignments, he sought it all over the world. But the stories closest to Abell's heart have been set in wide, open spaces like the western United States, northern Canada, and the Australian outback, with their high skies and endless horizons.

Wherever he went, Abell did more than shoot in color for the GEOGRAPHIC. To satisfy his artistic urge, he also took black-and-white photographs for what he calls his "photo diary." A few of those pictures have been published in the magazine. Others are featured in books and sold in galleries. "I never disbelieved in color," Abell says. "I thought it could be the equivalent of black-and-white. Now, 30 years down the road, I'm not so sure."

Uncertainty also plagued Jodi Cobb when she joined the GEOGRAPHIC staff in 1977. She, too, was intrigued with black-and-white, natural-light photography, but she had to deal with something that Abell didn't. She was a woman, the only one on the staff. "The magazine had had a token woman photographer, but she was gone when I took over," Gilka says. "It was one of the first things I wanted to

change. I was concerned that we should have women on the staff because I thought they would be better suited for some assignments. They have better access on some stories. The stories Jodi Cobb did on the lives of Saudi women or the geishas of Japan are good examples. No man could have done those as well as she did."

Cobb's sensitivity to other cultures began with her childhood. She grew up in Iran, the daughter of an oil company executive, and had circled the globe twice by the time she was 12. Then her family moved back to the States, settling briefly in a small city in the Texas oilfields. That move had a significant effect on her choice of career. In rural Texas, Cobb felt isolated, closed off. She desperately wanted to "be back in the world I'd seen. We devoured *Life* when it came in the mail. It was our link to the world, and its photographs always amazed me." A high school journalism teacher who'd written for *Time* shared Cobb's interest in the wider world and inspired her to go to journalism school. "I thought she was the most wonderful thing in the world," Cobb recalls. "I went to the University of Missouri on her advice to study journalism."

At Missouri, Cobb took a photography course during her senior year and fell in love with "the immediacy, the magic, and the visualness." She turned her camera mainly on her friends. "They were musicians, artists, and hippies. Making photographs was just part of their lifestyle. I found out later that it was an art form."

But Cobb's focus as an undergraduate was writing. After graduation, she got a job in New York City as a writer for *House & Garden.* She hated it and quickly returned to Missouri to get a master's degree in journalism, concentrating on photography.

"I was still very much interested in the narrative, the story," Cobb says. "When I realized I could combine the two, the narrative and the photos, I was in heaven. My master's thesis was a photo-essay about my friends, who were living on a commune in the Ozarks. That's where my style started developing. I was really interested in intimacy, in the small things that say a lot about a person. That began when I was hanging out in the commune."

Like Abell, her first job was in daily journalism. Before joining the GEOGRAPHIC, she worked as a photographer for the *Wilmington News-Journal* and the *Denver Post.* "It was great," Cobb says. "Good, practical experience. But I still wanted to travel, I still had that itch." While still in Denver, Cobb got a trial assignment from Gilka and did well. But she wasn't convinced that the magazine was the place for her. "I knew several people here. But it didn't seem like a natural fit for me because of my interest in the intimate. At the GEOGRAPHIC, the pictures had to be zingers, unique and dramatic images loaded with visual impact. I remember thinking, 'How am I, a black-and-white, natural-light photographer ever going to fit in here?'"

But the photographic life offered by the GEOGRAPHIC proved irresistible, and she joined the staff. Working in color and shooting blind turned out to be just as big a problem as she had anticipated. "It was a nightmare," Cobb says. "Color wasn't something I ever thought about in my work before I came here. That was a big adjustment. Shooting blind was another nightmare because you can't improve immediately on your mistakes, and I was making plenty of them."

Initially, she also sublimated her personal goals and interests. "He [Gilka] wanted generalists, people who would do everything equally well," Cobb says. "So I did everything. White-water rafting, stories on states and cities. In the beginning, some of the assignments seemed bizarre. I mean, how do you make a story about a state? It's a place. But I learned quickly, and they were happy with my work." Despite that satisfaction, Cobb still didn't push her personal style or try to specialize because she felt it necessary to do all the things her male counterparts were doing.

"I had this other thing of being the only woman. I felt I had to prove that I could do all the things the guys do," Cobb says. "So I did all kinds of stuff, hanging out of helicopters to shoot aerials, shooting rapids, chasing wildlife. And these weren't things that I enjoyed or really wanted to do. But I felt if I didn't choose to do something, it would be thought that I couldn't do it." After a few years, Cobb realized that she was so busy trying to prove things that what she wanted to do with her photography had been put on the back burner. "I felt that as the only field photographer on staff who was a woman, I couldn't afford the luxury of a personal style," she says. "It took a while for me to understand that I was keeping myself from doing things that interested me."

What interested Cobb were stories about the human condition, particularly the lives of women around the world. Her photographs are like pages taken from a visual diary detailing life in a hidden world. That intimacy conveys the feeling of having been allowed into the inner sanctum of her subjects' lives and psyches. In "Women of Saudi Arabia," published in October 1987, Cobb got behind the veils required by Islam and showed the women filling traditional Arabic roles. But she also shot them doing aerobics in Lycra leotards, driving trucks, and running businesses. Her close-up of physician Hanan Ali-al-Subeai examining a newborn baby boy is incredibly warm, human, and telling, exactly the sort of moment she seeks.

"I think the GEOGRAPHIC became steadily more committed to the honesty and integrity of the image and the story," Cobb says. "The magazine developed the courage to take on stories that they wouldn't have pursued in the past." Part of that change came from the management. But Cobb believes that the group of photographers who came aboard in the late 1960s and '70s also changed things.

"We were different from our predecessors. The way we worked was different. We came in with experience with available light and fast film," she says. "Because of advances in the technology of photography, we could shoot in situations that our

predecessors couldn't. We had little strobes and smaller cameras that let us get closer. At that point, you tap into a kind of awe and wonder that let our style happen."

The wonder of photography hit some of Cobb's colleagues before they had reached puberty. "Lightning struck when I was about 11 years old," says David Alan Harvey. "I was a newspaper boy in Virginia Beach, Virginia, and I just loved the paper's photos. My whole orientation was visual. But I didn't really watch much TV. I was just totally absorbed by the photos in the newspaper and *Look* and *Life.* Those magazines had absolutely brilliant photography. I saw it immediately as a tool, an art, and a lifestyle. And I said, 'Wow, that's me.'"

Harvey's youthful obsession led him to buy a Leica at age 12, with money earned from delivering newspapers, and begin taking pictures of Virginia Beach. His only swerve along the photographic career path came in high school, when he considered becoming a professional motorcycle racer. While he studied journalism at Virginia Commonwealth University, his desire to be a photographer returned even stronger than before. Harvey then got a master's degree in photography at the University of Missouri's journalism school and went to work for the *Capital-Journal* in Topeka, Kansas. His editor was Rich Clarkson, who would follow him to the GEOGRAPHIC. Harvey enjoyed the work, but he knew he didn't want to be in Kansas or with a newspaper.

"I felt I was a photographic artist, and that *Life, Look,* or NATIONAL GEOGRAPHIC would be the place for me," Harvey says. He got a fellowship from the Virginia Museum of Fine Arts, headed East, and produced a color documentary on Tidewater Virginia. Gilka saw it, liked it, but said he couldn't publish it because it was too personal.

In the early 1970s, Harvey came up with an idea for a story about Tangier Island in Chesapeake Bay. It was a hit, and he began working regularly for the GEOGRAPHIC. "It was my backyard," Harvey says. "Once I felt I'd done it justice, I was ready to work somewhere else." When Gilka put up a note asking if anyone wanted to go shoot a city story on Madrid, Harvey jumped at the chance, and in so doing, became one of the magazine's quintessential specialists.

"I was a C student in Spanish class, and I didn't know what I was going to do on the story," he says. "When I got there, the editor expanded it to be about all of Spain. I ended up driving a VW bus all over the country and getting hooked on photographing Spanish culture."

Over the years, he has traced Spain's influence throughout the world, shooting in Cuba, Mexico, and Central and South America. His photographs, particularly of people, brim with passion. "It's a passionate, visually oriented culture," Harvey says. "It's different enough from American life to be exotic, but there are enough similarities so that people can identify with the photographs; they understand what's going on. Whether I'm working in Cuba or Spain, I look for the everyday ballet, the

dance of life, the little moments that I saw as a kid in Virginia Beach. For me, it's about recognizing the universality of those moments."

The travel that goes with covering the Spanish-speaking world isn't something Harvey relishes. Getting off the plane in a foreign country, knowing he's carrying a lot of blank film, is more frightening than exhilarating. All the supposed glamour of the photographic life vanishes before he even gets into a cab. Often as not, the days in the field turn tedious.

"Sometimes I feel like a truck driver, just watching the miles roll by, waiting to get where I'm going," Harvey says. "If they paid me by the mile, I'd be way ahead financially. A lot of the time you're not thinking about making art. You're tired, bored, or scared." There's also a lot of down time for a photographer, when he's waiting, getting things arranged, wrestling with various bureaucracies.

But every once in a while, everything comes together. Travel, journalism, and art converge in a way that makes one think Bob Gilka must have known or sensed something about the young photographers he hired.

"After all the anxiety and boredom, you have a day or a morning or an hour, where it all comes together in a way that's kind of magical," Harvey says. "Then it's all worth it. That's what keeps you going."

Sam Abell
YELLOWSTONE NATIONAL PARK, 1972 • As if marking the 100th anniversary of our oldest national park, the moon rises over Biscuit Basin while darkness settles on this primordial scene, punctuated only by the hoot of an owl or the yelp of a coyote in the distance.

Craig Aurness
CALIFORNIA, 1987 • *Following pages:* Conjured by temperate, well-spaced winter rains, coreopsis and poppies, which germinate only under favorable conditions, provide an ephemeral show in Antelope Valley.

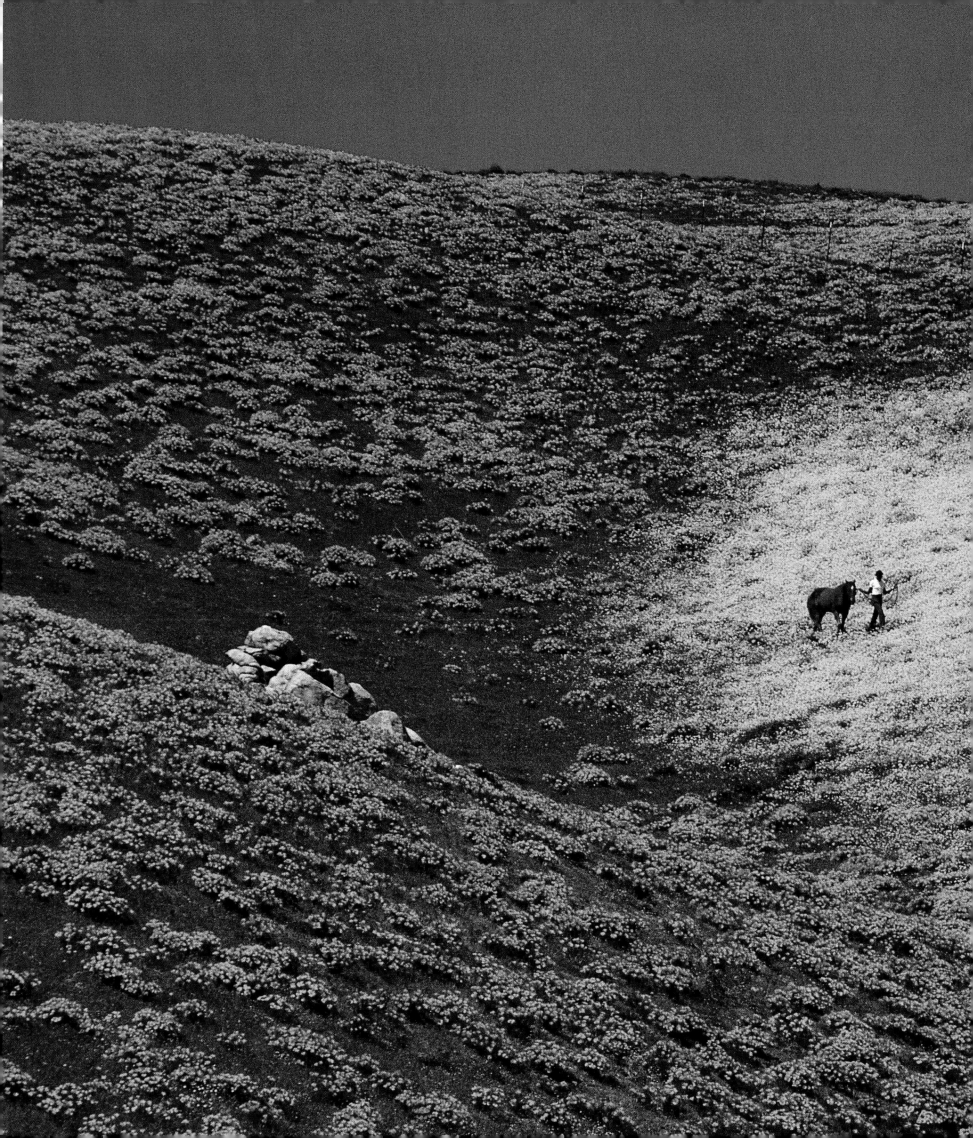

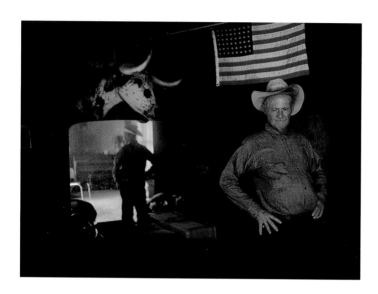

William Albert Allard

ARIZONA, 1971 • The disappearance of open rangeland threatens the livelihood of this old-timer who has run cattle on Arizona's Sonoran Desert for half a century.

Sam Abell

FORT MACLEAD IN ALBERTA, CANADA, 1984 • *Right:* At sunset, in front of his tepee, a man holds up his baby to the last remaining rays of direct sunlight.

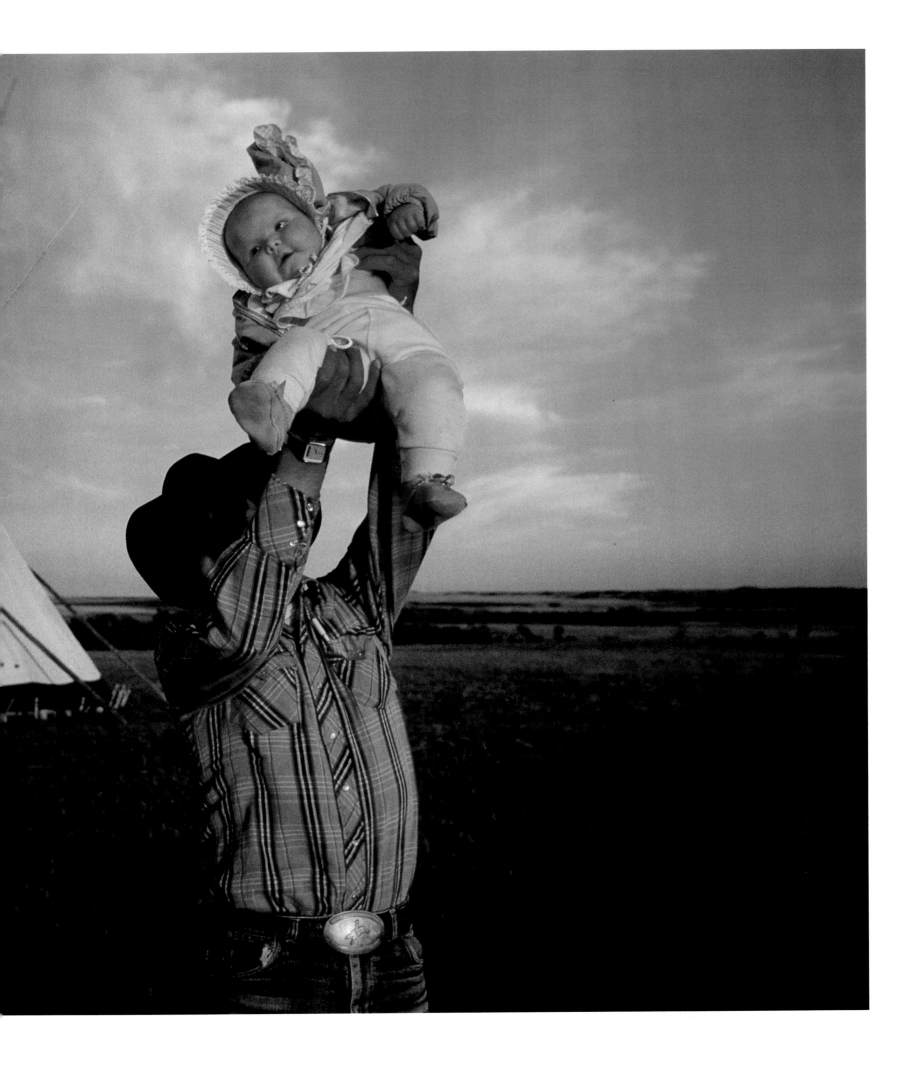

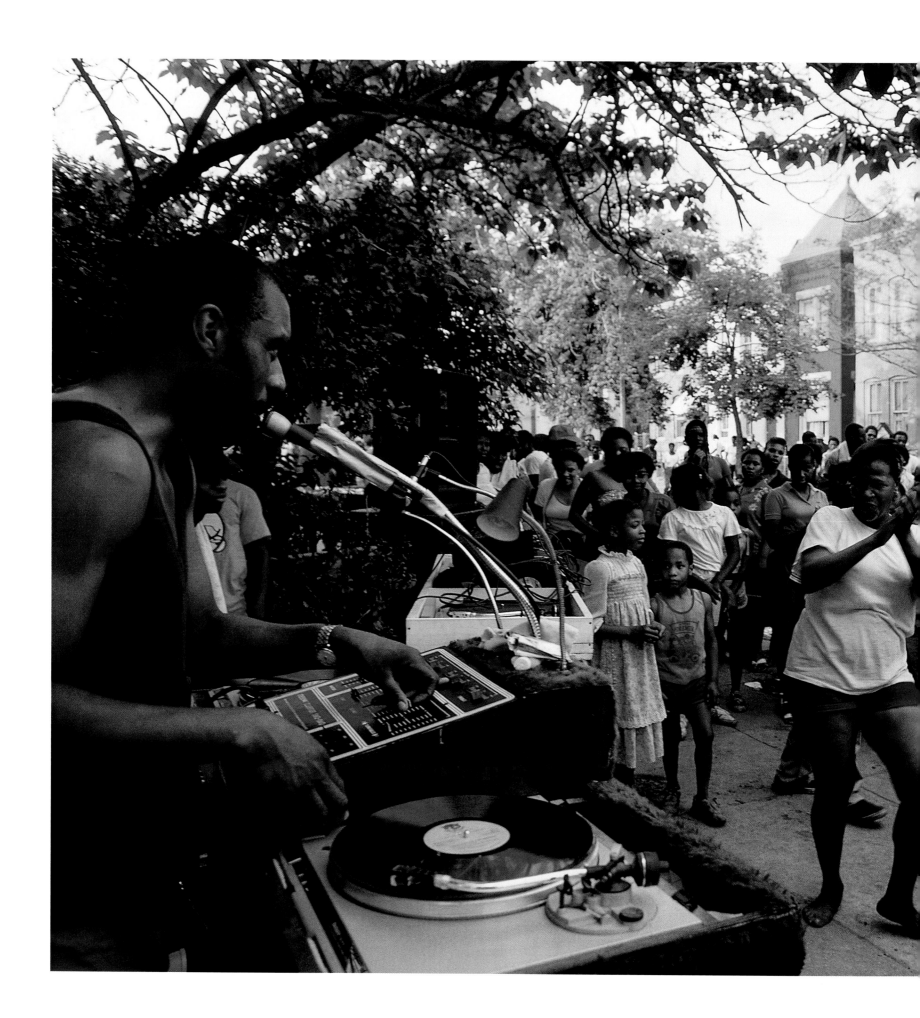

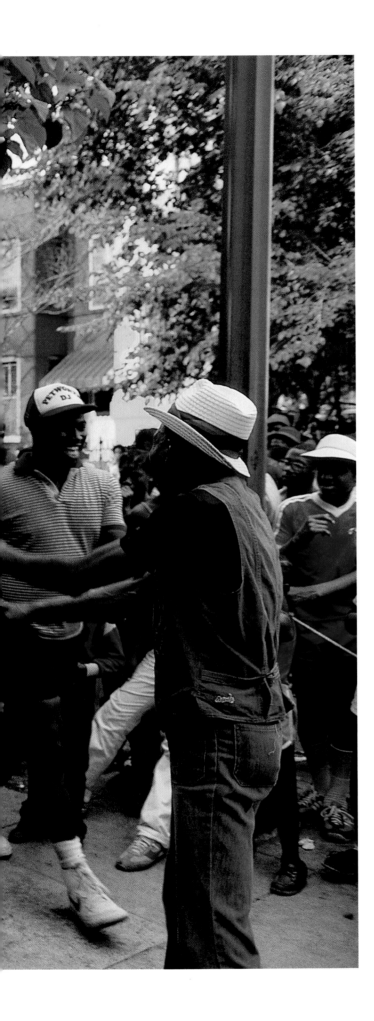

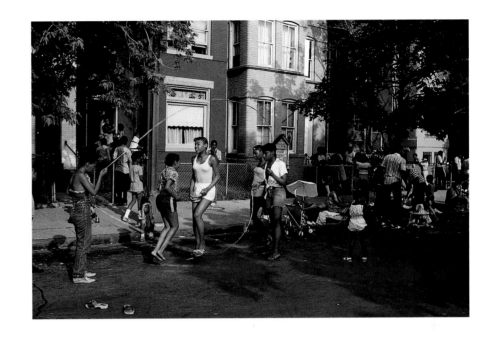

Adam Woolfitt

WASHINGTON, D.C., 1983 • Called locally "D.C." or "the District," the nation's capital is 70 percent black, the highest of any large city in the U.S., but not until 1973 did Washingtonians begin to live under majority rule.

Adam Woolfitt

WASHINGTON, D.C., 1983 • *Opposite:* A DJ spins records for neighbors in the Shaw area of D.C., as Memorial Day ushers in another steamy Washington summer, which once prompted the British government to designate Washington a tropical post.

David G. Allen

OREGON, 1979 • *Following pages:* Mallards explode from a lake in the National Wildlife Refuge System, which historically has given top priority to migratory waterfowl and is funded in part by hunters' purchases of duck stamps.

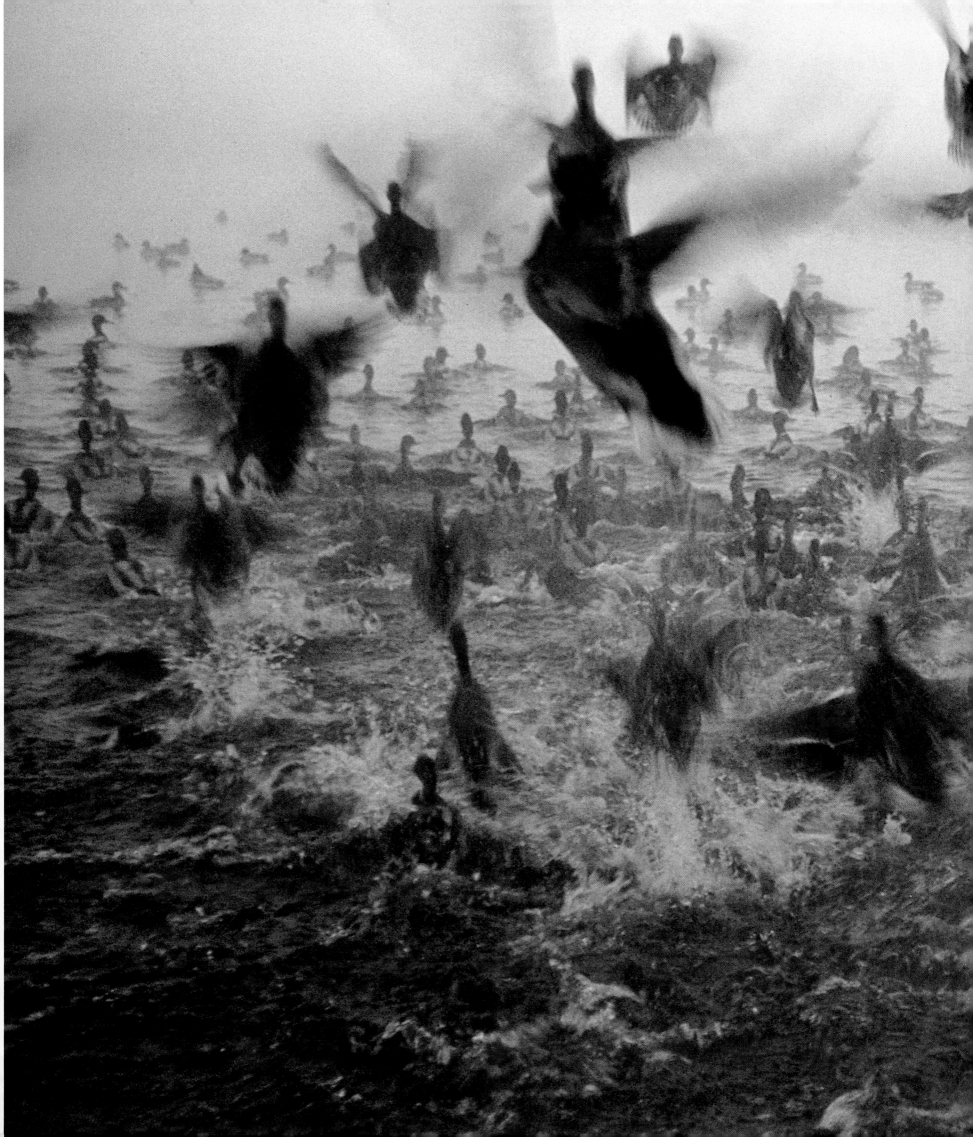

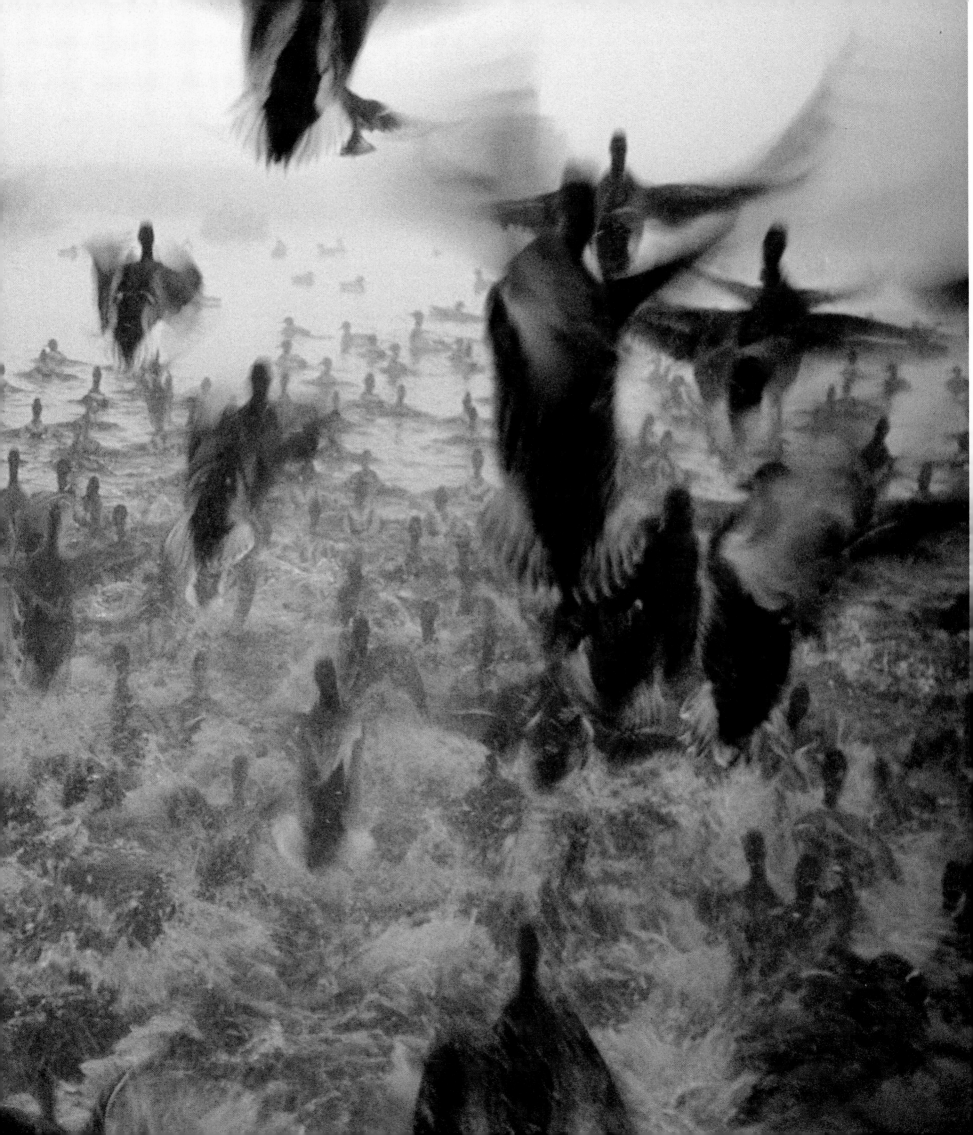

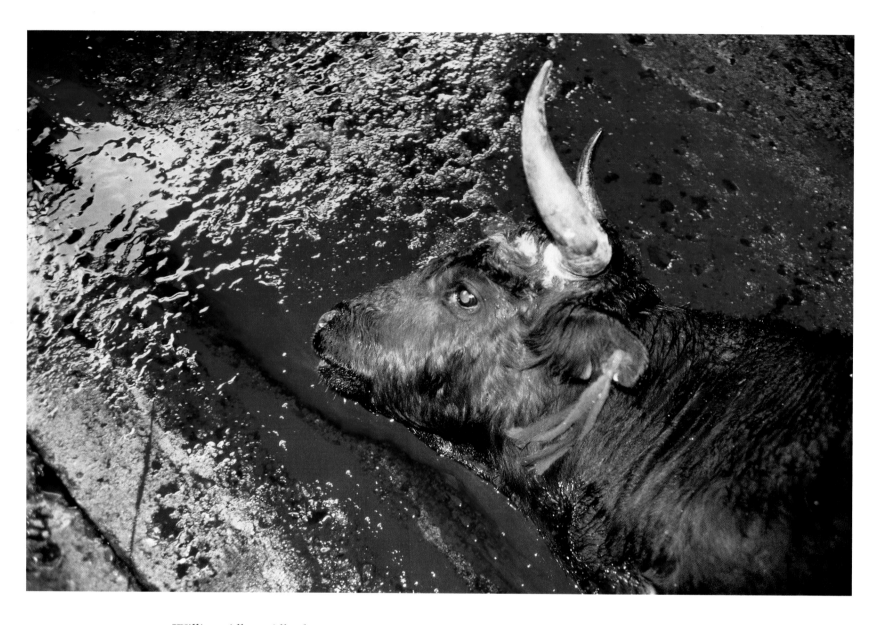

William Albert Allard

PERU, 1981 • In stark contrast to the redness of his own spreading blood, this black bull lies on the concrete floor of an abattoir prior to being skinned and butchered.

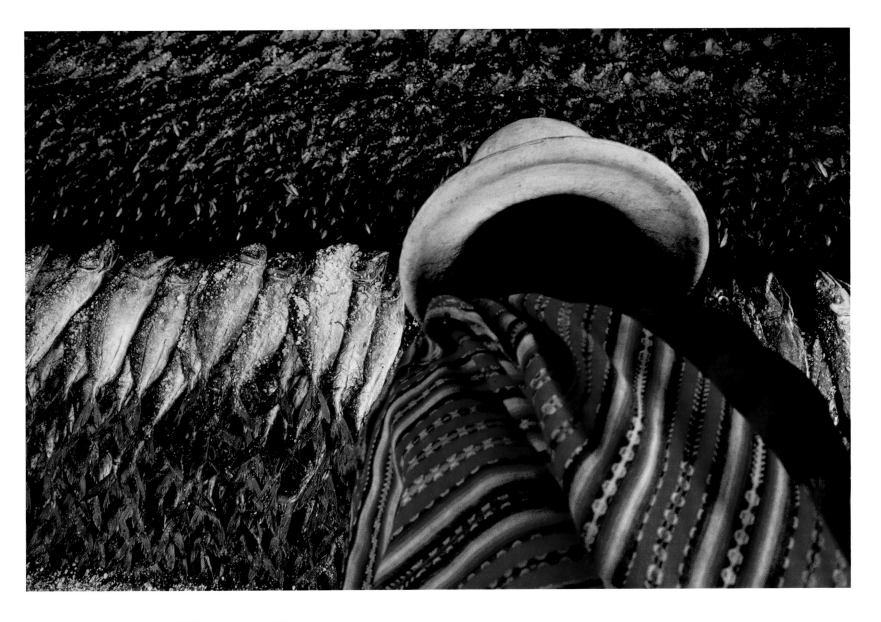

William Albert Allard
PERU, 1981 • Near Trujillo, a small town on the coast of Peru, a fisherman puts out his catch to dry by the sun.

Loren McIntyre
COLOMBIA, 1970 • *Following pages:* Twice a year, in stifling heat, Guajiro Indians earn money by harvesting the crystallized residue of seawater, on the last of the unmechanized flats of the national salt industry.

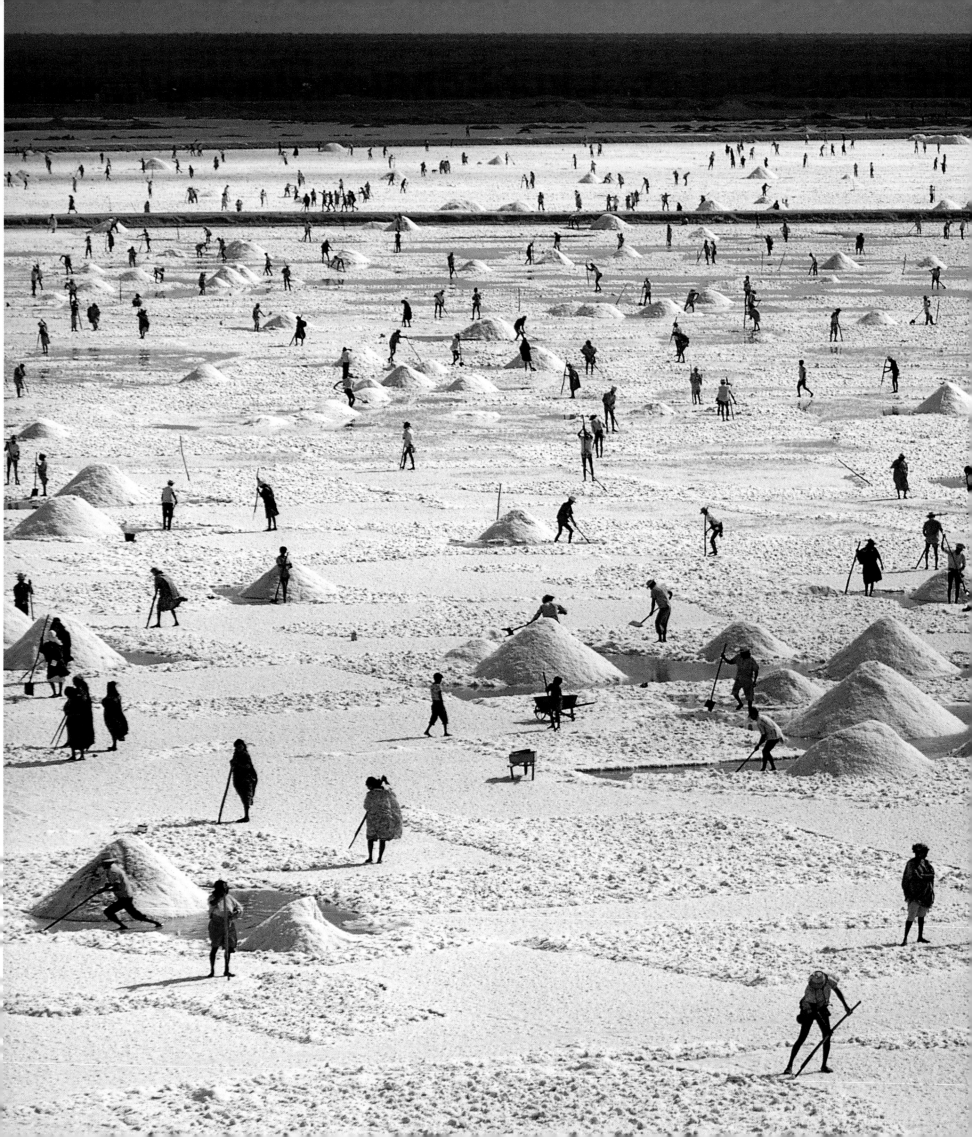

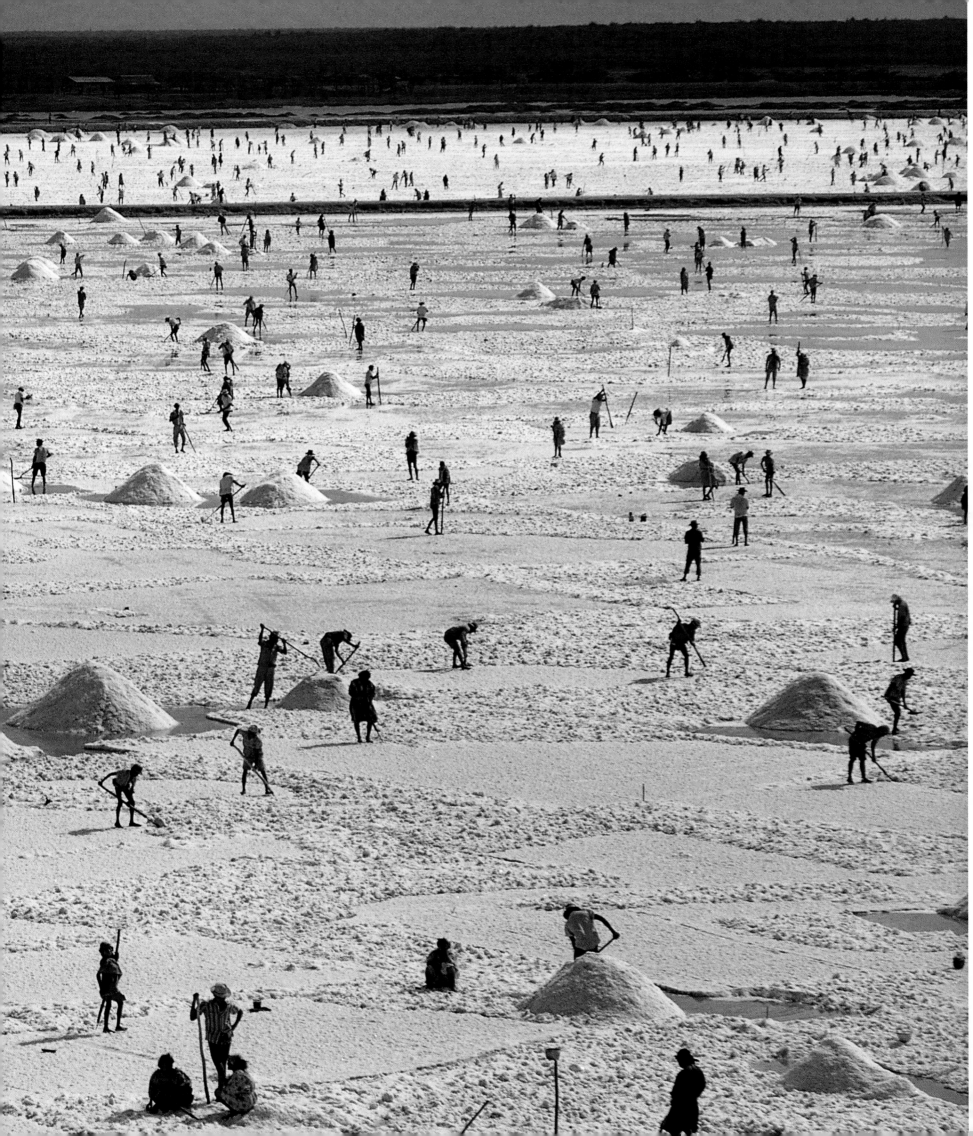

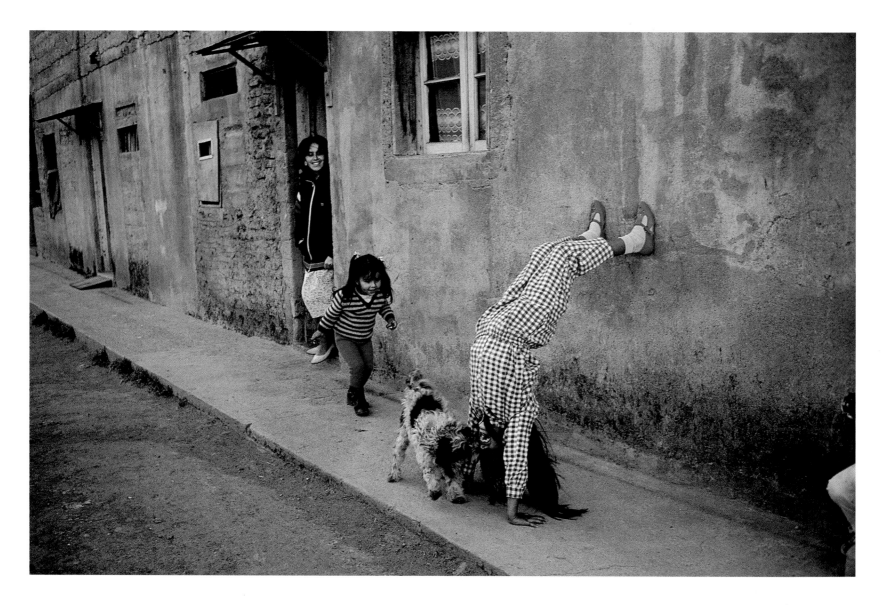

David Alan Harvey

CHILE, 1988 • Heels over head, a girl at play enlivens a barrio in Valparaiso, where the middle class is sandwiched between a small, wealthy elite and a predominantly mestizo low-income population.

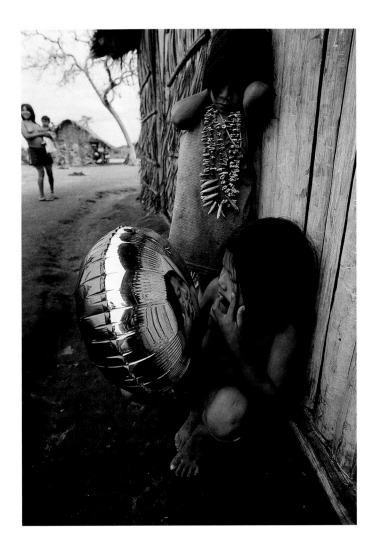

Jon Schneeberger

BRAZIL, 1988 • Captivated by her own image, an Urueu-Wau-Wau girl studies a plaything from another world at an outpost of Brazil's National Foundation for the Indian.

Jon Schneeberger

SWITZERLAND, 1985 • *Following pages*: Although Switzerland legally granted suffrage to women in 1971, that right in two Appenzell cantons still extends only to men, who gather annually in Appenzell-Innerhoden to vote on local matters by show of hands.

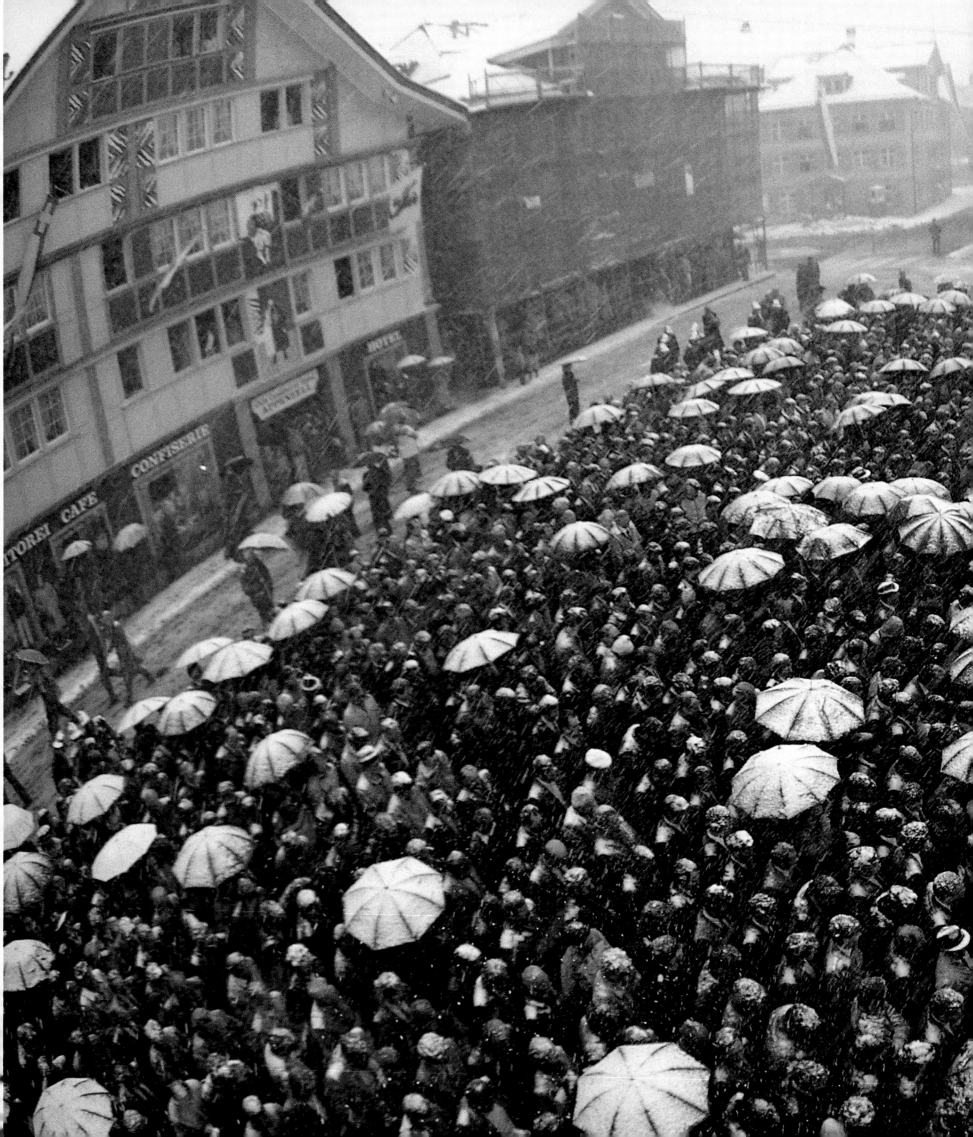

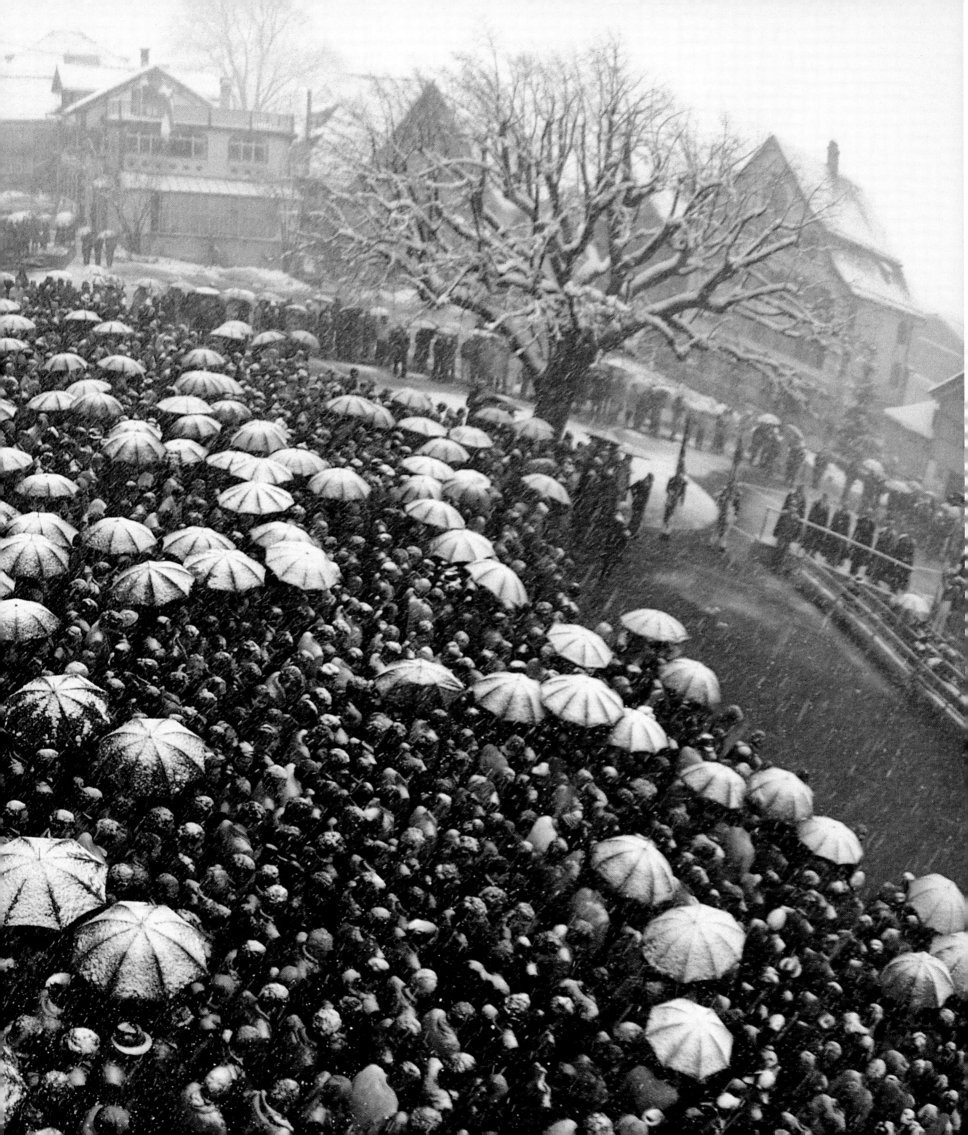

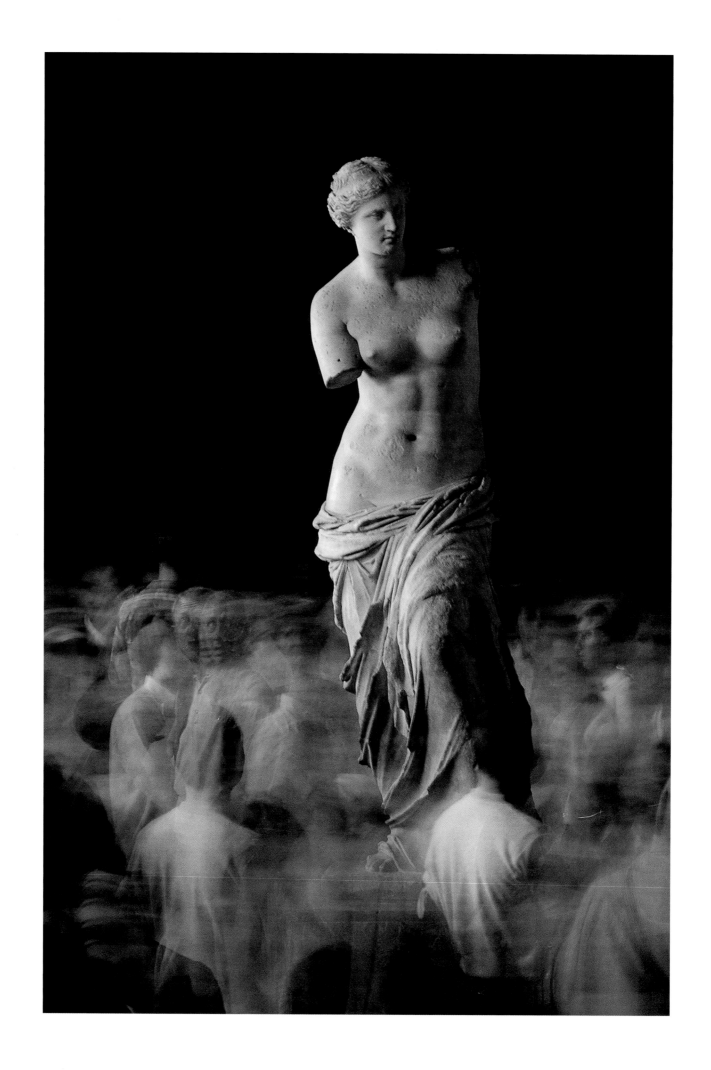

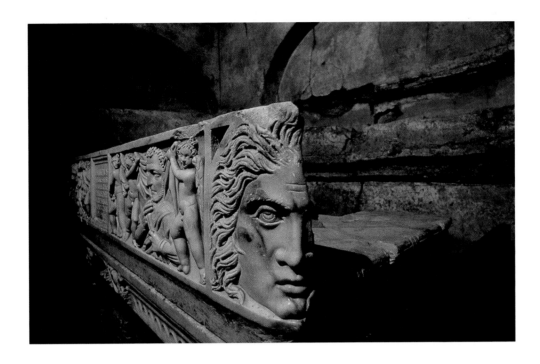

James L. Stanfield

VATICAN CITY, 1985 • Among the tombs of pagans and early Christians excavated in the necropolis beneath St. Peter's Basilica was this third-century A.D. marble sarcophagus carved for the Marcius family.

Bruce Dale

PARIS, 1971 • *Opposite:* Visitors circulate in a blur of time before the eternally serene "Venus de Milo," which after 2,100 years found a permanent home in the Louvre, Paris's incomparable art museum.

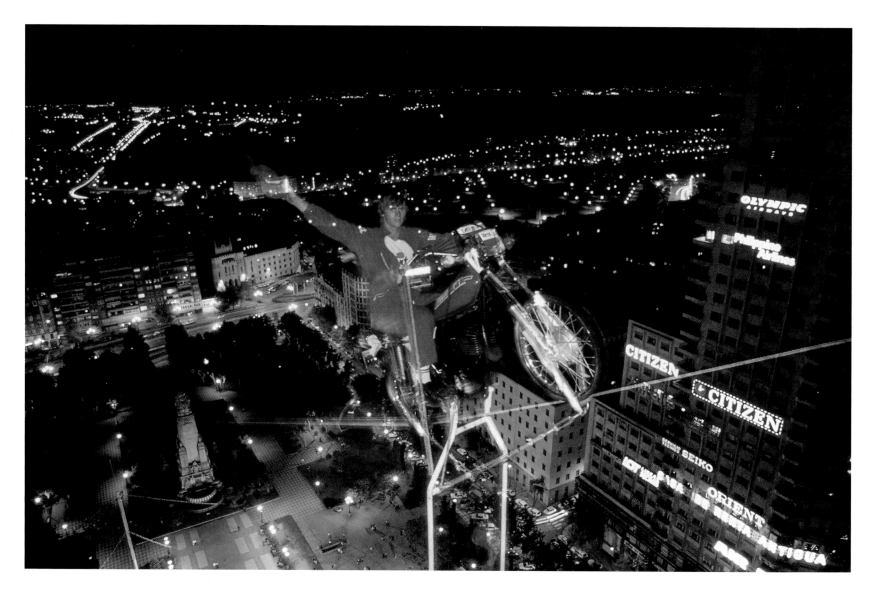

O. Louis Mazzatenta

MADRID, 1986 • Suspended 300 feet above Madrid's Plaza de España, this high-wire performer displays a bravado characteristic of the city's young, cosmopolitan population.

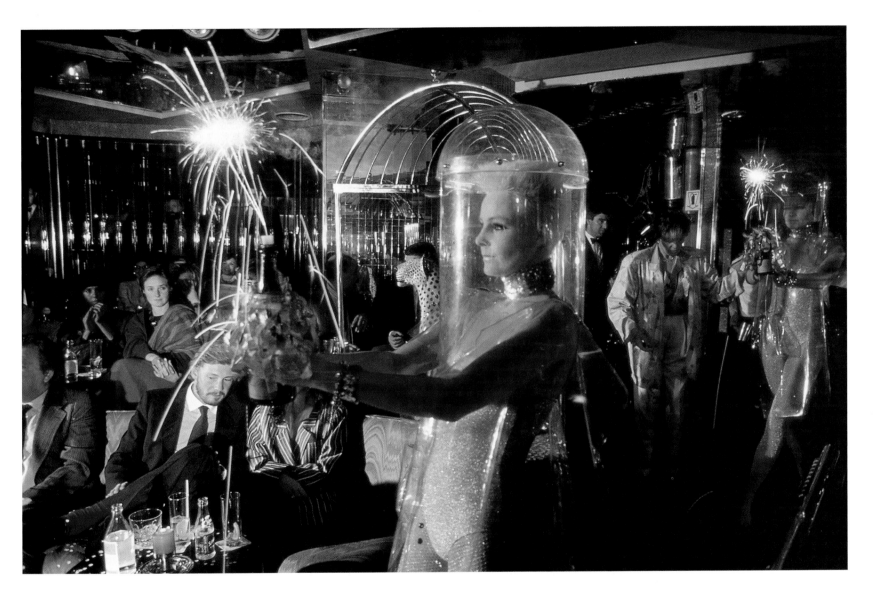

O. Louis Mazzatenta

MADRID, 1986 • Night people, Madrileños will catch an early movie, dine at 11, and then barhop their way to a *discoteca* such as Vanity, where they can witness an intergalactic fashion show.

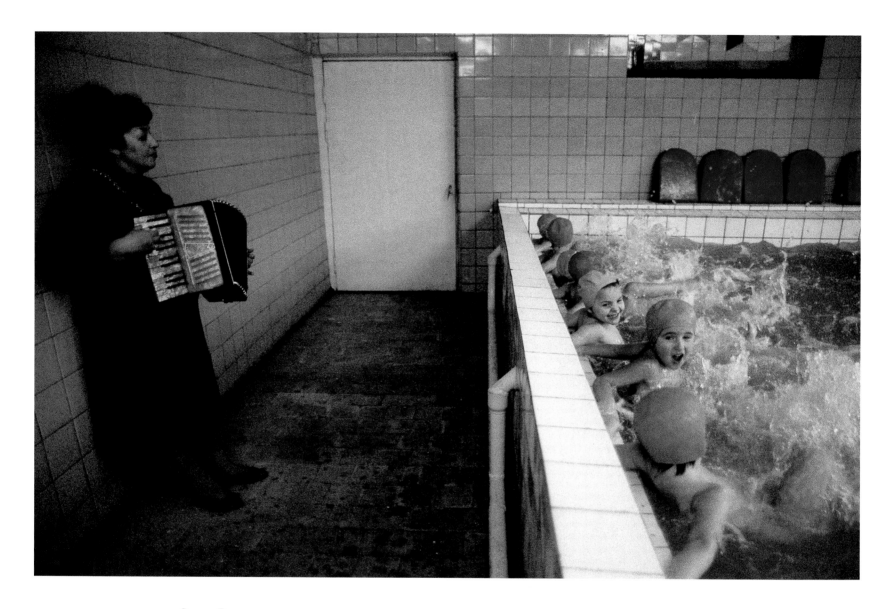

Steve Raymer

UKRAINE, 1987 • Splash-dancing kids time their kicks to the music as a woman plays traditional Ukrainian melodies for them in a Kiev day-care center.

Cotton Coulson

ESTONIA, 1980 • *Opposite:* Even under the protective eye of Comrade Lenin, this citizen of the Estonian Soviet Socialist Republic, which for only 22 years in the past 7 centuries had enjoyed independence, cannot help looking over his shoulder at what might be following him.

Nathan Benn

SOUTH KOREA, 1988 • *Following pages:* Seoul's historic South Gate sits forlorn among the moving lights of swirling traffic, which reflect the dynamic economic growth of the southern half of a now divided nation.

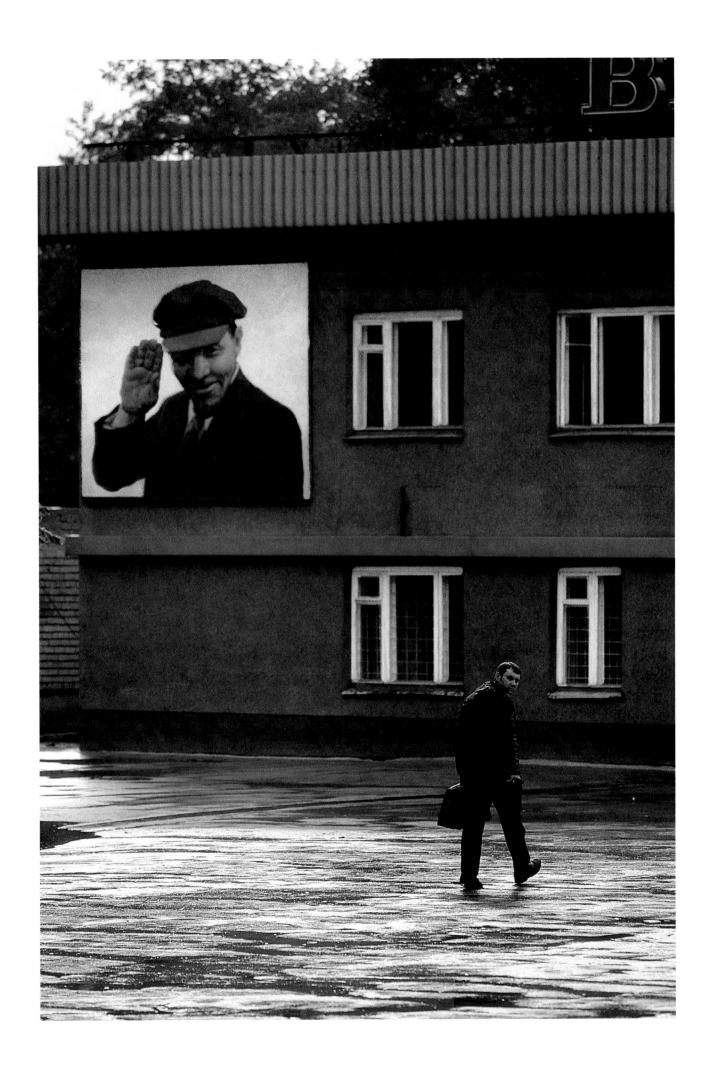

Paul Zahl

COSTA RICA, 1973 • Tadpoles graze voraciously in an underwater thicket, their transparent skin—flecked with color cells—revealing beating hearts and coiled intestinal tracts.

Cary Wolinsky

CHINA, 1984 • *Left:* Like an array of living gems, pastel-hued silkworm cocoons fill a frame in China's main agricultural research center, where nearly 300 varieties of silkworms have been studied.

Sam Abell

JAPAN, 1984 • A mother and daughter exchange traditional goodbyes at a street corner in the town of Hagi, where high, zigzagging walls were built in the 1600s to confound those who might try to attack the Mori daimyo's castle.

David Alan Harvey

MALAYSIA, 1977 • In a monsoon downpour, an Indian woman tending water buffalo is lucky to find shelter in this length of conduit.

Steve McCurry
INDIA, 1984 • India's summer monsoon floods a Delhi street, but it doesn't deter a vendor, standing ankle-deep in water, waiting for customers for his delicacies.

Raghubir Singh
INDIA, 1977 • *Following pages:* In a Rajasthan village, a crow drops in to see what tidbits he can scavenge among the earthen silos built to protect the villager's food for his table, seed for his fields, and grain for his livestock.

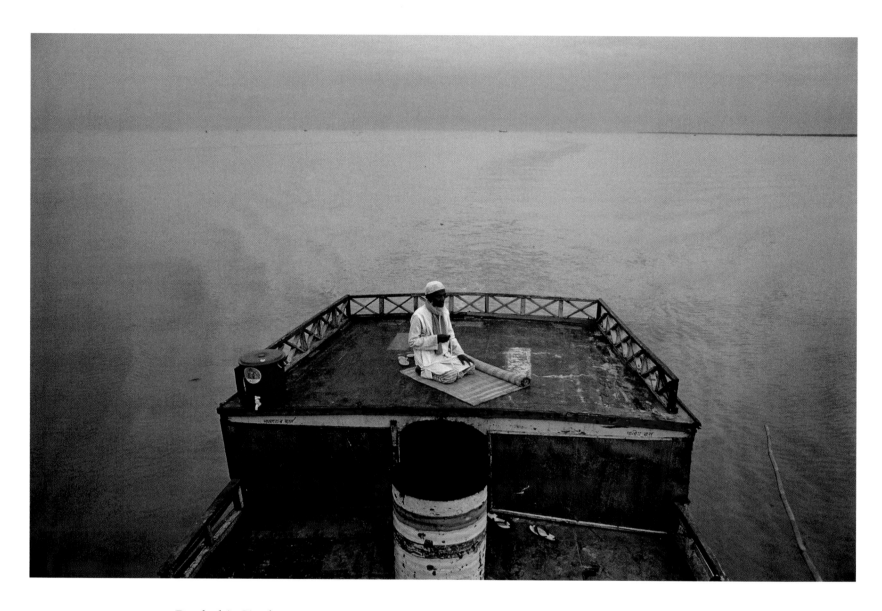

Raghubir Singh

INDIA, 1988 • Even while steaming through the middle of the Brahmaputra, this Bangladeshi Muslim does not forget to face Mecca and say his prayers.

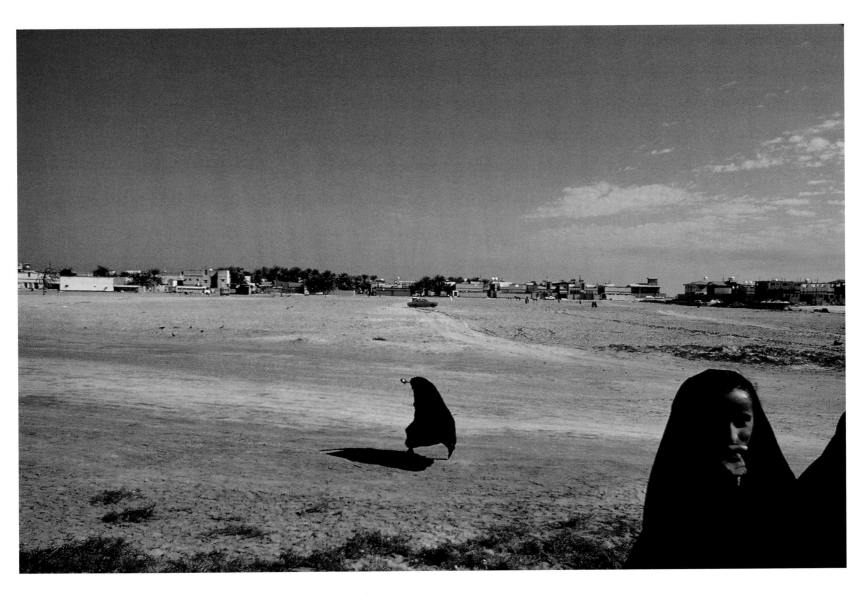

Jodi Cobb
SAUDI ARABIA, 1987 • A veiled Saudi schoolgirl cuts a strange-looking figure near Qatif oasis in a region known for its conservative customs.

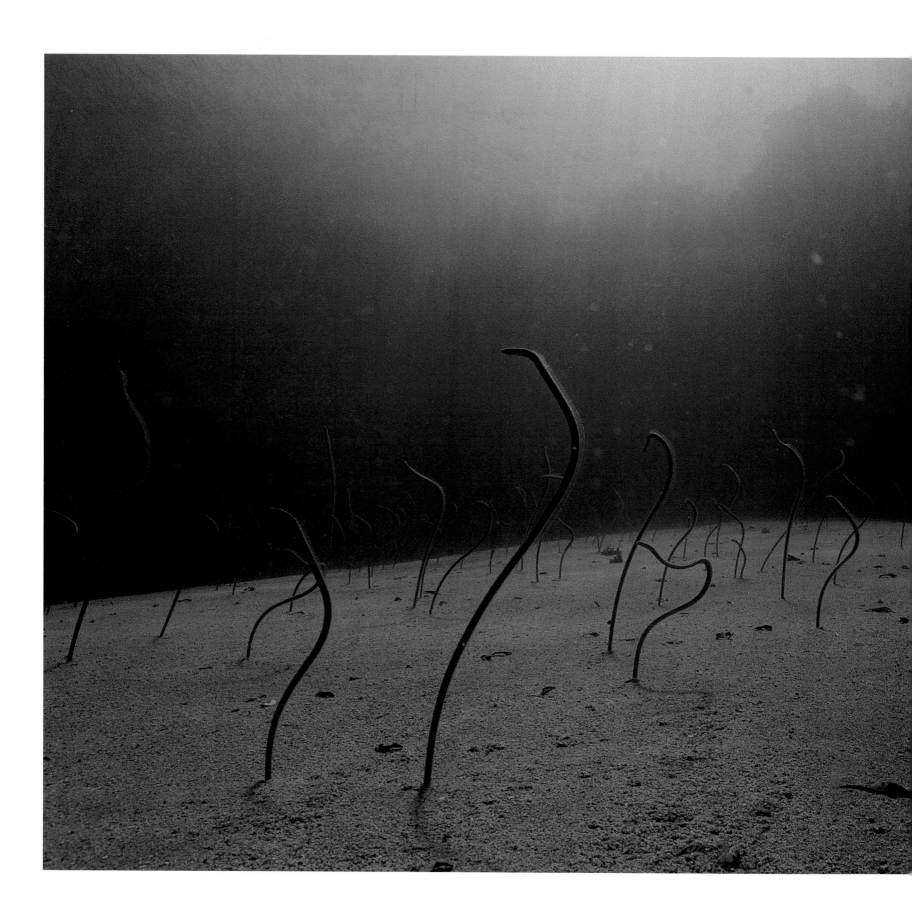

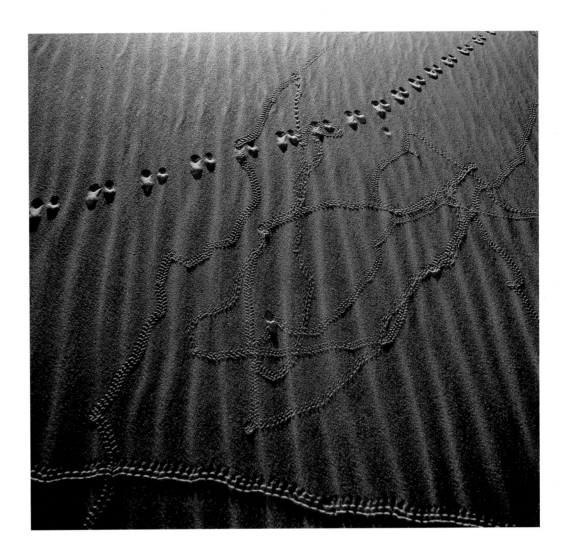

David and Carol Hughes

AFRICA, 1983 • Traces of nocturnal traffic patterns of zigzagging beetles and a bounding gerbil linger at dawn before the Namib's winds wipe the slate clean.

David Doubilet

RED SEA, 1983 • *Left*: Elegant dancers in a realm of illusions, wispy garden eels sway to the rhythm of the Red Sea but sink eerily into their holes if disturbed.

Bruno Barbey

MOROCCO, 1986 • *Following pages:* The living and the dead share a hillside near the early-13th-century walls of Fez where newly dyed skins dry in the sun amid whitewashed tombs.

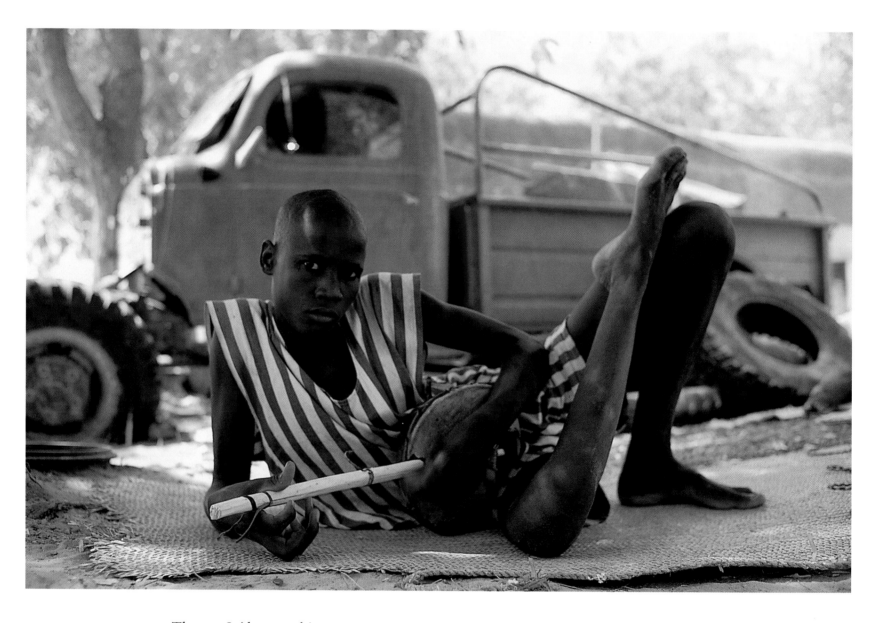

Thomas J. Abercrombie
CHAD, 1972 • Solace comes with a song for a young Muslim prisoner in a Chad government compound, whose internees once might have been doomed to slavery.

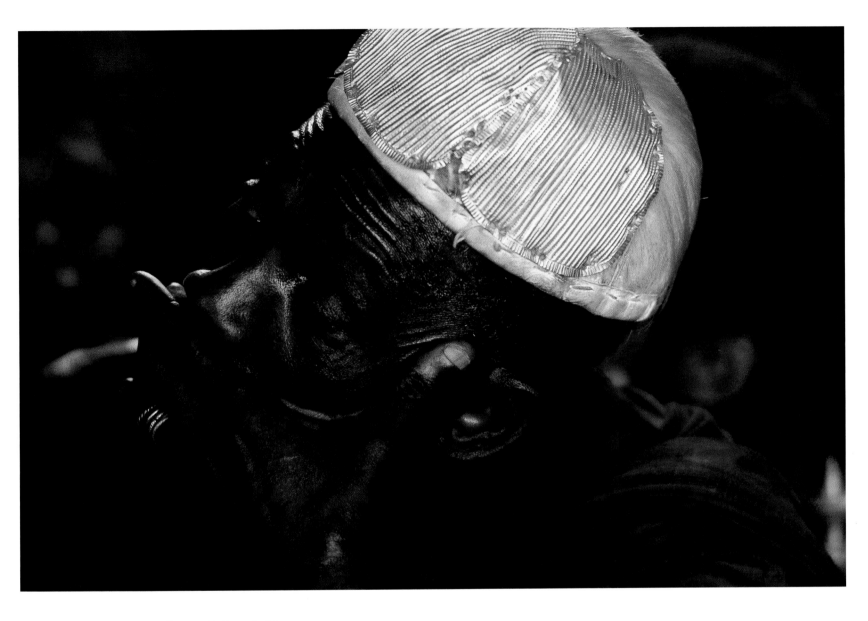

James L. Stanfield
GHANA, 1974 • A gleaming emblem of tribal affluence, this golden cap identifies the court crier for the king of the Ashanti tribe in Ghana, once known as the Gold Coast.

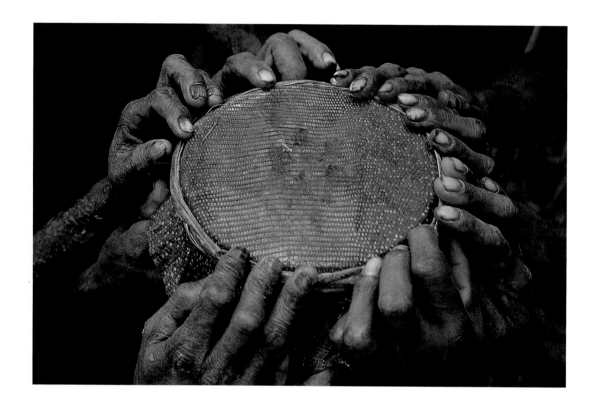

Malcolm Kirk

NEW GUINEA, 1972 • Many hands help stretch lizard skin over an Asmat ceremonial drum, which is doubly secured by a glue made with human blood and a rattan hoop.

Malcolm Kirk

NEW GUINEA, 1972 • Mourning the death of the husband they shared, Asmat widows squirm through the mud in a ritual intended not only to display anguish but to mask the women's scent from his ghost.

Penny Tweedie

AUSTRALIA, 1980 • Walking works of art, boys wear clan designs during their ten-day circumcision rites. Soon they will share full membership in Arhhem Land's ancient culture.

Rick Smolan

AUSTRALIA, 1978 • *Right:* Along a sun-fired outback sandhill, cameleer, Robyn Davidson, leads her caravan of Bub, Zeleika, Dookie, and baby Goliath, with Diggity dog playing the scout.

Sam Abell

AUSTRALIA, 1991 • *Following pages:* This truckload of butchered beef will soon be sizzling on the "barbie" outback style, to feed a crew during the yearly roundup at a cattle station in Kimberley bush country.

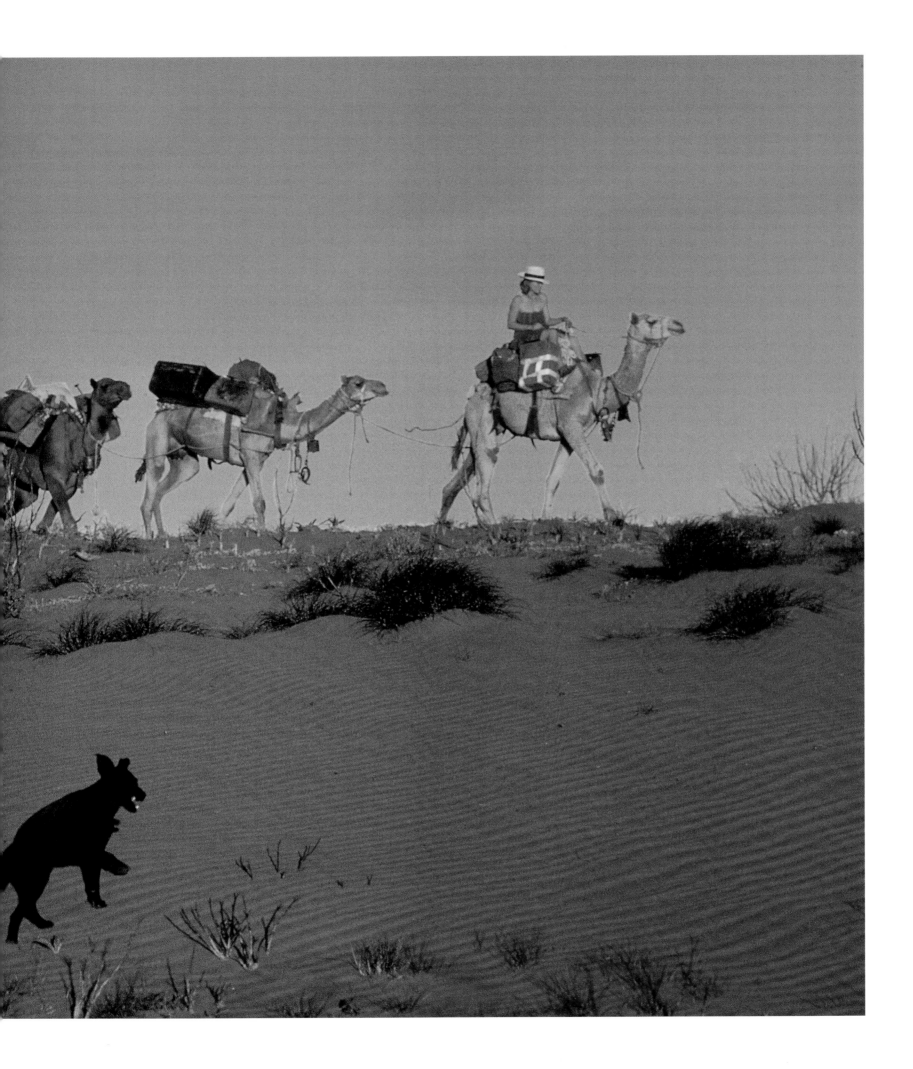

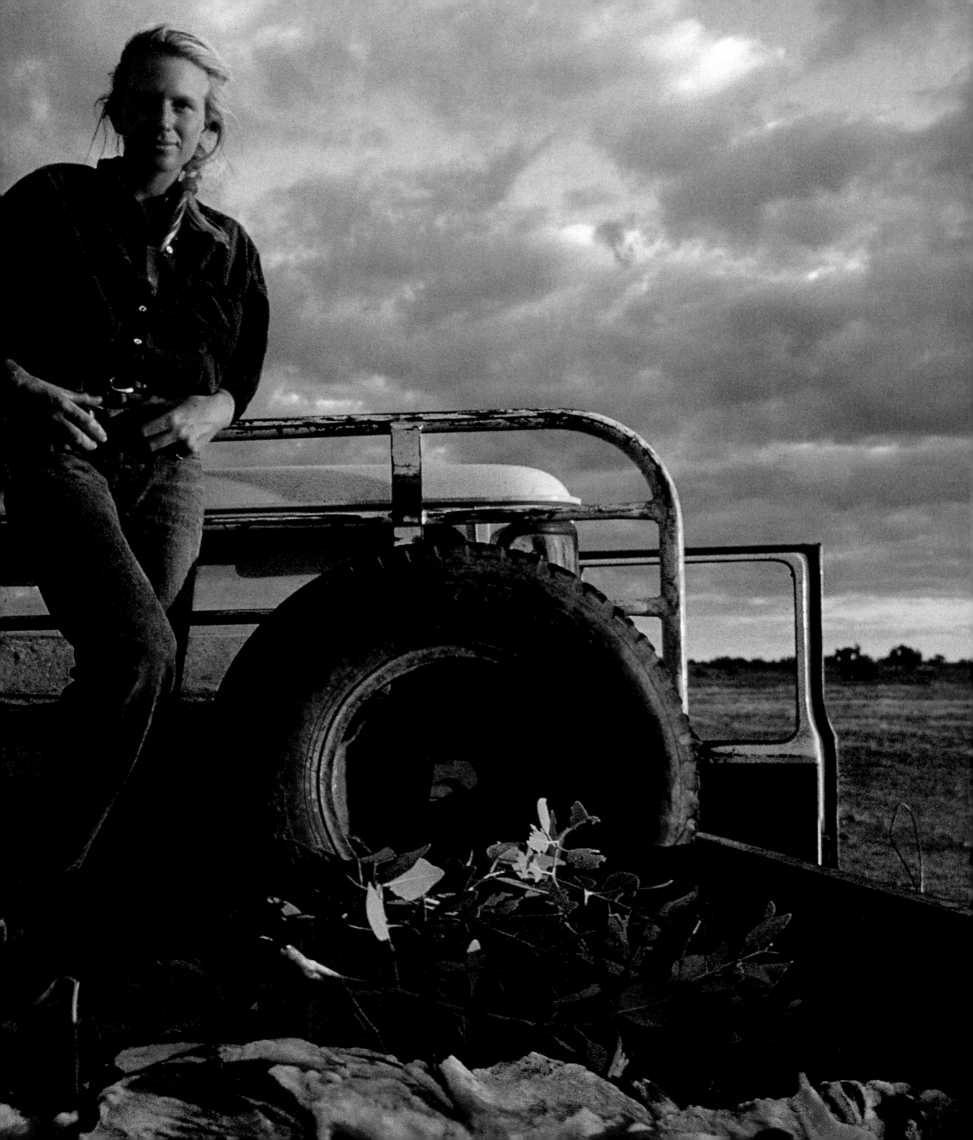

The Personal Viewpoint

ABE ARONOW

William Albert Allard

VIRGINIA, 1998 • William Albert Allard shares
a portrait with Sarah, his year-and-a-half old
springer spaniel.

One of the first NATIONAL GEOGRAPHIC photographers to pursue a personal style and specialization was William Albert Allard. He joined the magazine in 1964, bringing a strong portfolio of black-and-white photographs shot in natural light but no experience working with color. His photographs were intimate, unflinching and marked by sophisticated handling of pictorial space and the interplay of light and shadow.

The transition to color proved relataively easy and Allard was able to build on his strengths and create a signature style by mixing a strobe with ambient light. "My color work really evolved out of the black-and-white stuff I did in college," he says. "For me, the realness of the photograph has always been paramount. I had artistic training, but I came out of journalism school and was weaned on the picture story. But what we do at the GEOGRAPHIC is more akin to an essay than the linear narrative of a picture story."

Allard first specialized in stories about the American West. In the early 1980s, he devoted his talent, energy and passion to photographing Peru. His 1985 photograph of a Peruvian farmer (opposite) carrying bags of his produce to market catches the essence of its subject and of Allard's style.

The farmer is just emerging from a deep shadow. The coarse rope holding his burden and the prayerlike position of his hands become allegories for the poverty gripping Peru's peasants and their religious faith. The shadows' sharp edges divide the picture plane into abstract blotches of darkness and patches of subtle color, one of which reveals two girls walking against a sunlit wall embodying the innocence of youth in a hard but vibrant society. It's a complex, evocative and edgy photograph, by a pioneer of the personal viewpoint.

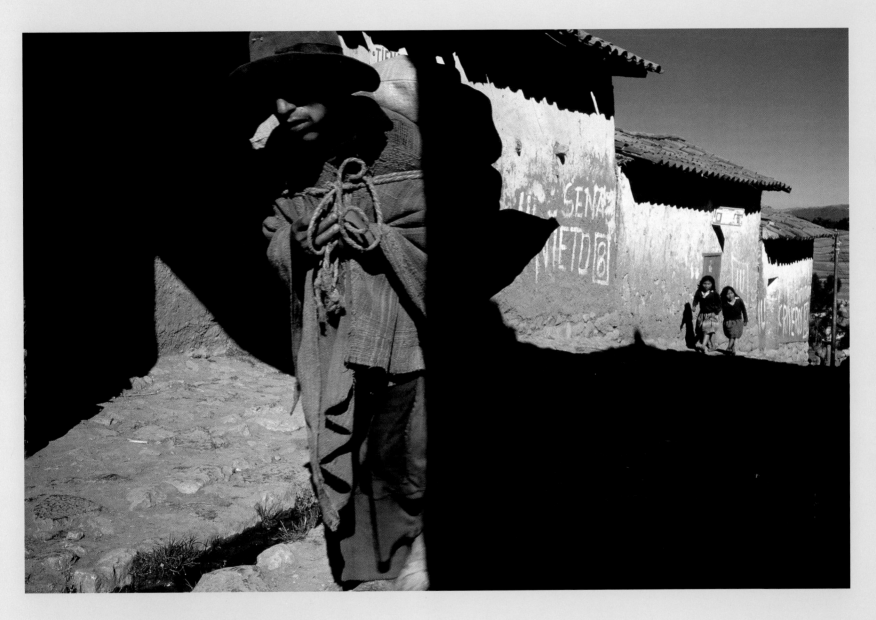

PERU, 1985 • Coming out of the shadows, a man in a small Peruvian village in the Andes carries his produce to market.

Sam Abell

WASHINGTON, D.C., 1998 • Sam Abell has
worked with the GEOGRAPHIC since 1970 and
has illustrated more than 20 articles on various
cultural and wilderness subjects.

JAPAN, 1980 • *Opposite:* This visual poem of a
tree framed by a window and seen against the
backdrop of timeless roof tiles illustrates what the
Japanese call seeing with the eyes of the heart.

Sam Abell is the most overtly artistic
photographer working for the National
Geographic Society. Since 1970, his spare,
lyrical photos have illustrated more than 20
articles on various cultural and wilderness
subjects. Abell's style makes understated use
of color and emphasizes the physical and
spiritual vastness of his subjects by anchor-
ing the perspective to a horizon line, then
using it to create a sense of limitless depth.
"I'm going for peace, solidity, and certainty
with the horizon," he says. "Once I find it,
I can play and improvise off of it and let
the perspective run to infinity."

Abell's picture of a tree (opposite),
framed by a window, against a backdrop of
roof tiles at the Tomoe Inn in Hagi, Japan,
is a shimmering masterpiece that looks as if
it were made from stained glass. Behind the
tree's gnarled old branches, the dappled
tiles seem to run to eternity, making the
picture the perfect visual equivalent of a
haiku, a traditional Japanese poetry form,
that described the scene: "A courtyard
window/ This tree stands remembering/
The old Tomoe."

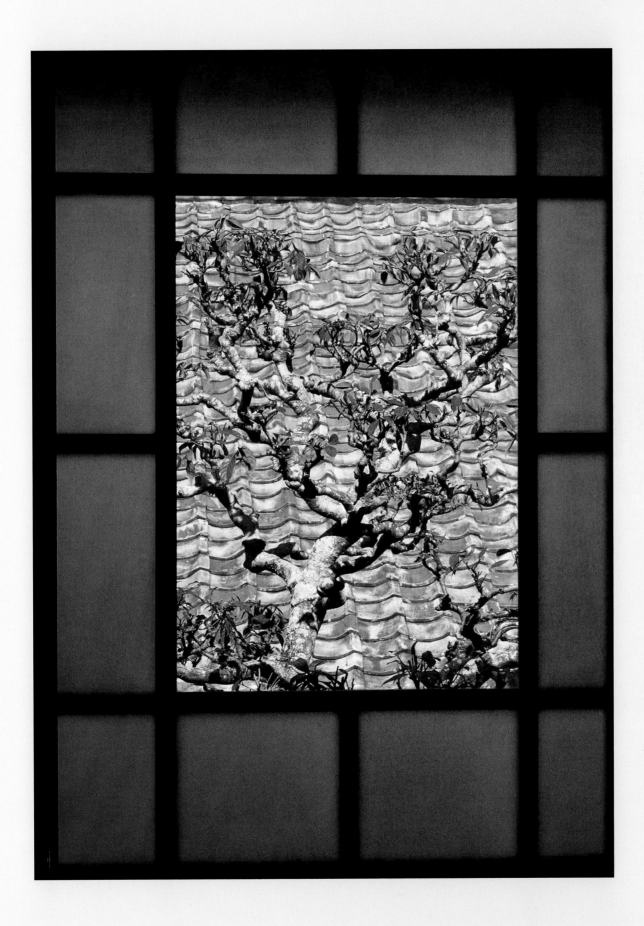

SISSE BRIMBERG

Jodi Cobb

WASHINGTON, D.C., 1995 • Jodi Cobb, hired by
Robert E. Gilka in 1977, proved her versatility as
a photographer before she began to focus on the
lives of women around the world.

When Jodi Cobb made the jump from
newspapers to the NATIONAL GEOGRAPHIC,
she already had a nascent personal style
based on intimate familiarity with her sub-
jects and a superb eye for the beautiful,
unstaged slices of life that tell a story. But
even though she continued to be vitally
interested in all aspects of the human con-
dition, she felt she had to downplay her
style and her desire to specialize. Because
GEOGRAPHIC stories were so broad, she
had to learn to function as a generalist.

Among her most arresting images were
photos that chronicled the lives of women
in cultures around the world. Her pictures
of Saudi Arabian women gave readers a
firsthand look at a world rarely seen by
Western eyes.

In the October 1995 issue of NATIONAL
GEOGRAPHIC, Cobb documented another
hidden world in a series of remarkably
beautiful and intimate photos of Japan's
geishas, who are both scorned as antifemi-
nist anachronisms and also revered as cus-
todians of a treasured past. Her stunning
photograph of a geisha (opposite) in
ancient traveling costume at Kyoto's
annual Festival of the Ages appeared in a
book devoted to Cobb's work, titled sim-
ply, *Geisha*.

JAPAN, 1995 • This modern-day Kyoto geisha wears an ancient traveling costume in the procession for the annual Festival of the Ages.

KENT J. KOBERSTEEN

Chris Johns

EAST AFRICA, 1996 • Photographer Chris Johns spent more than a year photographing the Great Rift Valley from helicopters, land rovers, and on foot.

Chris Johns had planned to become a veterinarian or a teacher until a friend interested him in journalism. After graduate work at the University of Minnesota, he freelanced, became one of NATIONAL GEOGRAPHIC'S contract stringers, and then joined the staff at a time when personal styles and areas of special interest were being actively encouraged.

Johns is a gifted generalist who can shoot anything anywhere and get beautiful, strongly evocative images. But his specialty seems to be working in difficult places under tough conditions. Working for the Society, he has climbed frozen waterfalls in British Columbia, been buried by an Alaskan avalanche, and narrowly missed the eye of an Oklahoma tornado. He has witnessed the eruption at El Chichon and the aftermath of Mount St. Helens' devastating explosion.

Over the years, Johns has also shown an affinity for Africa. Doing a story on the East African Rift he worked under almost unbearable conditions. "I've had hot rocks bouncing off my head before, but nothing like this, he says." I could stand there only five minutes before the stench and heat got me."

His willingness to endure hardship has consistently produced extraordinary pictures, such as the shot from the July 1996 issue (opposite), that shows a wind-whipped lion walking through a summer storm in South Africa's Kalahari Gemsbok National Park.

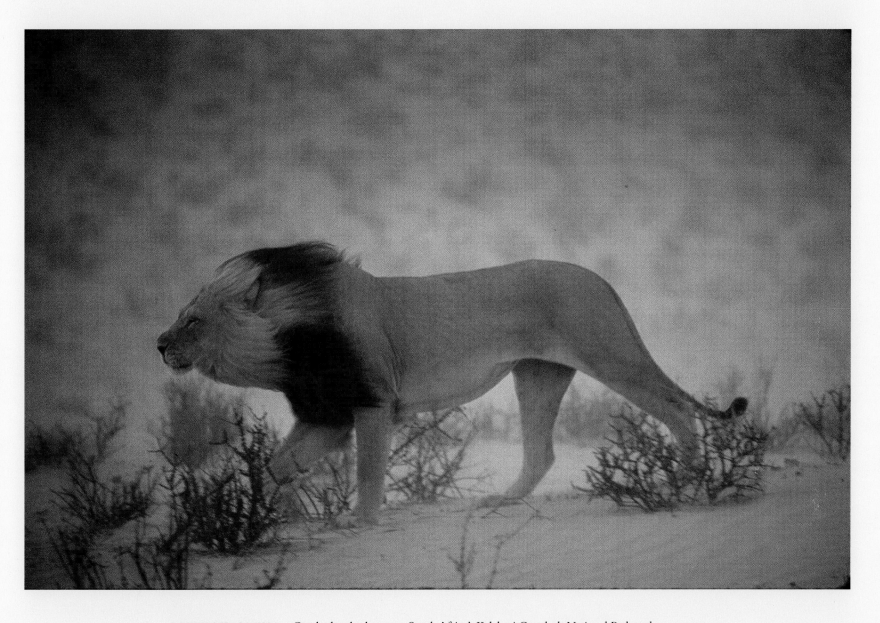

SOUTH AFRICA, 1996 • On the border between South Africa's Kalahari Gemsbok National Park and Botswana's Gemsbok National Park, a windswept lion patrols the dry Nossob riverbed. Here, transnational parkland encompasses an area larger than Vermont, allowing wildlife access to whole ecosystems.

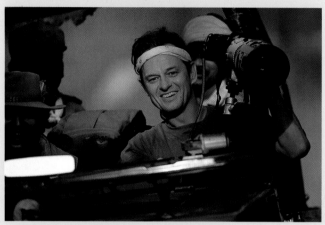

Michael K. Nichols

INDIA, 1998 • Michael Nichols is shown on assignment
photographing tigers worldwide. He spent two years tracking
the elusive animals and became an articulate advocate for
their preservation.

Michael "Nick" Nichols came to the NATIONAL GEOGRAPHIC staff in 1990 after producing highly regarded work for *Geo* and as a member of the Magnum agency. His specialty was photographing caves, endangered animals, and the lives of indigenous peoples, in a dramatic, impressionistic style full of movement and color.

Those traits come through clearly in a shot of a tiger keeping a watchful eye on its cub (opposite) that was published in a book of Nichols's photographs called, *The Year of the Tiger*. With its muzzy background and asymmetrical composition, it's a photograph that wouldn't have been published in the GEOGRAPHIC 20 years ago.

Through its continuing support of the latest in camera technology, the GEOGRAPHIC was often first in publishing photographs of what otherwise could not have been seen by the human eye. As early as 1913, in an article entitled, "Monsters in Our Backyards," David Fairchild made use of macrophotography to capture greatly magnified closeups of the "bugs" with which we share our environment. Somewhat later, through microscopic photography and the latest in medical imaging, the GEOGRAPHIC regularly took its readers on journeys through the innermost passages of the human body. And through its longtime sponsorship of undersea exploration, the GEOGRAPHIC contributed to developments in submersibles and remote cameras that enabled us to photograph the ocean's deepest trench as well as the wreck of the nuclear-powered submarine *Thresher* at a depth of 8,500 feet. In 1934 and 1935 Society-sponsored high-altitude balloons Explorer I and II set records at 72,000 feet that endured for 20 years, and toward the end of the century the GEOGRAPHIC went even farther afield to publish three-dimensional imagery from the planet Mars. In 1984, the GEOGRAPHIC was the first major magazine to feature a hologram on its cover.

"The GEOGRAPHIC was so straight, they didn't do that much interpretive work," Nichols recalls. "But it was the place I was training myself for. They photographed the wilderness, and I'd always had a fascination with wilderness. And you can really push things in the natural world. Photographing animals lets me really experiment and be personal in my viewpoint. I believe photography has to be interpretive; it's no longer enough to just be there. I'm an advocate. I want to do stories that make a case for helping indigenous peoples and endangered animals. But they have to be real because so many people trust us. If you get to the point where you can't make real pictures and have people believe that they're real, then you've lost it."

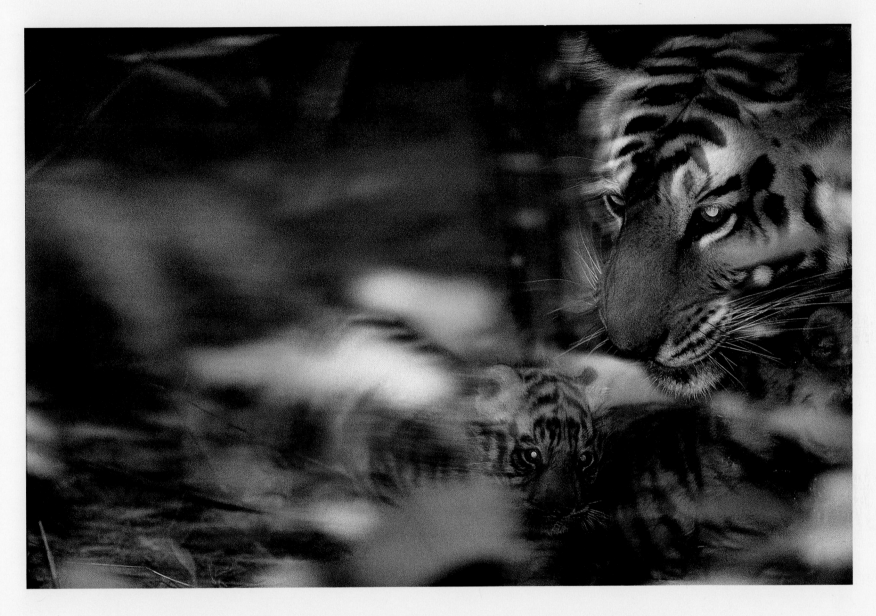

INDIA, 1996 • Making use of a remote camera whose shutter is tripped by breaking an infrared beam, the photographer captures a mother tiger moving her cub to a new den where it will be safer while she goes out to hunt. Nichols is an innovator in this technology, which he uses to serve his vision.

David Alan Harvey

WASHINGTON, D.C., 1999 • As he arrived for the
Geographic's annual photographic seminar, David Alan
Harvey was photographed by staff photographer
Michael Nichols, ready with his camera in the backseat
of a local taxi.

David Alan Harvey's affiliation with
NATIONAL GEOGRAPHIC began with a
1973 photo-essay on Tangier Island in
Chesapeake Bay, not far from Virginia
Beach, Virginia, his hometown. "It's still
one of my favorite stories," he says. "The
photography isn't very sophisticated, but
neither was the subject. It's about people
working, baking cookies, going to church,
living their lives."

Over the years, Harvey has become
one of the GEOGRAPHIC's quintessential
specialists, traveling the world to photo-
graph Spanish-speaking cultures. At home
or abroad, his rare ability to catch moments
when the physical, sociological, and psy-
chological strands of a story coalesce gives
readers vivid insight into his subjects.

Harvey looks for "the everyday ballet,"
the scenes defining daily life, such as a
1995 photograph of participants preparing
for a colonial fiesta in Old San Juan, Puerto
Rico (opposite). The image is graceful yet
powerful, a photographic tapestry woven
from light, shadow, color, and line. The pic-
ture conveys a sense of pomp, passion, his-
tory, and celebration under the blazing sun.

"When beginning photographers ask
me for advice, I tell them to photograph
their own backyard," Harvey says. "If your
pictures can tell that story clearly, honestly
and beautifully, then you're ready to go out
into the world."

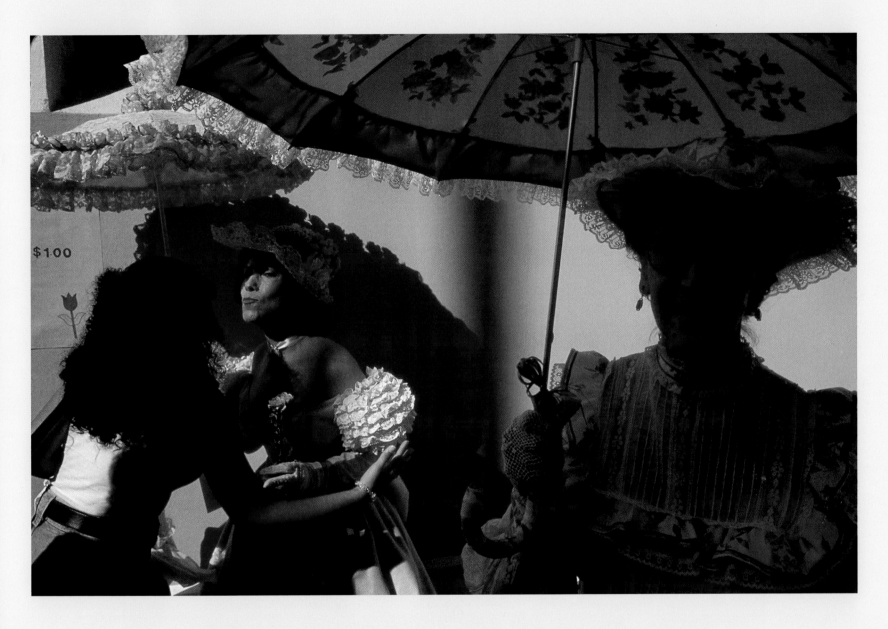

PUERTO RICO, 1995 • A specialist in Spanish culture, Harvey was on hand in Old San Juan to photograph these senoritas in colonial costume preparing to join the fiesta.

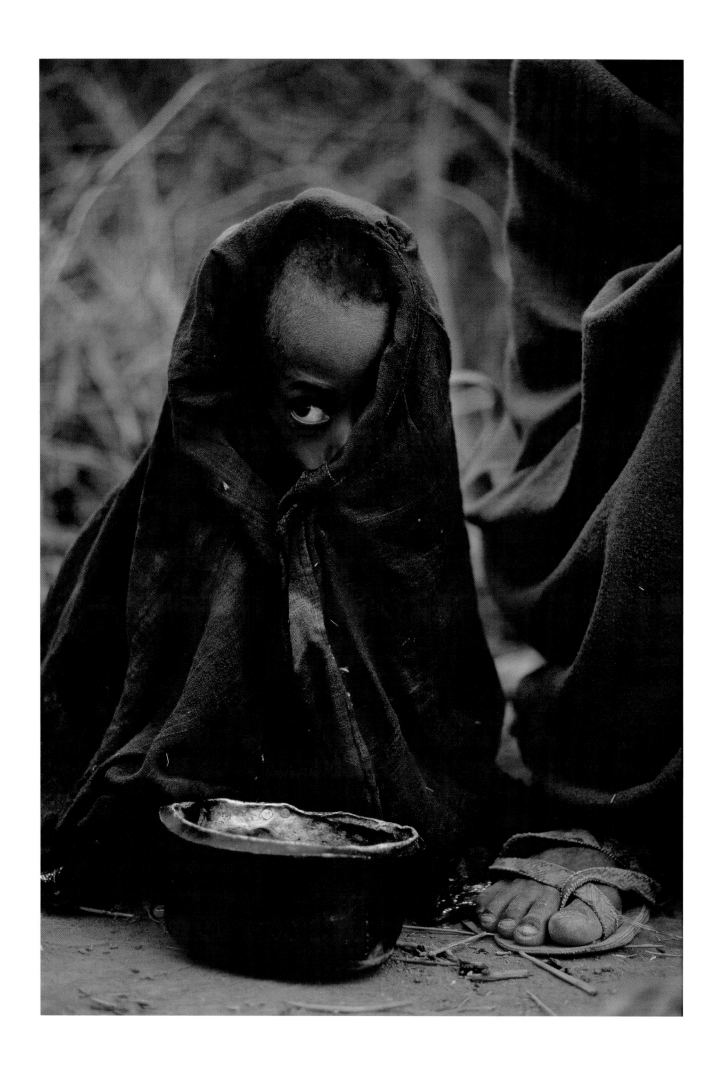

1991-1999

Imaginative Continuity

Fred Ritchin

A decade ago photography's 150th birthday was being celebrated around the world with exhibitions, conferences, and publications. And at the same time, the Chinese government was proclaiming that, contrary to reports, no students had been massacred at Tiananmen Square. The photographs, however, stated otherwise, and official claims made by the government of the world's most populous nation were widely rejected. While eyewitness accounts from those involved in such events are often disbelieved as being too subjective, the quasi-objective authority of the photograph remained, in 1989, essentially unquestioned.

The following year, in an effort to sidestep the potentially demoralizing impact of gruesome images that would evoke "another Vietnam," the U.S. government banned most photographers from depicting actual combat in the Persian Gulf. The American public was left with not much more visual information to attempt an understanding of the war than televised computer simulations and images taken from the limited perspective of "smart bomb" cameras. In recent decades savvy politicians from all parts of the world have learned that winning the "image war" may be more important than the outcome of actual events. It now seems probable that the last war fought by Americans to leave a comprehensive photographic legacy was the Vietnam War, which ended a quarter of a century ago.

Also in the early nineties, a bystander videotaped from his balcony an African-American man, Rodney King, being beaten by Los Angeles police. The existence of this documentary footage led to two celebrated court cases that riveted the attention of Americans. While police brutality had often been alleged in Los Angeles prior to this videotape, it was not until photographic evidence existed that such allegations were widely believed.

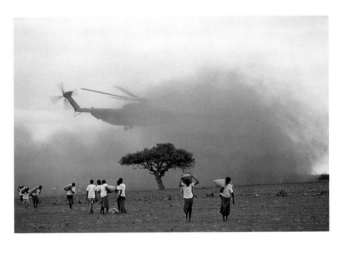

Robert Caputo

SOMALIA, 1993 • As famine sweeps the parched Horn of Africa, relief supplies, brought in by helicopter to avoid the danger of mined roads, are still not safe, for armed bandits often steal food to sell elsewhere.

Robert Caputo

SOMALIA, 1993 • *Opposite:* The future of the Horn of Africa— and of children like this Somali boy waiting his turn to be fed— remains uncertain.

In the same city three years later, O. J. Simpson, was one of just a few celebrities ever to be indicted for murder. *Time* magazine had his police department mug shot darkened and put out of focus for a cover portrait. Publicly accused of racism and, furthermore, of tampering with documentary evidence, the magazine's managing editor would explain to readers the following week that the publication's staff had only attempted to raise "a common police mug shot to the level of art, with no sacrifice to truth." Could anyone imagine an editor arguing in 1963 that Abraham Zapruder's grainy, amateur footage of President John F. Kennedy's being shot in a Dallas motorcade should have been similarly altered?

The battle over photography's role as societal witness was now intensifying. The photographer's power to authoritatively contest an official position of government and to dispute a carefully nurtured image of politicians, movie stars, and other celebrities was being attacked from many sides and, unfortunately, was being undermined by many publications that themselves depended upon the documentary authority of the photograph. In the rush to compete in a media-saturated society, photographs were frequently selected (and manipulated) more for visual excitement than for content. Rather than being used to help establish facts and interpret the meaning of events and the character of people depicted, the editorial photograph was increasingly used to titillate the viewer and provide a flashy environment for advertising. The advent of increasingly sophisticated computer graphics, available for the first time this decade as cheap software for even modestly priced personal computers, certainly accelerated but did not create this urge for more malleable, superficial imagery.

The editors of remarkably few publications actually grappled, at least publicly, with the increasing erosion of their authority as reliable commentators on the world around us. And some photographers, including those who specialized in depicting wildlife, began themselves to manipulate their photographs, showing sometimes what might have occurred rather than what did happen. NATIONAL GEOGRAPHIC, a pioneer in so many new photographic technologies, was also among the first publications to experiment with digitally altered photographs, most notably its cover on the Pyramids of Giza in the February 1982 issue, "a mistake that still haunts us." But the GEOGRAPHIC, to its credit, was also one of the few publications to offer a public apology and develop a coherent policy for handling such manipulation. In its April 1998 issue, editor Bill Allen wrote a letter to readers that outlined the magazine's guidelines: "Do not alter reality on the finished image, except when it is done for some instructional purpose. And then make certain we tell our readers what was done, and why."

Without such a policy, why would a gifted photographer such as George Steinmetz risk his life paragliding 7,500 feet above the Sahara desert in the equivalent of a lawn chair for the best possible image of the sands? He recalls "the remark

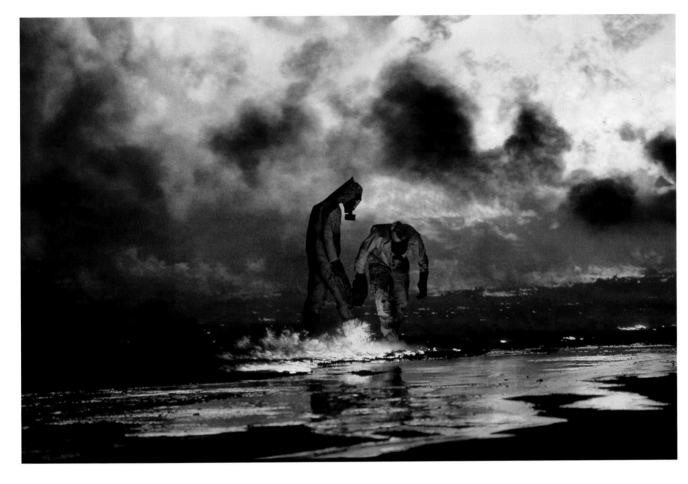

Steve McCurry

KUWAIT, 1991 • Resembling creatures from another world, environmentalists in protective suits survey the lasting damage to Kuwait's tar-encrusted fields amid the raging oil fires deliberately set by retreating Iraqi soldiers.

of an old barefoot nomad who had watched us [the photographer and two companions] fly: 'They want to die,' he said, 'but God has not chosen their time.'" Or why would Gordon Wiltsie dangle off the sheer face of Baffin Island Peak thousands of feet in the air to photograph fellow climbers preparing to sleep in tents hanging from the rock wall? Would any photographer put himself or herself at so much risk if the reader might doubt the authenticity of what was being shown, assuming that it could have been composed on a computer? What then would be the point of spending tens of thousands of dollars on expeditions if the magazine could just as easily fabricate any reality it prefers?

Obviously then the GEOGRAPHIC, as the only American magazine still consistently sending photographers on long assignments to explore various aspects of the world, has more at stake in reassuring readers of its commitment to traditional photographic practices than most other publications. In this decade, dominated by a clamor for imagery of celebrities to serve the often twisted cult of personality, it is the commitment to use photography to explore our natural (as well as unnatural) environments that might be construed as somewhat radical. In pursuing this strategy the GEOGRAPHIC has become even more distinct from other publications.

So, for example, photographer Steve McCurry's "After the Storm" (August

1991), with his extraordinarily eerie and vivid images of the environmental and human devastation left after the Persian Gulf War, is taken seriously by the reader because he or she knows that McCurry was there and, in a short article, even explains what it felt like personally during and after the war. "The photos I brought back show the black, hellish landscape—yet they cannot convey the fine mist of oil particles that hangs in the air, nor the deafening roar of the wildly burning wells."

Similarly, a global view on biodiversity (February 1999), a multi-part series on riding a bicycle across Australia (beginning December 1997), or a 90-day diary on Minnesota's North Woods (November 1997), all resonate with the reader because it's clear that an eyewitness, a human protagonist, is reporting back. And the GEOGRAPHIC's reportage on other overwhelming social and environmental issues like Indonesia's devastating fires, pollution in Eastern Europe, and alcohol addiction throughout the world, including its impact on newborns, depends on the established trust of the reader.

When the GEOGRAPHIC ventures into technically enhanced photography, one of its favorite arenas, with microscopic looks at bedbugs or three-dimensional visions of the planet Mars and the sunken *Titanic,* the power of such imagery comes from the enhanced perspective that approximates what it would be like to see at a 50-times magnification, or hundreds of feet underwater, or in outer space. To approximate (although never to match) and sometimes to improve upon human sight, depicting things that we usually would not have seen, has always been the most obvious achievement of photojournalism.

But the challenges to photographic authority that have been made in this notorious information age—the "photo opportunities" staged by media managers, the restrictions by governments and powerful individuals on what can be photographed, the manipulations of the photograph itself with the speed and efficiency of the computer, the ascendancy of videotape over the still photograph, as well as the plethora of imagery coming at us from numerous directions—have also initiated a healthy reevaluation of photography's strengths. One of the major questions to emerge asks if it is the photograph that is authoritative, this quasi-objective document, or is it the photographer, the author of the photograph, that one really has to trust? Many in the field of photojournalism already argue that the photographer is essentially very much the equivalent of the writer. Just as his or her words are not automatic guarantees that an event described happened the way the writer wants us to believe it occurred—or even happened at all, so too the photograph should not automatically be believed. Any photograph is an interpretation of events and not the "truth," and it is essentially ambiguous, relying on captions, headlines, and other contextualizing text, as well as the way it is placed on the page by the designer, for much of its meaning.

As any photographer or editor can aver, the statement that the "camera never lies" is itself a lie. The camera can make very different statements about what it depicts according to, among other factors, the photographer's choice of framing, the juxtaposition of pictorial elements, and the precise moment when the shutter is released. Photographer Henri Cartier-Bresson, the great French champion of "the decisive moment," considers photojournalism to be no more and no less than keeping a journal with a camera, a diary of the photographer's subjective experiences. Rather than primarily trusting the camera as a mechanical, objective recording device, one must consider the photographer as the author of the image-based statement just as the director is the ultimate author of a film. This is particularly true for photographic essays, even more than for individual photographs, because the essay form, of which GEOGRAPHIC is one of the few remaining practitioners among magazines, allows the photographer to make a more sustained, complex statement. It is not only the writer who asserts what it feels like to be in a particular situation, but also the gifted photographer—as in Mike Yamashita's imagery that not only describes Indonesia's devastating fires, but also his awe and fear at the enveloping smoke (August 1998).

One of the most prominent attempts by the GEOGRAPHIC in this past decade to acknowledge the photographer as author was the "North Woods Journal" by Jim Brandenburg, which he both wrote and photographed (November 1997). "I hoped with patience and endurance to renew my vision of the natural world." Rather than take numerous exposures that an editor would help select from for his story, Brandenburg set for himself a difficult challenge: ". . . for 90 days between the autumnal equinox and winter solstice I would make only one photograph a day. There would be no second exposure, no second chance. My work would be stripped to the bone and rely on whatever photographic and woods skills I have."

He continues: "My quest was both arbitrary and rigid. Arbitrary in that no one had compelled me, or even asked me, to perform it. Rigid in that once engaged, the constraints I had chosen would force me to examine myself and my art in a manner I'd never before attempted. The wild and isolated place in which I live, outside the small, end-of-the-road town of Ely, Minnesota, would never look the same to me." In an 18-page layout, including a foldout page, GEOGRAPHIC then gave the photographer the space to record his vision. His essay was not about any particular subject, but a subjective reflection on his relationship to the woods and wildlife that surrounded him. It was, in this day of high-speed telephone, fax, and internet access, a stark and simple meditation accomplished through relative solitude. He was not chasing the world, "parachuting" into situations as so many photographers for other publications do on assignment today, but allowing the world to come to him.

Interestingly, this reminded me of another story that GEOGRAPHIC published exactly a year later (November 1998), this one on the amazing 1915 adventure of

explorer Ernest Shackleton, with photographs by expedition member Frank Hurley and recounted by Caroline Alexander. Shackleton lost his ship in thick ice while attempting an expedition to cross Antarctica on foot. Instead he spent 20 months with his crew attempting under the most untenable conditions just to survive. This story of courage in the face of adversity reminded me of Brandenburg in the sense that each was a story of the human soul encountering nature out of human need. In the older case it was an attempt to confront nature at its most severe, to prove one can best it, whereas the essay set in Minnesota was an attempt to integrate one-self into nature, appreciating its rhythms.

This confrontation between humanity and nature is essentially what GEOGRAPHIC has always been about, whether told by a participant or by an observer. But another issue arises when certain visual strategies need to be renewed. Just as filmmakers have drastically changed their image strategies when making movies (compare, for example, a Hitchcock and a Tarantino movie), so too photographers cannot be expected to always tell their stories the same way and hold the readers' interest. Thus, GEOGRAPHIC, despite its long commitment to color photography, has been able to turn to black-and-white imagery when the photographer prefers it and the story merits it. Strikingly, a story entitled "Lullaby in Color" features Lynn Johnson's evocative black-and-white essay on Vincent Van Gogh (October 1997). His images are appropriately reproduced in color, and Johnson's images are allowed their own visual space without competing with the painter's palette.

Certainly the theme of animals on the verge of extinction is one that people have seen in the press and on television numerous times, but again choosing a different visual strategy and acknowledging the individualized approach of the photographer, the GEOGRAPHIC managed to make the issue fresh. James

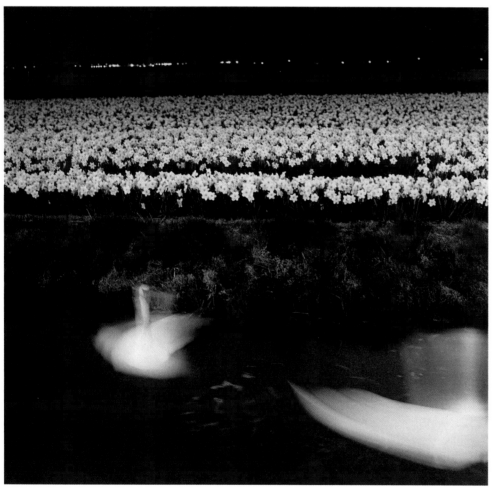

Lynn Johnson

THE NETHERLANDS, 1997 • *Top:* A recently discovered sketch by Vincent Van Gogh, in a Dutch hymnal from the church he attended until 1881, was photographed for an article on the artist. *Above:* For some photographers black-and-white was long the premier expressive medium. And for the Van Gogh story, the GEOGRAPHIC picture editor and photographer offered lyrical black-and-white photographs right next to the artist's paintings.

Balog's portraits of animals such as the great Indian rhinoceros, Florida panther, grizzly bear, West Indian manatee, taken around the world in front of seamless studio paper, manage to isolate the animals so that, bereft of their normal surroundings, the reader feels both their singularity in nature and their precariousness. His approach, entitled "A Personal Vision of Vanishing Wildlife" (April 1990), reminds us that natural habitats are no longer a given. The encroachment of the man-made is

such that in the future, if we are not careful, we might be reduced to viewing nature as artifact.

And furthering a technology that photographer George Shiras III pioneered for NATIONAL GEOGRAPHIC earlier in the century, Michael "Nick" Nichols set up cameras in the wild whose shutters are triggered by the breaking of an infrared beam. Using multiple strobes to augment natural light for a considerably more even illumination than Shiras's magnesium flares provided, Nichols's (and assistant Roy Toft's) photographs of tigers and monkeys on their own are intimate, fascinating documents that seem, without the presence of humans, respectful and empathetic. The images of the monkeys, in particular, could even be called self-portraits. "The monkeys jumped around and used up whole rolls of film. Roy and I set the camera out, then Roy went back a week later to check it and found that the film had run out in one day. The counter showed that the monkeys broke the beam more than a thousand times."

Earlier in the decade, "Growing Up in East Harlem," photographed by Joseph Rodriguez, similarly exclaims on the beauty around us, but this time the focus is on human beings. And Rodriguez points out in graphic, colorful photographs, that we too are endangered by man-made ills such as poverty and drug addiction. While GEOGRAPHIC has often extolled the beauties of the United States, this is a rare in-depth look at some of the social ills that plague us. And whereas many publications sensationalize the problem, this essay becomes an exceptional look at the human landscape from an empathetic viewpoint, one that in previous decades might have been done by some of the more news-oriented journalistic publications.

Similarly, Robert Caputo's "Tragedy Stalks the Horn of Africa" (August 1993) highlights the beauty and the ongoing anguish of people in Somalia, Sudan, Ethiopia, and Eritrea, suffering from famine, disease, and violence. In Caputo's detailed text and vivid, at times imploring, images the reader is updated on an ongoing apocalypse and what is, and is not, being done to ameliorate it. For many, it was undoubtedly the first look at this region since "Hands Across America" and the highly touted rock concerts of the mid-1980s. Caputo's work served as an effectively meditative and informative reminder, battling the numbing effect of seeing too many tragedies in the media, what William Shawcross had earlier called "compassion fatigue."

The essay on alcohol (February 1992) deals with how it is made and where it comes from, illustrating its impact by showing a man holding both a normal and a diseased heart, but also including a short photo

George Steinmetz
FLORIDA, 1992 • In an article on alcohol, this student, one of 300,000 who had come to Daytona Beach for a boozy spring break, starts the nightly bout of partying with a swig from the "beer bong."

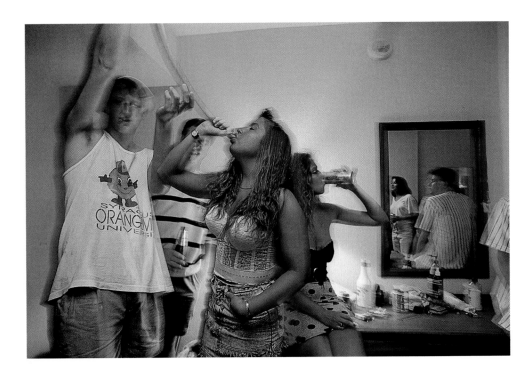

documentary on "fetal alcohol syndrome." One can understand the science of how alcohol is produced and its effect on humans, but the pictures of how children suffer alcoholism from birth offer gruesome testimony that even what should be one of the safest environments, the womb, can be polluted. Like GEOGRAPHIC's essay on Alaska ten years after the terrible oil spill from the *Exxon Valdez* (March 1999), or its essays on Eastern European and Indonesian environmental disasters, the story on fetal alcohol syndrome reminds the magazine's readers that much of the painful torment we inflict upon ourselves is created by human beings, individually and as societies.

Another style of photography that the GEOGRAPHIC embraced more frequently in the 1990s was photo-illustration, or the use of imagery to illustrate ideas that might not be obviously visual. In attempting to explain to its readers the revolutions in DNA, in information (October 1995), and in robots (July 1997), photographers and camera-less illustrators came up with clever ways of exploring the potentials of these changes. For example, George Steinmetz's "Ping Faces Pong" is illustrated with a futuristic image in which "a master-slave robot in a Salt Lake City warehouse draws back its paddle in tandem with engineer Jon Price, whose motions are measured by sensors and relayed via computer. SARCOS, Greek for 'flesh,' matches most human moves in speed and smoothness but depends on a human brain for direction." The following spread shows a robot called ROBODOC "poised over an obliging skeleton in Pittsburgh's Shadyside Hospital," ready to drill a cavity into the femur for hip replacement surgery. Each image manages to bring the future into the present, a remarkable feat for photography, which generally depicts the present to be seen as in the past.

What of the future at NATIONAL GEOGRAPHIC and in the world of photography at large? Certainly many in the computer industry have predicted a large reduction of the number of publications printed on paper and even of photographic prints and slides. Thousands of publications appear electronically on the World Wide Web, easily accessible to people everywhere with computers. Many newspapers already, for example, have their photographers work on assignment with digital cameras, which do not even produce a negative to be archived; instead, the image is in a computer file, which easily can be erased or altered.

GEOGRAPHIC's approach to cyberspace has been to use its Web site to foster discussion on issues in the magazine, and to introduce such special projects as the "crittercam," a camera attached to animals, as well as an electronic retracing of the Underground Railroad, where the computer user has to make choices each step along the way, which in some respects were similar to choices made by a person fleeing along this route in the 19th century. Other publications have made the mistake of simply posting their paper-based issues on the Web without utilizing the interactive possibilities that computers make feasible.

Similarly the GEOGRAPHIC, which over the years has mastered all kinds of

technological strategies, from frightening microscopic images of bedbugs ("Body Beasts," December 1998) to its three-dimensional images of Mars and the *Titanic* (August 1998), will now have to confront new ways of presenting the stories it has been telling for more than a century. The historic introduction of the 35mm camera or of various color-film processes will surely pale beside the imaging possibilities provided primarily by new software for the ever faster computer. Already Hollywood has been transformed with computer-generated animated films such as *Toy Story* and with startlingly real synthetic creatures such as in *Jurassic Park* and the *Terminator* movies. Scientists similarly are using a variety of new imaging strategies, from magnetic resonance images to artificial life strategies to renderings of mathematical hypotheses.

One can certainly imagine the GEOGRAPHIC of the future as embracing a variety of new image strategies. The impact of a phenomenon like global warming, for example, may be shown in some new kind of "future" photograph that can depict the changes in a particular area according to the best scientific predictions. Rather than wait for the environment to evolve, readers may even be alerted this way to what their own regions might look like if the well-known hole in the ozone layer is not corrected. Properly presented, these images might serve a preventive function, rather than support yet another essay that bemoans humanity's destructive disregard for nature.

In the future, camera-based photography will be only one way of "writing with light." We can be sure, however, that GEOGRAPHIC's staff will be thinking about and implementing many of the other ways.

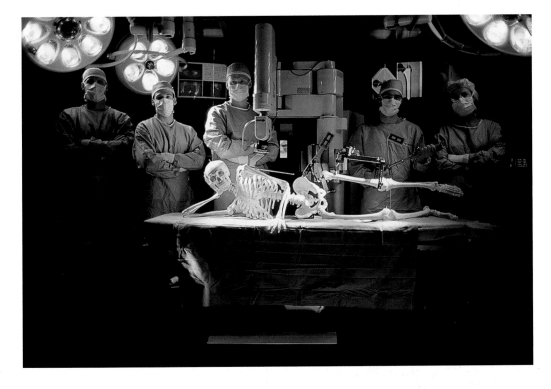

George Steinmetz

PENNSYLVANIA, 1996 • Imaginatively illustrating the rapid spread of industrial robot technology to even the operating theater, ROBODOC precisely drills a cavity in the femur of this obliging skeleton for a hip replacement operation.

Joel Sartore

IDAHO, 1992 • *Following pages:* A truck and a house, reflected in the rearview mirror, contrast with the emptiness that lies ahead, an imaginative way to photograph an ordinary scene.

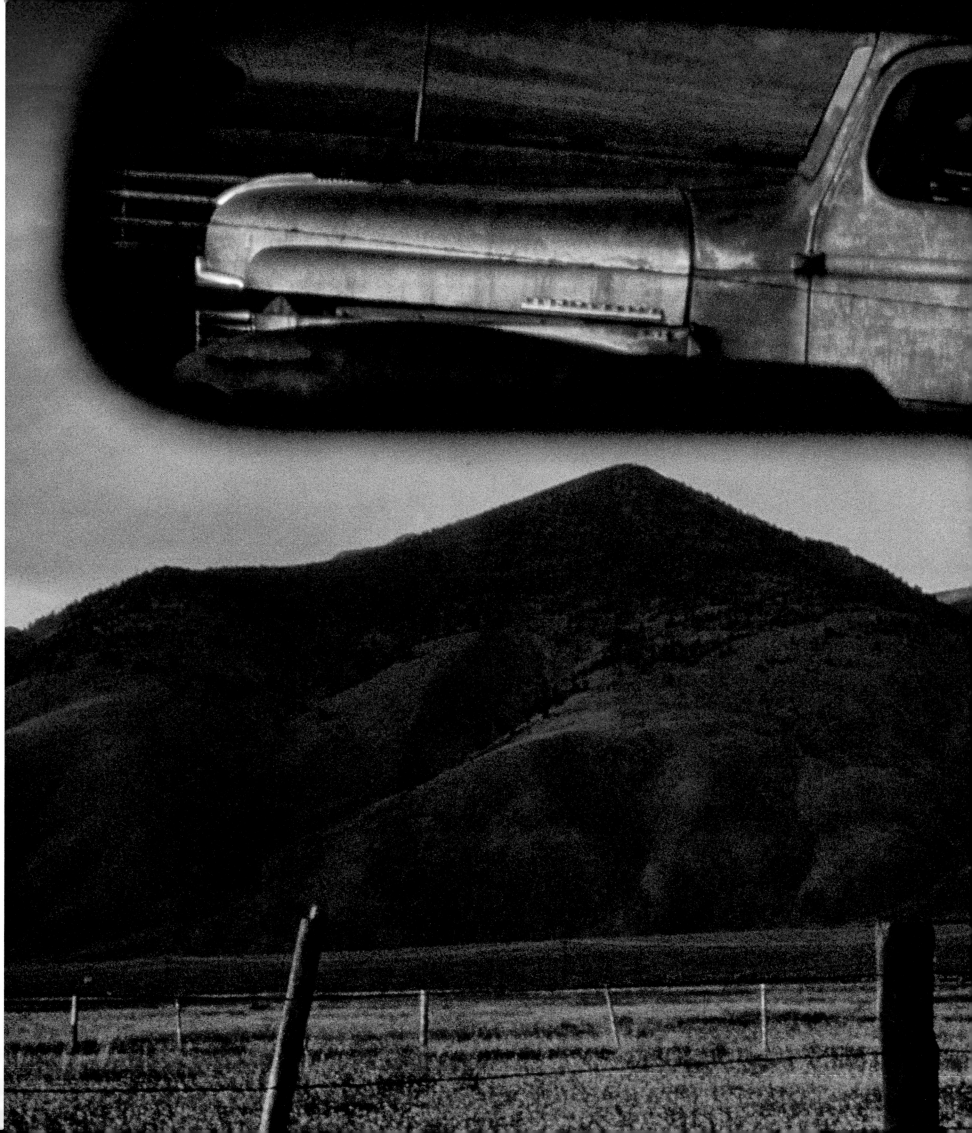

William Albert Allard

ARIZONA, 1991 • At a minor-league training facility near Phoenix, every young player competes play-by-play to become a "prospect" for advancement to the majors. Allard brought a unique perspective to one such moment.

William Albert Allard

TEXAS, 1991 • A moment of reflection during the national anthem, and then it's "Play Ball!" for these minor-leaguers, who hope to be spotted by a scout for the majors.

William Albert Allard

MISSISSIPPI, 1999 • *Following pages:* The sheer joy of performing well radiates from Big Jack Johnson, whose guitar wails with the amplified notes of Chicago-style blues.

Joel Sartore

MASSACHUSETTS, 1993 • Girls in angel costumes seem ready to soar as they accompany first communicants in
a St. Anthony's Feast procession to a Portuguese church in Cambridge, Massachusetts.

Joel Sartore

CONNECTICUT, 1994 • Morning rush hour comes early to train platforms in the southern Connecticut suburbs from which each weekday some 30,000 workers commute to jobs in New York City.

Medford Taylor

CANADA, 1993 • After a long stretch of cold, snowy days in Sault Ste. Marie, cabin fever afflicts a four-year-old who feels as confined as her dog.

Sisse Brimberg

CANADA, 1991 • *Left:* Near frozen Beaver Lake in the 490-acre Mount Royal Park that overlooks Montreal and the St. Lawrence River, skaters sneak away for a kiss among the trees.

James Brandenburg

OKLAHOMA, 1993 • *Following pages:* A bruised September sky spits out lightning over a tinder-dry tallgrass preserve—a land already prone to prairie fires and tornadoes.

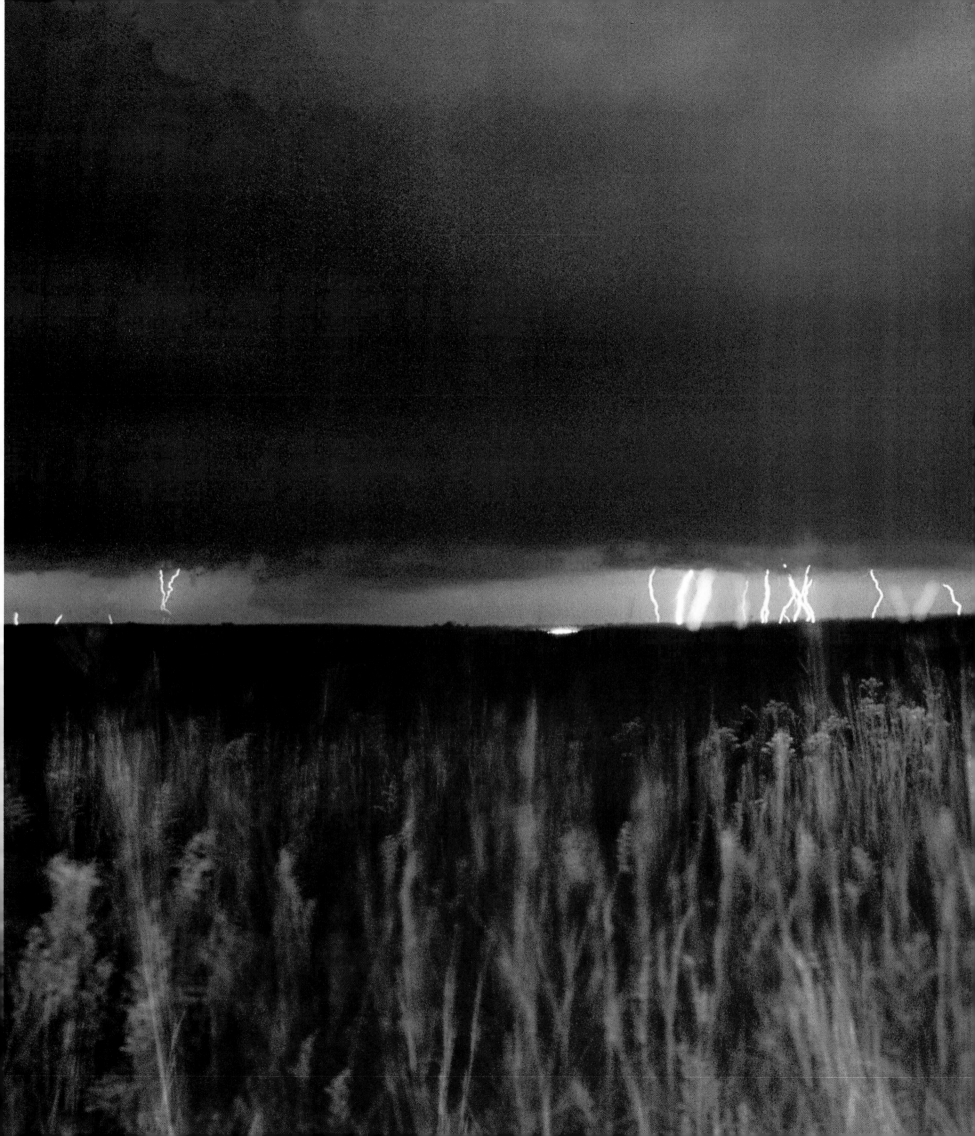

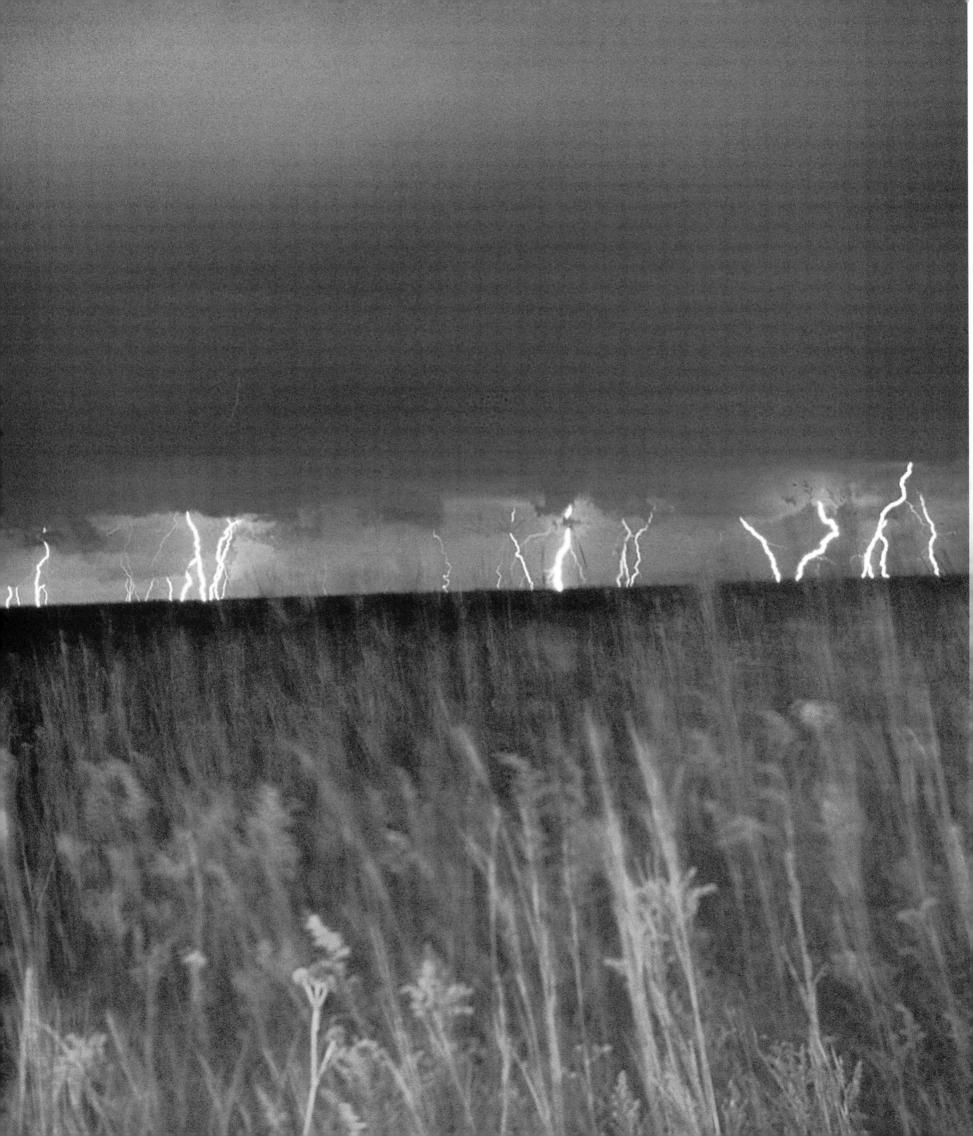

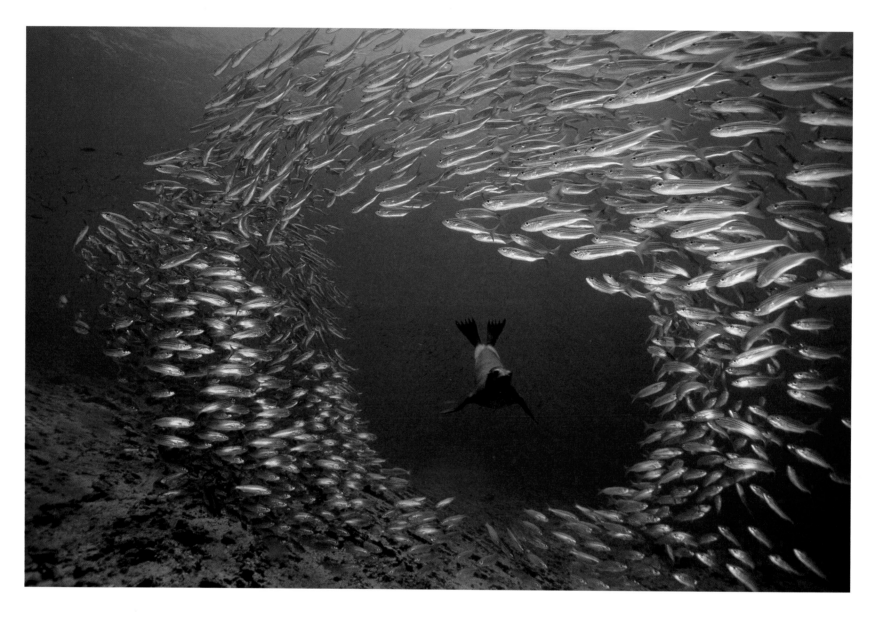

David Doubilet

GALÁPAGOS ISLANDS, 1999 • The hunt goes on as a young sea lion chases a school of salema, that circle defensively, creating a carousel of confusion for the hungry animal.

Stuart Franklin

GALÁPAGOS ISLANDS, 1999 • Marine iguanas—the only seagoing variety in the world—rely upon the sun to help regulate their body temperature in the day and clump together at night to stay warm.

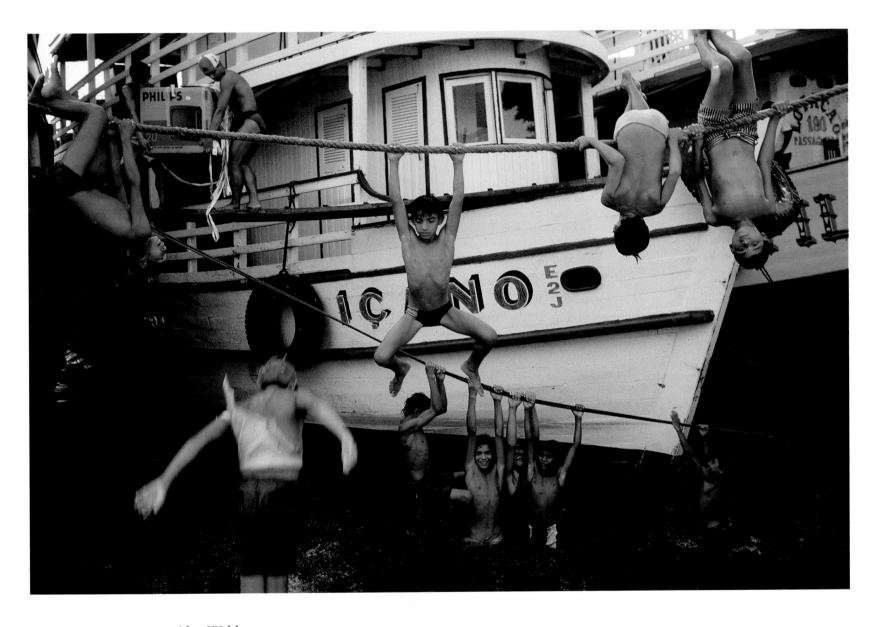

Alex Webb

BRAZIL, 1995 • Young *caboclos*—Brazilians of Indian and European bloodlines—find whatever entertainment they can in the hard world of Amazon River commerce.

William Albert Allard

PERU, 1995 • *Opposite:* In a country where Roman Catholicism is mingled with ancient Indian religions, this young woman wears a mask made of screen-door mesh with outsize features painted on for the Feast of the Cross.

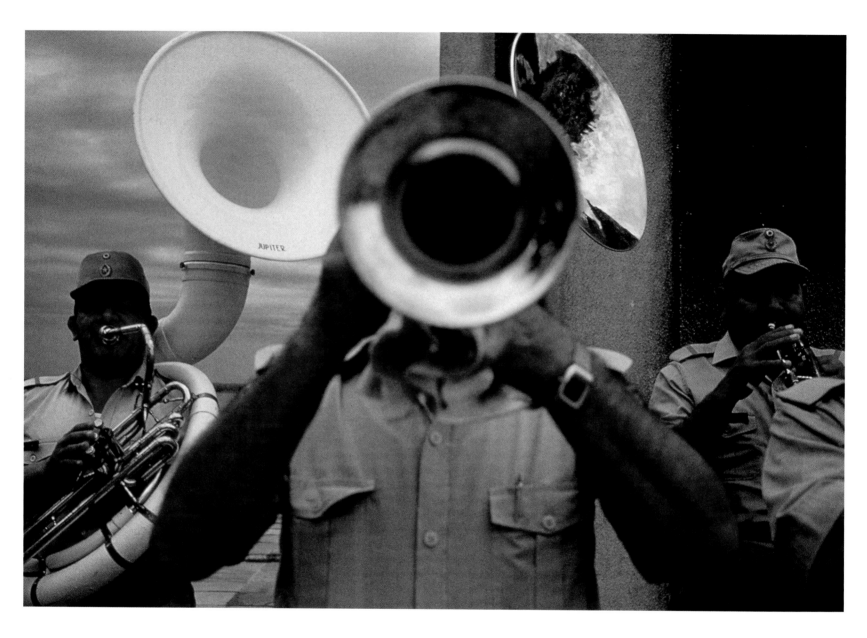

Alex Webb/Magnum Photos

MEXICO, 1994 • Long a traditional part of all kinds of celebrations in Mexico, this mariachi brass band was hired to serenade a backyard family reunion in Mexicali.

Sisse Brimberg
SICILY, 1997 • Explosions of paper streamers ignite the faithful during this celebration of the feast of San Paolo. Taking its English name from Egyptian papyrus, paper reached Italy a thousand years after it was first presented to China's court in A.D. 105.

Sam Abell

ENGLAND, 1991 • The show must go on at the Eastbourne bandstand despite bitter cold that has discouraged even the normally stiff-upper-lip British from attending.

Sam Abell

VENICE, 1995 • *Right:* The Carnival of Venice works its magic, but only for ten days now—a mere caprice compared to the two-month-long bacchanals of the 1700s.

Sarah Leen

RUSSIA, 1992 • Though times are hard for the Russian people, who see their nation unraveling in the fall of communism, young students still look ahead: "Tomorrow things will be better."

David Alan Harvey

BERLIN, 1989 • *Right:* In the early hours of November 12, 1989, a West German policeman guards a gap in the Berlin Wall at Potsdamer Platz as East German officers arrive to confront the formerly unthinkable.

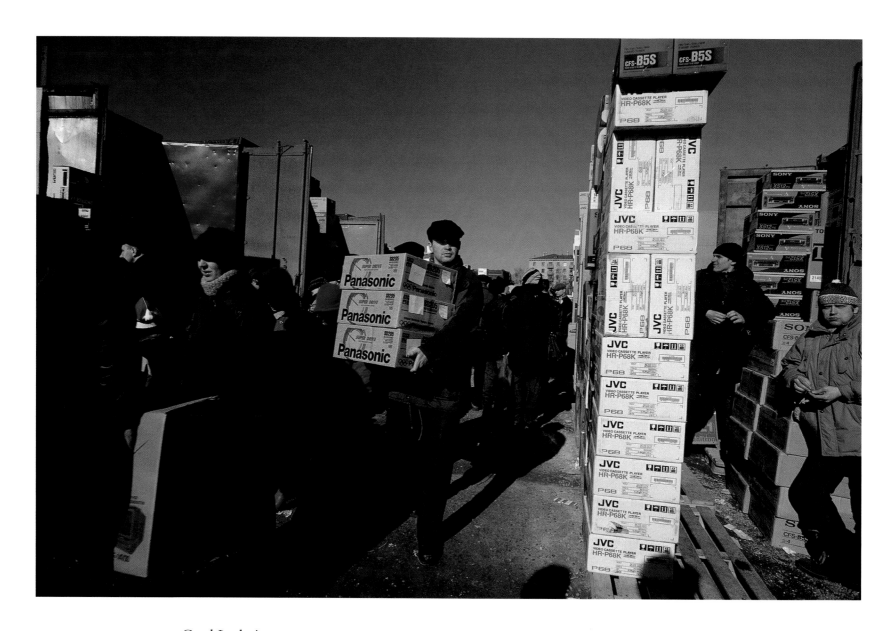

Gerd Ludwig

RUSSIA, 1996 • Filling the vacuum left by the collapse of Soviet communism, capitalism was quick to seize a foothold in Moscow through this open-air market where millions of dollars in costly imported goods are moved each weekend.

James Nachtwen

ROMANIA, 1991 • The citizens of Copsa Mica live beneath constant fallout from a carbon-black plant, which they defend against by coating their insides with milk, and stand on top of high soil levels of lead, zinc, and cadmium from the local lead plant. GEOGRAPHIC photographers brought to readers this grim picture of pollution in hopes of contributing to understanding the enormous difficulties faced after communism's fall.

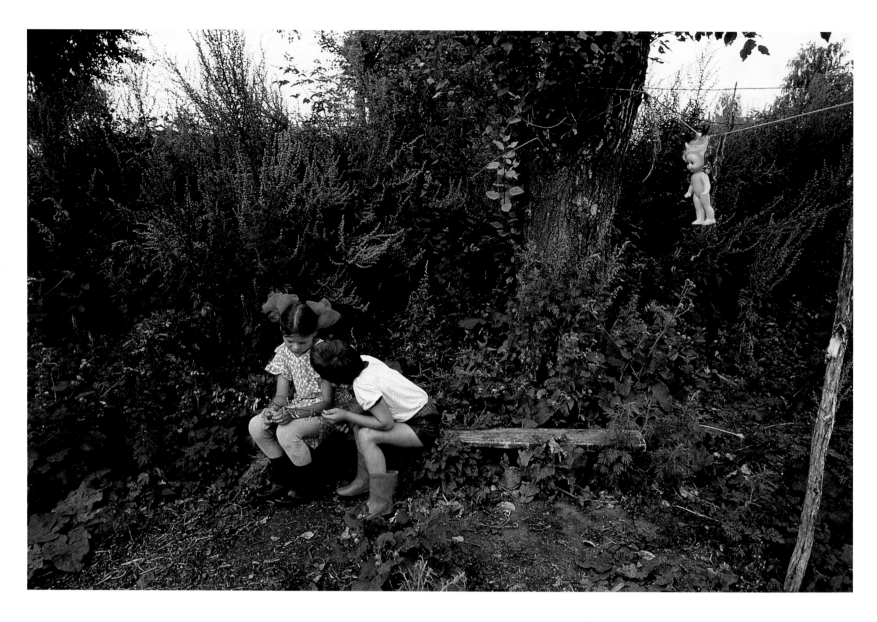

James P. Blair

RUSSIA, 1994 • While a doll hanging out to dry seems to listen over their shoulders, two young girls share secrets in a weedy garden on the banks of Volga Matushka, or Mother Volga.

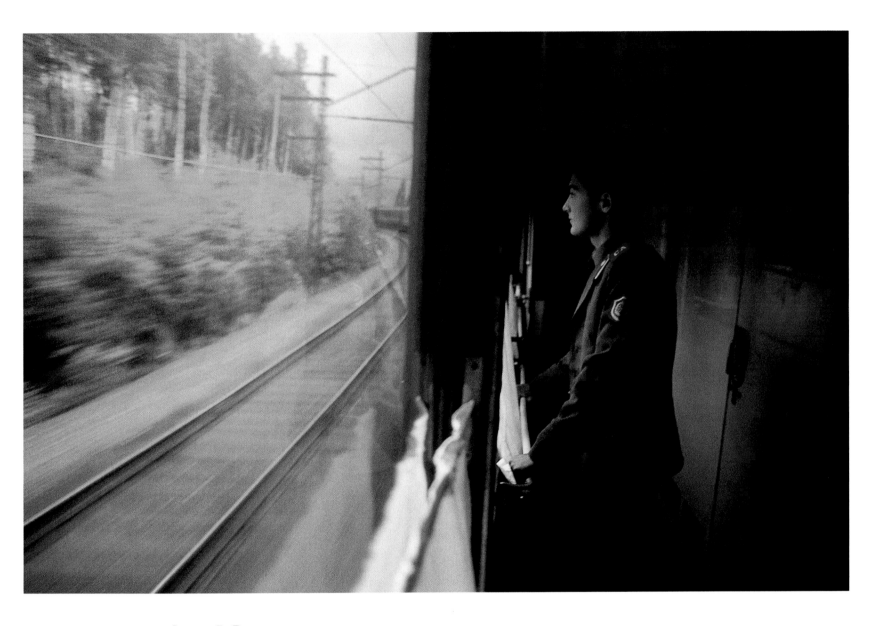

Steven L. Raymer

MONGOLIA, 1988 • A lone Soviet soldier contemplates the scenery, and perhaps what lies ahead, on a long train trip from Irkutsk, U.S.S.R., to Ulaan Baatar in the Mongolian People's Republic.

Damien Morrissot/Black Star

ANTARCTICA, 1990 • *Following pages:* On the Weyerhaeuser Glacier, a giant, hundred-foot-deep crevasse yawns wide open to swallow any sled team that recklessly passes too close.

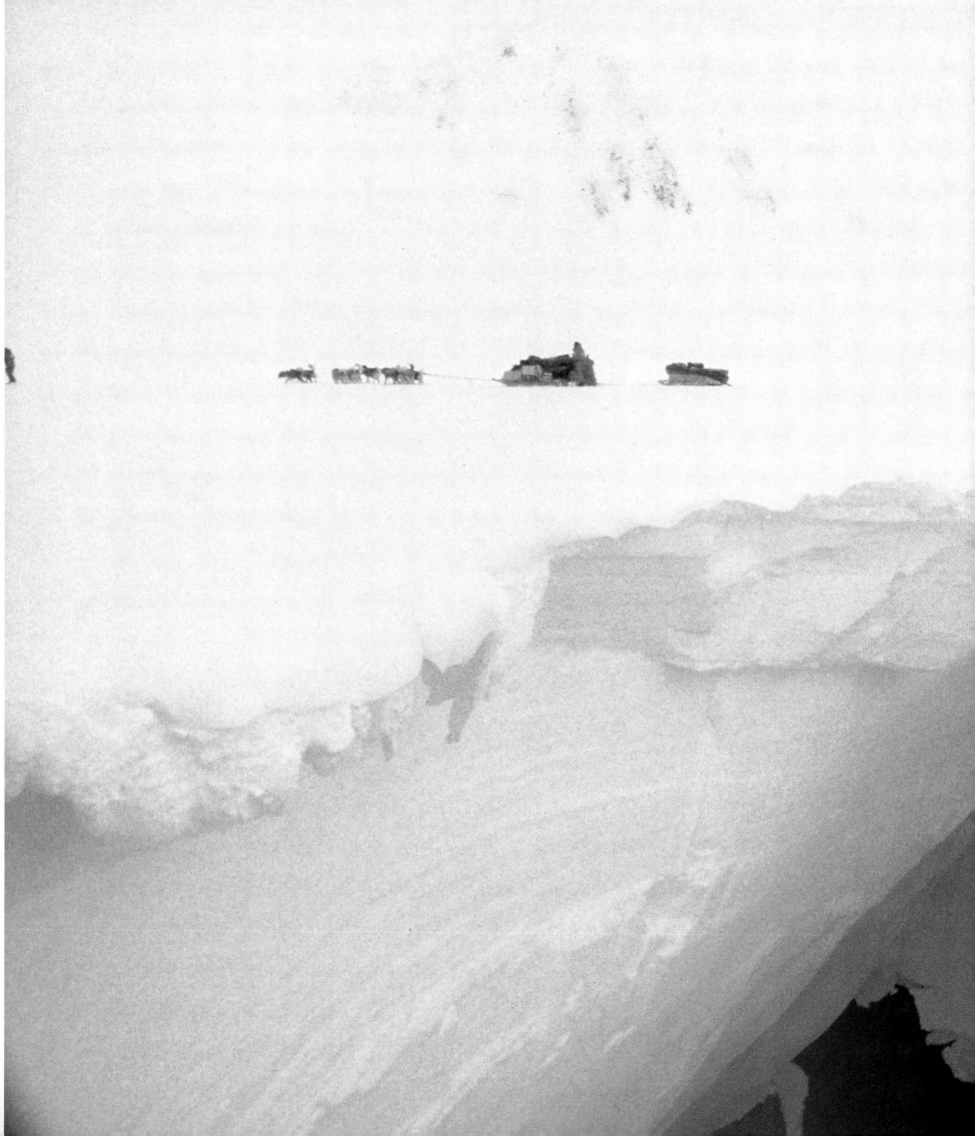

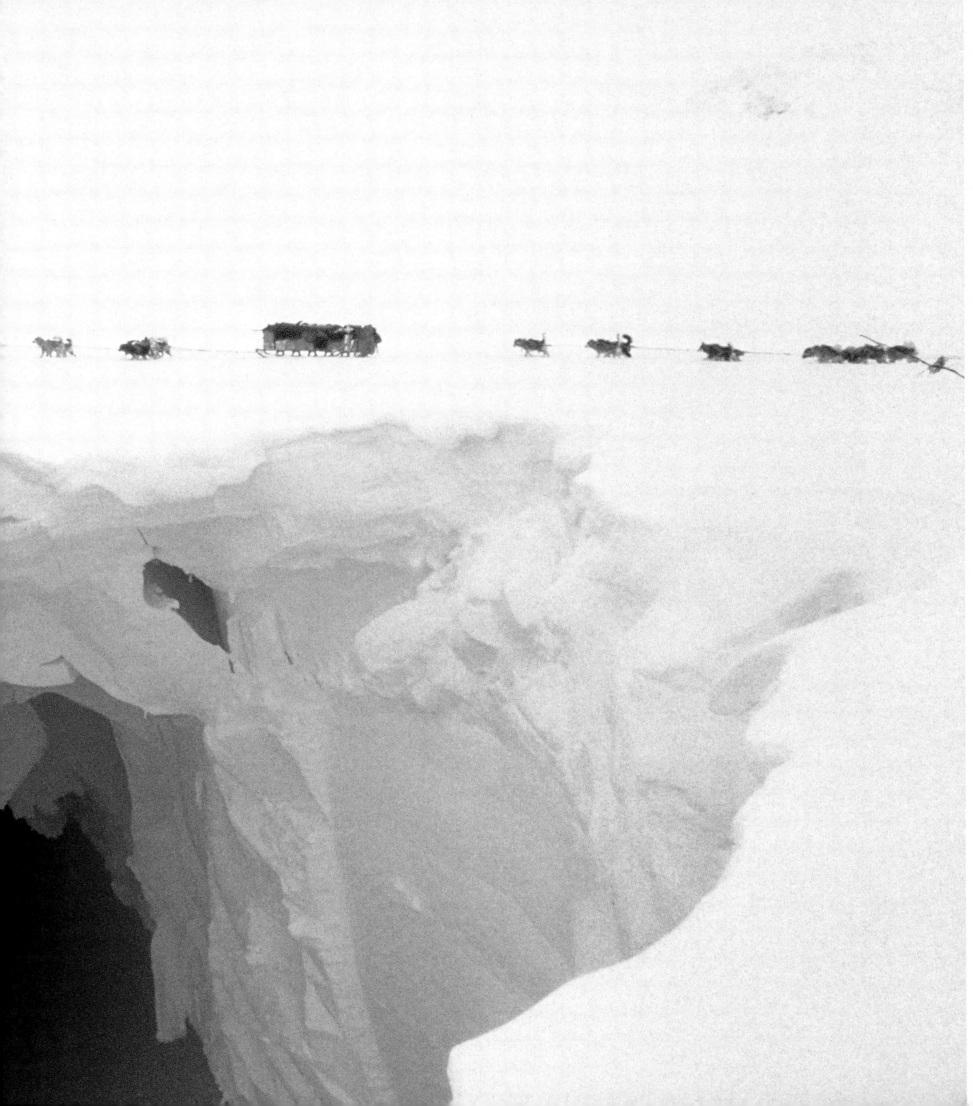

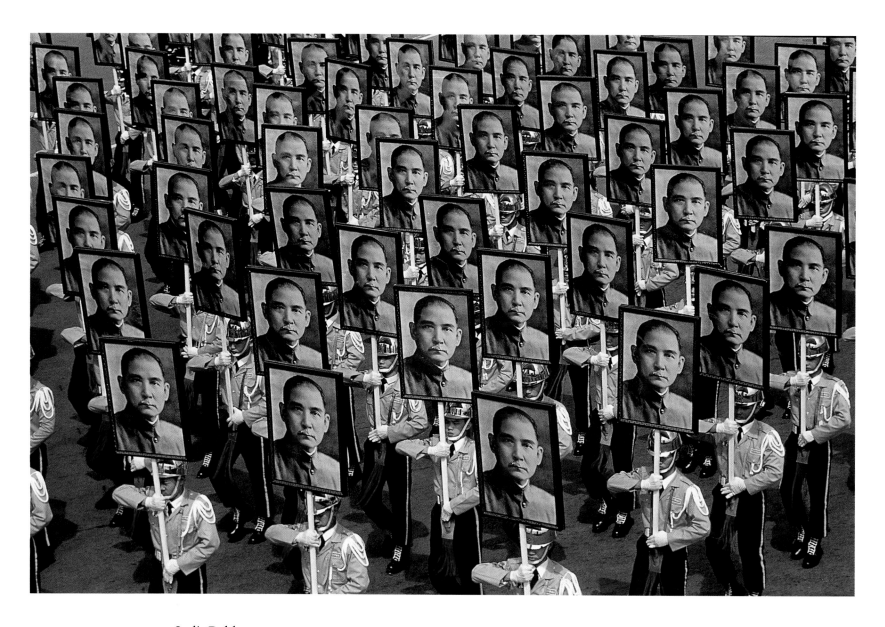

Jodi Cobb

TAIWAN, 1993 • Personifying freedom for the people of Taiwan, Sun Yat-sen's portrait is paraded by rank and file on National Day, which celebrates the 1911 revolution inspired by Sun that overthrew China's last dynasty.

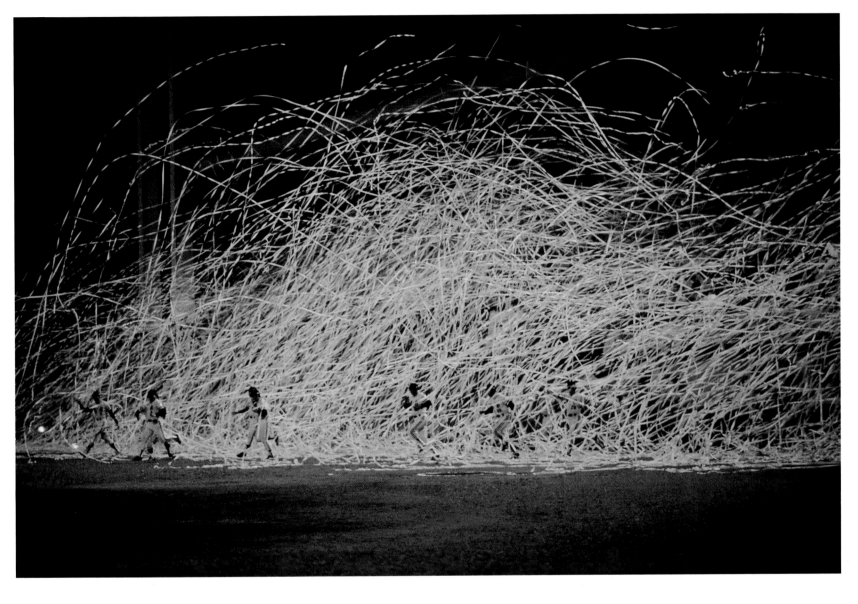

Jodi Cobb

TAIWAN, 1993 • A blizzard of streamers engulfs Taiwan's 1992 baseball champs, the Brother Elephants. Growing in number, fans enthusiastically support the island's only professional sport.

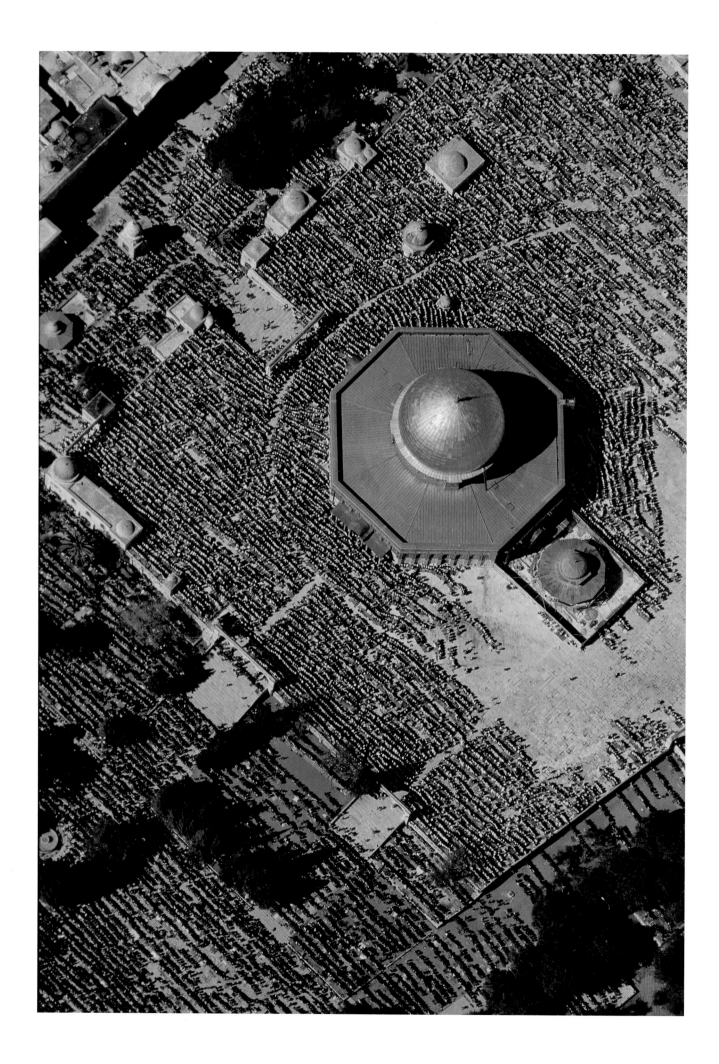

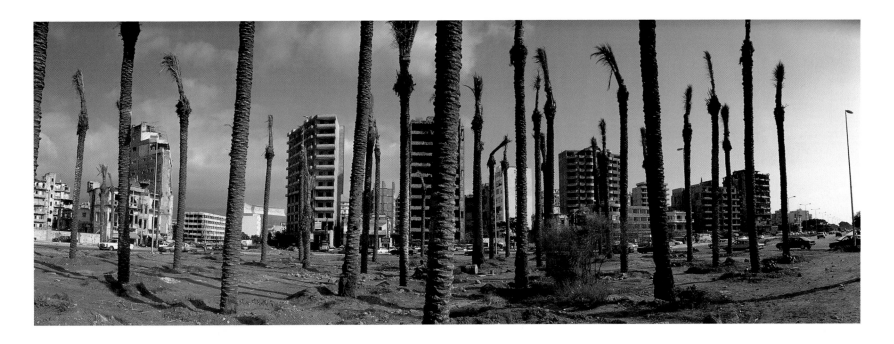

Ed Kashi

LEBANON, 1997 • Forlorn as the gutted buildings, newly planted palms signal first efforts to rebuild the Central District of Beirut, a city that has overcome adversity many times in a history that dates back to the Canaanites of 3000 B.C.

Annie Griffiths Belt

JERUSALEM, 1996 • *Opposite:* Completed in A.D. 692, the Dome of the Rock is surrounded by 200,000 Muslims who gather to pray during Ramadan on the Haram al-Sharif, or Temple Mount.

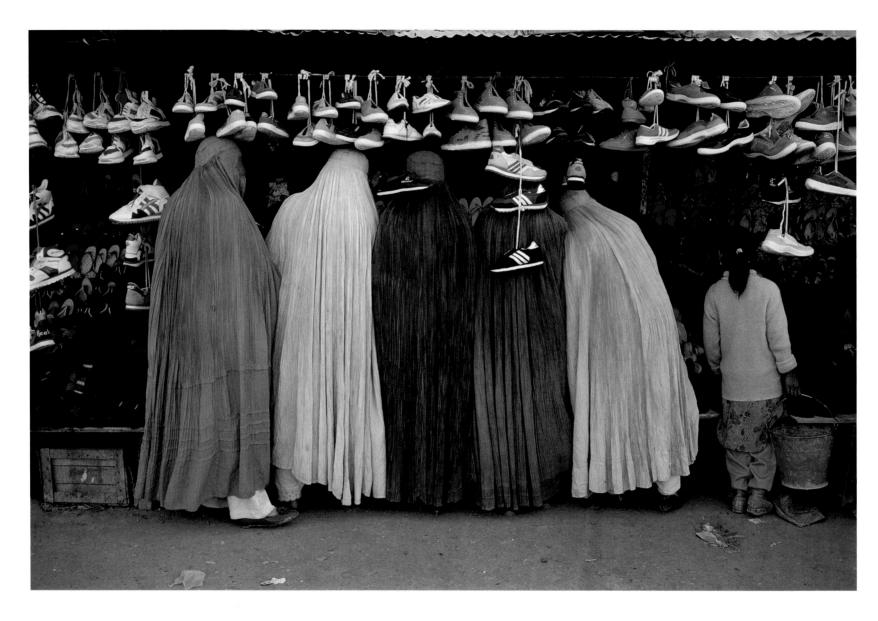

Steve McCurry

AFGHANISTAN, 1993 • Covered from head to heel in the traditional chadri, female shoppers at a Kabul street-stall signify the return of Afghanistan to fundamental Islam.

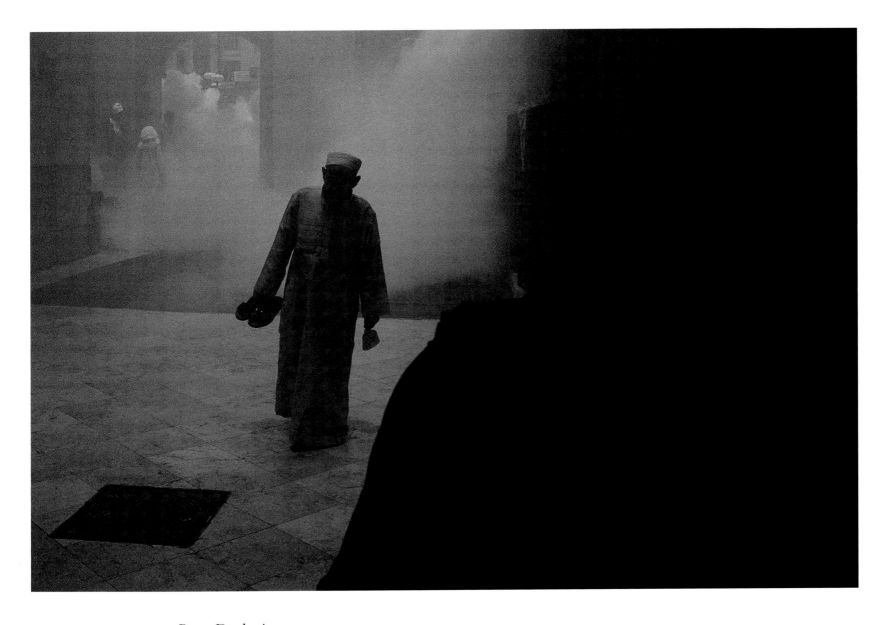

Reza Deghati

EGYPT, 1993 • Undeterred by a pesticide fog billowing in from garbage-strewn streets, many of Cairo's poor visit the thousand-year-old El Azhar Mosque in anticipation of a Muslim feast that commemorates Abraham's sacrifice, an act of faith revered by adherents to Islam, Judaism, and Christianity alike.

James L. Stanfield

AFRICA, 1990 • *Following pages:* In a scene that has not changed in centuries, camels bear the burdens in a caravan that passes across the barren desert of North Africa.

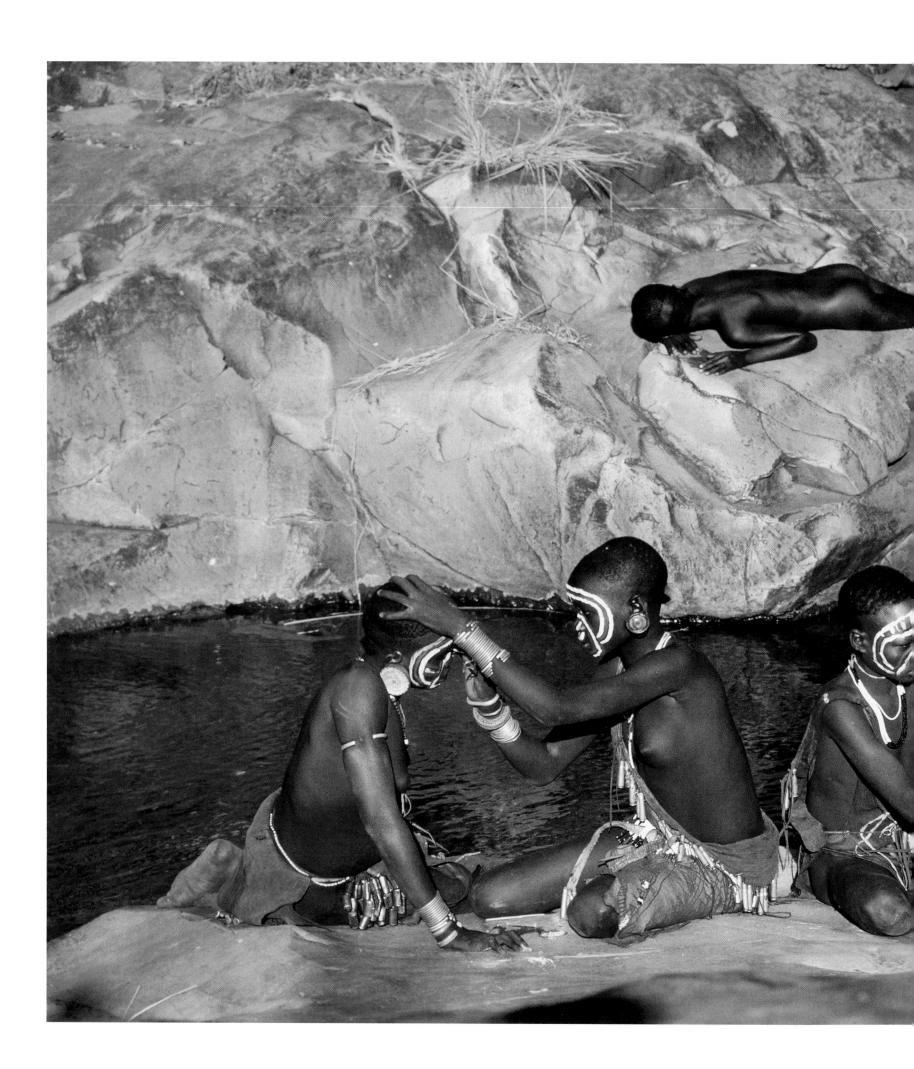

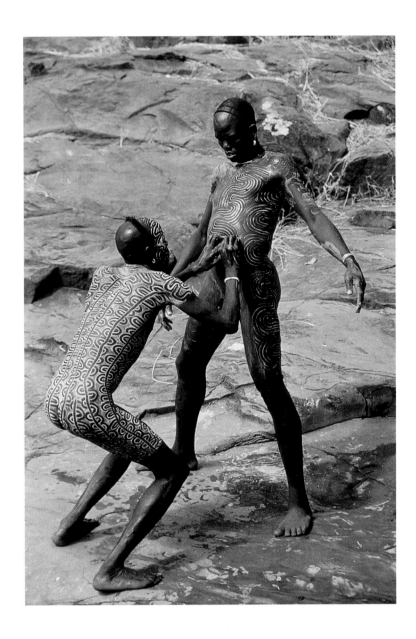

Angela M. Fisher

ETHIOPIA, 1991 • To impress women or to intimidate opponents, these young men decorate their bodies in designs worked with a chalk-and-water mixture that sometimes gets highlighted with ocher.

Angela M. Fisher

ETHIOPIA, 1991 • *Left:* While a boy bakes in the sun after a chilly dip in the Dama River, young girls on the opposite bank practice their beautification skills on each other.

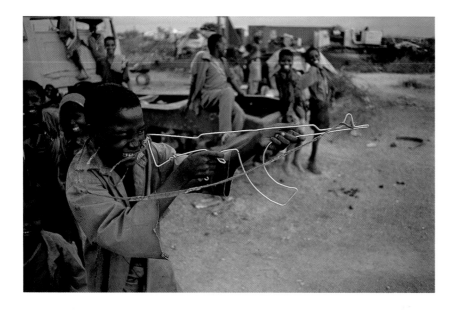

Robert Caputo

AFRICA, 1993 • In the streets of Mogadishu, which has seen more than its share of
violence and suffering, young children, often orphans, emulate the excesses of their
elders with toy guns made of scrap wood or wire.

Robert Caputo

AFRICA, 1993 • *Right:* Drought, floods, and civil war have left more than a million
Sudanese at risk of starvation. Symbolic of a tragedy only now emerging, this Sudanese
orphan sits despondent in a hut of sticks and plastic sheeting.

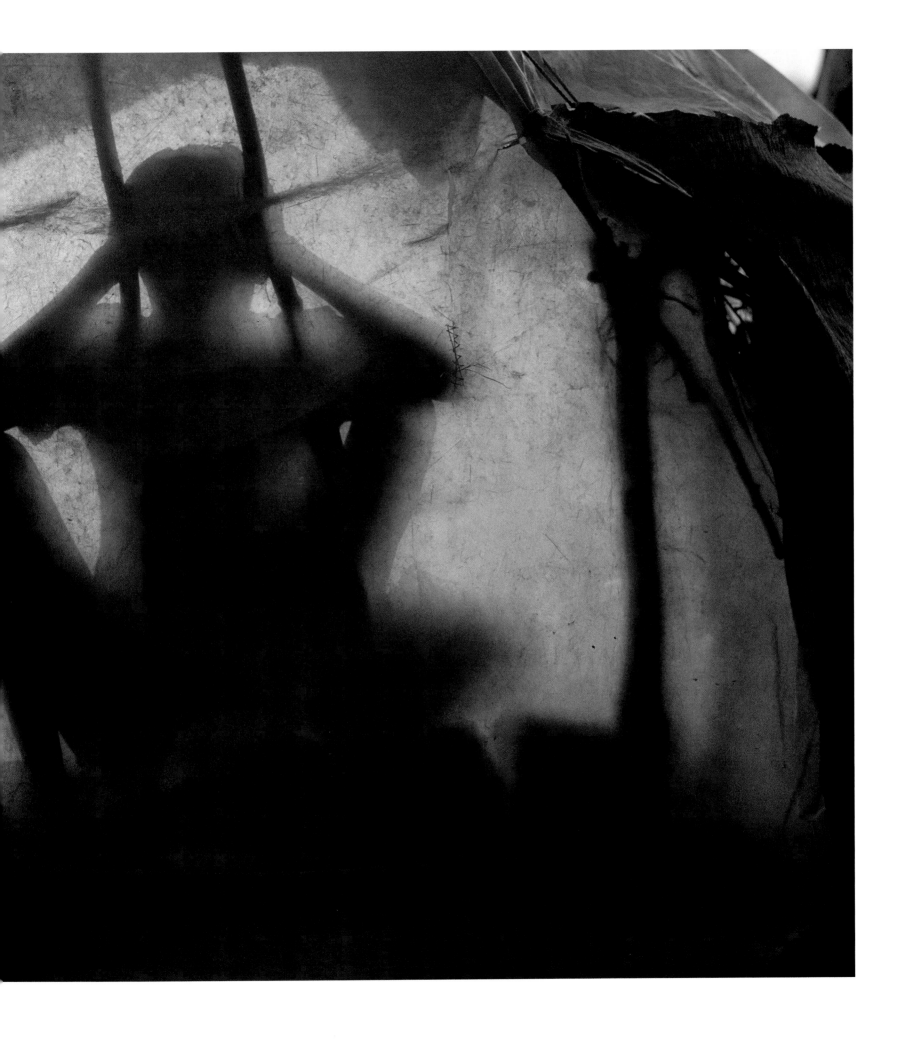

James Nachtwey

SOUTH AFRICA, 1993 • Flames blast an agricultural worker in
Natal as leaves are burned off sugarcane to make the cutting easier,
work that is often done by black migrant laborers who live in all-male
company barracks.

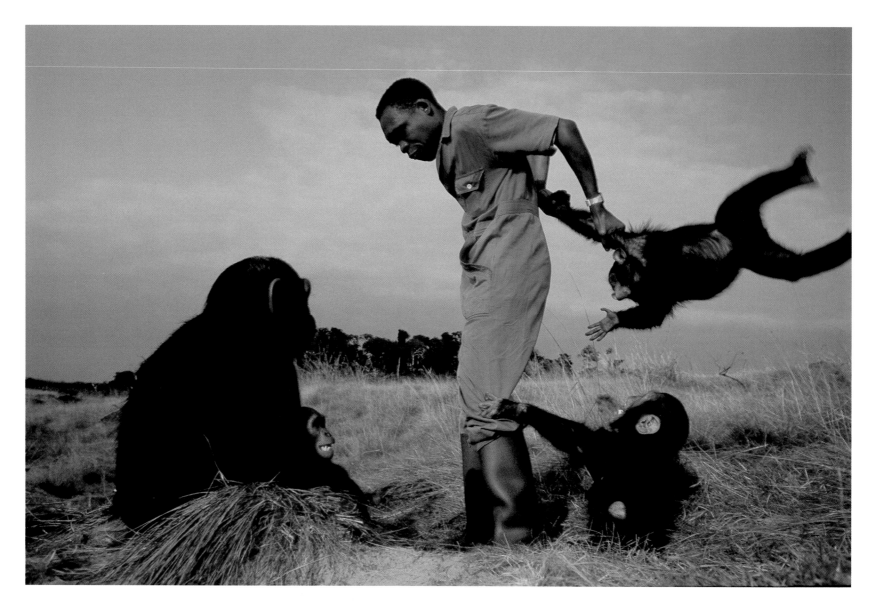

Michael Nichols

AFRICA, 1995 • Like humans, infant chimps crave affection and enjoy play. Here, they are eager for a turn at a swing around the caretaker who doubles as surrogate parent to 50 orphans at Tchimpounga.

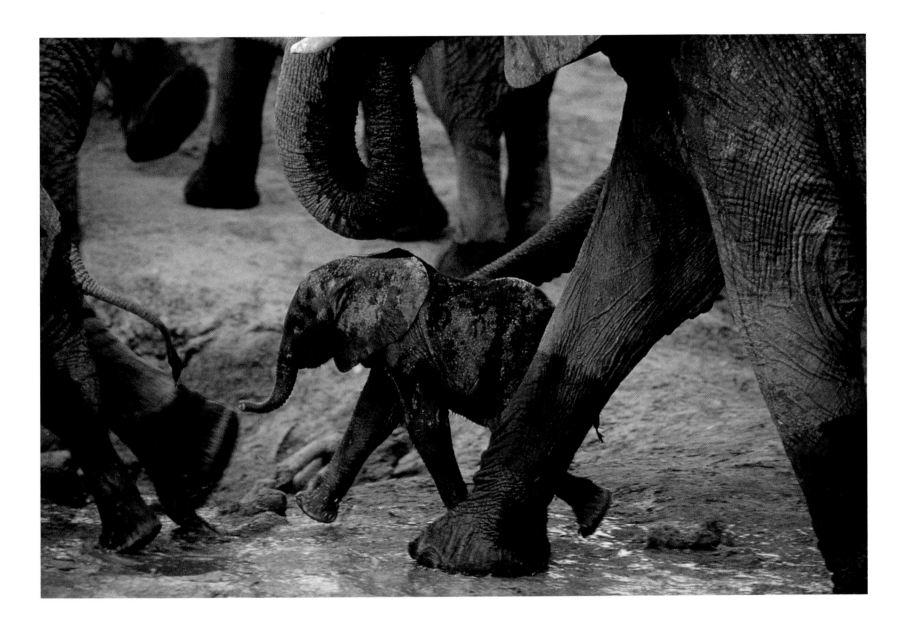

Frans Lanting
AFRICA, 1990 • A baby elephant of less than five weeks struggles to keep pace at a Savute water hole in Botswana, where the herd numbers more than 60,000 and continues growing, a threat to the habitat that may necessitate culling.

Chris Johns
AFRICA, 1999 • *Following pages:* After five yearling wild dogs spend several minutes playfully chasing and nipping a warthog, an adult male (wearing a radio collar) steps in for the kill, which takes less than 60 seconds.

Chris Johns

AFRICA, 1996 • As part of their preparation for manhood, these youngsters, who live along the remote upper reaches of the Zambezi, are exposed to fearsome rituals performed by Mshiki tribal dancers.

Chris Johns

AFRICA, 1997 • *Following pages:* A dust storm of migrating wildebeests pounds through Zambia's Liuwa Plain National Park, a little-visited refuge that the photographer calls a "rival of the Serengeti."

New Technologies

George Shiras III

ALASKA, 1906 • Slipping quietly along a stream until his lantern beam reveals the eyes of a nearby animal, Shiras then moves close enough to fire his flash powder and record the image on his camera's plate.

"It was indeed a red-letter day in world progress when, in 1829, the two Frenchmen, Daguerre and Niepce, combined their researches in chemistry and the camera, out of which emerged the daguerreotype. Down the milestones of a hundred years from that day, the brains of unnumbered students of photographic science have labored and traveled to perfect and simplify the need of mankind for faithful imagery, and thus create a language that is today more universally understood than any sounds formed by the human voice."

—*Melville Bell Grosvenor, "The Color Camera's First Aerial Success," September 1930*

It is this language of photography that NATIONAL GEOGRAPHIC, assuming it to be "faithful" and "universal," has presented on the pages of the magazine with great enthusiasm and as much technical flair as possible. It was a celebration of photography, the world, and the human capacity for invention. As Grosvenor, the grandson of Alexander Graham Bell, himself put it, "The fundamentals of the camera were known as far back as the twelfth century...but whereas pioneer experimenters of the Middle Ages groped laboriously forward, recording progress through slow decades and centuries, the modern development and refinement of the camera and the photograph—the stereoscopic camera, the motion picture, the natural-color photograph, the aerial photograph, the micro-photograph, the x-ray photograph, the sound picture—have all come within the memory of living men."

Such was his glee introducing his own "...first successful natural-color photographs made from the skies," following the "...first natural-color photographs to be made of under-sea life..." (January 1927) and "...the first series of natural-color photographs of the Arctic regions..." (March 1926), all published in the GEOGRAPHIC. But Melville Grosvenor, a future Editor of the magazine, understood that it was not only the history of photography that the GEOGRAPHIC should celebrate and acknowledge but also a parallel technological revolution:

"Of equal importance and value in the dissemination of knowledge through

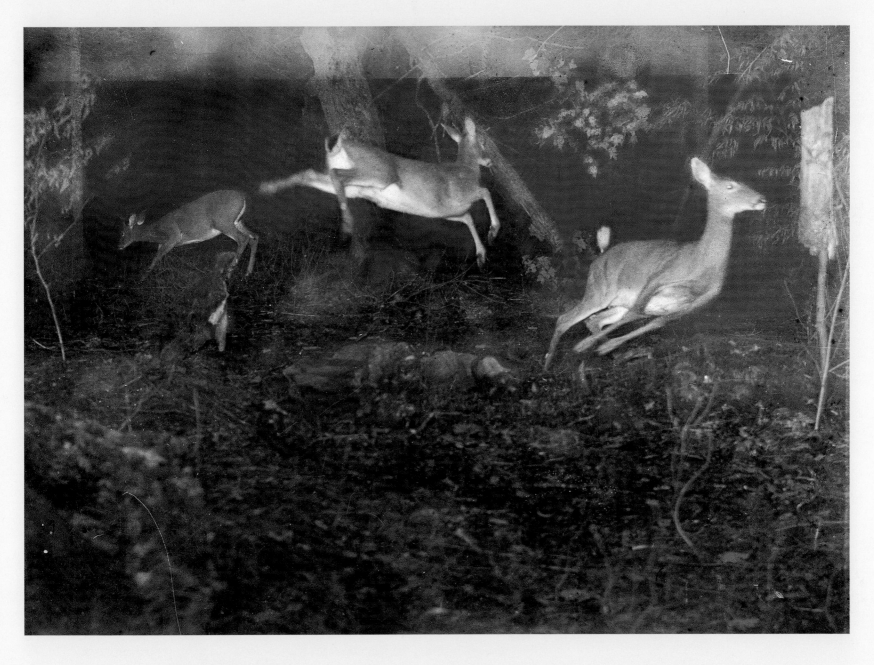

George Shiras III

MICHIGAN, 1921 • This animated scene came about as the deer first triggered the firing of a blank cartridge
and then set off the flash powder as they bounded away.

Bruce Dale
MASSACHUSETTS, 1987 • The carefully synchronized strobo-scopic light on Harold Edgerton's Hydraulic Happening Machine in his M.I.T. lab enables the photographer to capture the individual drops that make up the flow of water.

photographic records has been the contemporary development of photo-engraving, by means of which the details of a photograph may be transferred to the printed page, both in black and white and in color, and thus less expen-sively multiplied by the million. The educational value of this achievement is priceless."

For the GEOGRAPHIC, these two developments—the technologies of photography and of photoengraving—have resulted in making, as Grosvenor put it, "...the photographic illustration its handmaiden" to pursue its "...mission—the increase and diffusion of geographic knowledge...." And throughout the magazine's history, by peering underwa-ter and into outer space, using remote cameras on animals in the wild, pioneer-ing new forms of color film and "freez-ing" very fast moving objects, it managed to embrace and expand a repertoire of new photographic technologies.

For example, in the 1920s pho-tographing fish as they swam underwater and in color was a formidable challenge that had never been met before. The Autochrome, an early form of color photography that the GEOGRAPHIC had been extensively using, required a long exposure time even outdoors in normal sunlight. It was considered unsuitable for use in comparatively dark undersea con-ditions. But in 1926 W. H. Longley and Charles Martin, demonstrating entrepre-neurial and technical talents, suspended an entire pound of magnesium (a pinch was the normal amount) from a three-float pontoon to create a very large flash that could be triggered underwater.

While risking death or blindness if the magnesium accidentally went off too soon, Martin managed to photograph a group of gray snappers and a yellow goatfish as they swam by. Along with the powerful light source, Martin had also found a way to sensitize glass plates with an emulsion that reduced exposure time from a full second to one/twentieth of that. But the heat and humidity of the Florida Keys were such that he had to coat the plates before dawn to prevent the emulsion from melting. All of this seems about as far from today's "point-and-shoot" cameras as one can get.

Or, in another early example, "Wild Animals That Took Their Own Pictures by Day and by Night," George Shiras III (July 1913), had similarly tried to do what no photographer had managed to achieve before. Or, as he stated, "The purpose of this article is to show that a camera and accessories can be so arranged that any animal or bird and many a reptile, however large or small, agile or cunning, may have its picture faithfully recorded, during daylight or darkness, without the immediate pres-ence of a human assistant." While Shiras used magnesium powder, some eight decades later photographer Michael Nichols set up cameras in the wild whose shutters are triggered by breaking an infrared beam, also coming up with imagery that a human presence would have precluded.

Through its continuing support of the latest in camera technology, the GEOGRAPHIC was often first in publish-ing photographs of what otherwise could not have been seen by the human

eye. As early as 1913, in an article entitled, "The Monsters in Our Backyards," David Fairchild made use of macrophotography to capture greatly magnified close-ups of the "bugs" with which we share our environment. Somewhat later, through microscopic photography and the latest in medical imaging, the GEOGRAPHIC regularly took its readers on journeys through the innermost passages of the human body.

And through its longtime sponsorship of undersea exploration, the GEOGRAPHIC contributed to developments in submersibles and remote cameras that enabled humans to photograph the ocean's deepest trench as well as the wreck of the nuclear-powered submarine *Thresher* at a depth of 8,500 feet.

In 1934 and 1935 Society-sponsored high-altitude balloons Explorer I and II set records at 72,000 feet that endured for 20 years, and toward the end of the century the GEOGRAPHIC went even farther afield to publish three-dimensional imagery from the planet Mars. In 1984, the GEOGRAPHIC was the first major magazine to feature a hologram on its famous cover.

It is this combination of inventiveness and seriousness that has enabled the GEOGRAPHIC for so long to push the envelope of what we know about the world, and what photography has been able to show us.

Harold E. Edgerton
MASSACHUSETTS, 1987 • Shot through the head, the king of diamonds begins to disintegrate even while the assassin's bullet is still in the picture, another example of "Doc" Edgerton's ability to make time stand still.

Bruce Dale

MASSACHUSETTS, 1996 • *Top:* Killing time takes on a literal meaning in this stroboscopic photograph of a bullet shattering a wristwatch in a millionth of a second.

Sisse Brimberg

WASHINGTON, D.C., 1988 • *Bottom:* In preparation for shooting the December 1988 centennial cover of NATIONAL GEOGRAPHIC, a holographic image of a crystal globe shattered by a bullet, editor Wilbur E. Garrett examines the handiwork of photographer Bruce Dale in his basement studio.

Bruce Dale

CALIFORNIA, 1977 • *Right:* From the cockpit, the photographer activates two cameras mounted on the aircraft's vertical stabilizer to record the streams of light that trace a landing at Palmdale.

George Steinmetz
AFRICA, 1998 • *Top:* Aboard a propeller-driven paraglider, which Steinmetz devised and described as a flying lawn chair, the photographer finds that the Sahara is stranger and more beautiful than he'd imagined.

George Steinmetz
AFRICA, 1998 • *Right:* Captured from a spectacular angle, this aerial photograph shows salt being produced in Niger by evaporating briny well water mixed with salty earth in depressions.

William R. Curtsinger
BIKINI ATOLL, 1995 • *Bottom:* Gray reef sharks swarm toward a disabled Yellowfin tuna already hooked by an angler, challenging the rights to who gets this meal first.

Scott Parazynski

EARTH ORBIT, 1994 • Mount Everest and surrounding Himalaya peaks are conquered from a new perspective by an astronaut formerly scheduled to be on the mountain the same month he took this picture from space.

Carl Meade

EARTH ORBIT, 1994 • *Opposite: Discovery* astronaut Mark Lee flies free 165 miles above Earth as he makes the first in-space test flight of a miniature rocket backpack.

INDEX

NATIONAL GEOGRAPHIC PHOTOGRAPHS
THE MILESTONES

By Leah Bendavid-Val, Robert A. Sobieszek, Carole Naggar,
Anne H. Hoy, Ferdinand Protzman, Fred Ritchin

Published by the National Geographic Society

John M. Fahey, Jr.	*President and Chief Executive Officer*
Gilbert M. Grosvenor	*Chairman of the Board*
Nina D. Hoffman	*Senior Vice President*

Prepared by the Book Division

William R. Gray	*Vice President and Director*
Charles Kogod	*Assistant Director*
Barbara A. Payne	*Editorial Director and Managing Editor*
David Griffin	*Design Director*

Staff for this book

Leah Bendavid-Val	*Editor*
Marilyn F. Appleby	*Art Director*
Walton Rawls	*Text Editor*
James B. Enzinna	*Researcher*
Vickie M. Donovan	*Assistant Illustrations Editor*
Kevin G. Craig	*Assistant Editor*
Janet A. Dustin	*Illustrations Assistant*
Alexander L. Cohn, Natasha Lily Klauss	*Research Assistants*
R. Gary Colbert	*Production Director*
Lewis Bassford	*Production Project Manager*
Peggy Candore	*Assistant to the Director*
Connie Binder	*Indexer*

Manufacturing and Quality Control

George V. White	*Director*
John T. Dunn	*Associate Director*
Vincent P. Ryan	*Manager*

Special thanks to Martha C. Christian, Contributing Editor, and to the National Geographic Image Collection: Hilda T. Crabtree, Flora Battle Davis, Paul Lionell Petty, Vlad Kharitonov, Aleta (Ricky) Sarno, William (Bill) Bonner

Library of Congress Cataloging-in-Publication Data

National Geographic photographs : the milestones : a visual legacy of the world.
 p. cm.
 ISBN 0-7922-7520-9 (reg)
 ISBN 0-7922-7521-7 (deluxe)
 1. Travel photography--History. 2. Documentary
photography--History. 3. National Geographic Society
(U.S.)--Photograph collections. I. National Geographic Society
(U.S.)
 TR790.N37 1999
 779--dc21
 99-29397
 CIP

The world's largest nonprofit scientific and educational organization, the National Geographic Society was founded in 1888 "for the increase and diffusion of geographic knowledge." Since then it has supported scientific exploration and spread information to its more than nine million members worldwide.

The National Geographic Society educates and inspires millions every day through magazines, books, television programs, videos, maps and atlases, research grants, the National Geography Bee, teacher workshops, and innovative classroom materials.

The Society is supported through membership dues and income from the sale of its educational products. Members receive NATIONAL GEOGRAPHIC magazine—the Society's official journal—discounts on Society products, and other benefits.

For more information about the National Geographic Society and its educational programs and publications, please call 1-800-NGS-LINE (647-5463), or write to the following address:

National Geographic Society
1145 17th Street N.W.
Washington, D.C. 20036-4688 U.S.A.

Visit the Society's Web site at www.nationalgeographic.com